Also by Anne Hollander

Sex and Suits
Moving Pictures
Seeing Through Clothes

Feeding the Eye

Feeding the Eye

Essays

Anne Hollander

Farrar, Straus and Giroux / New York

Farrar, Straus and Giroux
19 Union Square West, New York 10003

Distributed in Canada by Douglas & McIntyre Ltd.
Printed in the United States of America
Designed by Jonathan D. Lippincott
First edition, 1999

Library of Congress Cataloging-in-Publication Data
Hollander, Anne.
 Feeding the eye : essays / by Anne Hollander. — 1st ed.
 p. cm.
 Includes index.
 ISBN 0-374-28201-3 (alk. paper)
 1. Costume—Social aspects. 2. Costume in art. 3. Art and motion pictures.
4. Clothing and dress—History. I. Title.
GT525.H646 1999
391—dc21 99-30594

To Janet Malcolm and Gardner Botsford

Contents

Preface

Since the arrival of cinema a hundred years ago, visual art has increasingly been perceived as if it were in motion. As this century ends, imaginative visual creation tends to be attempted less often in fresco and carved stone and more often on film or tape, on the dance stage or in clothes. The study of past art has even been revised accordingly, often in order to find the contingent circumstances of its origins rather than to discern and evaluate its abiding qualities. Along with film, the arts of dance have had an unprecedented rise during the last hundred years, and so has the art of couture. This ascendancy has been due to a strong development inside these enterprises that has been sustained by society's increased zest and respect for them, with all their mutability.

New changeable visual media—video, forms of temporary assemblage and installation, computer-generated imagery—have risen to mix with all the old traditional ones, besides dress, film, and dance. The result is that in the twentieth century, stage performance came closer to the world of pictures and statues, and many motionless works of art have become more like dynamic performances. Meanwhile, everybody knows that the physical aspects of sex (and religion, too) have always had easy relations with ephemeral arts such as dress and dance (and movies, too) since those arts invoke the living body and its performance of ritual acts, even when they aren't directly referring to them. We have lately seen more sex in art partly because of the new nature of art.

But whether it's fluid or stable, what interests me about visual art

remains constant. I assume that new created imagery represents a response of some kind to extant imagery, especially if it has any forceful meaning or any emotional valence in itself. I see the vitality of art persisting through the same regenerative processes that we find in life, and I do not believe it was ever created *ex nihilo*: artists make art by absorbing the effects of other artists' productions, transmuting them through a personal effort inflected by circumstance and then rendering a newly shaped thing back into the continuing stream. Original genius consists in the ability to do this most boldly, deliberately, and imaginatively, so that the public can perceive the works (maybe not immediately) with both recognition and surprise.

Artists' creative responses may be to imagery of the same epoch or of remote periods or to works in despised or irrelevant media; they may be sympathetic or antipathetic, or not even quite conscious. But they are always there, engendering yet newer works on new visual themes, or verdant variations on decayed or etiolated ones, right along with violent rejections of what's conventional and crude or sleek variants of what's out there now. Art has an endless life of created form, nourished and moved forward by individual makers, who are creatures of their own limited moment and give apt momentary significance to it. Tracing this life of art is always rewarding work, and I think works of art yield their secrets more willingly to those who do it.

I emphatically include the art of dress in these assumptions, opposing those who may believe it to be the pocket mirror of its moment only, with no life that isn't current. Dress is the one art we have all been practicing since prehistory, gradually following the shifting flow of taste, feeling, and custom, as we still are.

Like the other visual arts, the ancient art of dress, containing fashion and non-fashion in its long history of visual form, is perpetually being re-created by its practitioners—meaning everybody who gets dressed. And they, too, are all influenced, consciously or not, by the contributions of others past and present. The art of dress was made modern and mercurial by fashion, a cultural development of the European Middle Ages; and couture is a recent special case of modern design as applied to fashion, which is now drawing popular attention as a star vehicle. Dress, fashion, and modern clothes design all combine the qualities of still image making and performing art, and each pro-

duces a nexus of detached aesthetic effort, current social meaning, and individual sexuality.

The first thing that interests me in any visual image is how it really looks, as distinct from what its immediate cultural message may be. I want to see clearly what the actual form of the object is. Then I want to see how the shapes and lines of other visions vibrate in this one, as distinct from the echoes of other messages. I presume that this visual form, charged with all these vibrations, has meaning to communicate; and moreover I presume that this meaning isn't "distinct" at all, except on provisional inspection—that it's inseparable from the other advice the image offers. So if we want to get the whole point of an image, we can't rightly "read" it unless we can really see it.

In avowing the above interests and assumptions, I'm showing that I am of my time, as Honoré Daumier said we must be. I became permanently devoted to art, sex, religion, dance, clothes, and movies well before the middle of the twentieth century, and by then I had already begun to study them and read about their histories and varieties. I consequently inherited what has been defined as the Modern point of view about them, which was in its turn inherited from the Romantic view of them. The writings in this book reflect that complex viewpoint—with some evidence, perhaps, of my more recent education, the informal ways my viewpoint has mutated in the century's last quarter. Following my convictions about continuity, I've sought to find the underlying harmony between what I first came to know and what I have learned since, so I can feel prompted to find out still more as we and all our arts keep moving along.

All the articles now collected in this book were written to order, on assignment; each subject was either a book for review or a proposed topic. Each nevertheless concerned matters I was usually brooding about anyway and about which I relished the chance to write when asked. Now that they're gathered together, I'm not surprised to find that they have a strong family resemblance with respect to their underlying themes, apart from the amicable but sometimes distant relations among their stated subjects.

I am very grateful to all the editors who permitted me to enlarge on these topics in the journals where the essays first appeared.

Some Modern Legends

Isadora Duncan

Isadora Duncan refused to be filmed while she danced. The most eager prophet of modern bodily movement avoided the great new vessel of the truth of motion—unwilling, it would seem, to do without the audience rapport that was indispensable to her success. Her reluctance went with her noticeably religious attitude toward her own dancing and toward art in general. She found she rather liked going to the pictures, but the entertaining movie camera was certainly not the thing to register the sacred communion between Isadora, her muse, and her followers. That, rather, was for fellow artists to attempt.

The visual record of her work consists of artists' renderings, posed and unposed photographs, and written descriptions—much the same as that of Nijinsky's appearances in the same era. But Isadora was a true original, a real prophet, and she had none of Nijinsky's flavor of being a rare flower tended by responsible others; nor did she work in a known tradition that later generations could use as a reference in the absence of any film footage. Her admirers wrote of her in cloudy superlatives rather than in detail, as Nijinsky's also did, but Isadora Duncan, unlike Nijinsky, had detractors, too.

She still does, in the sense that her name is not unreservedly synony-

Review of *Life into Art: Isadora Duncan and Her World*, eds. Dorée Duncan, Carol Pratl, Cynthia Splatt; Foreword by Agnes de Mille (New York: W. W. Norton, 1993) in *The London Review of Books*, March 10, 1994.

mous with greatness but carries a whiff of the ridiculous. Why is this so? When we try to determine the reason, the lack of any comprehensive, mobile visual evidence is all the more tantalizing, since the great photographs by Genthe and Steichen lend Duncan their own dignified, suggestive beauty, whereas some of the indifferent posed shots or amateur snaps often verge on the funny. The drawings and watercolors are more interesting. They give a pretty good idea of the flavor of her dancing, and their own flavor helps support the ecstatic tone of many descriptions, since all three are products of the same epoch and emphasize the same kind of aesthetic response.

It's evident from old reproductions, old magazines, and old posters that a draped female figure with one raised knee, outflung arms, and a tipped-back head frequently appeared toward the end of the last century as a generalized emblem of aesthetic freedom with a tinge of sexual license, a discreetly Dionysiac vision—flying drapery, mobile seminudity, but no blood, no dirt, no brutishness. The artists who drew Isadora Duncan from life seem to be pursuing the ideal into this century, as if they viewed her new propositions for the dance with recognition, not surprise—as if, in fact, both she and they were continuing something that had already begun.

All the renderings of Duncan actually dancing, despite their great variety of personal style, show a curious uniformity in the poses. All the artists caught the same moments—and they were the ones you can already see in the academic and popular art of the previous generation, where Duncan herself must have seen them. Duncan's first European admirers, in 1903 and after, saw this rather purified ideal of natural sexuality and creative freedom coming to amazing life—besides coming from America, the home of Daisy Miller and other free female spirits of the nineteenth century.

Apart from Isadora's imprint on written and pictorial history, there exists the physical memory of the actual Duncan dances, which still dwells in the bodies of her artistic descendants, the students of the students of her original six pupils, the famous Isadorables. Of these genealogically transmitted dances, there are indeed films and videotapes, the works are still being taught, and Duncan classes are still being held. What emerges from all this is the strong, music-like construction of the dances and the complex physical training Duncan developed for herself

and her pupils; and yet in both scornful and enthusiastic descriptions, she was always perceived to be improvising, reinventing the music through her body as she heard it. Clearly she was a great genius of stage performance. Almost nobody can achieve the effect of inspired improvisation, in any stage medium, without very careful composition and rehearsal, so that none of the hard work shows at all.

Many music lovers hated her habit of imposing female solo dances on the profound works of Bach and Beethoven, and traditional dancers trained in the ballet found her movements sloppy and her aims incredibly pretentious. Her admirers were entranced by what was believed to be her complete naturalness, made evident by the absence of showy technical feats. "No leaps! No pirouettes!" they marveled; whereas the ballet master, choreographer, and dancer Serge Lifar, in his *Ballet Traditional to Modern*, said, "Isadora Duncan did nothing but run with her knees bent and her head thrown back . . . Her movements were of a hopeless poverty and monotony." The dances now on tape, in fact, seem various and complicated. What they nevertheless do lack is the sharp edge and harsh force so important in most modern neoclassicism, the unfamiliar and slightly unpleasant formal rigor that distinguished the works of modern artists seeking only the most radical methods, not the most pleasing motifs, in the classicism of the past.

The destruction of traditional styles was a vital theme at the turn of the century, and Isadora Duncan was an artist with advanced creative intuitions; but her neoclassicism was rather literal-minded, unlike that of Stravinsky, say, or Picasso. Ancient Greece was her model, but she was stuck in the entrenched Romantic idea that because Greek art expounded physical Beauty as Truth, Greek art was the truly natural art. That meant that its sacred visual vocabulary should not be tampered with, or treated with any modern aesthetic distance or any irony— postures and garments had to be meticulously studied and followed. In holding to this visual idea, she was very traditional indeed, and perhaps it was the real secret of her instant success. Studying the Greek friezes and vases as if they held the real secret of the human body put her in the same camp as Winckelmann but at a considerable distance from Cézanne—closer, in fact, to Gérôme and Alma-Tadema.

But her performances, which could seem so formless to the artistic avant-garde, so unseemly to staid audiences, were undeniably beautiful,

beyond criticism from either side. The movements, however vigorous, were never uncomfortably startling or ugly, always harmonious and decent, like those fondly associated with innocent childhood. Her greatest genius seems to have resided in her solitary, rather unassuming physical presence, her tall and well-made body dressed in plain drapery, animated by total conviction and native grace, moved by great music. She wore her straight hair plain, put almost no makeup on her gentle face, and hung up plain blue curtains for a backdrop; but she used the best and most subtle stage lighting available, along with the best works of certified musical giants. She danced, moreover, with bare feet, and that in itself was both infantile and licentious, faintly penitential, daring, dangerous, and inescapably disturbing. It wasn't authentically Greek, but it was great show business.

Isadora Duncan clearly appeared at her own perfect psychological moment: a generation earlier or later would have been no good. She might have pulled it off a hundred years before, as a sort of Corinne of the dance in the full tide of Romantic neoclassicism, but neither the heavily responsible mid-nineteenth century nor the fully streamlined mid-twentieth would have welcomed her brand of enthusiastic artless-ness, her brave female summons to unconscious forces, mediated nei-ther by the established rules of stage artifice nor by any brilliantly invented new ones.

Unlike that of most dancers, Duncan's stage career only ended with her life, accidentally truncated in 1927, when she was forty-nine; but the lack of discipline often associated with her art became manifest in her body during her last decade, as she gained weight and lost control of her beauty. She had gone through frightful suffering after the acci-dental deaths of her two older children, later followed by the death of a third after a few hours of life. She became weighted with sorrow, and incidentally with drink. By then, too, the epoch was no longer conge-nial to feminine fleshiness, and everybody's ideal natural woman was young, sleek, and taut, not soft, heavy, and mature.

Now dancing in a tragic vein, Duncan became somewhat laughable on stage as the 1920s progressed, but her influence was already profound and international, assured for a long future. Her pupils in Germany, Russia, France, and the United States were responsible for only a part of it. The rest was her legend, the memory and broad effects of her early

performances, the record of her relations with the great and small of her day, the pictures, and the anecdotes. With these went the eternal modernity of her message, which in sum consisted of a call for honesty, originality, and spontaneity—things often in short supply in the long history of art.

Many books have been written about Isadora Duncan, mainly about her impact, and she wrote an autobiography, mainly about her ideas. *Life into Art* is a work of homage, a sort of latter-day memorial edited by three American women who had separate reasons to admire her and who became friends. First among these is Dorée Duncan, granddaughter of Isadora's brother Raymond, who was himself a fervent and innovative disciple of ancient Greek modes of life and art. The other two editors came to an interest in Duncan through connections with the theater and with Paris, where they met Dorée, who became director of the Akademia Raymond Duncan upon the death of her grandmother in the 1970s. Dorée Duncan writes the acknowledgments and tells the story of the book's inception; Carol Pratl is a dance teacher and historian; Cynthia Splatt has written a book about Duncan's influence on the theater and her theatrical link with Gordon Craig.

The general tone of the text, written by Splatt, is uniformly and irritatingly adulatory, and somewhat dependent on cliché. We are offered little historical or cultural background to account for what is presented as the cometlike phenomenon of Isadora Duncan. Although her family is credited with a primary effect on her work, she is seen as utterly unprecedented, always an influence upon culture, never in any way enabled by its influence, consciously or not. The aim has been not to produce a thorough study but to register allegiance in the familial mode. The three editors are creative and strong-minded women, like Isadora herself, and they wish to see her as the first apostle of modern female freedom, the forerunner of all contemporary women's accomplishments—although this can really mean only personal and artistic accomplishments.

In this book, Isadora is hailed as yet another to whom the abolition of corsets ought to be attributed, but there is no record of her desire that women be free from any other sort of external constraint. Their right to vote, their claim for effective contraception, their need for wages equal to men's were apparently of no concern to Isadora Duncan. She

seems to have cared only about women's right to free expression, including sexual, of course. Nevertheless, she is hailed here not as a devoted bohemian in a long tradition but as an advanced feminist—the best kind, never shrill and strident—even though she had no political sense at all. She also had rather disastrous and dependent amorous relations with various men, in another old female tradition.

Teaching, however, was in her blood, and she made a great leader and missionary. The facts of Isadora's early life and upbringing in San Francisco, which are among the good things offered in this book, help to explain the force of her later career. They show how Isadora's performances could have the air of being transcendent lessons, not just shows. After her father abandoned the family, her mother, Dora, had run a dancing school to make a living, and so had her older sister Elizabeth. Isadora learned dancing, teaching, and performing simultaneously, during her earliest years. In the 1890s, all four sisters and brothers appeared in dance concerts up and down the California coast, creating their own material, and this helped to form the content of the dance classes they helped to teach.

Dancing was the stuff of life itself, nothing rare and unusual. Social dancing, waltzes and polkas, were taught at Dora's school; and the young Duncans made the artistic dancing up and figured it all out. They had some help from a bit of ballet training and the applied general principles of François Delsarte, whose originally Parisian school of aesthetic dancing influenced several generations of American dancers and teachers. Eventually, Elizabeth Duncan ran the German school Isadora founded, and Raymond not only founded the Akademia in Paris but at first set up a colony in Greece, where dancing and music went along with farming, spinning, and weaving, all on the ancient models. The other brother eventually became an actor. The whole of this California family seems to have been talented, stubborn, and compelling. In about 1908, Raymond permanently took up draped costume, long hair, and sandals, and could occasionally be seen in them on the streets of Paris and New York until his death at an advanced age.

Seizing the spotlight for herself and coming to life under its creative gaze was not the point of Isadora's artistic mission: dancing was inseparable from getting others to dance. Although she produced her greatest public impact as a solo performer, she gave many concerts with her first

pupils and later with large groups of children from her schools. It's possible that her audiences felt carried away by the feeling that they could be doing it, too—could move so freely, could allow themselves to be so transported by music, could even be so beautiful. It was a very different effect from that of the Russian ballet, with its glittering, weightless, whirling creatures from another world, or that of cabaret dancers with their shameful displays.

Agnes de Mille's introduction is another good thing about this book. She, too, cannot praise Isadora enough, but she does it with the advantage of having actually seen her dance. It was 1918, late in Duncan's career, and de Mille was a child. Isadora's body "shook with fat," she writes, and she reports being unmoved; but her mother was in tears, deeply touched by the grief expressed in Isadora's movements, and de Mille was impressed by that. De Mille notes that Duncan had no humor and that her mode was forever heroic or ecstatic; but she remembers the impression of simplicity and clarity her dancing gave, with a pure authority in it that kept Duncan herself from ever being really ridiculous. It's clear, though, why those of us who never saw her, who can only see the pictures and read about her, can get the feeling that she might have been.

The very best thing about this book is the illustrations, of which there are many never before published. De Mille says they are all the more important in the absence of films of Duncan's dancing—but I would agree with Duncan herself that movies of her would have been something of a shame. Modern viewers watching them as historical curiosities would find themselves at a great distance from the real Isadora, the exponent of sacred immediacy.

Meanwhile, there's a lot to see. The photographs here include old family pictures, always interesting, and very early shots of the young Duncans dancing together in Spanish costumes, Isadora as Primavera, and the like; many unfamiliar posed photographs, early and late, of Isadora promoting her art or her career, and of other people important in it; wonderful blurry snapshots taken by Raymond of Isadora dancing among ancient Greek monuments (in sandals, not barefoot) and many other snapshots of her squinting into the sun at domestic or convivial moments, sometimes dressed in current fashion, sometimes wearing experimental varieties of flowing costume other than Greek. There are photos taken at the Duncan schools in several countries, showing masses

of draped children dancing on the grass or posing in attitudes, with a draped teacher looking benign. There are illuminating pictures of Raymond's colony and academy, with many draped adults weaving and painting on fabric, and some of them dancing, too.

Then there are the masses of drawings, watercolors, sculptures, and prints—the list of artists includes Dunoyer de Segonzac, E.-A. Bourdelle, Auguste Rodin, and Gordon Craig, along with José Clara, Geoffroy de Chaume, Valentine Lecomte, and others. Some of the works are magnificent, like the ones by Abraham Walkowitz; others are dramatic, delicate, sentimental, very realistic or very abstract, or decorative; but all of them show the thrusting knee, the bowed or thrown-back head, the open arms, the whirling colored stuffs veiling the torso. None shows Duncan in midair. Along with running, she seems to have done a great deal of skipping and prancing, with her bare knees pushing up through slits in the drapery, but no high or broad leaping, no extended legs. Instead, she used the floor, kneeling and reclining, collapsing and rising. The face in the pictures is always blank—attention is riveted on those flashing naked legs and feet, those sweeping bare arms, that rounded exposed throat. All these artists help one to imagine the intoxicating effect.

Nothing in this book, neither in pictures nor in any quoted accounts, answers the vital question: What did she wear *under* the drapery? When I was about fourteen, having seen pictures and read descriptions of Isadora Duncan and being as intensely concerned with feminine habits as with stage custom, I put this question to my grandmother, another eyewitness. "She wore"—and my grandmother paused delicately—"uh, um, a sort of menstrual bandage." Wow.

Franz Kafka

The jacket photo for *Kafka's Clothes* shows him without any, sitting tailor-fashion on a beach, smiling above naked shoulders and a thin chest, the prominent ears rhyming with prominent bony knees. His swimming trunks are obscured in shadow. It's not the stiff-collared, well-buttoned Kafka we're used to, and the one introduced in this study is also unfamiliar. But he is convincing. Clothes might seem to be among the least of Kafka's interests, since he is usually taken as a devoted visionary, struggling only to purify his mode of expression in order to probe more keenly into the most painful matters of life and death and men's souls; and he is remembered as someone unworldly enough to break off his engagement in order to give himself only to his work. Mark Anderson has nevertheless shown that clothes mattered hugely to him, in life and in writing.

Clothes have always made a useful literary metaphor (language is the dress of thought, and so on), and they have also offered a useful descriptive device for most novelists, however surreal their vision. Simply finding instances of Kafka's use of each would not prove that he was unusually alert to costume. But Anderson's larger purpose is to reconnect Kafka with the worldly world he came from, and to show that he felt himself obliged to deal with it and live in it. He needed to consider his place

Review of *Kafka's Clothes: Ornament and Aestheticism in the Habsburg Fin de Siècle* by Mark Anderson (Oxford: The Clarendon Press, 1992) in *The London Review of Books*, September 24, 1992.

inside literary and human history instead of vanishing into the thin air of Modern Literature, where many readers have wished to keep him suspended.

Clothes exist to remind the self of the body, and to create a worldly body for each person. Anderson connects them with Kafka's interest in bodily states and qualities, both his own and those of his characters, as well as with his literary technique, the skillful cut of his fictional language, which created a unified body for his work. Anderson sees dress as a pivotal metaphor in Kafka's private thought, where it mainly stands for the mobile world of human exchange—at once vain and nourishing, both hampering to spiritual and artistic clarity and vital to continuing life. Clothing is itself malleable, like language and art, infinitely adaptable to alterations in form that change its meaning; but getting free of clothes altogether is impossible. One must simply get into a different costume.

Anderson's idea about Kafka makes sense in view of two sets of circumstances, one being the cultural ambience in Prague and Vienna during Kafka's youth, the other being that Kafka's father ran a wholesale dress-accessories business, buying and selling all sorts of captivating fashionable adornments. Kafka knew his father's shop, but he never had to work there or engage directly in the fancy-goods trade, like Gregor Samsa. He was free to observe the fashion business from an intellectual distance, but never free of it, or indeed free to think he should be. He had, moreover, an excellent eye for fashion, as letters and journals attest. During his young days as a literary aesthete, Kafka dressed with extreme elegance, subscribing to the Wildean theory that one must be a work of art or wear one—by which was meant one must do both—and thus following the creed of aestheticism that life itself should perpetually be transformed into art. Fin-de-siècle dandyism was based on the notion that clothes could accomplish this.

Kafka's youthful writings were also realized in the somewhat precious and purple style identified with the Decadence, which at the time was felt to be an expression of opposition to stuffy bourgeois values, a search for Beauty that rejected antimacassars and buttoned boots. Later, Kafka said that he wished to be made of literature, but by then he had discovered that turning oneself into writing meant constant hard work and sacrifice, not simply adopting a literary costume and posture. Yet he

never gave up the work of dandyism, either. Anderson describes him during his last two years of life in Berlin, very poor and ill but insisting on excellent clothes made by a tailor he could not afford, to sustain the physical image of a transcendent, coordinated self. He had kept his devotion to a bodily fastidiousness that expressed a desire for clarity and unity of form in art; he admired a cleanliness and limberness of performance that seamlessly identifies the physical with the artistic self.

It appears that Kafka was personally interested in the body-culture systems that flourished in German society at the time, and that he followed for years the gymnastics manual of one J. P. Muller, which had a picture of the Apoxyomenos on the cover and photographs of the author inside, a mustachioed version solemnly demonstrating the prescribed movements in the nude. Kafka was also interested in the Eurythmics of Jaques-Dalcroze and visited his school in Switzerland; and he was interested in the Dress Reform movement, on which he attended lectures. But gymnastics and acrobatics especially fascinated Kafka, who felt himself to be too tall, too thin, too awkward, and physically fragmented. His early devotion to sartorial elegance was among other things an attempt to harmonize himself, an effort continued by his bodybuilding regime. His health did give way to tuberculosis, despite all the Muller exercises, the vegetarian diet, the abstinence from alcohol, and the many hikes in the country; but the bodily effort had not been made to cheat physical death. Linked to the well-cut suits and to similar efforts in his writing, it was a private bid for aesthetic immortality; and that he achieved.

He achieved it against formidable cultural and personal odds. Like its cousin Art Nouveau, the Jugendstil movement was trying to make life beautiful by retreating from vulgar commerce and crude sexuality; it was a decorative artistic style that with all its suavity nevertheless seemed to lack force. Somewhat later, Adolf Loos and Karl Kraus, on the other hand, held that all ornament was criminal and that civilization advanced only to the degree that it rejected embellishment altogether, so that the resultant artifacts suggested a certain sterility along with their undoubted strength. Both such negative notions of the proper aims of art flourished in young Kafka's Prague, offering the idea that new art, in order to transform life, required some kind of withdrawal from it. It was a seductive thought for many artists. But these ideas did not offer

a way for Kafka to move forward—to avoid a self-limiting retreat but nevertheless to transcend what Anderson calls "the Traffic of Clothes."

He uses this phrase to mean the aspect of life embodied in Kafka's father's business. It means the style of temporal living that turns existence itself (which necessarily includes art) into a ceaseless set of aimless exchanges, a perpetual "traveling" that is mobile yet confining, false and distracting, erotic but joyless, incapable of acknowledging and articulating real psychological truth or of permitting the exercise of a natural dynamic energy that could make something new and authentically beautiful—something modern. Aestheticism turned out to be offering essentially the same false thing, disguised by a new style. There is a deep conflict suggested by the fact that clothes, if they are at all interesting, seductive, and complex, whether made in the stiffly layered bourgeois style or in the trailing gauzes adorned with arabesques favored by the Jugendstil, are difficult to keep clean and free of wrinkles. Kafka often mentions the dirtiness of dress, as if it were built in.

It is interesting to note, although Anderson does not emphasize this much, that for the Dress Reform people, and apparently for Kafka, too, the most false and distracting clothes, and unfailingly the dirtiest, are women's clothes. They were of course the whole substance of Papa's concern; we don't hear of him dealing in cravats and embroidered gentlemen's waistcoats, only lace collars and fringed parasols and the like. Ordinary women's clothes of the time—the pleated skirts and tucked shirtwaists, to say nothing of the jackets with passementerie, the hats with feathers or ribbons, the complicated underwear—seemed full of some profound unwholesomeness. Their drag on spiritual aspiration and clear thinking was somehow even worse than the one lurking in the multiple buttons and lapels, the starched shirts, stiff bowler hats, and cuffed trousers affected by the male sex.

Women themselves were often then seen to be entirely devoted to Traffic—to all human intercourse, sexual, social, and especially familial; to fashion, which keeps urging trivial shifts in custom and appearance; to the unreflective, repetitive, and unending busy-ness of housekeeping and shopping; and to commercial sexual traffic if they were prostitutes, another métier requiring endless repetition and exchange. Female dress with all its compromised lack of straightforwardness could easily seem the same as female life; so that if a woman appeared to be nothing but

her clothing, she could even seem to be assuming her proper responsibilities as a woman simply if she were dressed. A male artist could view her only from an entranced and baffled distance, unless he wished to tangle with those easily soiled and creased petticoats.

Men, however, were the ones who wanted to be artists, to bound like free-swinging nude acrobats above the flow of Traffic, to attempt the journey out of time and the river. And men's clothes, as opposed to women's—Anderson touches on this only at the end of his story—do offer a way out. The beauty of perfect male tailoring has in it the possibilities for transcendent modern abstraction that Beau Brummell originally saw in it. The perfectly cut suit, so perfect that it is unnoticeable, can finally create a perfect nakedness for the imperfect, disharmonious body of the aspiring artist. A writer may proudly wear it in Elysium, where it can rightly show his true genius to be free of ornamental lumber and awkward posing.

But Kafka, with his swiftly crystallized artistic ambition, was nevertheless deeply ambivalent about the aspect of life embodied in pleated skirts and passementerie, or indeed in elegant dress suits and gleaming neckwear. He felt the appeal of attractive clothes for both sexes, of sex itself, and of art in its erotic guises. Anderson demonstrates his debt to Huysmans, Octave Mirbeau, and Sacher-Masoch, to Baudelaire fully as much as to Flaubert. Withdrawing from all this was not psychologically or morally possible for the artist Kafka was becoming; backing away meant weakness, bad faith, and lack of conviction. Anderson shows that Kafka's ultimate strategy instead was head-on vigorous attack, straight through and out the other side. For Kafka, writing was a journey of no return on the religious model.

And so we get *The Metamorphosis.* Gregor, the fearsome beetle, clad in his functional carapace, is the new-made Modern Artist, the ultimate gymnast free to walk on the ceiling and fall without harm, who makes ultimate mockery not only of overstuffed chairs and polite behavior, of the dress-goods business and of domestic hopes, but of all the old realities—especially artistic ones. This includes the idea at the core of nineteenth-century novels that clothes, just like facial and bodily traits, always correctly express character. Persons in clean respectable costume are honest and hardworking; persons in showy or flimsy garb are dishonest and morally loose; persons in dirty garments are lazy and

unscrupulous, just as persons with sensual lips are sexually susceptible and probably gluttonous, whereas those with tight lips are naturally abstemious.

Horrifying to his family, Gregor's new "natural body" is beautifully articulated and abstract, like other natural forms and like the frightening emergent forms of modern art, although it is just as far from the costume of Greek nudity, or from Reform Dress, as it is from ruffles and tight business suits. It shows how form in bodies and clothes, and form in art, can climb free of limiting convention in the modern universe. There, one can see the thing itself, and nothing else. Gregor represents Kafka transformed into writing, as he desired to be. His body, dressed in its perfect animal garment, aspires to the condition of music; but it compromises all life's homely rituals, and it can't comfort him.

The power of form is manifest in the incomprehensible garments of the officials in *The Trial*, whose badges and straps and buckled flaps are the more terrifying to Joseph K. because they seem to have a significance out of his mind's reach. Joseph K. himself begins by believing himself guilty of nothing. But when he agrees to wear his own conventional black suit for his trial, he puts on the garments of a guilt that gradually becomes the truth about him. Ordinary clothes don't express the inner truth of the man so much as they create it, working from the outside in. They have the power, initially granted them by human imagination and desire, to create the human world, its inner condition as well as its visible one. It's foolish to believe one can retreat from them; but it's imperative for a serious artist (or for a free soul) to confront them creatively and use them to his advantage, unlike that hopelessly unfree soul and non-artist Joseph K., guilty of imprisonment in the busy and disorderly movement of human traffic, incapable of transcendence. He is, finally, made of clothes; he has given in to the paternal order.

The frightful machine in *The Penal Colony*, mechanically inscribing the condemned man's judgment onto his living body with needles, which lengthily embellish the words with an elaborate decorative accompaniment, demonstrates Kafka's knowledge that he needed to feel the mindless harm of excessive literary ornament in his system, or under his skin, in order to get beyond it and attain redemption through a finally transfigured form of writing. The punitive character of the situation seems to reflect Kafka's recent rejection of his fiancée, and his

awareness that his murder of love had dreadful costs. The garment here is again the resultant body made of art, a suit of writing that is immortal despite the death of the man. The only appropriate garment for the perfectly performing writer is a transcendent literary one, worn at the price of great travail and pain. Certainly no fashionable "traveling costume," the strapped-and-belted, fake-efficient kind of costume that Anderson finds Kafka most fascinated and repelled by, and no nostalgicized nudity and draperies, can properly fit him for his task.

Anderson gives us a Kafka more prey to artistic conflict than his technical assurance shows him to be, and much more involved in issues of dress than the unclad bug of his famous story would at first suggest. We have held on to the idea that the subject of clothes can't enter intellectual discussion (literary criticism, for example) without somehow debasing it; this book is a fine example to the contrary.

Gabrielle Chanel

Gabrielle Chanel is famous for the Little Black Dress, the Chanel Suit, and Chanel No. 5. The three can effectively sum up the Modern· Woman, suggesting female elegance without pretension and feminine allure without musk or whalebone. The Chanel style precludes the traditional forms of guile by which women have been supposed to arouse a man's desire in order to lay hands on his money, not to match his lust with their own. Chanel's celebrated inventions clothe a female creature who is all the more sexually interesting for being nobody's doll, besides being nobody's fool. Even further, they suggest an unaggressive physical sensuality, the deep pleasure of a self-contained bodily ease that demands no sacrifice of decorum or startling exotism to be immediately alluring.

Chanel is rightly more admired as a stylistic innovator than as a genius of pure couture. To a certain extent, her sartorial achievements were common to many dress designers at work between 1920 and 1940. The Modern Woman was a collective enterprise, and some of her new physical nonchalance and social agility were being celebrated by Jean Patou and Lucien Lelong, Alix Grès, and several others besides Chanel. But Chanel was certainly the first dressmaker to conceive of female modernity in bodily terms, to insist on a modest but dynamic self-possession as the most attractive note to strike in modern feminine

Review of *Coco Chanel: A Biography* by Axel Madsen (London: Bloomsbury Books, 1990) in *The London Review of Books*, December 6, 1990.

dress. It was the look of the working girl, hitherto unknown to fashion. She did it while Paul Poiret was still promoting sumptuous color and monkey fur, egrets and dramatic drapery, and while other designers still aimed to clothe an elegant woman in the air of complexity, mystery, and obvious expensiveness. Chanel's early designs were the first inventions of the haute couture to suggest the sharp appeal in the look of ingenuous poverty and youthful straightforwardness; and she naturally made it all the more appealing by charging huge prices for it.

The fact that Chanel is now more famous than all the other modern designers who soon joined her is partly the result of her extraordinary double career, which gave her the ability to preside over her own revival a generation after the eclipse of her most acute modishness and the closing of her house just before the Second World War. Given how contemporary her style still seems, and how recently she was on the scene in person, with her glittering little face, her round hats and soft suits, it is hard to believe that she was already twenty years old in 1903, and in her fifties during the 1930s. She achieved her hugest success and established her greatest fame only after the age of seventy-one.

Not many creators in the ephemeral arts have a chance to preside over their own rebirth. From Aubrey Beardsley to Busby Berkeley, they are usually at the mercy of crudely overenthusiastic interpreters who work on the verge of parody, carrying admiration near the limit and often over the edge of camp. In the late 1950s revival of the 1920s, Chanel herself returned to manage her own renaissance and keep it authentic. Her personal style was also intact, further enhanced by her famous aphorisms, which she had first begun to produce in her youth after discovering La Bruyère and La Rochefoucauld. Her invention always began with herself. She wished to be a source of personal feminine wisdom, not just of clothes for women, as in: "People can get used to ugliness, but never to negligence," and other comments in like vein.

Chanel also helped to set a new standard for female celebrity. While her career grew into a legend, it became possible for other female craftsmen, artisans, and tycoons to be public figures with as much bravura as opera singers, or as much prestige as writers and artists, and with no loss of respectability. Before the First World War, ladies appeared in the society pages, but the only women who welcomed personal publicity were performers or cocottes. Chanel's first public career as a couturière,

which began during the First World War, did carry the strong flavor of
flamboyant performance, just as if she were an actress or a *grande hori-
zontale* and not a dressmaker. She was always as notorious as her designs,
and occasionally more so. To get started, she did in fact have to be
someone's mistress, although her way of being Etienne Balsan's *petite
amie* had run to romping in his famous stables in jodhpurs, not appear-
ing on his arm clad in satin at Maxim's. Nevertheless, she began at the
top, succeeding as an attractive *grisette* in international turf society. The
people she met there became the first customers in her first enterprise,
a hat shop that Balsan financed; and her couture business stayed at the
highest level because of those early connections, many of which she was
in haste to repudiate.

Chanel was born in Saumur, in western France, in 1883, the illegiti-
mate daughter of a peddler father and a peasant mother. Her mother
died when Gabrielle was twelve. A week later her father abandoned her
and her sister, Julia, and Gabrielle spent the rest of her childhood in a
grim and strict provincial orphanage—a desolating experience she
would never discuss or even admit to. Since she was left on her own
very early, however, she was able to develop her opinions, seek her for-
tune, and establish the terms of her life without having to struggle
against the familial restrictions that inhibited so many gifted women of
her day. Humdrum needlework, the stage, or being kept were her main
options, and she had a fling at all of them before she opened the hat
shop in 1913.

To succeed in the fashion business, Chanel had to appear to be a
glamorous female performer, not a serious female craftsman, for good
reason. Not only had she no education and no real experience of cul-
tivated life, but she had no professional training whatsoever, either in the
theater or in millinery and dressmaking. Her appeal had to be as a prim-
itive being, a natural genius like a Zola courtesan. She initially made it
in millinery on flair and good judgment about professional staff, but
eventually her real talent for design made a success of her boutiques in
Deauville and Biarritz. At those resorts, her simple jersey ensembles and
plain straw hats thrilled elegant women accustomed to wearing silk and
feathers on the beach. This was during the First World War, well before
her initial collection in Paris in 1921, and well before Patou was mak-
ing similar innovations in sportswear.

Chanel's ideas about design sprang from her early poverty and a lifelong abhorrence of middle-class pretentiousness. As a poor and mutinous French girl on the rise, she seems to have hated being taken for a woman who desired the trappings of the haute bourgeoisie. Her later remarks about style were usually attacks on anything demanding or too careful. "Do you like those women in brocade who look like old armchairs when they sit down?" she asked rhetorically in the 1950s, about the use of boning and stiff fabrics for dresses. She found great satisfaction in the tone of upper-class English life, which she had encountered very early as the mistress of the English playboy Arthur Capel. She learned a great deal from British understatement, tempered emotion, and love of country ease. Much later, she was to translate all this into her softened, gallicized version of the tweed suit.

Once launched in couture, Chanel kept to the demimondaine mode, always attaching herself to famous men and appearing everywhere with great éclat, talking wittily and continuously, dressing beautifully, and by no means withdrawing modestly to her atelier to produce creations that could bring her fame only on the backs of other women. Madeleine Vionnet and Jeanne Lanvin, who had both undergone serious apprenticeship in couture, both did that; but Chanel insisted that couture was not an art, and it certainly did not demand an artist's brand of solitary devotion. Rather, she managed to promote her business from the beginning by being her own advertisement, adding the palpable excitement of her own sexual charm and gilded existence to the radical simplicity of her designs. In the new urban society that came into being after the First World War, where artists, poets, and performers came to mix with aristocrats and the new rich, she could finally legitimately join the *haut monde* of which she had once been only an entertaining lower-class appendage. Throughout her career, her designs were fashionable partly because she was a fashionable person; and it was important for their success that not only was she not an artist, she was not a lady. Instead, she was a star, the very first in her field.

As such, she has inspired several star biographies, of which Axel Madsen's is the latest. Biographies of Chanel that were attempted during her lifetime had to be given up, because they were based on interviews with her in which she provided so much conflicting material that it became clear she was perpetually lying about her own past and perpetually rein-

venting her own legend. After her death, primary research was neces-
sary to establish the facts of her life. Some of these are now fixed, others
are impossible to retrieve, leaving a residue of anecdote quite suitable to
Chanel's carefully tended personal image, akin to that of Lola Montez
and Liane de Pougy, or more latterly that of Marlene Dietrich and
Maria Callas.

Madsen's book takes note of the variability of Chanel's own accounts
of events and gives several if no single one can be authenticated. His
tour through her life is brisk and swift, with dramatic scenes brought to
life in dialogue and a few telling photographs to match. Much of his
material is from personal interviews, the other sources being biograph-
ical and autobiographical works chiefly by Chanel's European contem-
poraries. He has all the sensational material necessary for a star
biography: the love affairs with Grand Duke Dmitri, Igor Stravinsky,
and the Duke of Westminster among others, the friendships with
Colette and Jean Cocteau and Diaghilev among others, the parties and
dinners in great houses, the passionate attachment to Misia Sert, the pas-
sionate aversion to Schiaparelli and other rivals, the whole decorative
panoply of Chanel's intense connection with celebrated figures of her
epoch. He has madcap Coco casting the duke's gift of priceless pearls
into the sea over the side of his yacht; and he has her romantic, seem-
ingly improbable role in an aborted negotiated peace plot that she
successfully set in motion during the Second World War. As a star biog-
rapher, he offers the romance of her life in a faintly soap-operatic mode,
painting her as the girl whose lovers married others and who dulled her
pain with successful creative work, hiding her sore heart under a bright
mask until the end. He gives very little sense of any personal involve-
ment with his subject, any identification with the existence of such a
woman who did such work and led such a life, during her lengthy mod-
ern moment. Instead, he seems a bit in love with her, irritated and
moved and amused by turns.

To do him justice, he also describes Chanel's extremely unromantic
and complicated relations with the Wertheimer family, who were the
first to profit, at her expense, from the success of Chanel No. 5. After
various legal battles with her, the Wertheimers later ran her whole busi-
ness effectively, made her rich, and financed her extraordinary come-
back in 1954. Madsen is very interesting about her financial and legal

battles, and on the exact details of her life during the time her couture house was closed. He is less interested in couture itself, or even in clothes at all. This book has little serious analysis of dress, which might place Chanel's real work, apart from her self-image-making, into a right relation to the work of her colleagues. But he does give us Chanel's less-than-exemplary behavior toward her staff, whom she paid badly and treated insensitively, and her brutal rejection of most of her family, both in memory and in actuality.

In particular Madsen conveys Chanel's strong sexuality, which was the true secret of her success and obviously much stronger than her sense of power or money, or even of style and society. Her intelligence was mainly erotic; and she was sexually attractive all her life. She had no late recourse to being the distanced, trumpeting presence or demanding sacred monster that so many celebrated old women become when they give up making real connections with other people, especially erotic connections. Until she died at eighty-eight, Chanel was directly capti-vating in the same way she had been in her youth, and to persons of both sexes. This book itself is testimony that she still is. Her ideas about clothes were about enhancing feminine sexuality without the use of dis-tracting tricks, conspicuous lawlessness, or appeals to perversity. She designed the sort of thing she would wear herself, clothes that would promote her own personal earthiness, her own body, her own sense of men, her sense of comedy, and especially her own instinct for the uses of honesty and decorum in successful flirtation.

She wished to promote these qualities in other women, but especially to allow women to express their sexuality directly through their clothes as if through their skin, as if clothes were in fact the silky pelt of the female human animal. The flexible body and its natural movements must be enhanced by soft fabric and glittering surfaces, and even further enhanced by neat black and clean white, cool navy and pale beige. Not symbolic trappings but basic sexual confidence would announce any woman's true modernity and keep her free.

Although Chanel lived through the suffragist agitation of the early twentieth century and saw women's lives undergo great changes, she was not at all interested in female emancipation. She quite failed to rec-ognize the entrenched institutions hampering the free action of women, since she herself had simply clawed her way straight up from the bot-

tom without encountering them. But she also opposed any freedom from traditional sexual role playing, from the demands of male sexual fantasy altogether, which would have meant impoverishment to her. She was not interested in female education based on detached standards of learning and competence, and she claimed that women needed only a few precepts for life—never leave the house without stockings, a woman without perfume has no future, clothes should make you seem nude underneath, etc., etc.—precepts worthy of Gigi's aunt. Not a word about making a living, only suggestions about how to be attractive by having attractive habits (clothes among them), how not to be disgusting or irritating, how not to be false or silly. Then one could do anything— run a business, govern a country, enact any sort of purpose depending only on will and energy.

With such training one would not only be confident and invincible but remain young forever, just as Chanel herself seemed to do, and as her clothes allowed any woman to do. Simple garments in clear shapes and subdued colors are very becoming to lined, pouchy faces and aging figures, as the masculine scheme for clothes attests. Chanel's use of masculine ideals for feminine dress had to do with the lasting appeal of visual clarity and a sort of cool physical cleanliness, not with the need for a businesslike, asexual style for women, which might be useful in practical public life. Chanel had no part in the unsexing of women that seemed an inevitable, if temporary, aspect of the feminist movement in her time; she remained a champion of love as the ultimate aim of a woman's life, the engine of all other endeavor, and the ultimate beautifier.

But she would not marry the Duke of Westminster and stop working. Given her nineteenth-century conception of herself, Chanel's career was indeed plotted like a solo performer's. She had to control her appearances and her productions, and never claim respect or admiration as someone else's satellite. Lovers were for private and personal satisfaction. Her own star quality had to invest her at all times, and it wouldn't if she were the Duchess of Westminster. She could not feel flattered by the chance to live in idleness, and a duchess could not be a dressmaker. She remained "Mademoiselle" until her death, mistress of herself and her profitable business. Chanel obviously loved her work and loved excelling at it, feeling the satisfaction of making good things and seeing them influence the work of others. She loved being copied,

to see the spread of her power, but also because she believed in the continuing public life of fashion, not in its exclusivity. She hated what she called "drawing-room fashion," clothes that die after a moment of limited glory. She was the first couturier, against the rules of the Chambre Syndicale, to allow photographers at her showings on purpose to promote copying and permit "stealing." One of her maxims: "A fashion that does not reach the street is not a fashion."

Chanel may have been an insecure person, with her steady need to boast about her professional importance and her personal superiority, and her automatic habit of disparaging the achievements of others and the taste of their clients; and yet her manner worked. Some of it was a further demonstration of her knack for publicity and advertising, which had become important commercial phenomena almost at the same time that she had. Her boasting wasn't all uneasy self-assertion; it may well have been shrewd calculation, somewhat in the modern vein of political campaigning.

Chanel was one of the architects of modern material culture, a creator of the basic modern classics of female dress that must still be reckoned with by later designers for women. Her idea that sexiness is best conveyed in terms of self-respect rather than of folly remains in force, manifest in all modern fashion that keeps harshness from overwhelming femininity, informality from overwhelming courtesy, or startling invention from overwhelming anatomy. The easily fitting suits and simple dresses that are still the best envelopes for adult feminine charm were originally worked out with rigorous care. Madsen describes Chanel's methods, which were in fact quite similar to those of other female designers, who tend to concentrate on the living woman instead of on a fantasy vision. Unlike most male designers at the time, she never made sketches but worked the *toile* or muslin right on the body of the mannequin, who stood for hours while she cut and pinned. After that, the garment went to the workshop, where Chanel herself had no expertise and which she did not penetrate. Then she might work again on the basic shape and hang, again on her knees in front of the mannequin, after the dress had been made up.

Her designs had a slightly primitive, radical flavor, and they did not display the intricate draping and artful piecing through which many designers of her generation showed off their skills. Chanel once wrote a short appreciation of sixteenth-century fashion, and there are sub-

merged echoes of that period in her work. She used uncomplicated shapes but richly textured fabrics; ornament was external and independently commanding, never an extreme or fussy extension of the structure. Like the ladies in Cranach paintings, Chanel women might wear expensively simple black with white at the neck, pounds of gold chains and a little tilted hat, the whole ensemble informed with both dignity and irrepressible élan.

Applying ornamental edging to simple garments in luscious fabric and then adding many jewels also smacks of ancient Mediterranean and Middle Eastern custom, and of peasant dress from various regions. But Chanel could make judicious use of such primitive simplicities without betraying any trace of ethnic or historic flavor, just as she used schoolgirl motifs without suggesting childhood and masculine themes without invoking mannishness. The right pinch of coarseness or naïveté might invigorate a refined conception, but everything would be thoroughly modulated to express only the modern woman, ageless and classless in her abiding sensual appeal.

The classlessness of the Chanel style was partly what made it so enduring, although she herself did not live to see the larger reverberations of her sartorial notions throughout the modern garment business. It happened first in the United States, where her huge fame had begun in her lifetime, but it has now spread all over the world. At her death in 1971 she was still working at the highest level of couture herself, not designing ready-to-wear versions for the masses. But those versions were already in existence; and ever since, the vast numbers of women at every economic level who find that a nice suit, a vivid necklace, and a simple black dress will take them through most of life's public occasions are still testifying to the force of her ideas.

She herself witnessed the rise of self-conscious madness on the fashion scene, the plastic excesses of Courrèges and the sculptural space-age fantasies of Cardin, together with the great rise of infantile untidiness and programmatic immodesty in everyday fashion and the ascendancy of the costume principle in clothing. When denim, nudity, and nailheads took over the couture, she was coming to the end of her life. But despite the abrupt shift of direction in fashion occurring at the time of her death, her principles have not been abandoned. At the couture level, not only is Karl Lagerfeld officially continuing her program in newer,

quirkier ways suitable to this age of instant parody, but other recent designers, from Giorgio Armani to Donna Karan, still demonstrate her influence, still attempt the fusion of unaffected physicality with suave elegance.

Axel Madsen has written other star biographies, namely of Yves St. Laurent, Jean-Paul Sartre and Simone de Beauvoir, and a book about the love affair between Joseph P. Kennedy and Gloria Swanson. But he includes a great deal of sober information in this book, some of it most welcome, since it is missing from better written and more imaginative works on Chanel, and it makes this a presentable addition to the Coco literature. There are a few mistakes—Edward VII was not king in 1914, for example, and the mystifying Ballets de Monaco must mean the Ballets Russes de Monte Carlo. Besides stumbling prose and an unserious tone, his book's other fault is an absence of sufficient pictures: the few, especially of Chanel herself, arouse lust for many more, especially of the clothes themselves in their different stages of evolution. The reader interested in the subject must seek out Edmonde Charles-Roux's *Chanel* (1975) and Jean Leymarie's *Chanel* (1987) for more satisfactory visual material and perhaps more sensitive explorations of the woman and the work.

Vaslav Nijinsky

This book is a cry of pure pain, immensely difficult to read without groaning and sometimes weeping and getting up to pace the floor. Its flavor is aptly illustrated by the shocking photograph on the jacket of Nijinsky undergoing a catatonic seizure at the age of thirty-seven, about eight years after he wrote this text. With his necktie neatly knotted, his face shaved and his hair combed, hands curled up, the greatest dancer of his epoch—some say of any epoch—stares into the lens with a horrifying sacrificial patience. He would not die until the age of sixty, after more than three decades of being moved around from sanatorium to sanatorium in Switzerland and England.

Nijinsky began to write these notebooks just after finishing his very last stage appearance on January 19, 1919. It was a solo charity performance at a hotel in Geneva before an audience of casual guests, at which his ferocious dance of Life and Death appalled and terrified the spectators. (Romola Nijinsky wrote of the performance, "He showed us all of suffering humanity stricken with horror . . . he seemed to float over a mass of corpses . . . a tiger escaped from the jungle, ready to annihilate us all.") The dancer had come to Switzerland with his wife and little daughter to rest after an exacting tour in South America. This tour had

Review of *Nijinski: Cahiers: Le Sentiment*. French translation of the unexpurgated Russian by Christian Dumais-Lvovski and Galina Pogojeva (Paris: Actes Sud, 1995) in *The London Review of Books*, January 25, 1996.

in turn followed the painful upheaval, enacted against the background of a catastrophic war, of his complex relations with Serge Diaghilev, whose idiosyncratic mode of artistic tyranny had been ruling Nijinsky's life until the dancer abruptly married. He was in an understandable state of emotional fatigue, and the mountain air at first did him some of its famous good. Leisure, however, only proved Nijinsky more deeply unhinged than the doctors and the family had thought. The scary display in the hotel was the public climax of a progressive private derangement. Nijinsky abruptly stopped writing on March 4, just at the moment before being taken to Zurich for further examination, treatment, and eventual incarceration. He was twenty-nine years old. During the weeks following the last mad dance, his behavior had gone from increasingly extreme and strange to unpredictably violent. More advice and stronger measures had to be sought.

Writing with intense concentration during the day and far into the night, Nijinsky had filled four notebooks during the critical six-week period between January 19 and March 4 in the winter of 1919, when his short family life and professional career were about to die and his long life as a lunatic was about to begin. He had covered hundreds of neat manuscript pages that include a few letters which were probably never sent, ten pages of pencil illustrations not reproduced here, and some awful poems. The notebooks document his state of mind as it was then floating and darting and plunging among his ever-more-uncontrollable inward difficulties with the outward world, along with his intense desire to redeem himself and it, to purify humanity and merge with God. They record his artless love for people, his wondering contempt for their unworthy fears, customs, and tricks, his deep need to be loved and understood, his pleasure when he was; and they also document ordinary events, physical phenomena, memories, and observations with stunning simplicity and acumen, whether or not they are pure fantasy. The writing pours out in a flood of free association with very few paragraph breaks; there is resentment (*"Diaghilev est un cimetière"*), but no violence at all.

It is all embarrassing and beautiful, candid and lyrical, dully obsessive, endlessly repetitive, poignant and boring, informed with a naked feeling that plucks constantly at the reader's own emotional arrangements. The man is mad indeed, but like many madmen, he's often quite right about life, and refreshingly, he never loves the sound of his own clever

voice. Nijinsky is emphatically not a writer making literature out of his pain and confusion. He sounds a lot like a splendidly honest and unspoiled but insufficiently trained and very bright child. He hates compliments with their genial falsity, for example, but he loves applause, the unguarded sign of pure love. He often says he is God, or he is Love, but he seems to have no vanity and no false modesty, although he sees them clearly in others.

In this text, we never find the writer thinking of himself as a great dancer or even one with talent, or comparing himself with others, or speaking of other dancers at all. We hear only that he had worked very hard at dancing and choreography, with perfect certainty and pleasure, even when he was being hurried and overtaxed. He clearly feels his greatness only as a kind of deep natural laughter, a pure divine source. "I am God in the body. Everybody has this feeling, only nobody uses it. I do use it. I know its effects. I love its effects. I don't want people to think my feeling is a spiritual trance. I am not a trance, I am love." And more and more of the same.

Nijinsky begins his first notebook by describing in detail the big lunch he had eaten before the hotel performance, the need for his alimentary system to be emptied before he dances (*"quand tout sera sorti de mon intestin"*), and a last satisfactory visit to the costume maker, whose work he praises and whose poor family he helps. But from then on he's running and running in the snow, sometimes keeping pace with a sympathetic horse, or he's precisely planning a bridge across the Atlantic Ocean, or worrying about his wife's feelings, or figuring out how to win a fortune at the Bourse and give it to the poor, when he's not attentively describing his digestive system at work. Now he's admiring Woodrow Wilson and despising Lloyd George, or designing a really efficient fountain pen, or describing how he masturbates or how his little daughter masturbates. He comments on the small cross worn on a ribbon by the nurse—"She wears crosses but she doesn't understand what they mean"—then on the big cross carried by Christ; and he very much wants to publish his book, which he intends to entitle *Le Sentiment*, in order to instruct people about such things and to help free the world of hypocrisy and fear.

He writes, with endless repetitions, that Intelligence and Thought in action are Death, leading only to fearfulness and wickedness (and also to airplanes and zeppelins, bad fountain pens, stupid dance criticism,

and petty conventions of behavior—"*les Habitudes*"—which are also Death), and that what matters is intuitive understanding, which he calls "*le Sentiment,*" or "*la Raison,*" and Love. He finds himself in fact gifted at *la raison,* acute about people's real feelings despite their pretensions, and he earnestly wishes them to feel his, to use their intuitions instead of their *habitudes.* Sexual desire also makes Nijinsky very anxious when it operates in the world as one of the social conventions—flirtation, manipulation, exploitation, and the like. He's quite comfortable with physical sexuality, since he deeply loves anything to do with the way bodies work, but in society desire often seems to work against Love and Understanding and Reason, as he's not the first to notice. And yet it certainly isn't exactly Death, either. Near the very end, he includes some verses in a letter to Diaghilev, never sent:

> *I am a Prick, I am a Prick. [Je suis une Bite]*
> *I am God in my prick.*
> *I am God in my prick. Your prick is not mine, not mine.*
> *I am prick in His prick.*
> *I prick, I prick, I prick.*
> *You are prick, but not Prick.*

The translator scrupulously tells us that he's preserving the original capitalizations or lack of them. Then, later, at the end: "You want to hurt me. I do not want to hurt you. You are wicked, but I am a cradle-song. Lullabye, lullabye. Sleep peacefully. Lullabye, lullabye. Lullabye. Lullabye. Lullabye. From man to man, Vaslav Nijinsky."

The French text has been translated directly from the Russian manuscripts and published in the original order with no cuts, except for the omission of some letters from the last volume addressed to people not mentioned elsewhere. For sixty years, permission for such a project was effectively denied by Romola Nijinsky, the dancer's widow, although before her death in 1978 she did entrust the first three volumes to a friend, without exactly specifying that they not be published. Those volumes were variously sold and sold again, simply for profit as rare objects. The fourth volume, the one with the letters, was inherited by Romola's son-in-law, the conductor Igor Markevitch, who bequeathed it to the Bibliothèque Nationale. But at Romola's death, the rights to the whole text became the property of her two daughters, Kyra and Tamara, who never

gave permission for translation or publication, despite many requests since 1978.

In 1936, Romola herself had allowed a portion of the notebooks to be translated into English and published, in an edition from which she excised most of the erotic material, a great deal of the obsessive repetition, and all the execrable poems. Until now, translations into other languages were thereafter made from that English one—which I found, when I read it long ago, had a largely irritating and faintly false effect, perhaps because of Romola's mutilations. But now, face to face with this big unbearable document, it's easy to see why Nijinsky's original book might well have been suppressed by those who loved him as a man, especially by the wife who treasured the direct memory of his absolute beauty and surpassing greatness as a dancer. Romola had been a dancer herself, and not a very distinguished one. She was all the more certain to know intimately and adore his precise rarity, and to further adore her unbelievable possession of him. How could she bear people studying his tedious and childish reflections on food and money and Clemenceau, his confused religious effusions, his discussions of his penis?

Because what's truly unbearable is that Nijinsky's greatness and beauty have gone forever and can never be seen again, whereas his last insane screed, once published, can last as long as any book can and be the only thing the world has of him. The second daughter, however, has finally given in to the translators. She had never seen Nijinsky dance and had essentially been keeping a pious but outmoded faith with Romola. The glorious Nijinsky must be only a legend to her, and she must feel that now the notebooks should rightly be added to it, to blend the scribbling madman with the rutting faun and the soaring specter of the rose.

So far as we know, there were no films made of Nijinsky dancing, and we have to rely on descriptions, posed photographs, some snapshots, drawings and sketches, and the legend. But the legend itself, now that Romola and the others with the living memory are dead, has increased its power. It continues to permit imaginative leaps of all kinds, choreographic, cinematic, literary, and corollary—that is, there is no end to further imaginative work about the Nijinsky legend embedded inside the Diaghilev legend, which in turn vibrates inside the comprehensive legend of modern art in the first half of this century. With the Ballets Russes in 1909, Diaghilev brought the Shock of the New to Paris, the center of the artistic civilized world—and from Russia, of all places,

famous for being civilized only by the skin of its teeth, and only by copying France. A bit earlier, Diaghilev had done the same thing in reverse and brought the Impressionists to St. Petersburg. He was the first determined impresario of modern European art.

In 1906 Diaghilev had come to Paris with an immensely successful exhibition of two centuries of Russian painters; in 1908 he stunned the Parisians again with Chaliapin in *Boris Godunov*; and finally came the unprecedented Ballets Russes, quite unlike any other cultural enterprise, daring and elegant, serious and exotic, often harsh, modern in all particulars. The work of great new Russian musicians and great new Russian artists was integrated with dramatic new stage compositions that showed off the Russian dancers with their vital beauty, supreme technique, and powerful acting. Before this historic season, ballet in Paris had been attractive and entertaining, set to attractive, entertaining music. The Russian dancers and their choreographer Fokine, who had been impressed by Isadora Duncan's radical ideas, were creating a demanding new dance theater under the inspiring will of Diaghilev.

He had personally collected them all, along with Stravinsky and Bakst, among others. He had adroitly skimmed off the best artists in every medium and stolen them away from the rigid imperial Russian system. He then forced them into fruitful combination, into opening new aesthetic frontiers right there in the great capital of European art, as they never could have done at home. Between 1909 and Diaghilev's death in 1929, the Russian Ballet came to Paris almost every year, gradually introducing contemporary French composers and painters to French audiences—not only Prokofiev and Stravinsky but Ravel, Satie, and Debussy, not just Bakst and Goncharova but Dérain and Picasso.

At the beginning, the center of it all had been the magical figure of Nijinsky, flying onto the stage through the window, leaping head down with his feet straight up, stalking the nymphs with archaic animality, yearning with puppet pathos for the mechanical dancer. He incarnated both the abstraction and intense humanity of modern art in the twentieth century's first decades—the naked expression, the pure sexuality, the vivid originality of form, the unmitigated color. And then, of course, the madness.

Had Nijinsky stayed in St. Petersburg, he might have gone mad anyway—his dossier at the imperial school records that he was always emotionally unstable—but he would simply have gone on dancing *Coppélia*

and *La Bayadère*, or eventually *The Red Poppy* and other Revolutionary works. And nobody would ever have seen him soar up and stop a minute before coming down, or die in pantherlike agony as a harem slave, or ever have heard of him at all; and we would not have his settings of *L'Après-midi d'un faune* or *Sacre du printemps* to revive, reinterpret, study, and find the prophecies in.

About his *Sacre* of 1913, he said, "It is really the soul of nature, expressed by movement to music, it is the life of stones and trees. There are no human beings in it." He meant no individuals, only an inchoate human mass. Agnes de Mille, who quoted this remark, passes on a visual description of the dance: the whole corps with drooping spines, hunched shoulders, and curled fists, tucked-down heads and inward-turning feet, their bumpy jumps made only to hammer at the ground; and the primitive costumes, with wrapped legs and padded coats making everyone look like sore thumbs. Much in modern dance has explored this kind of effect again, partly because of the still reverberating echoes of the uproar that greeted the work's opening performance. The piece went straight against the pleasing idea of nature's benign beauty and instead offered brutal human answers to nature's brutality. Audiences are still guaranteed to feel uncomfortable with the theme. Nijinsky was a true original, going back to the most ancient sources for his newest creative explorations, reinventing art.

Other choreographers have reset the Stravinsky score commissioned for Nijinsky, always more palatably; and there was an archaeological attempt to revive his grim version. There will doubtless be more of both kinds, but none of us was there in 1913. There were only five performances, then three in London, and that was that. Nijinsky did one more ballet for Diaghilev in New York in 1916, to Richard Strauss's, *Till Eulenspiegel*, which was performed only that season and never again, although an unthrilling reconstruction was lately attempted in Paris. So once more, alas, there is really only the legend and some photographs.

And what if there had then been the resources now available to some of the mentally ill, something to stabilize Nijinsky's turbulent soul? Could he have stayed out of the madhouse and gone on to give us works of art that might eventually have been accepted and adopted, like Stravinsky's scores? Maybe, maybe not. He is nevertheless with us still, despite the desperate course of his ephemeral artistic life and the long diminishing death he had to suffer before he died. This volume brings him closer than anything could to seeming life, but it is recommended in small doses.

Martha Graham

The death of Martha Graham on April 1, 1991, slightly more than a month before her ninety-seventh birthday, finally permitted Agnes de Mille to publish her biography of the dancer, after nearly twenty-five years of work and four years of waiting. It is a measure of de Mille's reverence for Graham that she should have withheld until after the subject's death what is by any standard an affectionate and appreciative account of her life and art, rather than risk offending Graham's own sense of herself in the slightest degree. De Mille seems to feel that she is approaching something truly sacred in discussing Graham, not simply writing the life of a rare artist and an old friend who had become a touchy old woman. She tells us in her preface that Martha had wished to leave a legend, not a biography; and she knows she is transgressing.

De Mille even seems to share Graham's early illusion of herself as a deathless creature forever able to expound her original work through her own living body, eternally "an athlete of God," as she says, a David before the Ark. Graham's own book, finished just before she died and burdened with a reluctant acceptance of mortality in its last pages, nevertheless briskly begins, "I am a dancer." She knew she still was, although she gave her last performance in 1968, when she was seventy-four. At that age her creative fire was unquenched and her need to

Review of *Martha: The Life and Work of Martha Graham* by Agnes de Mille (New York: Random House, 1991) and *Blood Memory: An Autobiography* by Martha Graham (New York: Macmillan, 1991) in *The London Review of Books*, September 10, 1992.

dance her own work unappeased, but her body was in irreversible rebellion after decades of grueling punishment lately exacerbated by unhappiness, arthritis, and drink. Both Graham's memoir and de Mille's biography recount the dreadful arrival of what Graham calls the dancer's "first death," the end of the physical ability to keep dancing. When she collapsed and was taken to the hospital, her public thought she really would die, and some doubtless thought she should. Her performances were becoming limited and her behavior embarrassing, and perhaps it was time; her debut as a creative solo performer had been in 1926, when Isadora Duncan and even Loie Fuller were still alive.

But she didn't die. She recovered, gave up drink, dyed her hair again, and had her face lifted; but without the ability to channel her work through her own flesh, she swiftly became an icon and an institution and remained so for more than twenty years, making appearances, raising money, receiving honors. She invented new ballets only for a perpetually rejuvenated company in a changed world of new audiences who had never seen her dance but who had, in fact, seen a great many of her unconscious legatees perform in all the extant genres of theatrical dancing. De Mille says she became a superstar; and publicly she was clearly a *monstre sacré* almost indistinguishable from any other (Bette Davis, for example), a person entirely different from the unworldly, dedicated creator and pure fount of personal originality she had been during the first half of this century. In those days she had exemplified the problem of telling the dancer from the dance as nobody else ever had; and she had made something truly new in the world.

She has been compared with Joyce and Picasso, and some have added Wagner for the theatrical dimension; but you would have found it hard to believe in such comparisons if you had simply attended one of the company's presentations during the last two decades. There is a vast difference between what now happens on the Graham stage and what occurred during her concerts in the 1940s, when her flame burned at its brightest; and the transmutation seems to have been accomplished with her own connivance during the last period of her life. Until the end she claimed her due, taking bows with the company after every performance. Those who had seen her forty years earlier were happy to see her still, but their real applause was for what had happened then, not for what she was now letting others transmit in her name.

With all the breathtaking originality of her ideas, her medium had

been the present body in its immediate time and space, the tools of any performer. Despite the power of her invention, she left behind works essentially without texts, along with a few members of her original groups whose minds and bodies bear her distinctive imprint, and a generation of aging folk who lamely say, "You should have seen her." When these have all vanished, it will be time to see what she did that can survive the presently rather distorted state of her direct legacy. Dance notation was well developed in her time, but she never dreamed of using it then, and nobody thinks it's a perfect tool. There were some films made; but she distrusted the movie camera, and the films of her ballets are in any case essays in a different art. But there have been some recent efforts at careful reconstruction of her great theater pieces, with the help of her surviving original dancers, and these are certain to provide the core of work on which a lasting artistic reputation can rest, one that will continue to demand comparisons with great modern painters, composers, and poets.

In speaking of her fundamental contribution, it's important to insist that she was an American artist in the undomesticated tradition that includes Emily Dickinson and Frank Lloyd Wright, someone who made things in the risky artistic spirit that seeks personal sources and methods, programmatically refusing to begin by using what lies to hand. Her stage uses of the body, for example, eliminated the whole pictorial memory of represented emotion in any tradition of dance or pictures. She omitted the familiar postures of Grief or Triumph or Abandon or whatever that Isadora Duncan and Ruth St. Denis had relied on, and that traditional ballet and the silent film relied on, too, for their associative value. Graham paid no attention to long-standing conventions using debased references to Greek pottery or medieval carvings or Chinese screens that were commonly transmitted and recognized through popular illustration. What she says she found most congenial in art was the red streak in a particular Kandinsky painting she happened to see, well after she had begun to work out her way of dancing. She says that he and other modern painters, whom she discovered only after she had worked out her method, gave her the sense of having real "ancestors." She felt compelled to invent a new stage language in which to convey feeling, using common bodily tools but finding her own uses for them, and then training the whole body especially to keep expanding that language.

The language grew out of what she discovered the hinge of the knee

to be capable of, for example, or out of her discovery of ways to fall and rise that used the floor as a friend, not an enemy. She learned to roll familiarly on it, in a variety of styles. She learned to fall backward in a spiral, and instantly spiral back up; she learned to walk on one foot, inching along with toe, arch, and heel; to run on her knees; to stand straight and sweep one leg up in a great semicircle ending above her head, her shin by her ear. She mastered the emotive value of shudders and jerks that interrupt smoothly traced parabolas. Most basically, she linked all action of the head, thighs, and upper arms to muscular shifts produced in the torso by the intake or expulsion of breath; and then she allowed feet and hands to follow out that central impulse in various ways, instead of using the trunk as a pliant background for expressive gestures of the extremities.

She insisted moreover on communicating in a primordial mode without any recourse to recognizably "ethnic" or "primitive" signals that might comfort her audiences. She had learned about Near and Far Eastern dance from Ruth St. Denis, and she eventually studied the Hopi, Zuni, and Navajo dances of the American Southwest. She studied animals for the way they shift their weight, she studied the ideas of Jung and Freud, and she learned about comparative mythology from Joseph Campbell, who was married to one of her dancers; but she referred to none of this material directly in her work. She made it all up, but it was nevertheless recognizable. It was entirely "abstract," she said, but only if you consider orange juice the abstraction of the orange.

Her dances, especially the earlier short solos and the ones created with her first company, had a frightening raw originality, repellent and alluring, sometimes unbearable, but never ineffective; sometimes deeply beautiful, but never pretty or soothing. Their flavor was also very easy to ridicule, since, as she says in her own book, "I showed what most people came to the theater to avoid." It seemed altogether too much for some, who quickly took refuge in laughter. Stark Young, later an admirer, wrote of her in the late 1920s: "She always looks as if she were about to give birth to a cube." It's fairly easy to see a link between her impulses and those of modern painters and designers aiming to convey the sense of a stark truth at the core of multiform phenomena; but none of the others were doing it directly with their bodies.

It was all some sort of exploration on her part; she attributes her motivation to a "curiosity" about life. But the results, the discoveries,

required theaters and audiences. She was a true prophet or priest, the direct channel of revelation to a community, neither a private meditator on the mysteries nor a plain exhibitionist. She wanted to arouse deep feelings in audiences, not immediate thrills or intellectual comprehension, something akin to spiritual recognition. She was one of the first few in the twentieth century to propose dancing as the most profound of all the arts, the most basic spiritual conduit human beings can use. When she started her career, such an idea had become something of a joke, considered appropriate to defunct civilizations employing temple dancers or to marginal "primitive societies" performing rituals to make it rain. Western social dancing, with its august sources in folk and court custom, always had acknowledged importance, but theatrical dancing certainly had no serious artistic status in the United States in Martha Graham's youth. Most of it was considered wicked.

Even in England and Europe at the turn of the century, great stage art was created in operas or plays, for which ballet interludes were only an ornament. Pretty girls danced in music halls wearing much adornment and few clothes, but their physical training did not have to be very rigorous or their dancing very imaginative. Degas's dancers, for example, often look tired, but they do not seem to be undertaking very strict efforts to train the spine, arms, or legs. In the entertainment world, female acrobats had much harder preparation than dancers, and sometimes more enthusiastic responses. All such performers were believed to be prostitutes in their spare time, whereas great singers and actresses, although socially suspect, were at least granted the status of artist. Except for the great Russian Ballet, and a few Spanish, Indian, or other ethnic imports, stage dancing for its own sake was a frivolous affair, with no spiritual overtones. Americans did not even see the Russian Ballet until the 1930s, except for the entirely exceptional Anna Pavlova, who first toured the United States in 1910.

Isadora Duncan tried to be a creative dancer and failed in the United States until Europe had acclaimed her, and Ruth St. Denis, Graham's teacher, had the same experience. But both these American women acquired public fame chiefly as Great Eccentrics, especially Isadora. They also made deep spiritual claims for the importance of dancing itself, claims that helped to reinforce their fame as loonies. Their actual choreography lacked strict physical discipline or real originality, although they were both truly great stage presences, just as Loie Fuller had been.

Martha Graham certainly continued their theatrical tradition, which essentially consisted of strong feminine impact, presented as freedom of movement enhanced by interesting music, dramatic lighting, and ample yard goods.

But Graham had a basically corporeal genius. She had a talent quite independent of feminine magnetism, light, music, and drapery, despite her full use of those potent elements. Her exercise of her gift required a heroic, self-imposed practice unheard of in any other kind of dancing, and not undertaken by Duncan and St. Denis, who schooled themselves chiefly for greater degrees of lyricism and atmosphere. Even in the most taxing ballet training, composition is a separate matter not required of dancers. Graham invented the expressive and technical material of her art at the same time, forcing herself into it and through it with amazing single-minded concentration, and her troupe along with her.

De Mille writes wonderfully about what it was like in Graham's studio during the 1920s and 1930s. She herself had ballet training and went on to give solo concerts in a comic-balletic style, besides being a member of various ballet companies, and eventually achieving international success in revolutionizing the way choreography is created for the musical-comedy stage. De Mille is well equipped to describe exactly how the Graham technique developed, exactly what made her choreography new and influential, and also to bear witness to Graham's effect on the world throughout her long career. The two became friends in 1929, when Graham was thirty-five and de Mille twenty-one, although de Mille had already seen Graham's first dances and admired her from a distance.

She was in awe of Graham's dedication and faith from the beginning, and of the devotion of her dancers. Graham's girls all had jobs teaching dancing, and sometimes they also worked as salesgirls or whatever to help make ends meet; but they would come in the evening for hours of study and rehearsal, sometimes having to wait patiently while Graham figured out what she wanted them to try next. They ate little and slept less, and their personal lives suffered. Leader and followers alike believed in the ultimate worth of the actual work, which involved creating dependable, iron-hard muscles all over the body—back, abdomen, neck, and limbs—and a wholly flexible skeleton, rather like what present-day gymnasts must achieve, but with the aim of permitting comprehensive

dramatic expression in a range of emotional modes, to suit Graham's peculiar vision. It was constant hard and painful work, taxing to the mind and spirit as well as to the sinews and joints. Graham's teaching included a kind of inspirational, gnomic utterance: "When you do the demi-pliés, think there are diamonds on your collarbone, catching the light."

In all this there was no certainty of public success. Everyone was very poor, and likely to continue so indefinitely. Concerts could be given occasionally in auditoriums not being used for their customary purposes, for which Graham designed and made costumes herself, with the girls' help; and the whole enterprise was kept alive only by the famous Neighborhood Playhouse in New York, which nourished much youthful urban talent. Graham taught there for very little money, and the rest of the time did nothing but struggle with her own work. De Mille is still impressed by Graham's absolute lack of any impulse to sell out, to go on the musical or cabaret stage in order to bring in a better income. Graham had done a bit of both just after leaving the Denishawn school that Ruth St. Denis and Ted Shawn ran; but once begun on her creative path, she had no time and energy for anything else, and neither, apparently, did her dancers. Money was not considered of importance.

Graham had the ability to think this way because, although she had nothing then, she had been raised in an atmosphere of rather broad-minded affluence. Already wealthy, her father had become a doctor specializing in nervous diseases, what was once called an alienist. Her mother was attractive and diminutive, obviously elegant, a Presbyterian; her nurse and her father were both lapsed Catholics. Deep respect for religion rather than religion itself prevailed in the household; there was no repressive Victorian spirit quelling the young souls of plain strong-minded Martha and her two pretty younger sisters during her adolescence in Santa Barbara, California. When she wished to study dancing with Ruth St. Denis after having been taken to see her, nobody objected. Her father in fact instilled a certain aesthetic morality in his eldest daughter, a reverence for the fundamental artistic rigor that lies behind anything beautifully made.

At the same time, he also allegedly made her aware of body language, explaining the emotional sources for the unconscious hunching of shoulders or stiffening of arms. "Bodies never lie," she tells us he told

her. She was eventually to feel much more affinity with highly controlled styles of expressive movement than with any modes based on license, abandon, or catharsis. Her personal looks were dramatically neat and austere, even when she dressed in the same threadbare clothes for years. A scrupulous clarity of outline and integrity of shape also characterized Graham's work throughout her career: her modernism was of the neoclassic stamp, not unlike that of Balanchine, despite her preoccupation with visceral feeling. She also knew how to create in a fine comic vein, like other neoclassic moderns: "Punch and the Judy" and "Every Soul Is a Circus" are bitingly funny.

Elaborate cosmetics and wonderful clothes were also perfectly congenial to her. These feminine privileges in the theater of life had certainly not been frowned upon at home, even with all its proprieties. And with all the ferocity of her temperament, of which she repeatedly boasts in her book, she was a deeply feminine creature, manipulative and entrancing, a real Daddy's Girl. About the women's movement, she says in her book that she was baffled when it began, because "I always got whatever I wanted from men without asking." She got it from women, too, students and performers who would stay up all night to sew new costumes after she had changed the designs at the last minute, or unquestioning supporters like Bethsabée de Rothschild, who financed her school and tours, or indeed of perpetual votaries like Agnes de Mille, who felt something divine in her, just as she did in herself. Late in life, after forty years of physical and moral dedication, Graham felt free to indulge her love of fashion, high living, and personal praise; de Mille seems to find this just a touch disappointing.

The solipsistic character of Graham's early presentations, based as they always were on a single female character affronting or engaging with other female characters whether massed or separate, was importantly modified by the effect of Erick Hawkins on Graham's life and art. Her work began to take note of men and women, and consequently of real human life, not just of internal conflict. Men were added to the company, and for the first time, says de Mille, mirrors were added to the studio. Graham's long affair and unsuccessful marriage with Hawkins eventually disheartened her personally, but his presence made possible her most successful works, the American essays *El Penitente, Appalachian Spring,* and *Letter to the World,* and all the explorations of Greek tragedy. She avoided

European themes, allowing herself only a few disquisitions on Joan of Arc, Mary Stuart, and the Brontës, staying usually with the strictly native or acknowledgedly universal brands of female individuality. Notably, she also avoided explicit heroines from other cultural sources— no Navajo martyrs, no Hindu goddesses, no ancient Chinese empresses.

Graham's artistic development was hugely enabled during her first years of independence by another man who was her lover, quasi-father, and taskmaster, a mentor of exceptional talent, the musical scholar Louis Horst. He essentially taught Form—how to convey your idea in a firm and seaworthy vessel, so that the world, pleased or not, can feel its strength. Without such an influence, applied with harsh insistence, Graham's work might well have foundered in unintelligibility right at the start. But she always did well under imposed difficulty, and her discoveries, instinctively groped for, became inventions with coherent shape. Horst also provided piano accompaniment for class and performance, not just for Graham but throughout the dance world, and sustained many young dancers with bits of moral and financial support, often along with physical love. He was a musician, but his passion was for dancers, and he gave freely of his large musical understanding to the expanding medium of modern dance composition. Martha Graham was the most original of its exponents, but others were at work during the same decades, forming their own dance vocabularies and training their devoted students. There was intense rivalry among them, but all of them agreed in heartily despising the limitations of ballet and musical-comedy dancing.

Modern dance arose in the United States and Europe in vigorous opposition to ballet's elegance and to the pleasant vulgarity of show-biz hoofing, both of which were thought to be artistically inadequate in the demanding modern world. But modern dance then stayed on to penetrate and revitalize all stage dancing during the second half of this century, the ballet included, to help create a flexible range of possibilities for dance performance based on a high standard that finally did make dancing fully as serious as singing or acting. Such a range now requires strong comprehensive technique for practitioners in any one part of it. In England such a revolution was not considered necessary at the beginning, since both music-hall dancing and the traditional ballet had stayed in excellent shape there.

Graham was only one of several modern dancers who failed to take hold in London: Jaques-Dalcroze with his Eurythmics and later Harald Kreutzberg and Kurt Jooss were all European phenomena, accepted in the United States but not interesting to Britons. Anything too emotional in the form of bodily expression was apparently unacceptable unless it was broadly funny (clowns were all right, of course), even though raw feeling had a strong appeal in painting and sculpture. Isadora Duncan had done well at the turn of the century, perhaps because she made English people think of Lady Hamilton's "postures"; she offered the same sort of naughtily Grecian, allegedly high-minded self-exposure, best watched from a certain emotional distance. But Graham's convulsed torso and odd gestures doubtless aroused unwelcome personal associations in her audiences, just as she intended, and the English public weren't having any of it.

Martha Graham's primary contribution was indeed aesthetically moral and technical. She made expressive dancing into a modern artistic discipline, instead of leaving it to continue either as an obvious folk art, a purely sensational show, or an outlet for free improvisation. She raised the stakes, opening up its resources to both responsible creative effort and strict practical training. The same thing had been accomplished in earlier centuries by the great innovators in the history of the ballet, the men who had turned elaborate court dancing into a serious art instead of just a *divertissement* with symbolic associations, so that ballet could eventually become something wrought only by the gifted and devoted, rather than something occasionally engaged in by the well-born and cultivated.

That was a long time ago, and the ballet has continued to renew itself, certainly of late with cordial help from modern dance. In this century, it was not just the modern dance or the renovated modern ballet, but the Great American Musical Comedy, justly famous for its creative departures from operetta, music-hall, and cabaret entertainment, that owed the largest debt to Martha Graham, and that in turn brought her contribution into the mainstream of modern performing art. The traditional ballet could not adequately provide the dance vocabulary for really inventive musicals, nor could tap dancing and soft-shoe dancing; the Graham method of breaking down movement into units of fundamental expression was troped into the modern ballet idiom for the pur-

pose. Agnes de Mille's ballet *Rodeo*, for example, composed under Graham influence, was excellent, but it was even better when she translated it onto the musical-comedy stage for *Oklahoma*, where it had the chance of even larger creative influence. From the 1940s, the American musical enjoyed a great artistic freedom that allowed ample use of Graham-like methods for dramatic dancing, and this soon required much broader training for aspiring performers. To be on Broadway, tap and ballet were not enough—you had to have modern, too, and know how to master these demanding different techniques. The Graham students themselves went into other kinds of dance business, and into acting, where they could apply her corporeal lessons to the telling creation of characters.

From stage musicals to movie musicals and on into television advertising and music video, Martha Graham's physical language has made a path into the general consciousness. Her ideal of rigor has added structure to wild expression in other modes; her sense of the body's theatrical impact has permitted dance itself to recover its primary role in performance, to take center stage or center screen, and to carry the theme instead of just embellishing it, in productions that are not pure dancing. The ballet stays on the ballet stage, fulfilling its destiny; but Martha Graham's discoveries have now spread well beyond the Graham stage into all media where vivid dancing can stir the public's feelings all on its own. A profound American creator, a teacher, and an undoubted enchantress, she has also clearly been another of the mothers of us all.

Alix Grès

In September 1994, the Costume Institute of the Metropolitan Museum mounted an exhibition of works by Alix Grès (born Germaine Krebs in 1903) spanning the five decades of her career as a couturière. The show was accompanied by an illustrated catalogue in which the curators, Richard Martin and Harold Koda, dealt with her *oeuvre* in the most elevated aesthetic terms, aligning Grès with poets and painters, with composers and architects at the highest level of modern creative effort. Notably they did not place her in relation to any other contemporary designers of clothing, with the single exception of Mariano Fortuny, whose rare productions at an earlier epoch in the twentieth century evoked similar responses.

In our time this designer stands alone, it was implied; alone where any serious artist in civilization has always stood, essentially (though not of course practically) remote from utility and commerce, from society and politics, close only to the exacting demands of the work at hand, its internal challenges and its forever intractable medium. The catalogue further indicates that Grès is more specifically to be considered among the modern neoclassicists, those twentieth-century artists who linked their own inspiration with the disciplined expressions of earlier neo-classic periods. Mme Grès's path implicitly follows that of Raphael and Poussin, J. L. David and Ingres, Bach and Bellini—not the great past masters of excess, the Berninis and Rossinis, or the dealers in anguish, the Grünewalds and Goyas.

Dance Ink, Summer 1995.

Her modernity is thus to be classed with that of Cubism and Le Corbusier, of Hindemith and Brancusi, and not with Surrealism, German Expressionism, Futurism, or Abstract Expressionism, neither with Klee nor with Chagall. Grès cannot be linked with any modern form of art exploring absurdity and waywardness, social grimness and political madness, private demons, fakery and trumpery, the ecstatic and the dreadful, the current and immediate, or the potent charms of nostalgia—and most emphatically not with an art that bewitches the public in endless multiples of itself, in mass media for mass markets.

For a contemporary fashion designer, this is a hard path to walk. Fashion itself is now founded on waywardness, nostalgia, fakery, and so forth, certainly on markets. Any designer refusing to deal in them and to profit from them must lead the austere, solitary life of the dedicated artist right in the middle of a ferociously competitive, fad-driven, show business–like milieu, trying to maintain balance in a vertiginous world. And so Madame Grès did, calmly proceeding with her uncompromising work for fifty years, until she was inevitably forced out of business altogether—saw her atelier sacked, its *toiles* and half-finished garments brutally discarded, the dress forms chopped to pieces—for nonpayment of rent. At the last she withdrew in dignified sorrow to an old people's home in a remote part of France.

During the period just before the museum exhibition opened, cautious efforts were made to reach Mme Grès in her seclusion. Results were forthcoming: cordial messages from her, of pleasure at being remembered and honored in this way, of best wishes and thanks, were all transmitted through her daughter. Months later, the world was stunned to discover that Mme Grès had in fact been dead for almost a year when the show opened. The daughter had kept her death secret, inventing the messages and prolonging the illusion that her mother still lived—perhaps to feel, however temporarily, in real possession of her at last.

An artist's dedication is very stern stuff. The life and death of Mme Grès were not only solitary but secretive and unworldly in the extreme, although it is known that she indulged herself in certain extreme luxuries (a custom-made car with mink upholstery, for example; she owned various homes, and an Ingres), but these, too, were private pleasures. Personal display and social visibility were of no interest to her. She wore her famous turban to hide her hair at all times, like a nun, and garments

of utmost inconspicuousness to match her inconspicuous body—neat as a nun, too, nothing casual and scruffy. She neither went noticeably about the fashionable world or about town nor presided over a salon in the celebrity manner of Chanel. She did travel, however, and her works show the influence of her aesthetic discoveries, especially in Asia, where she learned to make robes that stood piquantly away from the body, sometimes with quilting, and jackets with a crisp flare to the skirt or sleeve.

Grès was not especially gifted for familial or social or even professional relationships, one must conclude. Her husband left her for good in 1937 after less than a year of marriage, and the life she resumed soon after seems to have been one of unrelenting dressmaking, most of it accomplished alone. She trained no one and had no assistants, although she did have technicians who finished what she had worked on in solitude for hours to perfect, draping and pleating and folding and pinning the fabric with her hands on the living body of the mannequin—no sketches. In this way she produced a collection of 350 pieces each year. The mannequins stood and stood and stood, and were fired if they couldn't stand it. Grès rarely saw her actual clients, although she had a few close friends among them, some of whom she dressed free. There are no rumors, scandals, or even plain reports about her personal life; those who worked with her found the deprived atmosphere somewhat oppressive.

Her devotion was to beauty and perfection; her obsession was the solving of abstract problems posed in terms of fabric to be arranged on the feminine body. Her clothes, so detached from normal fashionable life with its trends and fads, are therefore called "timeless"—to which one might add heartless, if one dared, and perhaps even passionless and humorless, despite the frequent drama of their textile conception. She clearly had the detachment from vulgar humanity needed for such work; the passion went into the medium, in this case the silk and wool and their infinite possibilities for beautiful wrap and cling, sweep and fall—but surely in the métier of fashion, a leavening of vulgar humanity gives bite and texture to the sartorial imagination. The austerity of the Grès fantasy gives it an immense overriding elegance, but it is faintly sterile at moments.

And how in fact do the clothes themselves justify the respect they inspire, apart from the respect for the designer herself and her inviolate

principles? To begin with, they are French, as she was. They exemplify not modern art or the essence of modern fashion but rather the purest haute couture in the unique French tradition, in which elegance and only elegance is the aim, not coquetry, energy, smolder, or wit. Those should be the properties of the woman, not of her clothes. To achieve true elegance in a garment, absolute technical perfection must match the highest quality of material and a sustained finesse in the design. There must be no perversity or bizarrerie in the aesthetic conception visible on the outside, and no cheating or carelessness in the interior construction or finish.

Elegance above all requires that there be no practical or aesthetic traps which might render the wearer ridiculous for an instant, however she might momentarily slump or stumble, however hastily or awkwardly she might suddenly have to move. She must be able to put on the dress and forget it. Once on, it must not need adjustment by the wearer. Fastenings, linings, edgings, and attachments must be absolutely reliable, and any ornamental elements must behave in total accord with the main shape and mass of the garment—there must be no big bow that might crush and need fluffing, no decorative drape that might slip and need hitching, no outsize silk rose that might waggle; and the skirt must always sway back into place by itself. The standard is the same in a good costume for any stage performer, especially a dancer.

Thus the dresses Mme Grès created by this standard barely live at all on the static mannequins in an exhibition, although their complex conception and structure may be appreciated. What they need is the performance, the coquette in action, her own wit in motion, her body on the move, the occasion in progress. Then the glorious width of the fabric, fifty yards of silk jersey without a seam, may float and swing and settle richly around the lower body, before gathering itself together to begin its intricate climb up the bending, breathing torso in serried interwoven folds, which finally part, or swerve, or simply stop, so the expressive shoulders and head may crown the composition.

Grès disliked cutting and piecing fabric with seams that might interfere with its fluid behavior. She had extra-wide materials woven to her order so she could constrain it and release it at will, concentrate the folds and then suddenly spray them out. It was not possible to wear a

bra with the draped dresses, or perhaps any personal underwear. Grès created an individual substructure for each one. "I do what I please with the breasts," she is alleged to have said. This meant moments of deliberately unexpected exposure, perfectly controlled by the original vision, never inadvertent—again, a tradition of the dance stage.

The famous similarity to Greek drapery that everyone wishes to see in these dresses is quite false. Although some Greek dresses were pleated and others hung in free folds, they fell directly against the skin and were never strictly laid down against a fitted lining, but all of Grès's were. What people mean is not actual Greek drapery, but Greek statues and paintings of drapery; and there they are right. Like all those who design Greek drapery for dancers, such as Bakst for Nijinsky's *L'Après-midi d'un faune*, Grès followed the effects created by sculptors and vase painters—she did not seek to find the way the garments worked in real Greek life. The desired effect is the breathtaking tactile beauty generated by a harmonious movement of flesh and fabric together, a counterpoint that looks both natural and perfect; and only representations in art can achieve this. The Greek artists showed how to do it, and they remain the best examples in the whole tradition of Western art. Nature alone is notoriously unreliable, usually accidental, casual and disharmonious, certainly when it comes to the combined action of bodies and cloth. Sculpture and painting, dance and couture must invent a beauty for it.

When Alix Grès was still Germaine Krebs, her middle-class parents had refused to let her study sculpture or to consider a career as an artist. They had no objection to polite feminine accomplishment, and she did study dancing, but they objected to a career as a dancer. The girl had desired these particular creative paths, she had felt herself fit for them. And she ultimately had her perpetual revenge, giving herself unreservedly like a priestess of art to endlessly re-creating her personal synthesis of beauty-in-form and beauty-in-motion, ignoring polite accomplishments, social status, everything but her own version of perfection. Dressmaking might be thought even less respectable than sculpture or the stage; but in France as nowhere else, haute couture was a serious calling, an elevated craft of the greatest prestige. Before couture was officially established in the late nineteenth century, French standards of refined elegance had already been world famous for three hundred years, bringing not only celebrity but revenues to France. Haute cou-

ture simply confirmed those standards, and that fame, in modern commercial terms. Among worldly and cultivated folk in the 1930s, when Germaine Krebs became Alix Barton and later Mme Grès, Parisian haute couture probably commanded as much reverence as Greek sculpture did; she chose her métier well. When her failing house had to be sold in 1984 to the plebeian businessman and politician Bernard Tapie, she could announce to him succinctly as she was escorted off the premises, "*I* am in the museums; *you* will never be there."

Toward the end of her career, she was immensely proud of preserving the highest French standards of dressmaking, even if it meant eventual disaster in the post-modern world. "The way I practice haute couture is totally ruinous," she said in 1982. "But it is essential that the image of French quality and elegance that I carry abroad with me survive." And later: "Today, luxury is confused with waste and excess, and its only value to the [French] authorities is that it is exportable, and therefore brings in foreign currency. But beauty has no price; it must be protected."

Ultimately it wasn't. When *Le Monde* broke the story of her death on December 14, 1994, it gave particulars of her life, career, and importance—contemptuously and justly referring to current famous practitioners such as Romeo Gigli, Jean-Paul Gaultier, Rei Kawakubo, and Martin Margiela as "stylists." The likes of them inhabit a new and different world, one where it is just as well that Grès cannot see what has become of the effort to protect beauty in the ancient classical sense, let alone create and maintain it.

George Balanchine

Following Balanchine is a work of great distinction, although it is certainly hard to read. Truly valuable and precise books about art are rare enough, but much rarer is a satisfying book about the exact character of serious criticism. This short and aptly illustrated study is both. It is also a species of autobiography, a personal memoir, a private revelation, a kind of confession, ostensibly because Robert Garis believes that true criticism is born of personal feeling and you can't describe the one without the other. Besides that, he is profoundly interested in himself. Writers have created masterpieces out of such an interest, but you need a lot of tact to make it work, and this writer's ability to make us share his self-absorption is variable. He's very good at searching his own feelings and memory to illustrate small critical moments and large critical perceptions, but he is less good at presenting himself apart from these, when he often seems to indulge in that insufferable habit, oblique boasting in the guise of ruthless honesty. We especially don't need this when it's beside the excellent point which he is using himself to make.

With detailed intensity Garis describes the way in which he has followed the work of George Balanchine since first encountering *Apollo* in 1945, when he was about nineteen, until the choreographer's death in 1983. Notably, Garis has not wished to use anything like the same detail

Review of *Following Balanchine* by Robert Garis (New Haven: Yale University Press, 1995) in *The New Republic*, November 13, 1995.

or intensity to track Balanchine back into history for our sakes: this is not a biography, even an artistic biography. Nor does Garis bring such passionate attention to considering critically the independent life of Balanchine's great works, to imagining them in other contexts beyond his own direct personal judgment formed from his own experience. Instead, he uses his immense powers of concentration to track his own perceptions into the past, into earliest childhood before he knew anything about ballet, to elucidate for us the process and materials out of which a dedicated critic was made, and then to show how he eventually came to flourish on the inspiring nourishment a particular great artist provided. It is, and it was meant to be, an exemplary tale.

Garis traces Balanchine's development through forty years by telling the story of how his own critic's heart and mind were confirmed and reconfirmed in their chosen work specifically by Balanchine's genius. To do this, he has made a sustained critical demonstration out of the whole text, at the same time describing how it was possible to do it and how it was done. The somewhat mesmerizing result actually requires not reading but study. It's almost immediately clear that this author is not only a dedicated critic but a devoted teacher—and that he would even prefer, like Miss Jean Brodie, to be a leader.

He makes the case for following him very persuasive, and yet he also shows that it's impossible; he will always be way ahead. We can't be him, with his daily, weekly, yearly attendance at the ballet that kept him in such close touch with the most delicate workings of Balanchine's imagination, whether technical and practical or emotive and allusive. But of course, that's not how he really means us to follow him. His tale is exemplary with respect to how performing art should be experienced and judged, not how often it should be attended, even though these things are obviously related.

Performance is indeed the point in this book, and in this form of art criticism. Garis's attachment to art began with music and novels, went on to opera, theater, and movies, only finally reaching ballet in the work of Balanchine, and finding other dance performances because of him. It is singular that Garis has remained the serious exponent only of the temporal arts, where all works have a beginning, a trajectory, and an end, perhaps enclosed within an overture and a coda or an introduction and an epilogue, the opening credits and The End. Since they can be fol-

lowed only in sequence from left to right or from first to last, such works must be undertaken and apprehended as journeys, no matter in what fragmentary circumstances they were actually composed. They represent the movement of life through time, as a quest with a duration, phrasing, and an outcome unknown at the start. They suggest that some lives are suites of dances, some are one long, slow struggle, others are short, bitter farces. And the separate sections of such works have the same temporal cast, just like the separate parts of lives and journeys—there may be different companions, different speeds and rhythms in each, unforeseeable resolutions and changes of key, but no escape from the sequential mode. Art and life are shown to have a common onward pull; perception and criticism require the intimate apprehension of a *process*.

A work of literature can only sit there in print, ready to be ingested piecemeal or at random, and it thus permits some detachment on the part of the reader, a choice about how to take it in. Operas are recorded and listened to in fragments in irrelevant contexts, bits of films may be excised and enjoyed in videotic privacy—although it's of course understood that the real work of art is the whole trip, *Parsifal* from start to finish, *Our Mutual Friend* from beginning to end, the uncut whole of *Les Enfants du Paradis*, and all three parts of Dante's *Commedia*. But with any of these, the point now is that there are mass-produced copies; with operas, different performances in mass-produced copies (if the music or video is all you want). Lovers of such works have easy private access to them or to parts of them at will, with control of how to permit their effects to work.

So far, dance is not really the same (except movie dance, made on screen terms). You have to be there, to see it all and follow it through, to share in its precarious immediacy and feel the intense physical identification it demands from its watchers. In performance, theater and opera naturally have the same immediacy as dance; but operas and plays do have texts, just as chamber music does. Whatever the violinist, the actor, and the singer may do, they produce only a version. The original is safe inside its words and its score, forever a potential vehicle for performers but perfect only on the page.

Dance is wordless and scoreless. Traditionally it has been taught from dancer to dancer, from choreographer to dancer, from body to body, because the notation systems that exist are insufficient. Dancing is too

much like play, or like ritual, or like life. In the work of a great choreographer such as Balanchine, all of what Garis repeatedly calls the "inflections"—the most delicate tonal effects the artist's decisions produce—depend entirely on the soul and body of the individual dancer at the moment of execution. There is nothing else. The moment of a critic's perception must be equally immediate and the memory a direct echo of that instant.

Therefore, although Balanchine made excellent ballets for the Diaghilev dancers and the Ballets Russes dancers, his greatness was ultimately confirmed for the world only through his hands-on creative thought and work with his own forever developing group of dancers, who were perpetually being trained and chosen and cast by him in the repertory he built for the New York City Ballet, using as a source the School of American Ballet, which was also tailored for his use. Some of this repertory included works he had done years before, like *Apollo* itself, which he re-created for the new dancers in the new ballet universe he was inventing. But his finished ballets were also transmuted whenever he used a different cast for them, especially different principal dancers, who would set the tone and bring the whole work into focus. The crucial flavor and texture would shift slightly, aspects of the music would emerge as having a different emotive character. During his long career at the New York City Ballet, Garis tells us, Balanchine was present at every performance of every one of his ballets until the end of his life. He was always working, never losing contact with any of them, his eye on the life of his art each and every time, the whole time.

That's the standard; he had to be there, and so do we. And so did Garis, following every step of the dance, every change of the cast, as often as he could. He wants to make clear that the work of acute personal action that goes into the creation of a performing art must be echoed by the work of acute personal receptivity in the viewer. Distance and calculation are not indicated. Good critical judgment must be filtered through "exhilaration," a vibrant recognition of the artist's thought in progress (which includes the dancer's performance or the singer's), an apprehension of what Garis calls the work's "identity," which illuminates the consciousness of the viewer as the piece unfolds on a given occasion. "Appreciation"—that is, knowing that the work is supposed to be good or bad, and accordingly standing back to try to approve or disapprove of

it—is essentially at odds with this transfigured condition, which is required for perceiving the shades of a work's real excellence and the exact flavor of its deficits. Before you can really know it, it must enter and inhabit you. Only then can your appreciative skills be put to good use or make sense.

Garis tells how, very early in life, he learned to recognize such transforming moments in himself and allow them to occur, and to distinguish them from mere progress in the sterile quest for approval and self-approval that by itself leads only to joyless expertise. The context in his childhood was religious. His parents had become devout born-again Baptists after a sequence of family afflictions, and the boy Robert and his brothers were encouraged to be transformed by faith, to accept Jesus—to be personally converted, not once, but over and over if the condition passed or proved false. Soul-searching in the form of testing private experience for its authenticity became a habit for Garis, who finally lost his faith forever at around the age of ten. He was, however, by then in possession of an excellent tool he would only later put to use with the sustained personal and professional profit that he describes and demonstrates in this chronicle.

Explaining how he set out in the other direction, Garis reports with precise candor his adolescent progress in seizing on music and literature with the ferocity of a contender (he was no good at sports), eager to win, to build a strong critical identity and have it acknowledged, wanting to like what was known to be good and for all the right reasons, winning if he did, checking himself out against prevailing opinion, following out its prejudices in the teeth of direct evidence until he learned better, always fighting for his views. He became an expert judge and obsessed appreciator of books and music the way some kids learn all about the Navajo or airplanes—to gain power, to be somebody. Later on, we find him pursuing a received standard path through recorded Glyndebourne productions of Mozart operas, rejecting certain performances for snobbish reasons without even listening to them, respecting others without exactly feeling the reasons why he should. By nineteen, however, the young Garis was inwardly prepared. He was actually hearing a live performance of *Le Nozze di Figaro* at the Metropolitan Opera in New York when Licia Albanese sang "Deh vieni non tardar," and he experienced his first true artistic epiphany in the born-again mode. He

fell directly in love with *that* music at *that* moment, accepting it totally without reservation, preparation, or rationalization. At last he could recognize this true ravishment as quite different from all the musical knowledge and operatic sophistication he had up to then been pursuing. And so the disparate habits of early youth thereafter found their common medium, and a real critic gradually took the place of the faith-seeking child and the competitive adolescent:

> My surprised reaction to Albanese's "Deh vieni" still seems to me the sine qua non, the experience without which I would never have become more than officially and generally involved in music instead of personally involved, and the same kind of thing was soon to happen with Balanchine. Before seeing any of his ballets I was ready to approve and like his work. I was even ready to fight for it, since I had conceived of him from my reading as a great artist whom it took unusually fine and bold and unconventional taste to admire. And yet my first experience with Balanchine was as powerful as my first experience of *Figaro* and as surprising. I had anticipated approving and loving *Apollo*, but I had not expected to be helplessly overcome by it to the point of shedding tears at the apotheosis.

Critical ambition and authentic pleasure could finally combine, and yield eventual self-knowledge and a satisfying life, not just a successful career. His candid self-appraisal is good to read, along with the other confessions of failure of nerve or will or joy along the critical path. Garis shows that the training of artistic judgment is vulnerable to weakness of spirit and character, not just to aesthetic misperceptions. False steps in perception can in fact never cease to come from instances of pride or vanity which forever threaten to cloud the judgment and produce the need for new conversions. Under it all is the desire to be a true judge—to seek the truth of art directly. By this means, it is implied, even the character might improve.

Garis goes on to unfold his critical journey through Balanchine's career as if it were the core of his own life, relating personal encounters and relations and professional experiences to this one unswerving passion and detailed preoccupation. In order to keep his responsive bal-

ance, to maintain the necessary innocence at the center of his increas-
ing experience, he refrained from trying to know the dancers or the
choreographer personally, or from taking any ballet training himself. He
is proud of not knowing the technical terminology. Such ignorance
seems to ensure that he keep his eye and heart fresh for the direct per-
ception of Balanchine's work, untainted by the poisonous enjoyment of
inside dope.

During all this time, Garis in fact became a distinguished critic and
professor of literature, and eventually wrote and taught about theater
and movies as well as ballet. But this autobiographical material is here
presented as if it fell into line behind Garis's practice of active critical
love upon Balanchine's art. The flavor of this practice as he describes it
is indeed musical, functioning as a sort of pedal-point, or an underlying
private song unfolding its delicious unpredictable phrases to accompany
or even to direct the progress of living, with other critical and practical
or emotional work undertaken on the model of this chief intimate, con-
stant, and satisfactory effort.

Notably, Garis had no earlier experience with ballet. He discovered
Balanchine and ballet at the same time, and he is not the only liter-
ary critic to do so, or the only music lover. I think of Richard Poirier
and Irving Howe, for example, who became interested in the art of
ballet only through the exfoliated modern version singlehandedly cre-
ated by Balanchine, the version that for the first time patently aspired
to the condition of music, and the best music, too. On Balanchine's
stage the bodies of ballet dancers came to be liberated from the chains
of spectacle and pantomime, while the course of their stage behavior
through any work was no longer weighted by the demands of an
externally applied plot. The dancers could manifestly enact pure
human situations through a ballet vocabulary that was newly honed,
deepened, and expanded expressly for the purpose, and composed into
works of unadulterated artistic exploration, like poems. And there lay
the secret.

Balanchine knew how to transform traditional ballet into modern
ballet without dreaming of abolishing its basic formal character, in the
manner of those revolutionaries who wished to escape ballet's strictures
by throwing ballet out entirely and reinventing dance, thus assuming the
risk of looking ridiculous. I believe Balanchine's works were so deeply
satisfactory to modern literary people because they were clearly created

in a supple and seasoned traditional language. He was making cogent and believable new use of old rules that had already been repeatedly modified, refined, and strengthened, tempered by fire and time like those of French or English in the making of their forever modernizing literatures. Musical language had had a similar trajectory of perpetual reform by inspired innovators. Ballet could be modernized by Balanchine because he understood how to take advantage of its evolving matrix, to perceive ballet as infinitely elastic rather than rigidly confining.

He didn't need to throw anything out, only move on with a reformed purpose and new ideas, as the famous ballet masters of the past—Noverre, Bournonville, Perrot, Ivanov, Petipa, Fokine—had done. Certain kinds of scenery and costumes had to go, so as to leave the character of the reconceived dance more intelligible and to emphasize the distinct body and talent of each dancer. This time, in the formally integrative modern period, Balanchine could move on to bring ballet into a newly ambitious relation to music, where each could illuminate the other's character and neither detract from the other's power. Representational and narrative effects, what Whistler called "claptrap," were strictly subordinated to formal considerations. The formal stakes were thus sharply raised, since the form itself became responsible for conveying the drama. Balanchine would say to each dancer, "Don't act! Just dance the part!" The dance and the individual body would do it all.

Garis deals wonderfully with the long relation between Balanchine and Stravinsky, two imperial Russians-turned-Americans-via-Paris, twenty years apart in age. Both were youthful stars of the Diaghilev enterprise, at opposite ends of its astounding course during the early years of the twentieth century, with some overlap in the 1920s. Later, the two collaborated in the United States—producing among other works *Jeu de cartes, Orpheus,* and *Agon,* with various reworkings of *Firebird, Le Baiser de la Fée,* and *Apollo*—and Balanchine set several Stravinsky works not initially meant for dance. Garis shows how Balanchine had to deal with Stravinsky's idea of what a musical ballet scenario should be, and he thinks that Balanchine could not always fully express himself through it. The occasional dulled-down result, under Garis's intense gaze, could seem like Balanchine manifestly trashing his own ideas, when he found himself dissatisfied with what he had first done (as in the case of a reworked *Orpheus,* for example) and wished visibly to

destroy it rather than be seen to have allowed his choreography to suc-
cumb to Stravinsky's plan for it.

Garis thinks Balanchine came to feel his own sovereign cho-
reographic genius to be at odds with the composer's idea of ballet
music—and this composer was a past master fully confident that a
choreographer's purpose was to produce a dance version of the com-
poser's score, not to make an independent work of choreographic art
that might open the music beyond itself. Stravinsky, despite his relent-
less modernity, had been brought up knowing the imperial ballet tradi-
tion, where there was no choreographer by that name, only a ballet
master who by definition arranged stage dances to fit stage music, as
courtiers had once danced formal dances to court music.

Balanchine, on the other hand, had been a full-course student at the
Imperial School of Music in St. Petersburg after finishing his ballet
training, and his father and brother were musicians. He understood
music itself perfectly, but his genius was for choreography, with no
thought that it was the servant of the composer. He had choreographed
to Bach and Mozart as well as to Bizet and Tchaikovsky, using works
that had never been intended for the stage. Stravinsky was offering his
highest praise when he said about his *Agon* score, "George will compose
a matching choreographic construction. He is a master at this": he obvi-
ously felt, Garis believes, that the music was "a sort of assignment for the
choreographer." But Balanchine eventually converted him. Later on,
Stravinsky was to say that Balanchine's art "explored" his music, as it
clearly did that of so many other composers.

To a lover of Balanchine who arrived there by an entirely different
route, the Garis account has a very alien cast. Garis refers to himself as
"interested in the arts" from the age of ten or eleven, but it was an inter-
est founded on the power of music, never straying far from that deep
stream into which can be troped the enterprises of film and literature,
with ballet and opera linked to them by the musical skein, the phe-
nomenon of the structure developing through time. Absent is any pic-
torial art, the art that bursts on the eye all at once—except one irritating
remark about having always preferred Géricault to Delacroix with no

further comment, a vain utterance he ought to have resisted. Of himself Garis reports no directly enhanced sense of still visual imagery, no moments under the spell of an apparition that proposes an alternative universe, or in front of an image where movement is illusory, built into the charged dynamics of the motionless picture, or one where the artist's thought must be perceived in layers, in the tension between alternatively or equally vivid figure and ground.

Garis recounts no rare, revelatory visits to museums, no poring over books of reproductions, no fixations on any book or magazine illustrations at home or school, store or library. Though his literary and musical judgment were burgeoning in his early days, his visual education was clearly not keeping up. Perhaps he would lay this to parental strictures; but the later growth of his eye couldn't keep up either, once all art became available to him. However well we find him following Balanchine's thought, he was clearly less able to follow his visual thinking.

Garis as critic distinguishes minutely and specifically among the qualities of dancers' performances and among the bodily styles of different dancers, precisely perceiving Balanchine's relation to each one's "dance identity," but he seems to have no comprehensive perception of the effect created by clothing each time any of them appears—no sense of the immediate visible apparition, with its unique combination of layered meaning and feeling, only of the perpetual process by which each identity is confirmed. He is not silent about costume, but nobody could miss the effects he singles out—certain notable colors, the shift of clothes in *Liebeslieder Waltzes*, the fan in *Don Quixote*, indeed anything worn by Suzanne Farrell, whose extraordinary sexual presence spoke so loudly through every fold of her garments.

I was hoping for an exact elucidation of those sartorial choices that made the Balanchine ballets and their performers look the way they do, and created those radically reconceived stage figures. One photograph shows Jacques d'Amboise in *Who Cares?*, but Garis doesn't mention the necktie around his waist in imitation of Fred Astaire, who always wore ties for belts when he practiced. By contrast he compares the décor and costumes for *La Valse* contemptuously to a "Bonwit Teller window" and says that the ballet eventually "transcended this chic mode"—demonstrating that he has no more eye for window display than for painting, and hence not much for stage dress and setting. So he has clearly missed a

good deal about the stage looks of his beloved Balanchine dancers over the years, and the photographs tantalizingly show more than he ever speaks of.

I was raised on the ballet, and I was its born-again infant. Expertise came later. I saw the Fokine masterpieces and the early Balanchine masterpieces, along with Massine masterpieces and Petipa masterpieces, plus *Giselle*; I saw Danilova and Baronova, Toumanova and Riabouchinska, Lifar and Lichine, all beginning in 1934, when the Ballet Russe de Monte Carlo had already been coming to Cleveland every year for some time and my mother rightly decided that at four I was old enough to go. I was old enough to be transformed, to accept it into my soul. Later there was the Ballet Theater with Markova and Dolin, Nora Kaye and Alicia Alonso, Eglevsky and Youskevitch, other ventures such as the Littlefield Ballet, Mia Slavenska and her ballet troupe, and finally the New York City Ballet. When I was in college in New York, I was also able to get standing room down front for the first visit of the Sadler's Wells Ballet to New York, another transforming experience, standing a few feet from Margot Fonteyn and watching her solar plexus radiate energy like the sun.

My mother had studied ballet in Cleveland and so did I, beginning as a child, with another Imperial School survivor called Sergei Nadejdin. We stared in the mirror, mastering the line with eye, will, and muscle, forcing the path toward perfection while Mrs. Hershberg thumped out Tchaikovsky, suffering the occasional small thwack of the master's slim baton. At the end of each class we practiced our *révérence*, for serene graciousness, humility, and *port de bras*. In fact, we were too fat, it would never really work, but how the soul and body sang with the effort! We studied the souvenir programs, full of pictures, and soon I was off to the library to immerse myself in the history of ballet, and brood further over all the ballets and dancers I would never see, the prints of Taglioni and Elssler, the photos of Kschessinska and Preobrajenska, Nijinsky and Bolm, Lopokova, Pavlova and Karsavina, whose memoir *Theatre Street* I read many times, along with Nijinsky's excruciating book about himself.

Central to me for these experiences was the figural vision, the dancer's body performing its exalted movements in its characteristic shoes, clothes, and headgear, so erotic, so exact, so magical in its transcendent artifice—and in all that, so like the characters in the great

paintings I was busy staring at in books. Ballet costume was part of each dancer's dance and each dancer's soul, all three made the vision together, and the pictures from the past confirmed and augmented the beauty of present visions. You could see the source of the new in the old. The immense difference between a tutu that fell to the ankles, a tutu that flounced to the knee from a low hipline, and a tutu that burst from the dancer's loins in a small, stiff spray was crucial to the personal drama embodied in each dancer at the moment of appearance, not just to the role. When I first saw the Degas statue of the fourteen-year-old dancer, I knew he was right to dress her up: we need the sloping tarlatan so as to see the skinny legs and sunken chest, we need the bow in back to see the monkey-face in front.

On stage each shape and flavor of skirt had its own relation to each toe-shod foot, to the ensemble of head and arms, to the tight focus of the torso; and each sat on each dancer differently, even as she simply crossed the stage in a preparatory walk. Disciplined hair, always hiding the artless ears, gave prominence to the dancer's rapt face, to the arch of the individual neck, to the precision of its turn. A crown or garland might sit regally high or tenderly frame the face. And the men! The endless leaping legs that went all the way up to the waist, offering glorious fore-and-aft landscapes sculpted in brilliant color or dazzling white, below noble torsos glittering with fervor or villainy, each different set of sleeves forming its own composition with the rippling legs and stately head. Suddenly, *Schéhérazade* had everyone in Oriental trousers, even the women in toe shoes, and suddenly each captive princess in *Firebird* had a dozen long, swinging black braids—all potent evidence of earlier reforms now strengthening a comprehensive visual language.

Then along came Balanchine's dancers wearing what everyone, including Garis, persists in calling practice clothes. A glance at Degas's works and other pictures, or into Karsavina's memoirs, shows that ballet practice for women was undertaken in tutus for generations and well into the twentieth century, and custom then ran to leg warmers over the tights and a whole range of individual gear not prescribed by any common rule. The characters that burst brilliantly onto the Balanchine stage were *costumed*; he chose those black or white tights, those black or white bodysuits, tunics, socks, and T-shirts. The ensemble might suggest gymnastics or the carrying out of ritual exercise, and indeed it often

suggests not only ballet practice but modern-dance practice, just as the *Schéhérazade* costumes suggest the harem. But it also suggests the black-and-white formal garments of players in a symphony orchestra, as if these bodily instruments were now dressed to match them, to create a new sympathetic visual resonance with the musicians' own full-dress echo of neoclassic simplicity. Both are clothes for performance.

It was soon clear that the range for this new costume theme is vast, like that for tailored suits. What were the decisions about when the black leotards should have tight leather belts or each white tunic a little skirt? Why did the men with black legs always have white feet and the black-legged women never? In the abstract dances, the sweep of female leg remains unbroken to the toe's end: the men's are chopped off at the ankles, as they are not in previous classical ballet—how was this arrived at? For the emotional ballets, how was it decided when to release the male and female dancers' hair and ears to produce yet another tonal variant in both the vision and the motion? The tutu theme itself was thoroughly expounded in many Balanchine dances, including floating or dripping versions that start and end at as many different levels as the stiff ones. What exact aesthetic explorations were these, and how did they arise to complement the dance? Why white legs here and black there? Why stiff skirts here and limp there? Who proposed these tiny visual allusions and references that make so huge a difference to the ensemble of bodies, movement, and music?

Garis has the answers to this sort of question only when the dancer, the music, or the choreography is the subject, but the clothes affect him even if he's not paying attention. He reacts strongly to the difference between what he calls "ugly leotards" and "elegant white costumes," but without saying exactly what produced the elegance or the ugliness, or saying who designed the nice white costumes. Garis gives the impression that the variously austere and dramatic clothes for his ballets were conjured by Balanchine himself or even by the dancers, that hardworking designers and craftsmen, naturally dull-witted and ham-fisted, were responsible only for costumes that needed to be stripped down, changed, or discarded. But dance costume is a refined theater art, and though all visual effects were subject to Balanchine's overriding authority, dress was not his métier.

Whom did he engage with, to produce all these subtle variants? I was

shocked to find no mention of the great Karinska in this book, another old Russian survivor who—unlike Chagall, Picasso, Dali, and other painters who presumed to design ballet costumes with no knowledge of cloth, cut, and seam, let alone dance—was an exquisite craftswoman and interpreter as well as a designer herself. She had the highest standards of skill and materials, and unfailing balletic taste, in both the traditional and the modern vein. Many of her designs are still on the Balanchine stage, with her minutely calibrated versions of standard ballet themes endlessly and elegantly modified. How did she get on with Mr. B? By the look of it, she understood him.

The history of ballet that informed Balanchine's own choreographic instincts was lacking to Garis when he began following Balanchine. He had to fill in the history later, but only in the light of Mr. B.'s new dispensation. Consequently, with some notable exceptions, the more spectacular and representational aspects of Balanchine's work often seem to Garis like efforts to please others more than himself, and to be less basically characteristic, even if exhilarating—he allows Petipa's influence on the abstract sequences of dances Balanchine developed, but not Fokine's influence on *Serenade* and others. Fokine doesn't interest Garis; nor Massine, nor Nijinsky, and certainly not Isadora Duncan. He looks at the old-fashioned aspect of Balanchine with appreciative condescension, in something of the same spirit with which he views the English maintenance of the Romantic and classic ballet traditions.

I remember finding the English ballet a magnificent undertaking whereby many old works—*Sylvia, La Bayadère, Cendrillon, Giselle*, and indeed *Swan Lake* and *Sleeping Beauty*—are offered with as pure a belief as they must originally have been, with none of the ignorance and failure of conviction that has led to carelessness or wretched campiness among some latter-day companies that have attempted them, nor any decay of the best standards for visual spectacle. They made a legitimate reference to the courtly tradition behind the whole enterprise of ballet, preserving a continuity with ancient nonprofessional effects. Nothing was ever too fast, too crisp, or too obviously difficult, but it was

always perfect and simple, never sloppy or hasty, poignantly beautiful and suggestive.

Garis views this rather disdainfully as chiefly exhibiting the limitations of "good taste"; and yet good taste is certainly what Balanchine himself never failed to have. Garis just likes it better when it's modern and doesn't see its recurrent value as a universal clarifier of artistic aims. What does interest Garis is the evidence of Balanchine's experiences in Hollywood and his serious artistic affinity with American popular culture, which Garis wishes to contrast with Jerome Robbins's allegedly shallow and crowd-pleasing musical-comedy spirit. This suggests that Garis's own relation to popular culture is uneven and uneasy, and that he envies both Balanchine's and Robbins's different kinds of ease with it.

Garis has only recently come to view the modern dance with any favor, more or less as a side effect of his devotion to Balanchine. He experienced no conversion, as some of us did, upon encountering Martha Graham—I believe because her sense of music was very spotty, for one thing, and you could often imagine the dances best accompanied by nothing but a drum. Garis evidently cannot love or even clearly see any dance that doesn't have a score he loves, and he admits it, not without pride. So he's not able to place Balanchine in the modern-dance context, either, and allow for any current lateral influences, along with possible past vertical ones he hasn't personally experienced and digested. But all this is made to seem unimportant to his subjective account, which illustrates his view of the immediacy of dance criticism based on the immediacy of dance itself. He thinks that getting all the allusions is fun but not essential for getting the point and following it. One might argue that some points are made through references and echoes, and you risk missing them if you discount those. He says confidently, about a ballet he can't exactly pin down the style of, "In fact, not having a term for this style is the best way to experience it." Maybe.

Garis often hints that the great Balanchine works may not survive. With the death of the master, his ballets have lost their own living power, even their power to engage viewers as they once did. This is owing to the nature of the medium. We know how a great painter or poet can make something which will indeed survive him and his culture, even taking with it into the future the beloved who was the

excuse, as Shakespeare often said and Rembrandt showed. But Balanchine worked with live human material inside an institution, itself a complex organism made of humanly fallible members and managers. So long as he had undisputed artistic authority over every aspect of his work, the ballets survived and developed and changed as Balanchine re-envisioned them, or were discarded altogether, if the right combination of dancers was wanting. Individuals who couldn't stand the tyranny of his artistic will had to leave. Since his death, it is the institution that survives. The ballets must simply stand by and patiently await their fate.

Garis finds the spirit of democracy invading the repertory of the New York City Ballet under Peter Martins's direction, sowing artistic death. Indifferent or ill-suited dancers are cast in roles to the detriment of the ballet, he believes, and only to serve an ideal of institutional fairness. Two casts may dance a ballet alternatively, to give more performers a chance, instead of one perfect cast dancing the piece until another is developed to be perfect in another way, or more so. While Balanchine was using his beloved Suzanne Farrell in ballet after ballet, other dancers felt neglected and ground their teeth; but Garis follows Balanchine in these decisions, too, with sympathetic fidelity to the choreographer's artistic compulsion, out of which his love was made.

But with Balanchine dead, the great modern ideal of art for its own sake, for the divine uselessness which invites and enjoins artists to develop their bold strokes and subversive explorations and minute refinements only on art's own terms, is once more subject to crude question. Not just Balanchine but Diaghilev, not just them but Baudelaire, not just him but Delacroix and a procession of others would turn in their graves at the pretty pass to which things have come. At present, art seems largely believed to be a sort of spontaneously generated personal gesture on the part of an ordinary citizen, a gesture with a natural intrinsic value equal to that of those made by all other citizens, protected under the laws of political equality and attacked under the same laws, as if its imaginative projections were subject to rules only of civil behavior. Real artistic quality and true artistic judgment are thus strongly encouraged to wither; and that's why this book is so valuable.

Garis has produced both a manifesto and an elegy. The elegy is for the Balanchine Enterprise, as he calls it, the serious modern art offered, for a time, at the New York City Ballet in the process of its creation by a twentieth-century genius. The fruits of Garis's critical attention to the Enterprise, set forth in this book in loving detail, are his funerary offering. The Enterprise cannot survive as Balanchine made it, and the ballets live only in their modifications by future dancers and choreographers—sometimes as undead, in zombie-like versions. Of course they share this fate with every other body of dance works, Martha Graham's for another example, along with *Giselle* and *La Sylphide* and *La Fille mal gardée*, choreographed so long ago that nobody is alive to mourn the originals. Film and videotape have lately arrived to help out the situation, but Garis is only cautiously grateful for these, possibly because of their limiting character—one time, one cast, with no possibility of a future dynamic for one closed-off and artificially viewed performance.

Garis is writing first of all for present and future devotees of ballet. But his larger manifesto is about the continuing importance of knowing just what makes any art great, exactly how its examples embody the artist's purpose, and what they can mean to you and me. In considering the examples of any art, the good work of true understanding always has to be repetitive and ruminative and slow—paintings have to be stared at, poems brooded over. Describing such effort over the span of a career is similarly repetitive and ruminative, and the conscientious reader needs a good set of living memories in order to follow Garis the critic without flagging, or even without exploding.

Henri Cartier-Bresson

Like Titian's, Cartier-Bresson's work began as the mirror of one epoch and is ending as that of another, simply because he invented the best mirror and kept polishing it. Cartier-Bresson's influence has been immense since his beginnings, not just on photography, but on cinema and photojournalism, so that he has been largely responsible for twentieth-century notions of what a superior realistic camera image should look like. Which is to say, for our sense of how modern life looks.

It is therefore most instructive to see how deeply his photographs draw for their verisimilitude on traditions of Western representation that prevailed long before the camera. In the full tide of current events, with no posing of subjects or manipulation of backgrounds and no cropping afterward, Cartier-Bresson manages to suggest Goya and Guercino, Metsu and Phidias, Daumier and Rossetti, Mantegna and Degas, and many others. He evokes such ghostly optical presences all the more strongly by avoiding the direct references often made to them by painters or by "pictorial" photographers. An eye with Cartier-Bresson's deep artistic sympathy can register and store the traces of past representations so effectively that he can transmit them straight into the receptive lens as if without knowing it. Thus he can conjure them up into the midst of life to tell a modern truth by purely modern means.

Review of *Tête à Tête: Portraits by Henri Cartier-Bresson*, introduction by E. H. Gombrich (London: Thames & Hudson, 1998), and *Henri Cartier-Bresson: Europeans*, introduction by Jean Clair (London: Thames & Hudson, 1998), in *The London Review of Books*, May 7, 1998.

This is what a great artist has always known how to do, although usually not in such a wholly distinctive medium. Cartier-Bresson's was photo-reportage, later to shift into portrait-photo-reportage, documentary film, and photojournalism, all of this a long way from Mantegna. It is evident from the pictures in both these books that the artistic past absorbed by Cartier-Bresson also comprised such giants of photography as Alfred Stieglitz and Edward Steichen—and look! here's Stieglitz himself, whose portrait Cartier-Bresson took in 1946, the last year of the great forerunner's life. Stieglitz's face wears a weary look not unlike that of Robert Flaherty, father of the documentary film, another great forerunner whose portrait Cartier-Bresson took in the same year.

A similar weariness infuses the faces of Georges Rouault and Pierre Bonnard in their 1944 portraits; but the relationship between these aged artists and the portrait camera is quite a different one. Both elderly painters are closely buttoned up, Rouault formally with waistcoat, wing collar, cravat, and homburg, his tired eyes not quite meeting the lens. Bonnard is informally but more totally packaged, with a thick wrapped scarf, a droop-brimmed cotton hat, a mustache, and spectacles all obscuring the physical Pierre, his gaze aiming far away into the light. These two are thinking of something other than this moment and this camera, which they only stoically permit. Picasso (never an Old Master, though finally an old man in his 1967 portrait) was also photographed in 1944, apparently in the act of undressing to recline for the camera, his hands fumbling at his belt and fly, his torso already naked, prunelike eyes staring, and an undraped bed right next to him.

In 1946 the Old Masters of the camera, on the other hand, were wearing wrinkled shirtsleeves without neckwear, the skinny Stieglitz lolling and polishing his glasses, a white lock falling over his brow, his glittering gaze fixed beyond us; the plump Flaherty with his hands on spread knees and two fingers delicately supporting a cigarette, his white wisps rising a little, his look reflective. These two fatigued pioneers are comfortably welcoming a young master and colleague. The Flaherty portrait recalls Ingres's *M. Bertin* (the drawing, not the painting), the bluff man with his hands on his knees in defiance of all portrait convention.

The glorious black-and-whiteness of all these portraits and scenes keeps them firmly in the great chiaroscuro tradition, which depends for its basic verity, even in painting, on the interplay of light and shade. They can therefore suggest the paintings of Guercino, whose drawings

are so telling, but not those of Piero; they can suggest Mantegna, because of his great engravings as well as his paintings, and Degas because of his paintings and monotypes, and his photographs, too; they suggest paintings by Daumier the lithographer and by Rossetti the book illustrator, paintings by the Goya who made the *Caprichos*, and by Metsu as one of the Dutch painters who could invite the light with such vital magic. Color has the same brilliant irrelevance to Cartier-Bresson's works that it has to Picasso's *Guernica*: all impassioned tints and hues are distilled into black and white and their varying combinations and relations. Cartier-Bresson has recently given up full-time photography to concentrate on drawing, saying that he is going back to where he began, which was as a student of painting. We can certainly tell.

In this book of portraits called *Tête à Tête*, the photographer has included a selection of his fairly recent drawings, which really are of nothing but heads, pencil and chalk investigations of the closely watched face's formal terrain, without depth or tone. They are very different from the photographs, where the artist floods the frame with associative material—hands, bodies, clothes, and whole bouquets of interior and exterior detail—and lets the face brim with momentary meaning. Cartier-Bresson is famous for composing in the viewfinder. We know he did it all directly, not only waiting for the right moment but shooting from the right place, so that the final framed arrangement might put the person near the edge and leave the center to some books, a wheel, a dog. Here is Lucian Freud (1997) gazing earnestly offstage, sitting just inside the lower right corner of a photograph dominated by the rear view of the big canvas behind him. The invisible painting is set on an easel that seems to frame and crown the painter's head; and we see an artist conversing politely while inwardly seized by a looming work in progress.

Sometimes the arrangement is very tight. Here is Paul Valéry (wrongly labeled 1946; he died in 1945) leaning on a mantel. He looks at us full face from the left side of the picture, where his pinstriped shoulder partly hides a vase of flowers, and a flowered dish sits near him. Near us, a small marble bust of the poet stares leftward into space in three-quarter view, guarding a framed picture in the center of the mantel, and of the composition. This is a photograph of Mallarmé and Renoir together, taken by Degas in 1895, when Valéry knew them all; and here's Valéry a third time, gazing out of the frame to the right above his bust, his profile

reflected in the mirror against which the photograph leans. This portrait, with its overlapping left-to-right waves of historic and pictorial intensity, is nevertheless delicate, pungent, and luminous as a Degas or a Whistler.

Or here's a little girl, seated in a tilt-back wicker armchair embracing a fluffy white cat (Mélanie Cartier-Bresson, 1978). Two strands of her hair fall symmetrically on either side of her face, and below it two clusters of the cat's ruff spread symmetrically over the two sections of her bent arm; at its angle, a spray of dark folds makes a chance beard for the cat's chin. Her hands lie quietly against the cat's flank; its paws rest soberly against her thigh. One above the other, the cat's face and hers turn at the same angle, their expressions still. The big chair's flat wicker weave is undulantly answered in the plaid pattern of the girl's skirt; the chair's rectangular armrests make a trio with the section of tabletop at the upper left corner. Under it, a system of curving supports balances a similar system supporting the chair at lower right. Concordant angles suggesting far wall paneling and near floor tiling fill the rest of the space. Light falls brightly on the two calm heads, emphasizing cat fur, catching some distant magazines and one near tile. This casual domestic image has an extraordinary peace and strength, in large part summoned by its structural authority.

In 1946 Cartier-Bresson photographed a black cat in the arms of a diabolically smiling Stravinsky, and a tabby startled by the regard of a reclining Saul Steinberg. Other props are more common and more affecting, chief among them the subject's own bare hands. One hand alone may clutch the brow (Martin Luther King, Jr., 1961), support the whole skull (Cecil Beaton, 1951), point its index finger into the upper lip (Colette, 1952) or into the lower lip (Tony Hancock, 1962), or feel the forelock (Francis Bacon, 1981); two hands may flatten against both cheeks (Lily-Brit Mayakovsky, 1954), interlock over the belly (Harold Macmillan, 1967), rise above the head to twist the hair (Svetlana Beriosova, 1961), chop the air in tandem for emphasis (Louis Kahn, 1960), or touch fingertips together in front of the mouth (John Huston, 1946). They may clasp one another in a range of expressive moves that the face may sustain or deny—see ancient Ezra Pound (1971), grim Irène and Frédéric Joliot-Curie (1944), coy Leonor Fini (1933), and the Duke and Duchess of Windsor sitting close together, their heads flirtatious, each using one hand to imprison the other hand (1951).

Detachable props give hands even more scope. What would Cartier-

Bresson have done without the cup, the pencil, the book, the cigarette—especially the latter, the modern emblem of private reflection, the sign that the subject is most himself? Or herself: here are Susan Sontag (1972) and Carson McCullers (1946), each raising a dark gaze to us under a brow tense with thought, each reaching to poise a cigarette over an ashtray. Giacometti (1961) stares nose-to-nose into the face of a bust he has made, his big foreground hand intimately cupping its shoulder while holding a tilted cigarette between two knuckles. This image was taken the same day as another of Giacometti clutching newspapers and squinting outdoors, his hand invisible inside his coat, a crumbling wall and door behind him, a different man altogether. Here is Carl Gustav Jung before a dark void (1959), a great seal ring on the creased hand that holds the pipe between his lips, a beam of light striking the mystic smoke and wrinkled brow together. Jean Genet's ringless hand is pudgy and partially bandaged as it waits to take the cigar from his lips, Parisian streets humming behind his leather-clad bulk (1963). Balthus in 1990 holds a porcelain coffee cup near his quizzical face as he regards us with his back to the light, the shape of his head inviting comparison with the highboy behind it.

There seems to be a preponderance of old and aging people in the selection Cartier-Bresson has made for this book, and they naturally bear the most resonant names, even though quite a few are unfamous. The famous in their youth include Truman Capote in 1947, T-shirted and sultry among huge leaves and white wrought iron, and sweet Marilyn Monroe in 1960, her bound-up golden hair crested with a black-spotted veil, her patient gaze turned aside as she waits in what looks like a television studio, full of mysterious heads and equipment. These two pictures, like so many in this book, are masterpieces of complex balance between figure and ground, illumination and obscurity, precision and blur. The look of the face may plumply harmonize with the look of the nearby sofa cushions (Jean Renoir, 1967), or it may harshly contend with the serene dome in the distance (Jean-Paul Sartre, 1946).

The volume entitled *Europeans* is full of children and adolescents, with just enough ancients to spice the vast mixture. Everybody here is nameless, but everybody has a nationality and a date. The panorama shows its subjects carefully fixed inside the careless sweep of its title, so we are

encouraged to gather the savor of a region and a moment from each shot. This Europe is not a single entity, but Cartier-Bresson does have singleness of mind, and the consistency of his vision holds all these disparate characters together. A few of them are trees or towers, nonhuman denizens of just here, just now. In 1956, a gray fortress squats in far-off snow behind a near screen of bare black poplars outside Bingen in the Rhineland; in 1964, three pollarded trees seem to keep watch over a windswept Hungarian plain; a year earlier, the interlocked descent of many terraced fields drapes a hillside in Aragon. Local human presence is conjured by the photographer's sense of how it was to live among these sights.

In most of the pictures he shows us just how it was. Many shots of ravishing village streets or glowing rural streams have a single figure hurrying out of the frame on urgent private business, or perhaps three or thirteen figures hastening away in different directions. Cartier-Bresson waits for the best moment (sometimes he waits for a running child or a bent gaffer to reach the center of a patch of sunlight) to point out that life is always personal, much of it is hidden, and surroundings are habits like others. In *Upper Austria, near Linz, 1953*, we see the small rearview silhouette of a man facing a huge breathtaking vista of mountains, mist and sun, a version of Romantic C. D. Friedrich's *Traveler above the Sea of Clouds*. A closer look tells us that this man is engaged in painting the railing in front of him, and just now stands back to survey his handiwork. In several different countries, Cartier-Bresson will show two or three people who grin or stare straight at the lens for a moment, seeming to acknowledge the man behind it and his purpose, before turning away and moving off to eat, or work, or find a fourth. This photographer, he wants us to know, is no intruder.

Cartier-Bresson is nevertheless famous for noting the transhistorical visual rhymes in what he sees, never mind current movements in the national soul. In Barcelona he sees a sleeping man's open mouth and profile unwittingly match those in the chalk drawing on the wall over his head. He freezes two black-clad, white-haired old women walking along an Athens street just as they pass a house where, high up out of their sight, two half-draped young caryatids support a second-story balustrade. In Zurich he watches a couple of people floating side by side on their backs in a still lake, oblivious of the pair of ducks floating side

by side a little beyond their feet. Sometimes such detached visions shift into sympathetic scenes: in Moscow (1954), two handsome and crisply uniformed soldiers walk briskly toward us. Only one has yet seen the two pretty girls standing ahead of them, near us; the girls are bored, they look aimlessly our way and don't see either soldier. They have curly hair, one wears a loose polka-dot blouse, the other one's slip shows through her thin dress. Behind everybody is a double trolley car about to stop. What will happen? Will something happen? This is yet another shot of the many that show pairs of pairs or a triple pair, and where not all the couples are human.

Then there are the groups. Heavily draped in black capes, elders gossip in the Abruzzi (1951), youths in caps lean on staves at the livestock market in Pamplona (1952), scruffy children scamper and caper in Paris, Rome, Epirus, Dublin, Berlin, Seville. Whores in tight bras lounge on colored tiles in Alicante (1933), tall booted men stand up to manage crowds of logs floating on a Swedish river (1956). Housewives do laundry. In Greece they stand thinly clad and knee-deep in a sunny, leaf-shaded pool, beating the clothes against a stone coping (1961). In Siberia they crouch down in heavy coats and kerchiefs on a dock built over a frozen pond, and wear gloves to dip the washing through a hole in the ice (1972). In Portugal two women smile as their spread arms stretch the sheets out for bleaching on the tall grass (1955).

And we find many kinds of throng. Ranks of stiff military, sometimes matched with ranks of arches or shrubs; seas of listening churchgoers, of milling fairgoers, of hustling demonstrators; neat rows of ballet dancers, loose rows of race-meet spectators, bored rows waiting for the procession to pass or for a glance at Lenin's tomb, prone rows of lace-clad new priests, veiled rows of girlish first communicants, shepherded rows of neatly coated schoolboys. One or two amid these crowds often look for an instant into the camera's eye, to give the moment its confirming nod.

Three images are in both books. These are neither portraits of any usual kind nor common groupings in the life of modern Europe but photographic monuments by which Cartier-Bresson must wish to be known. The first, entitled *Cordoba, Spain, 1933*, shows a round middle-aged woman in a plain black dress with one smooth white hand on her bosom, smiling slightly and squinting at the camera. She stands before a

sleekly painted poster from about 1913, which portrays a curvaceous young woman. This painted girl's body is molded by a stylized corset sporting embroidery and a bow, and her smooth white hands are holding up a corset lace. Like the middle-aged woman in front of her, the girl in the poster is squinting, because an advertising sticker has been rudely plastered above her nose, but she is still slightly smiling below it. Their hair looks similarly waved and arranged, the outline of their pale faces is just the same, so are their eyebrows and noses. We cannot fail to see that the girl in the poster, painted some twenty years earlier for display outside a corset shop, and the middle-aged woman are the same person, both a little the worse for wear now, the hand on the bosom saying yes, it was me. Corsets like that are ancient history now, and so is her slim figure, but the little smile and the waved hair, the graceful hand and the white skin remain. So in fact do the agreeable curves, when recast by Cartier-Bresson's magisterial camera to form a poetic unity with the faded sign.

The Peloponnese, Greece, 1953 offers the same theme in different terms. Here an eloquent old man in a wrinkled old suit and collarless shirt points at a wall on which hangs a photograph of himself as a young man. His photo is one among several rows of young men's commemorative portraits taken at the same time, some uniformed and some not, all framed alike and labeled with small brass plaques. Those who are not in uniform wear neat dark suits with stiff collars and ties below their smooth black hair and mustaches; the photographs have been retouched to enforce the smoothness, neatness, and blackness. The unkempt, gray-haired man in aged rumpled garments who now gestures toward them has great pride in his past, the speaking face and eager arm show how alive it is. With respect for that vitality, Cartier-Bresson has enlivened every little sag and random furrow in his fragile dress and person.

The third to make it into both books is called *Warsaw, Poland, 1931* in *Europeans*, but in *Tête à Tête* it is called *Warsaw Ghetto, 1931*, so that there be no mistake about what we are looking at. This shows a blind Jewish beggar, standing full-length in isolation like a Velázquez, one hand supporting a cloth sack against his body, the other hand cupped and held out toward us. Framing him is a jumble of wood and metal rubbish that forms a sort of shelter, and we can see its black innards behind him. A fall of muted light drops straight down on this beggar

like a judgment, striking the peak of his cap and the tips of his nose and ears, spilling over his shoulders, modeling the folds of his sack and pouring abundantly into his open hand. The light ignores the long thick beard, the lower folds of the coat, the columnar trousers and shoes, picking and choosing instead among the tangled bits of trash so as to honor his upright body with a pale draped garland of streaks and flecks. Right at the center of this discriminating fall of light, surrounded by the pearly gleams on cap, ears, and nose, by the silvery sheen on upturned brow and cheeks, are his blind eyes. Here is a subject unable to look into the lens and acknowledge the masterly mirror of his time. This one is seeking something else.

Simone de Beauvoir

Deirdre Bair states that her aim in this massive book is to help future societies assess the real contribution of Simone de Beauvoir and determine why she matters. Beauvoir's personal fame still rests on her connection with Jean-Paul Sartre, although her international fame as a writer is based almost wholly on her prophetic work *The Second Sex*, which was published in 1949, well before the current phase of feminism began. Besides that, she was the author of seven novels, a play, two books of philosophy, four volumes of memoirs, and about five other volumes of serious essays, apart from numerous introductions to the works of others and many articles for periodicals. Her own acknowledged view of the way she mattered was entirely as a writer, not as a lady friend or as a feminist. She laid great stress on this, and disliked being remembered only as the author of a feminist document—the book, she said, that "anyone could have written."

Significantly enough, Bair does not provide a list of Beauvoir's works. She claims to be disappointed by the prevailing emphasis put on Beauvoir's *life* compared with the attention paid to Sartre's *writing*, and yet she makes clear, in the form and nature of her biographical study, where she really stands on this. Although she scrupulously describes every writing project Beauvoir undertook, she shows that when all is really said and done, the life was the work. In fact, apart from the importance of *The Second Sex* to feminism, most of her other writings cannot compare

Review of *Simone de Beauvoir: A Biography* by Deirdre Bair (New York: Summit Books, 1990) in *The New Republic,* June 11, 1990.

with the great works of literature that lead vital lives apart from their author's. Beauvoir's philosophical works have not eminently endured, and her novels, using the same material as her memoirs, are ultimately unimaginative, limited by their confinement to her own milieu and her own kind of feminine philosophical perspective. Bair supports the view that despite her pride in her métier, Beauvoir's contribution to the future will not be as a creator but as an example.

She is, indeed, a great example. Perhaps only the future will properly understand how great, since, as Bair points out, many of her youthful admirers even in France have no conception of the way of life into which she was born or the kind of social and intellectual training she had, and consequently no sense of the heroism in the life she undertook. It is now both respectable and easy, perhaps normal, for a middle-class European woman to get an excellent education, become a writer, form friendships and amorous liaisons with other writers, edit a magazine, engage in politics, teach, travel, lecture—and never marry, keep house, or have children, to feel free to pursue, on the intellectual model, what used to be thought of as a man's life. It is, moreover, now considered *comme il faut* to cast such a life in the secular and godless mold. For Simone de Beauvoir, born into the haute bourgeoisie in 1908, such a course was initially unimaginable. She began not only chained to ancient European ideals of female domestic and familial duty but afflicted by the rigidly Catholic upbringing her mother imposed on her and the limited education then provided for French upper-middle-class girls. Before she could lead her famous life, she had to imagine it, and French precedents were conspicuously lacking. American and English girls were already socially much freer at the time, and ideas about their education were more advanced in those enterprising Protestant countries.

But history was in fact on Beauvoir's side, and so was an acute family poverty that precluded a dowry and an arranged marriage at the correct social level. Although French women did not get the vote until 1946, a freer social existence and a better higher education did become more easily available to a French girl just when young Beauvoir could profit from them. She did not have to run away from home to satisfy her rising intellectual ambitions, nor to avoid an odious proposed spouse. The family, moreover, did not try to keep her stitching by the impoverished fireside

throughout a genteel spinsterhood, but urged her to train to be a teacher and earn her keep. Her religious faith might just have to be sacrificed; they were proud of her prodigious distinction as a student, and she was still a credit to the family, even if unmarriageable on the right terms.

But she was pretty, too, and loved admiration; and her eventual heroic rebellion was manifested in the realm of sex. A true bluestocking was nothing new, but a female intellectual life was traditionally supposed to be carried on in a state of celibacy, modeled rather on the example of the great female saints and brilliant abbesses of the Middle Ages, who corresponded with popes, kings, and sages, arguing theology and swaying policy from the cloister. Seriously learned and thoughtful girls were supposed to avoid men or else to be masculine themselves, and leave not only marriage, children, and housekeeping but the whole feminine erotic life to their sillier and more worldly sisters. Female artists and poets were known to engage in free sexual expression—philosophers never.

Simone de Beauvoir's relationship with Jean-Paul Sartre was a triumph of the impossible, a liaison preserved in a precarious, constantly readjusted balance which Bair shows her managing more or less single-handedly so that their separate autonomy might be sustained, while she remained conventionally feminine in relation to him. This meant not conventionally female, as a procreative wife and guardian of his hearth, and not quasi-masculine, as a like-minded friend and comrade-in-arms, but imaginatively feminine, as a mistress and intimate. She would be a sort of co-conspirator, someone unaccountable, wondrous, exigent, exciting, necessary. But since this amorous project was undertaken by two intellectuals, the mistress also had to be a colleague, not a pure engine of primitive temperament and erotic pleasure but an equally well-equipped intellectual contender, who would provide constant mental excitement while never really threatening him as a thinker.

Meanwhile, the freedom Sartre wanted was not just abstract but specifically sexual, and he reserved the right to collect other women with her knowledge and approval, leaving her the same freedom, just as if she were a male friend with the same leanings. How to work all this out? There were no precedents for this style of joint life, not in French intellectual history, domestic history, or anywhere. No wonder

Beauvoir had to write about it constantly; no wonder the two of them had to discuss themselves constantly, together and with others, in print and in letters. It had to be grasped while it was happening, talked and written into existence and brought under intellectual control, in what appears to have been a great absence of wordless intuition. She solved the problem of his other women by entering into semiamorous relations with them herself, emphatically not as a rival male but as a fellow narcissist, continuing her feminine theme by playing sexual games with them under Sartre's voyeuristic eye.

During most of their long affair from 1929 until the 1970s, Beauvoir gave Sartre the priceless gift of her intensive editing, bringing to bear not just her formidable intelligence and understanding of his thought but all her linguistic skill and taste on every bit of his writing. She made him stop sounding pedantic and musty, clarified his diction, kept him up to his own standard. At the same time, as her letters show, she adored him and unreservedly lavished the treasures of her heart on him— notably always addressing him in the letters as *vous*, like a proper French bourgeoise addressing a beloved parent. She made it abundantly clear, and not just to him, that her intellect was at his service before she used it for herself, as a village bride's maidenhead was at her seigneur's disposal. In relation to him, her intellectual posture was going to be traditionally feminine, too.

Ultimately Sartre's life and work were better served than hers by her determination to keep her woman's place and yield nothing of her feminine right to have a thrilling lover to serve, adore, torment, and manage, rather than simply a reliable husband. She took great risks to do this, and she had no models to follow, other than the old ones she so bleakly describes in *The Second Sex*. Her behavior seems very contradictory and her attitude often obscure; she was struggling to find a modern path for the intellectual woman to take, one that would command respect for the full use of heart, body, and brain together, and for the full play of moral sensibility in a woman's life. She would not be a Muse of Fire, a woman known only for her legendary effect on great men, like Alma Mahler, Misia Sert, or Lou Andreas-Salomé, any more than she would be a wifely chattel; she would not choose another woman and be safe inside the homosexual fortress; and she could not be solitary, a priestess of worldly renunciation.

She invented the idea of intellectual union as an image of the sexual bond; but this meant arranging to be perpetually "had" by him in front of everyone, according to the old notions she had inherited of what the sexual bond was. Beauvoir's methods only point up how much things have changed in the way the sexes approach each other, and her example does not even properly stand at the beginning of the new order. She marks, rather, the end of the old. Beauvoir could not be a product of the future she helped to construct, which our daughters may so energetically possess. She could not travel that distance herself, only gaze across it from the mountain.

Inevitably her independent intellectual image was tarnished. It wasn't harmed by her unhallowed sexual liaison with Sartre, which caused such disapproval in the social world, but rather by her quasi-wifely insistence on his absolute importance in the universe, not just to her; and thus implicitly on her own importance only as an adjunct to his, despite her tireless writing. Her image as imaginative mistress was similarly damaged by her motherlike wish to stand between Sartre and the importunate world, monitoring his practical affairs, choosing what appearances he would or would not make, explaining him to others when he did not explain himself, all of this much to the noticeable irritation of spectators.

Thus she would deal with the unpleasantness and take the blame, being the villain so that he might go out to play unhindered and preserve his appealing flavor before the public. She was like the unworldly doctor's wife who collects the fees he fails to charge, or the charming wastrel's wife who staves off the creditors with shaming lies. In such cases, doctor and wastrel are always better company and seem wiser and nicer than madame; madame's status as true wife preserves her honor in the performance of these thankless marital tasks. Yet Beauvoir was colleague and lover, not wife. She often made him seem unhappily married when he carefully was not, and made herself seem hypocritical, since she proclaimed herself his critic and equal, not his agent and keeper. But Bair believes that Beauvoir assumed this awkward position in Sartre's life with his express connivance, and that they both understood his need to have her do it, as much as her wish to do it, however it seemed to outsiders.

As a free-standing intellectual woman, she might more appealingly

have chosen a clod or a sprite as a permanent male companion, some-
one providing Passion and Otherness in the male mode, who would
have given emotional support and who would not have gotten in the
way of her personal glory in her chosen field. Many creative men and
some creative women have certainly done this, but Beauvoir was not a
self-sustaining artist. Or she could have joined up with a great physicist
or a great cellist, and kept her own enterprise to a separate standard in
a separate world. By hitching her feminine intellectual's fate to the
career of a prominent philosopher, she risked losing her independent
identity as a thinker, and in fact she did lose it. She is often called one
of the foremost intellectuals and literary figures of her day, a leader; but
in those respects her name is never mentioned without Sartre's. She is
perceived as a part of his intellectual group and not separately, as Albert
Camus is, for example. Sartre himself, of course, is easily thought of
quite independently of her.

Her novels and memoirs are alternative expository versions of her
life, and that means her life with Sartre. Only *Memoirs of a Dutiful
Daughter*, which deals very movingly with her childhood and youth
before she met him, can claim independent importance as a memoir;
and Bair says that it evoked almost as much response from French
women as *The Second Sex* had done. But the others do not transcend
the complex trap of her fell attachment, interesting and informative as
they are. Her thinking, her political and editorial work, her philosophy,
her fiction, her other love affairs were all contained by her larger con-
nection with Sartre, which organized her life and produced the reasons,
the enabling conditions and the necessary opposition, even when she
was far from him.

Only with her inspired application of his philosophy to her study of
women did she find her separate universe and create a work that stands
outside him, and finally outside herself. It is the only book in which she
makes a large imaginative leap out of her own circumstances; that's why
it's so extreme, so repetitious, so stumbling, so crude by comparison to
some of her other productions. It is a great work because it is detach-
able enough to immortalize her. Everything else is stuck inside her per-
sonal myth. *The Second Sex* for once has no single woman at the center,
being or standing for her superior self; *all* women form the group she is
trying to join, and on equal terms.

Unlike the feminist writings that followed it later, *The Second Sex* is not a detailed program for the future but only shows the need for one. It is the first discussion that minutely describes how women have willingly placed themselves in the role of Object, sharing (often with profit) in masculine myths of the Other. Beauvoir articulates the process whereby women, by agreeing to live in comfort inside the fantasies of men, put themselves in a permanently false position.

They help to create a world, she wrote, where men are forever feeling betrayed, not supported, by the true character and quality of women, because when fantasy is governing perception, the truth appears as a blasphemy. Neutral facts about women are perceived by men, and by women themselves, not as welcome illuminations, but as bad news, festering blemishes on the lovely structure that both sexes agree is woman's proper moral and physical shape. Men need the structure and try to force its preservation; but they also feel entitled to hate the rituals of fakery that women perform to maintain it, especially when they fail. Women in such a world feel chronically in the wrong, most acutely wrong in moments when the truth of the self betrays the fantasy, but obscurely wrong in essence for agreeing to the fantasy in the first place. Woman as Object may be spared the heavy burden carried by primary Subjects only by suffering the dishonor of constant two-way self-betrayal. Much heavier burdens and worse sufferings are then not lacking, as women are given and often meekly accept every form of raw deal in punishment for representing falsity and moral weakness.

The sophistication of Beauvoir's account gave her book a lasting resonance, but her brisk solutions of 1949 were too simple for the way history was going. In her book she expressed hope for women only in the abolition of marriage, which would naturally follow upon the abolition of capitalism. Independent female work would create independent female self-awareness along with economic freedom, followed by universal respect for women's autonomy. But as the Cold War progressed and the revolutions of 1968 burst out and reverberated, she clearly saw that women were left unfree by the sort of political upheaval she had thought would redeem them. Women were still making coffee, not policy. Although she continued to maintain that "a Feminist is a leftist" and kept her own left-wing position, she also understood that after 1968 many radical women, finding themselves effectively sidelined, needed a feminist movement that was independent of ordinary radical politics. It

became clear that the liberation of women could not be achieved by ordinary political means unless sexual politics acquired its own radicalization. The leadership of such a movement she gladly put in the hands of others. During the twenty years of later feminism she lived through, she did not write a sequel.

She did, however, work hard for women. As feminism gradually took over much of Beauvoir's energy in the 1970s, her attentions to Sartre diminished; the care of him and his ideas was shared with others. In Bair's account, Sartre seems glad she had something to amuse her while he was busy with his book on Flaubert, who didn't appeal to her, or with the new philosophical ideas he pursued after *The Critique of Dialectical Reason* in 1960, which she deplored and rejected because they repudiated what he had achieved in 1943 with *Being and Nothingness* and therefore betrayed the essential Sartre; or with the left-wing groups in which her own interest had begun to wane. But she still dropped everything to travel with him when he went to follow the Revolution all over the globe, and only incidentally acknowledged her own growing feminist fame in those same places. In her interviews with Bair, she stuck to Sartre's preeminence as the important mind and saw herself as mainly the constant writer, the busy *castor*, as if writing were housekeeping—which it clearly was for her, a practical exercise in the mental cleaning up of untidy experience, a public way of tastefully arranging her secret inner rooms, a form of understanding and not a detached creative act.

So it was with Beauvoir's celebrated affair with Nelson Algren, and it finally drove him off. Their strong transatlantic passion lasted a long time and gave both of them great satisfaction, before her rage to write about it ruined it forever. It also somewhat redressed the balance between her and Sartre, whose many liaisons cumbered their life with heavy emotional furniture that constantly needed dusting and shifting, often by her novelistic method. Algren really loved Beauvoir and really wanted her to move to the United States to be with him permanently; but she persisted in fitting him into her larger plan with Sartre, and she couldn't understand why he couldn't understand that. She also actually published one of his love letters, and still she did not know what made him so angry. She kept him as a friend and informant, however, with all her genius for preserving relationships, and she wore his ring until her death.

What Algren didn't know, apart from the terms of her peculiar arrangement with Sartre, was how much she was part of a wholly French literary and intellectual tradition, something only occasionally echoed in America and not transportable. To go and live in America she would have not only to give up her philosopher and her language but to become a different person. Only in Paris (and in French) could she live in public as a full-time professional intellectual, interpreting political developments and literary movements, sifting and considering current events and historical moments according to abstract ideas, undertaking to apply a refined apparatus of educated thought and principle to everyday occurrences and register the results—and, very important, conducting this daily life of the mind not only in essays, plays, and novels but in conversations and interviews, in cafés and in a crowd, in active politics and in constant full view. It wouldn't have been the same in Chicago among the low life Algren liked.

American responses to the spectacle of Sartre and Beauvoir include a certain irritation at their sense of their own importance, their belief in themselves as the center of the thinking world. This notion could seem quite true in the Paris they inhabited, soundproofed as they were inside their coterie and able to hear only the immediate resonance of their own utterances, even to each other. Behind their Parisian table at the Café de Flore stretched the long history of French intellectual life, back to the realm of the salons and the *philosophes,* the tradition of enlightened discussion and educated, dynamic exchange that continued in the later Parisian worlds of Balzac and George Sand, Baudelaire and Zola, all mounting barricades and sitting at café tables, too. Supporting it all was the general legacy of French culture to which Sartre and Beauvoir were conscious and honorable heirs, however modern their immediate concerns and however unconventional their personal association. They could justly feel themselves candidates for lasting importance, at least Parisian importance, and at least while they sat there.

The daily life of Beauvoir and Sartre in their great days sounds like the prolongation into maturity of urban student life (before the days of multisex residence halls), when nobody had any money or a real apartment, some lived with their parents, and people slept in marginal furnished rooms. Lovers and friends and followers left their cramped quarters to spend hours and hours in coffee shops, talking and talking, meeting and parting, grouping and regrouping, conniving and intrigu-

ing, writing and thinking in each other's company, and incidentally eat-
ing and drinking when finances permitted. No bourgeois domesticity
whatsoever, but an unrooted state of perpetual adolescence in the great
city, the tolerant and abundant mother of it all. Beauvoir and Sartre
moved from hotel to hotel, each in a different single room, or Sartre
lived with his mother, and real life and work went on for years at a
sequence of café tables, or occasionally on the barricades. Later they did
have apartments, often uncomfortable and ill equipped, although Beau-
voir's last one was fairly grand, acquired on the proceeds of the Prix
Goncourt.

She won the prize in 1954 for *Les Mandarins*, an enormous novel
about the problems of urban intellectuals in a postwar world. She
showed how the personal politics of thoughtful people, though origi-
nally founded on clear principles and high ideals, lose all hope of purity
in the aftermath of a war tainted by collaboration with the Nazi regime
and blackened by the Holocaust. Memory is haunted by deaths that
occurred through the slimy betrayals of friends, not just at the clean
hands of enemy troops, and all political thought is clogged by a trou-
bling lust for reprisals. Meanwhile, politics are swiftly polarizing, and
the need for self-defining action is immediate. Beauvoir dramatizes the
conflict between the writer's own impulse (pictured as unworthy) to
withdraw from the mess and write for posterity with a clear head and
the pressure on the writer to banish his fastidious detachment and join
the fray to save his soul.

These problems are not confined to that particular moment in his-
tory, and the novel generates real excitement. It also has constant rapid
dialogue, many changes of scene, a touch of violence, a thread of senti-
mentality, and some intermittent sex; it reads like the screenplay for a
prolonged television series. Alternating with the intellectual dilemma is
the personal struggle of the central female character. Although the novel
otherwise depends on an omniscient author, this main woman's part is
rendered in the first person, so that we are left in no doubt about her
finer brand of insight and honesty. Other women respond to pressure
by vamping every man, selling out, going mad, or turning perversely
self-destructive: our heroine may weep a lot, but she keeps her objec-
tive stance, her sexual dignity, and her ability to speak the truth. And
most of all, you see, she really understands men. Beauvoir makes the
character a psychiatrist, so that this version of herself even has a license

for her superior knowledge of others, her self-control, her irritating tolerance. She also has a true love and real work, unlike the other women in the book, and a healthy sexual appetite. By using the first person to convey this paragon, Beauvoir makes the novel judiciously self-aggrandizing, which compromises her excellent perception of male points of view, to say nothing of other female ones.

Beauvoir's own importance as a writer was compromised by her careless prolixity, by the steady rush of unedited utterance that flooded across the barriers between fiction, philosophy, and memoir. With all her crisp intelligence, she still piled up loose heaps of prose in an attempt to tell many truths at once, collapsing boundaries with great urgency but insufficient art. There is a conspicuous lack of poetic compression in her work. Her excessively serious, confidential mode of writing gives an emotional cast to her whole career as a woman of letters, and it well conveys the poignant conflicts that may hamper a modern woman's creative work. She is a great witness to female experience; but a lack of rigorous self-editing finally keeps her out of the writer's pantheon. She preferred to turn her editorial forces on Sartre's efforts, to make sure that he got there instead.

Bair's book is packed with information, a monumental example of excellent organization and responsible apparatus. The sustained personal tone, established from the start by her description of six years of interviews with Beauvoir, gives an agreeable unifying texture to a long, detailed story. Bair is perpetually discovering this remarkable woman and explaining her to us, responding throughout to Beauvoir's behavior and feelings, both directly as they talked and indirectly as Beauvoir presented herself in her writings and appeared through the eyes of other informants and writers.

The book is designed as a sort of corrective to Beauvoir's own subtly cooked memoirs, a broad emendation partly elicited from Beauvoir herself, whom Bair reports as eager for the exercise. Yet the text and the many notes, while describing biographical events quite impartially, are punctuated with references to what Beauvoir said directly to Bair about the events in question and how she seemed to feel about what she said.

The overall effect is successful: you feel you know the woman better than she knew herself, and you're glad to get past the rebarbative, humorless image she seemed deliberately to project.

The trouble is, you also feel you know Bair better than she might like. Bair very properly writes this book as a feminist, without overemphasis, and she makes us conscious that she is a woman dealing with another woman's career in the light of modern feminism—a sister, not just a detached biographer writing a writer's life. But there is another side to it. Bair's welcome sisterly presence on every page unfortunately exposes her as a writer less profoundly devoted to her own language than her subject was. She displays an unseemly level of linguistic carelessness, using "flaunt" for "flout" four times, for example, and "centered around" on nearly a dozen occasions. "Imprecation" is used twice incorrectly to mean "exhortation," "cower" appears as a transitive verb, and "symposia" is used as a singular. Phrases such as "equally as important" (twice) and "they accepted to believe in it" are not grammatical, nor is the sentence "I did not disavow her of this idea." Such displays of a shaky command of English raise doubts about Bair's relation to language altogether; her uncertain ear for English arouses doubts about her ear for French, and perhaps her ear for French civilization. She leaves no glaring misconstructions or mistranslations, only a lingering mistrust. Her many flaws in diction suggest that despite her intelligence and levelheadedness, her attentive and copious reading in French and English, and her great skill in molding huge amounts of diverse material into readable paragraphs, this American writer cannot take the complete measure of her learned and cultivated French subject—who, despite her excesses, was a thoroughly classical writer.

Yet there is ample reason to be grateful for her book. One of the best sections tells us how *The Second Sex* found its American publisher and its English translator, a tale in itself of dreadful, semicomic transcultural misunderstanding and of heroic labor. The lengthy and devoted undertaking of H. M. Parshley, the zoology professor who made the only English translation of *The Second Sex* and edited it for an American public, had an unhappy outcome, since his name never got on the title page, he was paid very little, and he literally died of the effort. All honor is due to Parshley, who also immersed himself in unfamiliar French and German philosophy and hunted down the references Beauvoir failed to

give. He was a privileged white male scientist, not an oppressed woman; but it was his faith in the value of *The Second Sex* that ensured its early fame among English-language readers, and many translations into other languages were later made from his.

Bair's detailed story of Beauvoir's and Sartre's activities during and after the war is also very welcome, with its exact elucidation of the parts they played in the Resistance and their behavior during the Occupation, and in all their sometimes dubious political involvements. Bair is extremely good at sorting out rumors and their sources, tracking down and synthesizing alternative statements and explanations to form a believable, coherent whole from a great deal of confusion. With all her sympathy, she does not spare or excuse her subject, so she therefore seems trustworthy about the unpalatable elements of Beauvoir's life and character that Beauvoir herself glossed over in her literary self-examinations. These include her often embarrassing abrasive manners and displays of cruelty, along with the lame behavior that seemed to verge on collaboration during the war. On the other hand, Bair is quick to scotch malign reports if she can prove them wrong, and the inexpert reader comes away with the comforting sense of having a true account.

Bair's biography deftly rescues Beauvoir from herself, wrenching her right out of her heavy French frame. The reader can't help being affected by the author's rapt attention to this twentieth-century ancient monument; Bair's youthful amazement at Beauvoir's actual humanity is catching. Along with the facts, she renders Beauvoir's vivid memory for fifty-year-old humiliations, her fits of anger and amusement, her brusqueness, her vagueness, her devotion to strong drink, and her tendency to self-deception, all with a sort of affectionate piety and wonder. And she makes us see her plainly and feel for her sharply, as she follows Beauvoir through her long, fierce, moving, and radically exemplary woman's life.

Yves St. Laurent

Alice Rawsthorn begins her book about Yves St. Laurent with a dramatic prologue evoking a period late in the designer's career, specifically late January and early February 1990. This opening functions as a sort of morality play, suggesting how we might view the story that follows. Yves St. Laurent is introduced receiving a thirteen-minute ovation for his 1990 spring couture collection, a show comprising numerous dazzling examples of his homage to clients, artists, and predecessors who have inspired him for thirty years. At the finale the fifty-three-year-old designer mounts the runway looking fit and happy, and with unprecedented bonhomie he invites a select number of the adoring crowd to dinner in his own home, a huge Parisian duplex apartment laden with rare objects and hung with Goyas, Matisses, and Warhols.

Very late that same night, after the famous guests are gone, there's a small fire in the bedroom, an accident of bad wiring. The celebrated designer instantly cracks up and breaks down. He is helicoptered without delay out of 55, rue de Babylone to his exquisite château in Normandy and thereafter flown by private jet to his palatial hideaway in Marrakesh, accompanied by his pampered dog and perfect servants. Once there, Yves St. Laurent locks himself in one room, refuses to eat for weeks, drinks two quarts of bourbon a day, and screams with fury at all who approach the door, especially those who remind him that he has

Review of *Yves St. Laurent: A Biography* by Alice Rawsthorn (New York: HarperCollins, 1996) in *The London Review of Books*, February 6, 1997.

a ready-to-wear collection to prepare in very little time. Anxious faces at the Paris shop: What to do? Curtain.

So that's the opening theme, recapitulated at the end: public triumph and private torture, with the implied moral that a precious artistic gift must not be abused by unworthy means for gaudy but shallow ends. Fashion design naturally can't measure up to high art, and it also makes ferocious temporal demands. The fashion designer had better be ready with quick and canny strategies of visual style and jungle tactics in the marketplace. If it's the contemplative arts of poetry and painting that he's really fit for, he should stay off the catwalk and out of Babylon, or he will finally prove fit for nothing.

The foregoing doesn't describe Rawsthorn's main theme in this long, detailed book—that emerges later. As prologue, however, it fits very well just before her account of St. Laurent's childhood and youth, which indeed sound like an artist's beginnings. Yves was a sensitive, well-bred boy given to solitude and reading, highly gifted for drawing, tormented by rough schoolmates in his native city of Oran, in French Algeria. The reader notes that though he was certainly intelligent, sensitive, and studious, he seems to have been visually creative mainly in the theatrical dimension, loving movies and illustrations, inventing costumes, settings, and scenes for a toy theater, and making images of clothed models or characters. He didn't do sketches of the city or the scenery, and his fantasy drawings weren't of vehicles or cell structure. His youthful sensibility allied itself with that of Proust; his artistic ambition finally crystallized into stage design, and he did a good deal of that during most of his career as a fashion designer.

Throughout her account, however, Rawsthorn maintains an opposition between St. Laurent's stage work and his fashion work as if between an obviously higher and a lower calling. She insists that St. Laurent was "artistically and intellectually frustrated" by the demands of fashion design and always creatively nourished by his work for the stage, that he found "limitations" in fashion that the stage did not impose; and she implies that he would never have felt frustrated in mind or talent if he had worked only in the theater. It's clear from this that she has not worked there herself. She also seems not to care much about it, since we get no idea from her book of what St. Laurent's frequent stage designs were actually like, despite her conventional piety about how

superior a creative channel it must be. It seems likely that as a costume designer, St. Laurent made an excellent couturier; his fancy dresses for costume balls were sumptuous, but not nearly so interesting as his clothes.

Design for the theater is not one whit less frustrating than fashion design, and for some of the same reasons; but the long tradition of the stage borrows constant glory from the high arts of music and literature, and some serious painters have gilded the still subfusc métier of costume design by doing sketches for stage productions. Most such works—by Chagall or Picasso, say, or Leonardo da Vinci—are rightly admired as pictures by the artist in question, not as significant contributions to stage history. They need radical transformation when real costumes are to be made from them, but they have served to raise the artistic prestige of stage design. Fashion has no such support. On the contrary, it bears a heavy weight of ancient discredit that still burdens many of those who work in it and write about it. There is therefore some real interest in finding a comfortable niche for the fashion designer, whose large presence on the cultural scene dates back only about a hundred and fifty years. Is he or she an artist? an artisan or a courtesan? Are they mountebanks or demons? thieves or servants of the people?

For years the tailor and dressmaker (both of them men until the late seventeenth century) stayed firmly backstage in society, roughly in the same place as the chef—that is, celebrated only privately among private clients, who took the credit for the products of his well-recompensed though publicly unacknowledged professional genius. Fashion was understood to be a sort of magic visual spell cast on the surface of social life, deployed on the bodies of prominent men and women but cooked up in secret by faintly infernal adepts—to whom, of course, any dazzling creature could seem to have sold his soul, or more especially hers, as the real price of excessive material perfection. The large sums of actual money spent were perhaps felt to be mere metaphors for that underlying transaction.

The smell of brimstone still clings to fashion, so it is kept down by being made frivolous, a dangerous ancient god disguised as a capricious elf, a teasing force to be uneasily propitiated if not quite believed in. Fashion is currently being tamed by efforts to chain it up in Cultural Studies, and there's still the old placatory impulse to puff it up by call-

ing it art, always with some sort of irony or apology. Thus, modern fashion designers—often extremely rich and good-looking, often homosexual, and nowadays often women—lack some fundamental credibility while they are being adored, a lack that makes many fashion reporters long to report failures and miseries in connection with their glamorous successes. Most are writing in the spirit of gossip, not criticism, just as Rawsthorn does in her fashion-journalist vein. Rawsthorn elsewhere cites Holly Brubach of *The New York Times* (an exception) comparing Yves St. Laurent's career with some foreboding to that of Paul Poiret, the brilliant, rich, and famous couturier of the period before the First World War and just beyond, roughly 1904 to 1920, who died poor and unheard of in the middle of the Second World War.

Poiret, too, posed provisionally as an artist, knew Isadora Duncan and many modern painters and was a radical innovator, creating trousers and young-boyish looks for women, mid-calf-length skirts, and long, sleek, uncurved torsos, well before the famous between-the-wars modernization of women. And, of course, he antedates all the post–Second World War designers who still repeatedly take credit in one way or another for women's recurrent sartorial rescue, by which women are "freed" from "cumbersome" clothing. It was said of Worth, the founder of haute couture, in the 1860s; and Rawsthorn naturally claims it again for St. Laurent. It's the one good action couturiers are allowed in serious retrospect, by contrast to the frothy accomplishments they are gushingly praised for in their heyday. This old liberation myth is based on the stupid idea that wearing fashionable clothing can ever be other than wondrously demanding. Each of fashion's great liberating moments is a sudden shift in the nature of its demands, not a diminution of them. The middle-aged always hate the change, the young always love it, *voilà tout*.

Fashion designers, those masters and mistresses of ephemera who have been allowed to achieve immense public fame ever since Worth, do seem similar to theater people, who were also long viewed with queasy mistrust and contempt as well as fascinated passion. Couturiers have an affinity with performers, many of whom have been their good friends— except that the works of Mozart and Molière stay and glow after their interpreters fade and die. The fashion designer's work can only stay briefly—"*Il faut pardonner la mode; elle meurt si jeune!*" (Fashion must be forgiven; it dies so young!) Cocteau said—and be artificially preserved.

Like stage costumes, couturiers' work is often embalmed in exhibitions that can be ghastly essays in necrophilia, unless a truly imaginative historical sympathy has conjured and mounted them.

Clothes do get true immortality in works of art. Holbein and Gainsborough, Hals and Ingres and all the others have amply registered centuries of sartorial genius. But when we stand and stare amazed at those incredible garments, no great tailors' names leap to mind. All those precursors of Yves St. Laurent were unhonored and unsung in their day, and so they remain. Do we care? The renown of the modern fashion designer suggests that perhaps we should, but not everybody can feel certain it matters.

Happily, fashion photography has now acquired as much aesthetic respectability as any photography, although this double process has been even more recent than the couturier's public glory. The modern masterpieces of camera art that invent half the beauty of modern fashion, just as the painters did that of the old, now bear the names of both designer and photographer, along with that of the stylist and model. Fashion magic has been personalized, and all the adepts get the personal credit due them, along with revenues inflated by a modern form of celebrity that is itself a formidable commodity and yet another candidate for devil's agent. And there, of course, is the rub. Some basic way to stay on the side of the angels still eludes fashion, the more notably intimate it gets with fame and fortune.

Yves St. Laurent provides an excellent focus for a study, not of aesthetic trends in modern fashion, about which Rawsthorn's book is fairly rudimentary, conventional, and often self-contradictory, but of the modern fashion business, its development, its operations, its force, and their effects on the public and on its own personnel. Yves St. Laurent is the name of a designer, but also of an international, multimillion-dollar fashion company, the success of which largely depends on the sale of perfumes and cosmetics that also bear his name. Rawsthorn undertakes to describe how such a man and such a company were fused and evolved together in the second half of the twentieth century, to demonstrate what in fact a modern fashion designer actually is.

Her man is a good subject for this because he began work at the age of nineteen in 1955, during the crucial period after the Second World War when the invention and production of fashion was being revived in France, still following rules that had been in effect more or less since the turn of the century. The very young St. Laurent helped significantly with this revival under *ancien régime* principles, but he went on to force changes in both the styles and the rules of fashion more than once in succeeding decades, always with an intense personal dedication that drained him emotionally while it enriched and glorified him, and that has nevertheless preserved his personal credit as a serious man and an honest practitioner.

At the end of the century St. Laurent is still at work. Rawsthorn makes him illustrate in his own person—in his feelings and personal responses, in his self-destructive afflictions and fantasies, in his differing methods of designing—just how the once comparatively small and exclusive business devoted to fashion has risen and swollen, broken apart and been efficiently reconstituted on a scale so huge that it reflects, with a certain commercial coherence, the incoherent life of the whole contemporary world. If his will, spirit, and health hold up under the strain, St. Laurent will doubtless be engaged in more evolutions of the now global fashion business. His talent for actual clothing design has proved, again and again under adverse and oppressive circumstances, to be more flexible and durable than that of many stars in the modern fashion firmament. He has said, "The important thing is to last": so he probably will, despite explosions.

But the truth is, Yves St. Laurent is only half himself. His other half, and the other half of Yves St. Laurent the company, is the dynamic and powerful French business entrepreneur Pierre Bergé. Nearly half this biography of St. Laurent is therefore quite rightly devoted to the life, struggles, feelings, fantasies, achievements, and reputation of Bergé. The creation of YSL, the fusion of man and company, could not have occurred or survived without the imaginative gifts and incessant practical endeavor of St. Laurent's lover and business partner, surrogate father and best friend, steady champion and exasperated guardian. Rawsthorn's account of Bergé and his relations with the YSL enterprise—with the designer first, then with the business created and repeatedly re-created around him—is presented as a much more vivid drama than any revolution in the design of garments.

Rawsthorn's way of conveying the effect of the fashion collections she didn't personally see is to provide samples of the reviews and remarks from other witnesses she interviews. The reader does not get the impression that she studied any actual clothes or photographs of them so as to describe them from her own responses. We need these descriptions if the collections are to seem believable as important episodes in fashion history. But for Rawsthorn these and other fashion shows are really episodes in the epic of modern business; and for that, the reviews are far more important than the clothes themselves. Judicious criticism of the clothes is, moreover, an impossible luxury for any reporter on the spot: there is no time. Fashion itself moves fast, but faster still is the movement of money.

If a designer gets bad reviews at a fashion opening and immediately bans the press from all future ones, he may seem to be indulging in a silly fit of pique, but in fact such a move is often a necessary business tactic. Commercial buyers may, in advance of a show, pay huge sums against the clothes they expect to order from it in large amounts, and these advances help to defray the heavy cost of producing the show itself. If the opening gets bad notices, the funds may be immediately withdrawn and the company may instantly fall into devastating debt. In fashion, a hysterical allergy to adverse criticism isn't artistic vanity but the haunting dread of swift financial loss.

Rawsthorn's book displays the effects of, or perhaps the reasons for, her ten years as a writer for the *Financial Times* in both London and Paris. She unfolds her skillful narratives of Bergé's adroit financial maneuvering for YSL with an impassioned flair quite missing from her descriptions of the clothes, costumes, and fashion changes. Her illustrations are pictures of persons significant to YSL, man and company, with only a very few of St. Laurent's sketches and no photographs of the clothes; the eye is given only a minimal suggestion of what he actually did. There are, of course, other books with pictures of his work, and this book is best read with at least one of them at hand.

Rawthorn's keenest attention bears on how the YSL empire came into being, making her shy, bespectacled subject into an international icon, and on what happened next, including what happened personally to Pierre and Yves and to everyone close to them. She is also minutely concerned with the background to this great success, the shifting economic and political scene in contemporary France on which Pierre

Bergé came to move with such agility and so prominently for the sake of St. Laurent and YSL. Pages are devoted to twists and turns in the notorious sale of YSL to Elf Sanofi, the government-supported French conglomerate, as well as to the many deals with numerous licensees and changing backers. It gradually emerges that this tougher half of her double hero is Rawsthorn's real favorite.

Young Pierre, unlike young Yves, rebelliously quit his boring school and stuffy home in the provinces to seek literary fame and left-wing causes in Paris. It's the bracing story of many a literary beginning, though it didn't have that ending. Bergé lived the other half of The Artist's Youth. Later on, as his business triumphs accumulated, he continued to believe himself more alert to art, artists, and the political left than akin to leaders of finance and industry. Bergé apparently felt like half an artist, needing completion by another half-artist. Indeed, it was not in any scruffy Parisian milieu of artistic dedication that Pierre met Yves but at the home of a society hostess in 1958, when Bergé was already the lover and business manager of the modish but bad painter Bernard Buffet. Yves was then the slim and fetching twenty-one-year-old heir to the undisputed haute couture throne of Christian Dior, who had just died of a heart attack at fifty-two, leaving his famous fashion company in the lurch. Tender young Yves had taken over, because Dior had recognized him as the most salient talent on the design staff, but when he met Pierre, Yves was still acutely on trial as the one person responsible for sustaining the firm's crucial future. Dior had given haute couture its biggest postwar boost and was seen by some as the economic savior of France. Had Yves the strength to catch up the standard and gallop onward? He certainly had, but not alone, and not under the name of Christian Dior.

That evening, the story goes, it was love at first sight. Bergé dropped the seasoned, worldly painter and took up the fresh, pure couturier, thus slightly changing the nature of the cultural entity he was destined to form and share in. His own talents were certainly creative, and they at length emerged as nonartistic. Once in intimate union with a truly gifted second self unpropelled by worldly drives, he could concentrate on making the resultant blend of imaginative energies into a prodigious success. The true fusion involved three—YSL the couturier, YSL the business, and Pierre the energetic author of the enormous, complicated, delicate machine that combined them.

Yves had always been a prince, long nurtured in family approval. After dutifully finishing school, he was eventually placed in his métier through the efforts of a watchful mother with good Parisian connections. Stage design wasn't available; couture was; it didn't matter much to anyone at the time, and Yves seemed well suited to either profession. But one great difference between the two does emerge, once the designer in either hits the top. Whereas design for the stage is negotiated show by show, and there can be helpfully uneven gaps between its periods of frantic effort, the haute couture designer must produce two collections a year of about a hundred designs each, one in August and one in January, like clockwork. He can never stop unless he dies, retires—or fails. Dior began this work at the age of forty and collapsed under the strain in twelve years.

Yves St. Laurent found the life very hard when he became chief designer for Dior at the age of twenty-one, but twice as hard at thirty, when he undertook to add two ready-to-wear collections each year in between the couture collections. By that time he had left Dior for military service, had broken down during basic training and spent months in hospital under questionable drug and shock treatments, had been cavalierly replaced at Dior by another designer during his absence, and on his recovery had been set up in his own haute couture business, with capital heroically raised by his devoted Pierre.

After four years of struggle and increasing success, Bergé and St. Laurent had the inspired idea of offering a mass-produced, lower-priced line of the designer's original work in its own boutique, designed separately, on principles appropriate to factory production as well as to youthful taste. The clothes in the Rive Gauche boutiques, of which the first opened in 1966 (there are now hundreds worldwide), offered no embroidery and beading, fur and feathers, elaborate hand construction and precious fabric; but they had the St. Laurent flair and vivid style, and maybe one could afford them. Within a year, other French couture designers were following suit; and a rash of designers working only in ready-to-wear soon began sky-rocketing to success without doing haute couture collections at all, although most had been trained in it. The prestigious Chambre Syndicale de la Haute Couture de Paris, which set the high standards and granted the licenses for exclusive haute couture businesses, had also ensured them respectable venues for showing collections and good press coverage. Now new organizations were formed

to look after the public-relations interests of ready-to-wear designers, so that *pret-à-porter* could burst into organized fame and snag its own media prestige. France was saved again.

With the ascendance of French designer ready-to-wear, haute couture gradually shrank in importance and size after its great revival period from the late 1940s to the mid-1960s. It kept its high reputation but changed its position to one of even greater rarity and bizarrerie, and it was even more dependent on its perfume sales. Meanwhile, ready-to-wear designers gradually evolved into stylists who did not painstakingly invent each ensemble from scratch but assembled collections according to what the market seemed to seek and the factories were prepared to make. This mass cookery has lately included some Yves St. Laurent designs that have become components of the fashion patrimony, and wrongly seem to be up for grabs. YSL successfully sued Ralph Lauren for just such a theft.

A clever sense of what will sell, not training in clothes design, is now the prerequisite for success in ready-to-wear fashion; and new designers have come to seem more than ever like mountebanks and con artists. St. Laurent, who pioneered good ready-to-wear fashion, has not. He keeps his faith with the classic modern ideal for the design of clothes established by Chanel and some of her colleagues, using his own original ideas, old and new, in ever modified inventions and variations—an ideal essentially based on using the principles of menswear for women. The principles boil down to creating a fluid, multipartite envelope for the body, complementing its shape and movement, and establishing a constant visible harmony between the body's structure and that of the clothes without heavily emphasizing either one. This masculine sartorial ideal, suitably reworked and disguised to fit feminine traditions, has in fact subtly opened further possibilities in the uses of women's motifs for menswear. The ever-boyish Yves keeps earning his title as Grand Old Man of Fashion, while fashion as usual grows younger and newer each season. He's become something of an integrative force, making sense of old and new together as the century winds down.

But the life of a designer creating four collections a year with only a few weeks between them is unbelievably taxing, since besides the constant work, it includes being on the public scene and within reach of the media on which success depends. Yves St. Laurent was a delicate

creature from the beginning, then damaged by his time in a brutal mental hospital, eventually prey to drug and alcohol addiction, bouts of suicidal depression, and physical disabilities including obesity and sciatica. He has frequently shunned the public eye, and consequently been rumored to be dead, or to have AIDS or cancer; but he has reappeared, flourished, and intermittently had a wonderful time. His alter ego has seen to that—until recently, when Bergé has begun to involve himself elsewhere, in difficult wheels and deals that don't concern YSL. These have included his ill-starred direction of the Paris Opéra and a disastrous effort to set up another fetching young man as a couturier.

Rawsthorn's dramatic prologue is entitled "The First Refusal." By the end of her book the reader can see it as a prelude to St. Laurent's possible future rebellion against the entire setup, out of the sense of being abandoned, isolated, enslaved, or maybe just colossally tired.★ His self-image as a tortured poet, a Baudelaire with a Proustian soul, might sustain him in retirement from fashion, and he might go back to his beginnings as a dreamy half-artist. He has often said, however, that he couldn't leave designing: "The couture would miss me too much." And he's right. When St. Laurent leaves, fashion will lose a truly great talent for just that, and a rare one of those who have helped it an inch or two toward an authentic honor of its own.

★In a radical move, YSL has lately hired the young designer Alber Elbaz to do the ready-to-wear collections. St. Laurent will continue to design the couture collections.

Modern Arts: Dress

Accounting for Fashion

Accounting for fashion has become steadier work than it used to be. The hunt for meaning in cultural trends focuses on clothes more than ever in these self-conscious days, and current clothes are now found to be emotionally loaded in ways that only stage and screen costumes once were. Role-playing is now an acknowledged common game, with clothing a chief medium. Though novelists and poets have always considered the resonant meaning in everyday dress, only lately have ordinary journalists dwelt on it and ordinary people referred to it in everyday speech, much the way they make common use of psychoanalytic terms. The looks of clothes were once conventionally thought of as trivial phenomena, essentially the same even while they changed, so that the changes had no serious meaning. Now appearances and their variations are generally assumed to be profoundly important in everyone's life. More column inches were devoted to the shifting hemline of Japan's new princess than would have been remotely possible fifty years ago.

Dress, while being essential to human life and commanding equal status with food and shelter, has always persisted in being uncomfortably significant instead of reassuringly natural or practical. The myth of Adam and Eve shows how long people have understood that there is no natural dress, not even any naturally protective dress; there is only mean-

Review of *Fashion, Culture, and Identity* by Fred Davis (Chicago: University of Chicago Press, 1992) in *Raritan*, Fall 1993.

ingful dress. Animals, smart as they are, don't have it—dress requires opposable thumbs and some kind of cosmology. I would say it looks very much like art, but clothing has lately been more often compared to language, since language also depends on the symbolizing impulse and also varies enormously among cultures. We are generally invited to consider the linguistic model in thinking of anything cultural, even though language itself is fundamentally nonmaterial and nonvisual, and doesn't really make its symbolic connections the same way visual material does.

Consequently, the belief that all we ever do is read clothes or listen to their statements, that we wear them only in order to deliver messages, has dulled the desire to understand them by really looking at them, and has stunted our capacity to grasp the way responses to clothes work, for both wearer and viewer—the process Balzac and Baudelaire knew how to convey. Just as with other modern visual art, such responses include feeling the inner echo of visual memory and unconscious fantasy, the vibrations set in motion by clothing's actual forms, whatever other functions it is serving.

Modern fashion, invented by Western civilization in the late Middle Ages along with courtly love, perspective, sonnet form, and many other great imaginative devices (aptly including the accurate mirror made with silvered glass), has served to confirm the relation of Western dress to the other developing Western arts. It has lifted clothing out of its earlier condition as first-order, unselfconscious symbolic art, and made it into an imaginative and self-reflective visual medium. Fashion has allowed clothing to detach itself from the task of being the stable (and often stabilizing) visual projection of social custom and common belief, and allowed it to become a wayward representational art, something essentially fictional like painting or movies. In life, it has a basically subversive purpose: fashion keeps present to the public eye the fact that normative human arrangements are always under unexpected threat from unstable human impulses, sexual expression being the main one appropriate for an art using bodies as its theme.

With the development of fashion, the look of clothing could be used mainly to refer to itself and to mock itself, to explore its own expressive possibilities, not just its primary usefulness or primitive meaning. Clothes could suggest things quite different from what was conveyed by

their wearers' speech and actions, or from what was true of their wearers' social sphere and ethnic stamp, or from their own practical uses. While still generally defining a person's current social place, dress could be the conductor of the most intimate and personal dispositions, not only feelings but aesthetic choices with personal historical significance—not only the wearer's immediate surrounding world but the style of his self-perceptions within it. At the same time, such meaning in clothing as in art could in part consist of the responses of spectators, who could each contribute personal imaginative and emotional material, perhaps unspoken or even unconscious, to the sum of significance in any person's clothed appearance.

Ever since industrialized fashion began to offer everybody a vast array of constantly varying mass-produced garments and adornments to play with, it has in fact been possible for many of the suggestions and satisfactions of clothing to be aimed mainly at the self, not the viewer. Inward convictions about the appropriateness of personal gear are what is primary, not the desire to communicate. Choices can now include inwardly significant rejections, the host of visual options not taken up— negative choices that are of course invisible. When you observe people on the subway, you can often be certain that some of them don't really know or perhaps much care how they look; but you do know that they decided on their effects and must to some degree be satisfied with the result. And often you can't begin to imagine what lay behind their decisions and produced their satisfaction. Obviously, many choices made by modern consumers are unintelligible to most spectators, who respond to them only with their own different associations and assumptions.

There are, moreover, now so many vital modes of fashionable dress simultaneously in flux and on view that the intentional social displays made in any one of them can reach only a limited audience. Out in public space, nobody has to be responsible for rightly perceiving the modes he doesn't know or care about, but everybody responds to what he sees. The ordinary result is that the famous messages allegedly sent by clothes are not always the same ones as those received by the unaccountable and inventive eyes of others. One might call them gestures of reassurance made toward the private consciousness, while quite other unconscious material is perceived (also largely unconsciously) by viewers. Thus fashion, while binding modern people together in its dynamic

and competitive visual orbit, draws on individual personality for the power of its effects. Fashion is essentially created in the use that each wearer and viewer makes of it, even when many of them are similarly dressed and watching each other dance in concert on the same stage.

The systematic modern study of clothing was undertaken as part of the study of custom spurred by the post-Enlightenment desire to notate and classify human culture from a scientific point of view. Costume is the most vivid custom of all, the first to be perceived in any direct study of human beings, and it became clear that its visual displays were linked, sometimes closely, to other significant cultural behavior. The great European voyages of discovery in the sixteenth century produced pictures of distant modes of dress no less exotic than accompanying descriptions of modes of cookery and worship, remote from known habits in Europe. All such phenomena looked equally amazing; nobody was as yet trying to discover exactly what it meant to the participants, and crude conclusions were often drawn.

The trappings worn in tribal societies often had elaborate and varied embellishments, and it was assumed that each detail existed to have a clear and simple meaning comprehensible to the group—all the more so because it wasn't very clear to outsiders. Later, it was easy to assume that the same sort of orderly meanings must apply to fashionable trappings in the modern world, especially since fashion produced such bizarre effects.

The first French and Italian costume books illustrating how clothes looked in different European countries date from the same sixteenth century, but this was well after quirky movements of fashion had begun to take over European elegance. Like those who drew the pictures for the explorers, the costume illustrators were eager to give an exact social function to each outfit—an Antwerp bourgeoise dressed for church, an Andalusian peasant dressed for dancing—as if to suggest that persons in neighboring lands were somewhat like exotic natives, who wore clothing with a primitive meaning that reflected specific and fixed custom. In other words, these books give the impression that all Antwerp ladies in the sixteenth century always wore exactly the same thing to church, to display their proper awareness of proper tribal behavior, and thus to send the right message. This would accord with the way outsiders thought the rules ought to work, but it would not allow for any play of fashionable imagination in Antwerp.

Sociologists are still trying to treat fashion as if it were costume, a visual variant of custom, a complex game of which the obvious symbolic content can be given an intelligible structure by (and for) people who aren't playing. Some of this effort has produced enlightening results, and Fred Davis's book *Fashion, Culture, and Identity* has much to offer. He follows the methods for studying the mechanisms of symbolic exchange devised by George Herbert Mead and Herbert Blumer, here concerning himself with how these might work in the domain of modern fashion. Early in the book he approvingly quotes Blumer to the effect that clothes may "speak," but they certainly don't listen, and they never converse. So much for the language model. Davis is refreshingly impatient with the linguistics-inspired effort to decode dress codes too precisely.

Davis has rightly decided that ambivalence is built into fashion— although such a term is inadequate to its delicate perversities. Most important is his theory that fashion provides the means of creating a social identity for each participant that is not a sign of class or status and that can be communicated in both directions, inward and outward. According to this view, it is a fundamental ambivalence about the constantly-to-be-re-created self that gives fashion its dynamic character and keeps it on the move. This idea seems to me basically right, and it has the welcome quality of recognizing the personal dimension in fashion, which is what makes it not simply tribal custom let loose in a market economy.

Another important thing Davis has discovered is that fashion has no critical tradition, as art and literature and theater have, and as cinema now has. There have never been writers trained in art history and fashion history who have steadily commented on its current condition for current publication. The result is that the largest body of serious writing on fashion has been the work of sociologists of one flavor or another. Most of the huge amount of fashion journalism is written by people who took it up by chance and might well move on to something else, not who chose to write about it out of deep interest in or even a strong liking for the subject. Davis has also discovered that fashion designers have no more refined or profound conceptions of fashion than do fashion journalists; designers often like to say they have nothing to do with fashion at all. Fashion historians don't have much to offer about the present state of things, or often anything very satisfactory to

say about the action and cultural character of fashion in the past. For current research, people with hard information are clearly the most helpful—people who run the fashion business in all its manifold aspects, who can describe their jobs and provide sales figures.

Davis has naturally found himself most comfortable basing his book on the work of other sociologists, briskly disposing of their ideas or partially approving of them as his own argument proceeds. But it is noticeable that quite a few of the thinkers he quotes (Veblen, Simmel, Kroeber, *et al.*) have worked hard to account for fashion without looking at it closely or liking it much. Blumer, the "symbolic interaction" man to whose memory the book is dedicated, is an exception in having studied fashion at first hand in Paris in the 1930s, Davis tells us, but we are not told how he got started or how he responded, only his conclusions. When it comes to fashion, the posture of detachment that this whole mode of inquiry demands usually produces an unmistakable tone of amused condescension that insufficiently veils a fastidious disapproval, in the manner of a Renaissance European surveying the habits of antipodean natives. Davis, for all his protestations about how others think it's silly whereas he thinks it's serious, is not exempt. This author is once again not a player, and he wants us to know it.

He has for the most part ignored the visual material in fashionable clothes of all kinds, the richly suggestive looks of fashions as they unfold, perhaps so as not to be led astray and made a fool of by what he still seems to think is fashion's essential harlotry, at worst, or ridiculousness at best. This is the old view—that fashion is the seductive destroyer of true value—a view Davis's mentors seem to have imparted to him without his realizing it. He is willing to link fashion to art, but in the wrong way; he wants to compare modern designers to modern painters. This won't work, since the most important creation in fashion is not accomplished on the drawing boards of Christian Lacroix or Jean-Paul Gaultier, who may want to speak of painters in the same breath with themselves but whose efforts have little to do with the workings of the public imagination about its clothes.

Davis describes fashion as if every new idea in it starts with a famous couturier and then spreads out through the fashion business, gradually losing its force through much copying until it is finally extinguished. He fails sufficiently to emphasize that most fashion designers are largely

unsung but gifted professionals whose original work for ready-to-wear manufacturers provides the basic means by which the art of fashion can be practiced by everyone, whether or not they are impinged on by the inventions of famous designers. Lacroix and the others burst theatrically on the scene at prescribed intervals and cause much talk, but most of their ideas die immediately. The ones that catch on are often improved, not debased, by the nonfamous designers who modify them for the public. Great couturiers still do create great garments for their private clients, now fewer in number than ever; and then the client, as always, has a large contribution to make. But the loudest pulse of modern fashion does not beat in that rarefied ambience.

In a certain way it never did; designers of fashion for the very rich were always accompanied by designers of fashion for everybody else but the destitute and most isolated. Fashion can be shown to have mattered to persons in all ranks of ordinary society ever since it started, certainly in towns and cities, where garments were made by hosts of tailors and dressmakers, or at home by women, or sold secondhand and remodeled, in a constantly changing stylistic flux similar to but not directly dependent on the changing modes in high life. You can see them in popular prints illustrating ordinary life, which can be dated by the clothes even if nobody elegant is in the picture.

New shifts of overall emphasis or bodily style, here also attributed to designers, usually take a long time to arise and dominate the scene; premonitory stylistic movements are visible at many levels at once—wide shoulders, low waists—before a particular designer does something that garners him all future credit for the shift. In earlier centuries, no credit was awarded to tailors or dressmakers for brilliant fashionable inspiration—it was the king or the financier, the courtesan or the queen who was believed to have thought it up. Meanwhile, the general sense that shoulders should start to slope, for example, seems to have struck the public eye all at once, and nobody tried to name a source for such shifts—except fashion itself, of course.

An awareness that fashion is an art created by its wearers thus has a long history, and our sense of this primary truth has only lately been obfuscated by the famous fame of designers. An overview of fashion reaching back into pre-designer times suggests that present designers are following rather than leading public taste. At any one period, their works

resemble each other more than they differ, just as elegant outfits have always done. Designers have in fact made a great, democratic ready-to-wear version of fashion possible; but the ones who have really done it are like those who are designing the wonderful commercial packaging, the differing styles of lamp and drinking glass, or indeed who design the many kinds of vivid athletic shoe and vivid fetishistic shoe, the baggy or skin-tight skirts and pants, the endless varieties of blouse, shirt, jacket, vest, sweater, belt, and bag with which the diverse performances of modern fashion may be undertaken. Most low-priced modes are independent designs aimed at various markets, not crude imitations of expensive ones.

It is not actually true that fashion has speeded up in the last half century. It is enlarged public awareness of fashion that has done so, and the number of players and would-be players has quickly increased to cover the globe. The well-publicized thrice-yearly efforts of named designers make them, too, seem to be whipping us along; but fashion itself has had much the same tempo ever since it started. You can date elegant dress by the half decade in Flemish paintings of the fifteenth century (though not farm clothes, I'll allow, which tend to take a generation to change). But once changeability of form becomes the main visual proposition for clothes, the rate at which forms change remains similar, even allowing for differing rates for a range of differing forms. Where fashion is in motion at all, the same temporal rules seem to apply, whether it's in a Pennsylvania high school, a few Italian ducal courts, or a whole modern nation. Visual rhythms of delight, indifference, and distaste are apparently like certain other fairly stable human rhythms, the ones based on how long a baby takes to be born or on how the alternations of night and day and season must be managed. Fashion has not existed everywhere or always; but once in existence, its pulsations are fairly basic. People's eyes get interested and then get bored at about the same rate, once they've taken up the habit of continually changing their diet.

Davis stresses invention and dissemination, but he hasn't sufficiently emphasized the large role of lag and inertia in fashion, the staying power of some elements, both small and large, in a medium so famous for quick change. The more enduring motifs are not predictable, of course—and not always the same. New things produce an effect on the ones that stay around without extinguishing them, creating a new visual

relation that promotes the ambiguity Davis has seized on as a fashion keynote. The process stresses what I would call its subversive character, the requirement that no meaning stay the same, that no rule remain in force, that nothing ever become too comfortable to look at or too easy to grasp. Fashion has made itself into the image of the questing modern psyche in its permanently discontented state; the fashion cycle can never be a circle.

Consequently I think it's confusing to propose a firm opposition party called *anti-fashion*, as Davis allows himself to do here, and to see it as forever going up against the powerful force of fashion. It's in fact quite clear that fashion itself is anti-fashion and produces its own border skirmishes. Davis admits that anti-fashion movements are perhaps better described as simply fashion movements of one kind, and has obligingly outlined their principal characteristics—Utilitarian Outrage, Health and Fitness Naturalism, Feminist Protest, and so forth. The sartorial expression of such ideas have been part of fashion itself since the eighteenth century; before that, there were various attempts at sumptuary legislation that even temporarily produced official anti-fashion fashion.

Modern fashion is now laden with allusion and suggestion of a purely pictorial kind, playing constantly with the imagery of the clothed figure that has become our common legacy through all our pervasive visual media. Shapes of collar and sleeve are no longer symbolic in themselves; they chiefly carry strands of reference to figural traditions in film, television, and advertising photography, which in turn draw on the whole ancient figural tradition of Western art. That tradition, which began with vase painting, mosaics, frescoes, and manuscripts but eventually continued into posters and illustrations, first became available to the general public with the dissemination of printed pictures in the Renaissance. Ever since then, the same stylized visual standards of bodily attitude and clothed appearance could be taken personally by many different people at once. Thus, Renaissance ladies and would-be ladies could learn to stick out their stomachs and hold up the folds of their gowns, eighteenth-century men to dispose their legs with dash, and modern people of both sexes to square their shoulders and hold their stomachs in.

The real interaction occurs between that figural tradition and the

actual creation and wearing of clothes. The image-making character of modern fashion-bound dress forever keeps its details from having direct symbolic social meanings that can be satisfactorily determined. It is always a representation of another representation, altered by fragmentary material from still others. Each of these defies exact symbolic definition, although their visual sources could certainly be traced; but that seems not to be a sociological sort of enterprise. The meanings both offered and seized in the social world of clothes can be found in the mesh of visual reference itself; this, it seems to me, is most profitable to study, the way movies may be studied along with paintings and engravings and commercial illustration, as part of a history of connected imagery with its own emotional force, borrowing only ephemeral, incidental, and often contradictory social significance along the way.

The best general thing about Davis's book is that he admits finding the material intractable. In order to arrive at such an admission, moreover, he has worked hard to make sense of the scrambled ways in which fashion works, and he has made an excellent synthesis of the best available theories, all of which he gives us in clear *précis*. His approach to the subject is fresh, sane, and intelligent, if lacking in the sort of visceral sympathy that I seek. He makes too much of dealing seriously with a conventionally frivolous subject, and therefore seems to be apologizing. I am convinced that an emotionally driven imaginative commitment, a truly poetic and erotic sensibility about clothes, would be the best foil to sociological detachment and the best aid to an enlarged understanding of fashion. Davis quotes the Herrick lyric about a "sweet disorder in the dress," and elsewhere mentions Italo Calvino; but he seems to keep a strategic distance from the greatest literary illuminations of fashion, and he also seems not to look carefully at pictures at all or to seek in them any enlightenment for his subject. But he has read an enormous amount about clothes, pondered the results, and offers his interesting conclusions with suitable modesty and clarity.

The Decorated Body

The striking jacket photograph for *The Decorated Body* shows the beautiful naked back of a young black woman entirely covered by a raised pattern of scars. This unsettling image produces hope that the text may explain it objectively enough to make it more comfortable to look at; but on the back flap, the author's photograph shows his face covered with large geometric areas of thick paint, his eyes masked by dark glasses, and his neck muffled in a black turtleneck. This aggressive portrait casts instant doubt upon the degree of the author's anthropological detachment, and the book itself confirms the suspicion. Robert Brain announces in his preface that he intends an enlightened comparative cross-cultural study of all the body arts, from tattoo to teased hair, and he deplores the hypocrisy of those European explorers and Christian missionaries who first encountered the decorated body and straightway tried to suppress it; but almost immediately he betrays a high level of reverse prejudice.

Dr. Brain considers the whole scope of personal adornment in the Christian West to be enslaved to something he quaintly calls "the whim of fashion," and leaves it at that. Such reductive diction smacks of similar terminology, such as "painted savage" or "benighted heathen," for which Dr. Brain elsewhere expresses much contempt. He avoids dealing imaginatively with what is really interesting about cosmetic fashion

Review of *The Decorated Body* by Robert Brain (New York: Harper & Row, 1979) in *The New York Times Book Review,* March 2, 1980.

in the West. There is a good deal of wrongly aligned comparison in this book between various tribal body arts and European ways of embellishing the physical self, all of it so worded and so illustrated as to make Western custom seem pernicious, hypocritical, and ridiculous while Nuba, Bangwa, or Maori customs seem serious, creative, and authentic. What we do is called "conformity," what they do is called "celebrating the social body"; Western habits produce "artificial constructs," tribal methods produce "created images." All told, this book is something of a paean to the Noble Savage—punctuated by expressions of scorn for Civilized Man—rather than a measured anthropological comparison. Dr. Brain tends to view the whole West and its history as one undifferentiated culture, somewhat the way missionaries once viewed the heathen.

Too bad. Western use of cosmetics and body sculpture may have its extremes and its drawbacks, but if taken as a varying form of personal and social expression, it may prove as objectively interesting and complex a human phenomenon as the more striking customs of New Guinea. The pictures in this book are particularly biased: those depicting Western life are mostly exaggerated satirical cartoons, whereas all the tribal peoples appear in artistic renderings or flattering photographic portraits.

But even so, Dr. Brain's passionate bias stands him in good stead. It gives the book a zealous expressive power and a lasting claim on the imagination that a neutral tone could never achieve. In his first chapter, "The Painted Body," he offers eloquent descriptions of the way a people such as the Andaman Islanders or the Caduveo of Brazil use body painting, the most flexible of all these arts. Sometimes they have it applied for secular and pleasurable intent and, according to individual taste, by friends and relatives; at other times, for rigid ritual purposes, they may be painted in prescribed ways by specialists in the task.

The significance of the painted motifs may be multifold; and so an entire range of visually expressive possibilities is available to the group, depending on the occasion or inclination, employing a few basic colors and using the body "as a canvas for the spirit," as Dr. Brain puts it. Painting the body becomes a general artistic medium for the communication of very different meanings and feelings—some personal, some ceremonial, some both at once—and not a simple ritual display. In such a cul-

ture, to be unpainted is to be unfinished or, as Dr. Brain says, to be dumb. He is careful to insist that any simple interpretation by foreigners of the motifs in body art can only be condescending and probably wrong, or at least insufficient. The languages of body decoration are as complicated as any other kind, and each one is largely unreadable outside the group.

This book, as others have done, shows that the Nuba of the southern Sudan demonstrate the kind of finesse in body painting most likely to appeal to Westerners. They groom and tend their bodies more or less according to our own standards and to an even greater extent, washing, depilating, oiling them, and exercising them into perfect shape. Then the paint is applied in elegant designs drawn from natural forms, always following the given contours of the body's structure and musculature or enhancing the shape of the individual face. The result, according to the photographs in this and other books, is dazzling to the eye and quite satisfying to our sense of how one might celebrate physical perfection. Dr. Brain points out, however, that one of the things most baffling and offensive to European missionaries in South America was "the long hours the Indians spent in cossetting, oiling and painting the sinful human body, when they should have been fishing, farming or hunting." That the power and pleasure of art should take such a form and demand so much time and energy among "uncivilized" people made Europeans uncomfortable. Such practices probably seemed too close to the worst refinements of decadence, instead of being suitably simple, rude, and wild.

Even more uncomfortable for us now, as undoubtedly for Westerners then, are the forms of body art that permanently alter the natural shape and surface of the body or the face. Dr. Brain again wants to compare some of these with severe tight-lacing, breast-reduction, or rhinoplasty in the West, but he keeps using the wrong arguments. It will not really do to compare certain violent extremes of fashion that were in fact frowned on in their time and indulged in by only a few with standard practices common to all members of a tribe and requisite for full status and identification, or to liken undetectable and optional cosmetic surgery done under anesthesia to deliberately painful, compulsory, and obvious scarification.

The photographs of carefully scarred, tattooed, mutilated, and con-

stricted bodies are unnerving, and indeed the text proves a valuable guide here. Dr. Brain emphasizes that all such tribal mutilation is based on the belief that real disfigurement is caused only by its absence. In these cultures, to be unscarred or unmutilated is to be incomplete—to lose out on full humanity, to risk identification with the helpless beasts instead of with the potent gods—and to be without the visible right to full status according to age, sex, and rank. Surface scarring tends to denote the irreversible changes in the life of an individual: for women, perhaps the menarche or the birth of a child; for men, perhaps the first kill in the hunt. Without them, the individual's experiences are not seen to have registered or, in some way, to have occurred at all. His life lacks meaning and his body lacks beauty.

Discussion of the permanent body arts begins with tattooing—that being the easiest to take, perhaps—and proceeds through cicatrization, ear disks, lip plugs, circumcision and clitoridectomy (no pictures, fortunately), and neck and skull deformation. Dr. Brain continues to warn that simple explanations are inadequate. Anthropologists who study these phenomena intensively nevertheless disagree about what the details of a given practice signify to the participants, and broad generalities such as "This mark is believed to ward off evil spirits" are not very illuminating. Dr. Brain advocates interpretations that link deliberately applied body art with both social organizations and cosmology, and that take the complexities of both into account, along with their relation to the individual. Meaning may intensify and attenuate or shift back and forth from direct to indirect. As in any art, the meaning is carried by the technique itself, and beauty is achieved by the integration of human invention with raw nature.

But for us the problem of the permanent body arts is the pain. In all these processes one person must severely hurt another, and what about the meaning of that? Missionaries and colonial governments alike suppressed these practices in the past, and Dr. Brain himself rather condescendingly remarks: "I suspect that few readers will doubt the wisdom of these governments or be able to accept that scarring is an aid to beauty. On the whole Westerners regard self-mutilation as a sign of psychopathology and have always taken a poor view of its manifestation in both our own and exotic societies."

Perhaps. But the appeal of pain in the service of beauty or sexual

pleasure is very strong all over the world, including Western culture, despite our self-aware and enlightened views on its significance. To Westerners, bodies bearing the beautifully regular signs of deliberately inflicted pain cannot but suggest certain extremes of erotic indulgence, as well as plain torture. It can be as disturbing to contemplate inflicting such scars on someone else as it is to think of willingly suffering them. To explain the process as a simple test of endurance, given and undergone, seems insufficient. Trying to stop it indicates more complex feelings than simple disapproval.

Painful tattooing, so well and thoroughly described here as ennobling to Maoris and Marquesans and as a refined art among the Japanese, is also shown to be sought in the West by criminals and deprived members of society who suffer what Dr. Brain calls "a sense of diminished personality." What, then, might this indicate about the Marquesans? Must we believe that it is good when they do it and bad only when we do it?

It is easy to seize upon the romantic idea, as Dr. Brain seems to have done, that all such peoples, by engaging in the constant external and ritualized manifestations of feeling and belief through the medium of bodily figuration, thus manage a sane ordering of all fear, conflict, sexual drive, aggression, and so on. Such a system can seem like a safe and comfortable way to live, compared to what we experience by our own methods. Dependent on very different notions of truth, personality, time, and history, we grapple with our personal demons, permitting the unconscious to operate haphazardly through our freely chosen dress and behavior; we create changeable religious and social forms that seem only partially and ineptly to express our needs and wishes; we maintain and transmit a desperate and uncertain struggle with the unreasonable and the inexpressible in ourselves and in the world.

But it likewise remains clear that unchanging tribal societies are also traps without escape. If painful scarring or mutilation is required at each critical stage of life, and acceptance by the community depends on it, with the only alternatives being death or ostracism, then any personal fear or loathing of the process is in dreadful conflict with the need to belong. Unusual sensitivity or the power of detachment have no hope of expression in such societies. Pain must be visibly borne and its traces forever remain, and a fierce virtue must be summoned to justify it. Any

reserves of horror and bitterness and rage that result may, and indeed must, be duly visited with ineluctable vengeance upon the next generation; and the costs of such a system remain invisible and immeasurable.

To the first European explorers and colonists, all this must have been at least dimly discernible, even while they spoke of the simple vanity or the inhuman barbarity of the tattooed or mutilated savage. Disgust, pity, fear, fascinated admiration, and a kind of envy must have contended before the sight of men and women who wore their individual achievements, common beliefs, ancient histories, idle whims, and serious purposes vividly and often indelibly and painfully on their own naked flesh. Such figures must have seemed like apparitions conjured out of a forbidden dream. It was undoubtedly both unwise and absolutely wrong to try to stamp out the decorated body; but when one contemplates a Sumatran girl's teeth filed to sharp points or the pattern of scars on the breasts of a woman from the Cameroon, one can certainly understand the impulse.

The Tight Corset

David Kunzle has chosen an awkward moment to write seriously and in detail about corsets and tight-lacing. The last decades of the twentieth century are a period when, as he allows in his preface, the practice is viewed "as one of the quintessential Victorian social horrors, the forcing of young females into narrow corsets being regarded as morally and hygienically on a par with the forcing of small boys into narrow chimneys." In the present feminist atmosphere, the historical corset is associated almost entirely with the oppression of women, if it is taken seriously at all. Mention of it most often seems to conjure a vision of idle, neurasthenic ladies fainting on sofas and prevented by their stays from doing useful work or having serious thoughts.

Kunzle is brave to offer a full-scale history of the corset, but even braver to expand and elaborate his heterodox view of it—that "the corset gave in the past as it still does, vestigially, in the present not merely physical support, but positive physical and erotic pleasure." He presents a huge body of evidence to support this view, which in turn leads to an even more heterodox theory that tight-lacing was an expression of both sexual and social revolt—a symbol not of repression at all but of a sexual rebellion that was a significant aspect of the class struggle. To make

Review of *Fashion and Fetishism: A Social History of the Corset, Tight-Lacing, and Other Forms of Body-Sculpture in the West* by David Kunzle (Rowman and Littlefield, 1982) in *The New York Review of Books*, March 4, 1982.

such a claim convincing, Kunzle has proceeded with care into disputed territory to establish historical connections among the realms of fashion, politics, sex, medicine, and morality without sounding cranky or fatuous. To see a tightly constricted body as an image of freedom takes not only imagination but historical tact and a fine anthropological detachment; Kunzle displays all three.

Painful compression is glaringly absent from current female torsos, although standard erotic taste still runs to high narrow heels, long red nails, and multiple holes in the ears. Puritanical Americans still enjoy the pleasures of self-punishment, although now the luxury of severe bodily discipline usually takes the form of stringent exercise and curtailment of food and drink, not the systematic application of tight corsets and starched collars. The new methods of self-torture seem to connote moral freedom and physical purification while the old habits suggest social tyranny supported by sexual hypocrisy. A good look at them in context is probably not such a bad idea, as a possible hedge against smugness.

Studying only the element of constriction in dress might seem slightly perverse, but Kunzle's book has the virtues of certain other acknowledged classics, notably Steven Marcus's *The Other Victorians,* in which matters once glossed over as unworthy are shown to have instructive connections with official history. Even most costume history contains spongy generalizations about the past meanings of clothes, copied without demur from earlier books. Rarely has an aspect of historical dress been intelligently discussed with enough reference to complex civilized life to engage an educated reader. David Kunzle is an art historian with a special interest in the arts of popular social protest, and his earlier book★ traces the history of European pictorial broadsheets, picture narratives published from the fifteenth century until the early nineteenth. He is accustomed to studying history in the mirror of popular response. Looking at corsets this way—and having plowed through mountains of significant trash as well as standard classics in at least four languages—he is exceptionally well equipped to explain them to modern readers.

A tight fit around the body began to appear in Western clothing for both sexes at the beginning of the fourteenth century, and "fashion" as we now know it then began in good earnest, along, of course, with so much else. Mode in dress ceased to be a matter of regional custom and

★*The Early Comic Strip* (Berkeley: University of California Press, 1973).

became, like the other arts, an index of Western social flux, sexual stress, and individual expression. One basic element of fashion was a variable mode of shaping the midsection; and as sexuality more and more infused the forms of art, dress also divided the sexes in this respect with great visual energy. Women's legs were engulfed in fabric below stiffened rib cages, tight waists, and exposed chests; men displayed their legs but tended to stiffen and hide their arms and shoulders, chests and necks. The rigid shapings of male dress were generalized over the whole body, suggesting armor divided into parts, a well-organized force of will, and a kind of total corporeal tumescence. Men were often constricted, but their tight waists were accompanied by padded chests, sleeves, and cod-pieces, or stiff collars and rigid boots. Women stiffened only the center: the rest could flow, spread, and swell with the vivid signs of organic life.

Once set in motion, fashion kept changing; but after about 1500, when bones came into use for stiffening garments, various forms of bodice stays were a constant feature of Western female costume for four centuries. Until the seventeenth century the stays were incorporated into the dress itself. During the eighteenth century and after, they were sewn into a separate garment, which became the corset and was thereafter a part of underwear. Over so broad a span of time and place, stays obviously altered in aspect and significance according to the facts of female life, but they seemed, Kunzle suggests, to confer a basic female self-respect. Women wore corsets in factories, in fields and shops, in mansions and palaces. They wore them teaching school in Montana, dancing in Viennese ballrooms, selling fish in Amsterdam, or managing businesses in Paris. Milkmaids in barns and housemaids running up and down stairs wore them; only serfs and the destitute had to go without. Yet corsets differed, like women, in shape and social character.

And like women, they provoked enormous hostility throughout modern history. No other item of costume has drawn so much attention in print and excited so much wrath. Centuries of misogyny seem to have been concentrated in the form of hatred of stays—for undoubtedly it was in her corsets that Woman seemed to be most blatantly insisting on her sexuality. In the first Renaissance days of bodice stiffening it was the thrusting up of the breasts that was most deplored, and early reformers blamed stays on sexual vanity. In the late eighteenth century, objections may have had the same underlying motive but were made on the grounds that corsets violated nature and blasphemed the sacred classical propor-

tions. In the nineteenth century, health and maternal functions were allegedly threatened by stays, and willful slavery to fashion was held responsible. For centuries, women apparently wore their corsets in spite of public opinion. The clearly erotic meaning of stays was always hard to condone, even though many men were excited by them and women enjoyed wearing them. High heels and makeup have had similar histories.

A tight corset sexualizes the body not simply by thrusting the bosom and hips into prominence but by showing how it must feel to be wearing it. The sight of discomfort voluntarily endured for the sake of an acute but obscure satisfaction is very disturbing. It makes Europeans squeamish about Ubangi lip-stretching, Sumatran teeth-filing, and Chinese foot-binding, for example. Among other things, extreme tightness seems to suggest a sexual readiness deliberately prolonged, an erotic tension stretched to the breaking point. Similarly, the display of self-inflicted sexual pain seems to invite sexual cruelty.

Kunzle distinguishes between normal corset-wearing, which was almost as common as skirt-wearing despite the fuss made about it, and the fetish of extreme tight-lacing. The latter was a personal obsession which occasionally seemed consonant with fashion but which was never condoned and rarely practiced by truly fashionable women. Even when fashionable dress required tight and long stays, fetishistic tight-lacing was practiced only by a few. Extreme practitioners laced themselves gradually smaller and smaller, patiently training their figures to the absolute minimum that could be borne, measuring themselves constantly, taking pleasure in the accomplishment, in the triumph over pain, and ultimately in the sensation itself. This state of mind quite clearly has nothing to do with an interest in fashion; but there were periods in fashion history when it seemed to social critics as if it did.

After the corset was made so as to be opened and closed with hooks up the front, the wearer could put it on herself. The garment could be laced up the back in advance, hooked on, and then tightened by pulling sideways on the ends of the laces, which emerged through loops at the waist. Holding on to the bedpost while somebody else tugged from behind was not necessary after 1845, although such collaborative practice was often an important part of the fetish. The image was certainly the main feature of pictorial satire, but it shows more about how corsets were perceived than about how women got dressed. It is true, however, that before the French Revolution stay-lacing required help.

Extreme tight-lacing and public dismay about it seem to have intensified after 1760, and continued to increase throughout the nineteenth century, parallel to the rise of industrial wealth and the dissolution of old social hierarchies. Kunzle repeatedly demonstrates that in such a European social climate, tight-lacing was an expression of sexual and social aspiration—"an *arriviste*, never an *arrivée* custom." Severe tight-lacing was most likely to occur among upwardly mobile young women trying to assert themselves, escape the maternal stereotype, and gain power in the world, if only through erotic expression. It was partly the socially subversive flavor of the practice among allegedly respectable women that aroused disapproval. In the middle 1860s, for example, tight-lacing was lumped with other pushy habits affected by "fast" young girls, such as meddling in politics and striving to become learned. Strong-minded and tight-laced girls were condemned in the same breath, not contrasted. Their loins were girded with more strength than was seemly.

By the 1880s European female fashion had achieved an intense erotic emphasis focused on an hourglass torso rising above a very narrow, tight, long skirt that flowered into a bustle and train at the back. The sensual vigor of such clothing, in a period of great sexual repressiveness, brought out all the force of submerged terror in the reformers, including women, then crusading against fashion in the name of reason. Conservative male reformers spoke of freeing women from their folly and their furbelows, but Kunzle believes that what many of them really felt was a strong impulse to restrict the sexual liberty so evidently taken by the expressive details of women's dress—especially by the disturbing corset—and to shackle women in the real bondage of steady maternity and honorable domestic labor. For that kind of pure, sweet, noble life, of course, unattractively loose-waisted and unnoticeably simple garments are just the thing.

The frightening inference was that the tight corset, far from being an encumbrance, was in fact the vital key to a woman's *toilette*, its generating engine, the vibrant source of the pleasure she felt in her billowing silks and quivering feathers. The intuition that suffering might be undergone to take pleasure caused a lot of the stir about corseting in its heyday. Restrictive masculine clothing of the same period imposed suffering only for good form's sake. It had no trace of autoerotic flavor, and so it escaped the same degree of censure and ridicule. Tight-lacing was a celebrated feature in the personal arrangements of famous fin-de-siècle demimondaines, for whom extreme narcissism seemed a correct

public posture: milk baths and a fourteen-inch waist were both socially forbidden and thrillingly sexy. Horrifying rumors were circulated that such women even had ribs removed to allow for tighter stays.

Tight corsets were also worn by men, especially during the days of the great Regency dandies, and most significantly during the rise of military dandyism all over Europe following the Napoleonic wars. Kunzle again suggests that the very tight neckwear and very tight waistcoats then worn with stays by men expressed an anxious insistence on the self, on personal and even sexual worth, specifically in the struggle to push oneself up the social ladder. Many Regency dandies were upstarts, not landed gentry. Their claim to social distinction and acceptance had to lie in a personal style, even a physical and erotic one, just like that of similarly ambitious women. Kunzle finds a related social anxiety underlying the rigid military dress uniforms of the same period, which were especially strangling at the neck and waist.

Such gear was worn (also with stays) by officers all over Europe, as if they wished to undertake hardships even in peacetime, to appear in training even in the ballroom. As the outward sign of a capacity for endurance, such gear was a claim to honor as well as a goad to masculine pride whenever it uneasily confronted the effortless confidence adorning a grand lineage and an inherited fortune. Naturally enough, such a gamecock stance in men was easy to ridicule as preposterous vanity and even effeminacy; during the early nineteenth century, military and civilian dandies were mercilessly lampooned by the popular press. As opposed to social ambition, however, Kunzle likens the severest form of tight-lacing among very young girls to anorexia, a similar sign of acute psychic distress. It was a way, he suggests, of "numbing pain, or of replacing a psychological stress with a physical stress and discipline easier to bear and better rewarded."

In Victorian England, tight-lacing had very little chance of being directly defended by its practitioners, since the received attitude toward it was so intensely disapproving. But during the 1860s, *The Englishwoman's Domestic Magazine,* under its forward-looking and youthful editor, Samuel Beeton, opened its correspondence columns to discussion of this controversial subject. A flood of letters arrived describing an unmistakably erotic pleasure as well as a general sense of well-being achieved through extreme tight-lacing. A heightened physical awareness and energy, not weakness and sluggish languor, were often attributed to the practice. Women of eighty wrote that they had tight-laced all their

lives and never had a day's illness, and so forth. This material nicely balances the medical horror stories about corseting collected by feminist historians, and all the familiar testimony about what a martyrdom corsets often were. Kunzle demonstrates that inveterate tight-lacers were actually quite hardy and tough; the ones who died or languished under its influence were already undoubtedly the victims of existing ailments or weaknesses. Out of fear or prudery, doctors at a loss for diagnoses might well attribute more symptoms to the effects of corseting than a true scientific spirit ought perhaps to have allowed.

In the twentieth century, extreme tight-lacing sank out of sight and became one of many other "kinky" obsessions. The most outstanding present-day tight-lacing fetishist is Mrs. Ethel Granger, who made the *Guinness Book of World Records* in the late 1950s with her thirteen-inch waist. This active and healthy lady is now more than seventy-five years old and still tight-lacing, and we are assured that she "can still walk for hours in her size three shoes with their five-inch stiletto heels." There is a picture of her to convince the incredulous.*

On the surface of fashion, twentieth-century female clothing has generally abandoned constriction to aim at expressing an ideal of comfortable freedom—an aspiration not always lived up to in sartorial reality. Woman's trousered leg, not her girded loins, has been the chief vessel of that ideal in modern life, and the reason is not so much that pants are actually freer (some constrict a lot) but, more than anything else, that female trouser-wearing seems to be the most satisfying symbolic repudiation of nineteenth-century sexual views. Corsets did reappear to fortify rebellious girls who flouted convention in late-1930s historical films like *Jezebel* and *Gone with the Wind*, and the wasp waist was even more ostentatiously and cinematically revived in the early 1950s. But the very different social temper of the 1960s soon took the look of dress in other directions.

David Kunzle obviously has as deep a sympathy for variations of sexual expression as he has for variations of social protest, and he works hard at understanding possible links between them. His book is social history in depth, not entertaining commentary. It is encyclopedic in both the good and the bad sense: we are perpetually given more than we want to know, but on the other hand, if we ever do want to know something about the subject, we will surely find it here.

*Mrs. Granger has died since I wrote this article in 1982, but others have taken her place.

Kimono

Like many kinds of traditional dress and ancient custom, the Japanese kimono was invented in the nineteenth century. It was early in that epoch, when Western social change became so swift, that Americans and Europeans began to cherish the idea of age-old assumptions being expressed in unchanging customs and traditional costumes. The kimono of Japan has since appeared to modern Westerners as a lovely relic of antiquity, sort of like the Beefeater's outfit, seemingly un-changed in form and laden with wonderfully ancient rules of wear that have been faithfully observed for centuries. And because kimono is now a female form of dress, it has lately come to look like the very image of an equally ancient tradition of female bondage, effectively imprisoning Japanese women in its tight, silken grip for hundreds of years.

But all of this is an illusion. "Kimono" is a modern word and kimono a deliberate modern creation. Its present form and rules have a history little more than two generations old. It also has an active imaginative function in the lives and minds of modern Japanese; it does not simply represent the dead weight of traditional culture. Kimono is not a mori-bund phenomenon only waiting to disappear, perhaps to leave a crip-pling residue of primitive belief to trouble modern lives, but a vital and

Review of *Kimono: Fashioning Culture* by Liza Crihfield Dalby (New Haven: Yale University Press, 1993) in *The Yale Review*, Winter 1994.

present facet of Japanese self-imagery, unlikely to fall into disuse so long as the Japanese wish to keep their distinct cultural identity.

In this, kimono differs entirely from the European folk costumes that have been fixed into a reduced and crude shape chiefly for tourists to admire and that have no inner dynamics and no normal role in anybody's life. Nor is it like common and authentic native clothing, the saris or chadors for women or the flowing galabiyahs for men worn as everyday modern dress. It is perhaps a little more like the present-day Scottish kilt, which has great importance in Scottish self-awareness and also dates from the nineteenth century, even though it invokes remote times.

Liza Crihfield Dalby's book *Kimono* shows, however, the ways in which the modern Japanese kimono is truly unique, just as the history of Japan is unlike any other in the world. In the nineteenth century, while other countries were dwelling on ancient traditions in artificial ways, under the threat of galloping industrial modernity, the Japanese were just becoming aware that their own current usages *were* ancient traditions and that modernity itself had left them out. For nearly three hundred years, between about 1600 and 1867, the Japanese had been isolated from other cultures and had no way of considering their familiar complex civilization against any standard but their own. When modernity impinged upon them at last, they suddenly saw themselves as a small static group in a vast and advanced new world.

We are used to the idea of great cultures feeding and being fed by distant civilizations along trade routes and pilgrimage roads, as well as through exploration and various forms of aggression across seas and borders throughout history. Textiles, pottery, cookery, music, works of art, elements of language, modes of war and science, love and politics have all moved around the world, giving people a steady idea of otherness and of their own relation to it. But for a very long and crucial period, Japan was cut off from such exchanges. Western fashion had also moved around for its special inspirations ever since the Middle Ages. Foreign ways to dress, either reported by travelers or seen at home among newcomers, were obliquely reflected in domestic modes—the tenacious idea of the exotic seized on Western fashion very early. Again, Japan learned nothing and taught nothing in that sphere for hundreds of years.

Dalby is eloquent about Japan's sudden discovery in 1867 that its own

normal clothes, comfortably reflecting the complexity of up-to-date
Japanese life, were really picturesque native costumes. Her book offers
many close discussions of special aspects of her subject, but the most
striking story is about the effect of Western clothing on Japan at the
time of the Meiji Restoration in 1867. That moment of shock eventu-
ally resulted in the existence of modern kimono, but not before nearly
a hundred years of creative management and psychological modification
were lived through. What to make of modern Western clothes? Dalby
says that "Japanese clothing . . . at mid-[nineteenth] century, was com-
pelled to acknowledge itself as merely ethnic clothing in a world ruled
by pants and jackets." Modern dress was not simply Other, it was the
One. The Japanese clearly had to adopt it without delay, in order to be
taken seriously as anything but a colorful tribe; and that was easier said
than done.

Nothing could be more different from Japanese habits of dress at every
level of society. Buttons, for example, standard Western fastenings since
the thirteenth century, were unknown in Japan. Cut and fit, also dating
back to the Middle Ages in Europe, were quite unknown. All Japanese
clothing was formless with respect to the human body, taking its shape
entirely from the way it was wrapped and tied. Since clothes weren't fitted,
there was no strain on seams; garments were tacked-together lengths of
cloth taken straight from the bolt, with other straight pieces attached for
neckband and sleeves. For thin figures, extra fabric was absorbed into the
seams, never cut off; clothes were very easy to make and easy to take apart
for cleaning and reassembly. Now, suddenly, the whole idea of tailoring a
garment to fit a specific body had to be grasped and digested, along with
the idea of Western fashion, which constantly modifies the basic decisions
about what sort of cut and fit to aim for, especially in female dress.

Japanese women of elegance, from the empress to the geisha, at-
tempted to import and adopt Parisian bustles and corsets in the 1880s,
not fully realizing that these effects were essentially ephemeral, that
shapes of sleeves and bodices changed every year, along with the level
and bulk of bustles. Japanese fashion had never been a matter of chang-
ing basic shapes but of shifting surface effects. The physical character of
elegant difficulty was entirely different, too. At the time, Western female
finery fastened up the back with hooks or laces; all Japanese clothes
wrapped over in front and were tied on. Tight-fitting leather shoes were
required with European clothes; no Japanese had ever worn any.

A great deal of official Japanese rhetoric was generated about the superiority of Western clothing, especially male clothing, as efficient and functional by comparison to Japanese dress. The sudden need to *be* efficient required clothing that signified efficiency, even if it was tremendously awkward to wear and hard to take off or put on. Hybrid effects were common, as Dalby's illustrations piquantly show. A man would wear a Western overcoat over his Japanese clothing, with Western shoes below it; or he might wear only a Western hat and umbrella with it, or Western trousers below and Japanese garments above, or the opposite.

On the international scene, however, it became obvious that the exquisite ceremonial robes in which Japanese diplomats and statesmen had been accustomed to appear on state occasions looked like theatrical costumes among Westerners wearing formal morning dress. It was essential that striped pants and cutaways of perfect cut, fit, and taste be adopted forthwith in Japan, with no compromises whatsoever. The profession of tailor had to be imported and established in Japan for the first time; Japanese clothes had always been made at home, and Japan's artisanal expertise had gone into the creation of fabrics, not garments.

Later on, at the turn of the century, newly emancipated Japanese women gave up trying to adopt the dress-over-petticoats-and-corset system. They took to using bits and pieces of Japanese dress, some of them masculine, that approximated the dashing look of European fashions, along with Western hairdos and accessories. It was only in the 1920s, when Western feminine fashion became radically simplified, that Japanese women took it up consistently and successfully. At the same time, Japanese effects—loosely wrapped coats and robes—became fashionable in the West, and Japan permanently joined the international fashion exchange. All this took more than fifty years, partly because our great modern visual media, by which eyes may be swiftly trained without conscious will, did not yet exist.

Meanwhile, what about "kimono"? The word is generic, meaning something that hangs from the shoulders, but Liza Dalby makes it clear that no clothing terms were generic in Japanese. Each garment had its own name, depending on which part of the body it covered and what sort of function it had. The Japanese wardrobe had many specific pieces of clothing, and they might all be worn with considerable ease and carelessness, flexibility and invention. All the delicate gradations of

social class and personal status we now associate with Western dress were expressed in its vast range. These might be figured in differences of general flavor such as we know very well in Western dress— careless simplicity, sober correctness, ostentation both splashy and heavy, imitation-poverty, imitation-lawlessness. There was no such thing as "kimono" until the Japanese began to adopt Western dress.

The rigidity and formality that characterize modern kimono were developed in deliberate contrast to the informality and variability of modern *Western* clothing, with all the Western schemes for registering class, status, and taste that the Japanese absorbed. Kimono came to have one name, one form, and one function, which was to signify a self-aware "Japaneseness," and for that purpose, kimono is still being constantly refined within prescribed limits, which only intensifies the immense significance of its internal distinctions. In the nineteenth century, the only momentous distinction to be created was between *wa-fuku*, Japanese clothes, and *yo-fuku*, Western clothes. In the beginning, *wa-fuku* contained the whole universe of dress while *yo-fuku* was the single foreign monster to be grappled with. Gradually the position was reversed. *Yo-fuku* became the normal modern universe of dress and *wa-fuku* became kimono, period.

The costume itself—the straight wrap-over robe with neck band and sleeves, tied at or near the waist with a formal sash, or obi—is indeed of great antiquity. It was once the inmost garment worn under the huge multilayered court robes of the tenth century; and it is authentically Japanese, not a Chinese borrowing. It was originally called *kosode*, which means narrow sleeves, since its own rather wide sleeves were slim by comparison with the sweeping outer glories of court dress.

Such simple inner garments were unisex, but Dalby is careful to point out that it was the women of that remote imperial epoch who were creating the new purely Japanese aesthetics of clothing, just as women were making the first serious artistic experiments in Japanese vernacular literature. Men were staying with conservative, classical Chinese forms of elegance in both dress and verse, which were essentially borrowed. There is, therefore, an ancient precedent for modern kimono as a predominantly feminine aesthetic province. In the Middle Ages women were inventing uniquely Japanese possibilities in dress, not being constrained by them; and the same is true now.

The *kosode* gradually emerged on the surface by the seventeenth century, to become one primary form of Japanese urban dress for both sexes. It was worn by men for serious civil pursuits; but during the earlier rise of feudalism and the creation of a noble warrior class, much nonurban male dress had taken on military flavors, with a short, wrapped coat worn above a form of pants and emphatic shoulder extensions for formal outer garments—the samurai effect, totally masculine, often utilitarian and extremely prestigious, but not exactly elegant. During the early seventeenth century, however, among urban elite societies of various different kinds, the *kosode* was often worn in captivating ways by male stage performers playing female parts. They might set its fashion even among women, and also set a fashion for playing crossover games.

One remarkable aspect of the Japanese sartorial scheme is the absence of sexual suggestion in the forms the garments take—except, perhaps, for those big shoulders. The similarity of shape among all the wrapped and tied robes throughout Japanese history shows a colossal lack of fantasy about two-sexed human morphology. No anatomical exaggerations and distortions for the two sexes, of the sort so common in the West for so long, have characterized Japanese clothing. A man in drag, that is, does not have to pad his bosom, nor a woman compress hers.

Female erotic suggestions have been made by different adjustments of the same garments—dragging the *kosode* on the ground, lifting it, or wearing it tucked up; wearing the obi low or high, dipping the collar low in back. Men, wearing the same essential garments as women, could give feminine suggestions to their clothing with the tiniest changes; and women could do the same the opposite way. The actual body underneath was essentially unexpressed by the form of the clothes, with regard to its sex or to anything else. The theater of dress was entirely a surface show and kept the body's secrets.

Geisha, like actors, were all men in the early seventeenth century, which saw a great flowering of art, literature, and theater. At the end of that century, fashion also became a thoroughgoing enterprise, with commercial establishments seeking custom through the publication of attractive pamphlets. Dalby prints some illustrations from a few of these, which offer diagrams of flat garments to show surface pattern, and quick sketches showing chic poses and gestures. Since the fashion busi-

ness was simply the fabric business, new style in dress depended on the inventive weaving, dying, printing, painting, and embroidering of silk—while the *kosode* remained a standard shape. How to get thrilling effects in wear had to be suggested by fashion leaders, some of whom were undoubtedly these inspired fashion-magazine illustrators, along with male actors and cultivated urban ladies.

A hundred years later, the geisha were all women, and they had formed the wonderfully fluid and poetic element in Japanese urban society that they still sustain. They were always different from licensed prostitutes, who had a rigid style of dress and behavior based on ancient Chinese models and who were also formally trained in sexual arts. By contrast the geisha, like court ladies of the Middle Ages, were advanced poets of dress. *Kosode* fashion was one large arena for their imaginative talents, the display of which was the geisha's whole value and purpose. Geisha were trained in conversation and musical performance, not sex. The sexual possibilities geisha offered were oblique, never open or even legal; the geisha's function was to be interesting and delicious, not available. Dalby shows how geisha, to that end, became professional kimono wearers and still are, even though they now represent tradition instead of fashion. Their imaginative choices are still freer and their effects more dashing than those of other modern kimono wearers.

Dalby is most eloquent about the geisha because she has been one herself. The force behind this excellent book is Dalby's personal passion for the whole cultural realm she discovered while learning to wear kimono with the exacting perfection of a professional, which meant learning to feel natural in it. She wrote a doctoral thesis in anthropology based on her personal researches, which was published in 1983 under the title *Geisha*. The physical and moral education she received in the process clearly moved her to undertake the much greater scholarly effort that created *Kimono*.

The author, coming to kimono at its current stage of development, was obviously struck with its vitality and importance, its difference from the preserved "folk costume" of other modernized and Westernized cultures. The kimono derives from the dress of one group in upper-middle-class urban society, not from the nobility or the peasantry; it was always sophisticated, and it still is. But when it first "discovered itself" in the nineteenth century, as Dalby puts it, the kimono began to formalize its more fluid possibilities and to give itself rules it had never had,

before it found a national role and a name. The new rules were in keeping with ancient ideas, and they helped to provide a sense of what it meant to be Japanese—a thing nobody since the seventh century had ever needed to consider. Men and women could now feel inscribed by kimono's multiform signals. Since the unclad body had no special integrity of its own, a body clothed in meaningful kimono could now take on its peculiar native moral strength along with its rules for color, sleeve form, pattern, and texture.

Kimono is now worn only by women, who undertake to keep expressing the beauty of the principles its details convey. These principles comprise consideration for marking the separate stages of human life, the progress of the seasons, the symbolic importance of occasions, the relations between generations, and the integrity of families. But kimono is never obligatory, it is always a choice. Whenever women wear it, kimono is conveying these things with delicacy and nuance, and of course with beauty, while Western clothing is simultaneously speaking in its own complicated medium. It is the combination that satisfies modern Japanese souls.

Although men wore kimono privately for a time after the inauguration of Western dress for public purposes, the male version is now reduced to one form, the cotton *yukata* for acutely informal home use. Japanese of both sexes now seem to feel that kimono's cultural importance is rightly managed by female imaginations and manifested on female bodies at certain times— weddings and funerals, opening ceremonies for schools and institutions, formal public occasions of all sorts. Modern young Japanese girls who lead the same lives as their Western counterparts will nevertheless wish to have at least one kimono for their trousseau, and will spend the fortune they cost to have one made. Geisha relish the opportunity to collect many; and rich women, says Dalby, may take up kimono wearing as a kind of hobby, selecting the silk and patterns for numerous subtle ensembles appropriate for different activities, different times of day, and different states of mind.

Another moving chapter in Dalby's book is called "The Other Kimono." By this she means the actual peasant dress that might very well have become the national costume of Japan, in the manner of Tyrolean or Ukrainian costumes, if upper-middle-class city clothes had not won out. It isn't the fabulous robes of the medieval Heian period or the sumptuous *kosode* of the baroque Edo period that are truly past

and lost—those are amply preserved in museums. It is, rather, the entire range of indigenous lower-class clothing that has vanished from Japan, the wonderful, convenient garments in striped and padded cotton or rough silk, the many cotton coats in modest but striking woven patterns. All these once shared in the general high level of Japanese talent for perfect visual balance; their simplicity was never crude. They were also ingeniously remade, patched together of different stuffs in vivid combinations.

After Western clothing had swept all levels of Japanese society, efforts were made to preserve or at least to classify this huge segment of Japanese dress; and it did last a long time in some rural areas. But jeans and T-shirts and the rest have replaced it all by now, despite the obvious fact that the native versions were eminently practical and needed no improvement—besides being beautiful, of course. Dalby shows some photographs and prints from the late nineteenth and early twentieth centuries, showing women working in neat, wrap-over tops and pants tied around with handsome full-length aprons, for example, the whole ensemble dyed with indigo in various vivid patterns. This sort of female dress was in the ascendant during the Second World War, and kimono went into eclipse; the present "traditional" silk kimono, with its suggestions of antiquity and nobility, is an invention of the 1960s.

Liza Dalby's splendid work of costume history is of a kind that rarely comes along. Her descriptions are specific, her pictures apt and thoroughly documented, her notes enlightening; and she deals with her subject out of personal engagement with it, not to prove a point about something else. She has also explained the relation of Japanese dress to the culture at large in graceful and intelligent language, which is very welcome. I find myself wishing, however, that she had kept her remarks about *Western* fashion entirely neutral and general, or even had made none.

I don't understand how she could write, for example, that Westerners are unaccustomed to thinking about dress as political; it seems to me we are doing nothing else. When she wants to make Japanese effects clear in Western terms, her comparisons go lame when a lack of attention to fashion permits her to speak of a "cocktail dress" as something currently modish, or to assume that everyone knows that white linen should not be worn in September or that beehive hairstyles are unqualifiedly ridiculous. Also, she shouldn't sneer at "Heidis in dirndls"—

Heidi was a Swiss girl; dirndls are Austrian or Bavarian and are still worn unselfconsciously in those regions.

Never mind. Dalby has a true love of Japanese dress and its history, all other kinds of clothes seem uninteresting to her, and she doesn't care if it shows. In fact, it makes her book a real treat. The subject is dauntingly huge, and she has managed to encompass it with admirable skill, skipping back and forth through time by necessity, speaking broadly and focusing closely by turns, but with care, so that the reader can end by feeling that he has a true grip on things.

Men in Black

Black was the prevailing color of men's garments at certain periods in European history, but it's been an important masculine color through-out world history, much more important than it ever was for women until the present. Male authority—collective and individual, spiritual and worldly—male cruelty and malice, male hypocrisy and depravity, as well as willing male surrender to impersonal duty; male self-discipline and self-loathing, self-effacement and self-importance; male chill and male zeal; male learning and scrupulous intellect, male good judgment and moral excellence, male physical beauty, strict commercial probity, and vast emotional depth have all seemed appropriately manifest in male black clothing, right along with common courtesy toward death, real grief, and total despair.

Because of these potent symbolic elements, and probably others I've forgotten, all of which hang in inky solution and refuse to separate out, black gear has again and again become provisionally chic or supremely elegant for men of every class and age. From the Burgundian court dandies of the fifteenth century to the leather-clad street dandies of our millennial moment, black masculine fashion has had an edge. For that matter, a great deal of the power in female black garments has derived from their original male usage. When women have worn black, they

Review of *Men in Black* by John Harvey (London: Reaktion Books, 1995) in *The Economist,* February 1996.

have often been laying claim to the larger dignity, graver sorrow, more legitimate power, stronger personal impact, more honorable humility, and more effective wickedness of men.

The sartorial mysteries and paradoxes of masculine black are imaginatively discussed by John Harvey in *Men in Black*, where he focuses his story of black male costume on its most remarkable climax in the nineteenth century. In France, England, and the United States, the male figure blackened as that century advanced, causing sensitive literary men in those countries to shiver at the spectacle of universal mourning increasingly offered by their whole sex. Gone were the brilliant waistcoats and pale trousers of earlier decades in the century, long gone the green and blue coats, the stripes and bright buttons of the Regency and Directoire, even the cheerful smocks once seen in the countryside. Urban gentlemen, respectable professionals, shop clerks, and waiters all came to wear black, day or night, followed by farm laborers and tradesmen on festive occasions in rural towns and villages. Everywhere men were wearing the color of loss and death, while the vital enterprises of imperial and commercial expansion, along with political and social reform, were churning and booming. What was going on?

Harvey is acute on the nervous fear expressed in this nineteenth-century masculine blackness, especially in England. He starts with the inherited blackness of Puritan worldly renunciation, which he finds linked to clerical, clerkly, and thus eventually to financial acumen. This somewhat infernal association can produce the inward sense that God smiles on the tense accumulation of riches by frowning on the relaxed spending and enjoying of them. But amassing wealth as England was doing produces the constant fear of losing it; and then, if we instructively reverse the Bible quote, perfect fear casteth out love. So a love-starved but righteous blackness, feeling divinely enabled by the power of money, can freely revel in the moral right to inflict merciless cruelty on helpless others in the name of Christian virtue.

If that truly was the prevailing spirit behind the infinitude of black frock coats, there must also have been loving and generous men who mourned the fact, together with morose or servile wretches who suffered from it, all of whom were wearing their black with a difference. Sure enough, Harvey soon brings to bear the whole Dickens *oeuvre*, its differingly black-clad cast of male (and some female) characters exam-

ined against the prevailing physical blackness of smoke-mud-and-fog-shrouded Victorian London, its filthy secrets hidden inside sooty build-ings. Harvey has gone into this theme before in his wonderful 1970 book, *Victorian Novelists and Their Illustrators*, where he showed how black-and-white illustrative imagery confirmed in printer's ink the black spirit of the age, the dread behind the precarious wealth, the relentless progress, and all the ferocious decorum. Now, however, he wishes to account for the insistence of black in the bodily imagery of all masculine power. He notes, for example, that at crucial periods in history, certain troupes and troops of men in black have cloaked diversity of class and personality behind a uniform refusal of tint, on purpose to impose a common aim by force. The force may be brutally physical or spiritual and moral, the one sort easily reinforcing the other to produce general threat, while the impersonal black garb shows total personal submission to its ascendance. The early Dominicans attempting to hold imperial Christendom together and the later ones enforcing the Inquisition are thus linked to the modern SS by their aggressive outer darkness.

In another recurrent mode of black, deep grief in high places both sets the fashion and usurps the high moral ground. The sorrowing black clothing assumed by Philip the Good of Burgundy, Philip II of Spain, or Catherine de Médicis of France could soon become at once the black of lofty spiritual privilege and the black of insolent chic. These emotional shades of black still survive in contemporary dress for both sexes, with satanic black present since the beginning. But the balance has shifted. Harvey rightly observes that black for men now has less seri-ous clout than black for women, and it tends to be worn fashionably by the comparatively powerless rather than by Western male heads of states, armies, and banks.

Harvey finds a preponderance of white clothing on women in his-tory, and he thinks of white as an alternative lack of tint. I would argue that the power of much white feminine dress has derived not just from the desire to enact a refusal, as black clothing does, or from an insistent purity that rejects the corrupting touch of color, but rather from the lust to take on color that white projects—perhaps even the lust to be marked with blackness, the pale yearning of the unwritten page. White-ness is light, potential visual life itself, the universal source of all color. Thus, a white feminine radiance invites the stain from life's dome of

many-colored glass, indeed already contains its essence. To render women's clothes and many other things, generations of painters have demonstrated the panchromatic character of white. In past fashion, white feminine dress, as Harvey notes, often assimilated itself to the white body it covered; and to that I would add that it suggested the readiness of a milky skin to blush, or to be enhanced with vivid paint.

I admit I would have welcomed something more, in line with Harvey's fine eye for book illustration, about the effects of modern black-and-white cinematography on the perception of masculine black clothing (beyond that of Dracula, to whom he does devote a brilliant paragraph), and on the new effects of modern feminine white.

The effects of black or white clothes on black skin of either sex are not much taken up in Harvey's investigations, although he deals with black skin as itself a garment (Othello) and with blackened skin (actors playing Othello). He gives examples from Japan and China, Greece and Russia, and deals briefly with Jewish black and Muslim black, but there's nothing about African or Indian uses for black male clothing. This book is nevertheless very wide-ranging without being long; it is succinct and especially graceful in tone. Harvey acknowledges the limits he has set himself, and further displays an admirable conviction without arrogance about his arguments, responsibly admitting that they are speculations impossible to prove. His modesty and intelligence in expounding them make them convincing, and his scholarship is highly impressive.

Fashion and Image

The beauty of dress comes alive in art. Ever since the breathtaking achievements of the ancient Greeks, dressed perfection has been embodied in sculpted or painted images, visions of enhanced reality that teach the eye how to see clothes and teach clothes how to look. Images show how artists tailor the figure to suit the fashion, so that it wears its clothes to advantage. The eye is then taught to see living clothed figures in the light of the image, and to believe what it sees; the authoritative fiction creates the received truth.

Living bodies can shift only a little to match artists' vision of them; people can get fat or thin, and alter their posture. But fashion itself can change extremely, spurred by brilliant images offered in the world of art, and it can mold ordinary bodies to suit its own laws. Clothes in the everyday world try to measure up to the fleeting elegance that artists imagine and make real; modern artists of the fashion camera are heirs to an artistic tradition that has continually established and reestablished the true view of clothes.

For centuries, courtly artists attempted to render elegant clothed figures as if they were eternal icons, displayed in as timeless a harmony as possible even if the fashions were bizarre. The stunning effect of Bronzino's portraits comes from the way the cumbersome, rigid clothing his princely subjects wear is made to seem easy and inevitable on them, however heavy and taxing it may really have been, and however

Aperture, 1991.

hard it was to keep the clothes in proper trim. Although clothes were made by tailors, fashion in the sixteenth century was inspired, regulated, and moved along by such artists as Titian and Bronzino, who could turn absurdities and grotesqueries into graceful adornments, and even produce a longing for more of them.

In the superior painterly world, noble personages in all sorts of awkward gear were visually created and presented in a state of ideal dignity and refinement. Painters set a standard for perfect appearance that might be followed by the living originals, who could feel beautified by their trappings instead of trapped. Consequently, still bigger lace ruffs and even thicker silk skirts might continue in vogue, even into the next generation, because Rubens and Van Dyck and their seventeenth-century colleagues were still rendering them glorious to see, supremely becoming, and apparently effortless to wear.

In the days of ducal courts, empires, and absolute monarchies, the aim of such images was a certain false permanence. The desired effect was that of continuity with past and future greatness, so fashionable figures in paintings tended toward substance, stasis, and presence. Painterly realism had a sumptuous quality, laden with the riches of tradition just as the actual clothes were laden with padding, starch, and metallic embroideries. Later styles of painting itself followed later ideals of elegant living, with their different ways of seeing the beauty of fashion; and fashion changed to suit. Rococo notions demanded a sense of wit and delicacy in dress, even though the shape and construction of clothes did not change very much; so painters lightened up the palette of elegance and made the clothing seem light as air. Fashion required frothy accessories and mobile postures, ideally offered in the compelling imagery of Boucher and Fragonard, where billowing flesh and fabric seem made of the same lovely stuff, a cloud of erotic allusion lightly spiced with rue. The burden of greatness was lifted from chic—people could relax and lean back, or sit on the grass and flirt.

And right about then, the inauguration of fashion plates caused a significant new accord between art and fashion. For the first time, printed pictures of ideal figures sporting modish clothes with superior flair were published in magazines devoted to the mode. Elegant paintings were no longer the only vehicles for the image of dressed perfection. The fashionable world, moreover, had outgrown the confines of court life: it was living in cities and mixing with interesting strangers.

The new fashion art, born to suggest the impersonal flow of urban visual life, replaced the fixed stars created by courtly painters of the past. Fashionable dress now had to capture the idle, scanning gaze of the general public, to seek appreciation even on the open street. Anyone could play, and fashion plates—outrageous, delicious, captivating—showed the way to do it.

Fashion plates began at a high level of taste and an affinity with the best art of the eighteenth century, but they declined a great deal during the next one. Nineteenth-century fashion-plate artists developed a separate illustrative style that showed no impulse to keep pace with the evolution of serious art. As a result, fashionable dress itself began to seem more and more like vain folly, steadily losing moral and aesthetic prestige as its components became more elaborate and its image less serious. As fashion-plate imagery became more frivolous, suggesting insipidity and moral nullity even while it purveyed the effects of puckered taffeta and draped satin, the very details of fashion seemed more spiritually burdensome, more at odds with earnest pursuits and dispositions. Manifold flounces and braid, feathers and veiling, trains and crinolines took on the ambiguous and limiting flavor of feminine narcissism. An exquisitely clad woman became an unaccountable apparition, fascinating to the eye but obscurely threatening to the soul, disconnected from the reasonable arrangements of life.

During all this time, photography was developing in huge creative bursts, though it remained retrograde in dealing with the image of female elegance. Until the very end of the nineteenth century, fashion had no interesting new food for the ravenous camera eye, and dress showed no desire to be created anew by the shaping spirit of the lens. Fashion's own debased illustrative medium held the image of fashion firmly in its genteel paw and stifled the possibility of an imaginative camera life for fashion. Portrait photographs of fashionable personages tended to imitate the effects of Old Masters, instead of exploring explicitly photographic ways to enhance fine clothes. New painters did better. The glittering visions of the Impressionists added new possibilities to the aura of elegance, new magic to the surfaces of silk dresses and powdered faces, an optical value that fashion illustration did not suggest. They offered a new integration of fashion with the general texture of life, so that the beauty of rich clothes and the beauty of the natural

world did not seem at war. This was a prophetic move, and the camera took it up much later in the twentieth century.

It was modern design and modern art, however, which totally changed the look of fashion for a few short years after the turn of the century. Fashion illustration took a leap forward, inventing an avant-garde style for the image of the clothed figure that linked it to other objects designed in the new spirit of reduction and abstraction. The increasing prestige of modern architecture and industrial design raised the concept of design itself much higher on the aesthetic scale. Fashion design could once more come into line with fundamental creative endeavor, for the first time in centuries.

Fashionable dress was quickly reduced in scope and increased in clarity; women's clothing borrowed the essentially abstract shapes of male tailoring and began to match the spatial character of the male clothed figure, instead of spreading out in waves of fantasy. The graphic art in which fashion was purveyed again bore a relation to the newest developments in modern painting and printmaking: the body in its dress became a clear-edged, streamlined object made of cubes and cylinders or of flat geometric patterns arranged with dazzling finesse. French fashion art displayed connections with the works not only of Braque and Leger but of Symbolist painters such as Maurice Denis, which lent further aesthetic luster to the whole idea of fashion.

All this time the camera had been continuously influencing the perception of new architecture and design, of man-made things as well as of natural phenomena. The vigorous beauty of the modern world was increasingly celebrated and virtually invented by great photographers, whose vision eagerly included the clothed body along with deserts and bridges, cityscapes and rural desolation. Fashion photography, like eighteenth-century prints, began its life at the highest level of camera art, which manifested more aesthetic authority and creative power than any other graphic medium of the advancing twentieth century. And so fashion itself was redeemed, not only from the tacky illustrative graphics of the past, but even from the impersonal world of modern design.

By the 1930s, in harmony with movies and photojournalism, fashion photography began to render the passing chic moment for its own sake, instead of fixing the mode in a timeless image indebted to the old history of painting or even to the new course of the decorative media. This

shift of emphasis had a decisive effect on ideals of dress and irreversibly changed the look of modern clothing. Instead of being designed as objects similar to chairs and cars, clothed figures in fashion art began to look like characters in small unfinished dramas, caught in fantasy moments of acute tension and resonance that had no future and no past. Fashion itself, the very clothes themselves, gradually came to fulfill an ideal not just of free movement through the action of living but of quick replaceability. Mass-produced moments were to be swift experiences clad in a shifting sequence of mass-produced garments, each ensemble soon giving way to a complete new one, just as the evocative pictures similarly came and went.

In sharp contrast to past centuries, it became a modern assumption that clothes were not to be remodeled or even radically repaired, only replaced. Although fashion used to change constantly in the past, garments did represent the sustained continuity of living. They embodied the phrasing of human life, the tough and flexible endurance of human society itself. When a mode shifted, extant clothes could be picked apart and the costly fabric refashioned, so that something new grew out of the destruction of the old and fashion could build and rebuild on its own past. But the modern camera began to suggest the absolute contingency of anything elegant, even something in itself stiff, thick, and still. Since the 1930s, fashion photographs have aimed to show that desirable looks depend on ephemeral visual satisfaction, the beauty of the immediate moment only, which exists totally and changes totally; transition to the next moment occurs by no visible process. The clothes that make persons fit into such images are, moreover, made out of inexplicable fabrics by unseen means, in industrial processes that can be swiftly adjusted to make whole new sets of garments in great numbers on short notice, each meant to live for a few perfect moments and then be replaced.

Under the influence of the increasingly suggestive fashion camera, garments now look not only quickly disposable but dependent for their value on quick changes of psychological ambience. With the camera for its chief medium, fashion can seem like a sequence of costumes illustrating a narrative of inward events. The photographic message shows that a modern woman may keep visually transforming through clothing with no loss of personal integrity or consistency, preserving her emo-

tional equilibrium by dressing all the parts she plays in the continuing drama of her inner life, besides simply getting dressed for her outer one. The postmodern woman has further learned that disparate, incongruous wardrobe items may not only cohabit in one closet, as if on backstage costume racks, but be combined. In the new world of freewheeling, overlapping, unrooted camera images influenced by generations of cinema and video, athletic shoes and jeweled chiffon may be worn not just in quick succession but together.

Practical life is not directly addressed by the fashion camera, any more than it was addressed by Bronzino and Boucher. Women are in fact better able to fit everyday actualities into their closets without direct reference to dream images—those, rather, are for the health of the soul and the nourishment of the inner eye. Women actually build up useful collections of garments in a very clinical spirit, negotiating the marketplace with wary prudence; but the flame of pleasure and fantasy nevertheless glows behind their eyes, lending imaginative force to the enterprise and making it a creative act.

The potent imagery of fashion art provides the glow and generates the true art of dress, feeding the imagination and pushing the visual possibilities of clothing into new emotional territory. Designers need it and work under its influence, relying on the camera to realize what they propose, to ratify its virtues and expound its value, just as the tailors of the Renaissance needed Titian. Today's fashion is almost entirely perceived and judged through photographs and videos disseminated in the media. Most of the vast audience for fashion sees the work of designers only through the camera's eye, and responds not directly to fabric and cut but to fabric and cut explained, translated, and ultimately transfigured by varieties of camera magic. Actual clothes can only follow in the camera's wake, doing their mundane work of enabling the flow of physical life and sustaining the social world. The deep aesthetic pleasure they can give, the sparks of visual delight they can strike, are always largely in debt to the ideal fictions the lens has created, the vivid images that give fashion its true life.

Androgyny

When Quentin Bell applied Thorstein Veblen's principles of Conspicuous Consumption and Conspicuous Waste to fashion, he added another—Conspicuous Outrage. This one now clearly leads the other two. In the 1980s we want the latest trends in appearance to strain our sense of the suitable and give us a real jolt. The old social systems that generated a need for conspicuous display have modified enough to dull the chic of straight extravagance; the chic of shock has continuous vitality. Dramatically perverse sexual signals are always powerful elements in the modern fashionable vocabulary, and the most sensational component among present trends is something referred to as androgyny. Many modish women's clothes imitate what the film star Robert Taylor wore in his 1940s publicity stills, and Michael Jackson's startling feminine beauty challenges public responses from every store window, as well as in many living replicas.

The mode in appearance mirrors collective fantasy, not fundamental aims and beliefs. We are not all really longing for two sexes in a single body, and the true hermaphrodite still counts as a monster. Something is causing us to project some extreme imagery that emphasizes sexual ambiguity, but the emphasis is in fact quite selective. We are not seeing a complete and free interchange of physical characteristics across the sexual divide. There are no silky false mustaches or dashing fake goatees finely crafted of imported sable for the discriminating woman, or rich

The New Republic, January 28, 1985.

and luxuriant jaw-length sideburns of the softest bristle sold with mois-
turizing glue and a designer applicator. Although the new ideal feminine
torso has strong square shoulders, flat hips, and no belly at all, the corre-
sponding ideal male body is certainly not displaying the beauties of a soft
round stomach, flaring hips, full thighs, and delicately sloping shoulders.
On the new woman's ideally athletic shape, breasts may be large or not—
a flat chest is not required; and below the belt in back, the buttocks may
sharply protrude. But no space remains in front to house a safely cush-
ioned uterus and ovaries or even well-upholstered labia: under the lower
half of the new, high-cut minimal swimsuits, there is room only for a cli-
toris. Meanwhile, the thrilling style of male beauty embodied by Mr.
Jackson runs chiefly to unprecedented surface adornment—cosmetics
and sequins, jewels and elaborate hair, old privileges once granted only
to women, to give them erotic advantage in the sex wars of the past.

The point about all this is clearly not androgyny but the idea of
detachable pleasure. Each sex is trying to take up the fundamental qual-
ities not of the other sex but rather of the other sexuality—the erotic
dimension, which can transcend biology and its attendant social
assumptions and institutions. Eroticism is being shown to float free of
sexual function. Virility is displayed as a capacity for feeling and gener-
ating excitement, not for felling trees or enemies and generating chil-
dren. Femininity has abandoned the old gestures of passivity to take on
main force: ravishing female models now stare purposefully into the
viewer's eyes instead of flashing provocative glances or gazing remotely
away. Erotic attractiveness is offered as a commodity separable from the
banal sexual equipment of ordinary male and female individuals, and it
appears ready to exert its strength in unforeseeable and formerly for-
bidden ways and places. Recognition is now given to sexual desire for
objects of all kinds once considered unsuitable—some of them inani-
mate, judging from the seductiveness of most advertising photography.

Homosexual desire is now an acknowledged aspect of common life,
deserving of truthful representation in popular culture, not just in
coterie vehicles of expression. The aging parents of youthful characters
in movie and television dramas are no longer rendered as mentally
stuffy, physically withered, and conveniently out of the running, but as
stunningly attractive sexual beings—legitimate and nonridiculous rivals
for the lustful attentions of the young. The curved flanks of travel irons

and food processors in a glossy catalogue make as strong an appeal to erotic desire as the satiny behinds and moist lips of the makeup and underwear models. So do the unfolding petals of lettuces and the rosy flesh of cut tomatoes on television food commercials. In this general eroticization of the material world, our visual culture is openly acknowledging that lust is by nature wayward.

A female body, to register as attractive under current assumptions, may now show its affinities not only with delicious objects but with attractive male bodies, without relinquishing its feminine erotic resources. Male beauty may be enhanced by feminine usages that increase rather than diminish its masculine effect. Men and women may both wear clothes loosely fashioned by designers like Gianni Versace or Issey Miyake to render all bodies attractive whatever their structure, like the drapery of antiquity. In such clothes, sexuality is expressed obliquely, in a fluid fabric envelope that follows bodily movement and forms a graceful counterpoint to the nonchalant postures of modern repose. The aim of such dress is to emphasize the sexiness of a rather generalized sensuality, not of male or female characteristics; and our present sense of personal appearance, like our sense of all material looks, shows that we are more interested in generalized sensuality than in anything else. In our multiform culture, it seems to serve as an equalizer.

In fashion, however, pervasive eroticism is still frequently represented as the perpetual overthrow of the restrictive categories left over from previous epochs, a sort of ongoing revolution. We are still pretending to congratulate ourselves on what a long way we have come. The lush men and strong girls now on view in the media may be continuing a long-range trend that began between the two world wars; but there have been significant interruptions and an important shift of tone. In the 1920s and 1930s, men had smooth faces, thick wavy hair, and full, pouting lips, as they do now, and women often wore pants, had shingled hair and athletic torsos: but the important point then was to be as anti-Victorian as possible. The rigid and bearded Victorian male was being eased out of his tight carapace and distancing whiskers and made accessible; the whole ladylike panoply was being simplified so that the actual woman became apparent to the eye and touch. Much of our present female mannishness and feminized manhood is a nostalgic reference to the effects that were fashionable for men and women in those pioneering days, rather than a new revolutionary expression of the same authentic kind.

There is obviously more to it. We have already gone through some fake Victorian revivals, both unselfconscious in 1950s and self-conscious in the 1960s and 1970s, and lately our sense of all style has become somewhat corrupt. Apart from the sexiness of sex, we have discovered the stylishness of style and the fashionableness of fashion. Evolving conventions of dress and sudden revolts from them have both become stylistically forced—there have been heavy quotation marks around almost all conspicuous modes of clothing in the last fifteen or twenty years, as there were not in more hopeful days. Life is now recognized to have a grotesque and inflated media dimension, against which ordinary experience is measured, and all fashion has taken to looking over its own shoulder. Our contemporary revolutionary modes are mostly theatrical costumes, since we have now learned to assume that appearances are detachable and interchangeable and have only provisional meanings.

Many of the more extreme new sartorial phenomena display such uncooked incoherence that they fail to represent any main trend in twentieth-century taste except a certain perverse taste for garbage— which is similarly fragmented and inexpressive, even though it can always be sifted and categorized. We have become obsessed with picking over the past instead of plowing it under, where it can do some good. Perversity has, moreover, been fostered in fashion by its relentless presentation as a form of ongoing public entertainment. The need for constant impact very naturally causes originality to be confused with the capacity to cause a sensation; and sensations can always be created, just as in all show business, by the crudest of allusions.

In the 1920s, revolutionary new fashions were more important but less brutally intrusive. Photos from the 1930s and the early 1940s show the young Tyrone Power or Robert Taylor smiling with scintillating confidence, caressed by soft focus and glittering highlights, and wearing the full-cut, casual topcoats with the collar up that we see in today's ads for women, then as now opened to show fully draped trousers, loose sweaters, and long, broad jackets. Then this was an alluringly modern and feminized version of male beauty, freshly suggesting pleasure without violence or loss of decorum, a high level of civilization without any forbidding and tyrannical stiffness or antiquated formality. At the same time, women's fashions were stressing an articulated female shape that sought to be perceived as clearly as the male. Both were the first modern styles to take up the flavor of general physical ease, in timely and pertinent

defiance of the social restrictions and symbolic sexual distinctions made by dress in the preceding time. Now, however, those same easy men's clothes are being worn by women; and the honest old figure of freedom seems to be dressed up in the spirit of pastiche. We did come a long way for a while, but then we stopped and went on the stage.

Strong and separate sexual definition in the old Victorian manner tried to forbid the generally erotic and foster the romantic. Against such a background, to blur the definition even a little automatically did the opposite; and so when Victorian women dared adopt any partial assortment of male dress, they were always extremely disturbing. They called attention to those aspects of female sexuality that develop in sharp contrast to both female biology and romantic rhetoric. Consequently, when female fashion underwent its great changes early in this century, such aspects were deliberately and vehemently emphasized by a new mobility and quasi-masculine leanness. Women with no plump extensions but with obvious and movable legs suddenly made their appearance, occasionally even in trousers. They indicated a mettlesome eagerness for action, even unencumbered amorous action, and great lack of interest in sitting still receiving homage or in rocking the cradle. Meanwhile, when men adopted the easy casual suits of modern leisure, they began to suggest a certain new readiness to sit and talk, to listen and laugh at themselves, to dally and tarry rather than couple briskly and straightway depart for work or battle. Men and women visibly desired to rewrite the rules about how the two sexes should express their interest in sex: and the liberated modern ideal was crystallized.

But a sexual ideal of maturity and enlightened savoir faire also informed that period of our imaginative history. In the fantasy of the 1930s manifested in the films of Claudette Colbert, for example, or Clark Gable and Carole Lombard, adult men and women ideally pursued pleasure without sacrificing reason, humor, or courtesy—even in those dramas devoted to the ridiculous. The sexes were still regarded as fundamentally different kinds of being, although the style of their sexuality was reconceived. The aim of amorous life was still to take on the challenging dialectic of the sexes, which alone could yield the fullest kind of sexual pleasure. Erotic feeling was inseparable from dramatic situation.

By those same 1930s, modern adult clothing was also a fully developed stylistic achievement. It duly continued to refine, becoming man-

nered only in the early 1960s. The famous ensuing sartorial revolution, though perfectly authentic, was also the first to occur in front of the camera—always in the mirror, as it were. And somehow the subsequent decades have seen a total fragmentation both of fashion and of sexuality.

Extreme imagery, much of it androgynous, like Boy George's looks or the many punk styles and all the raunchier fashion photos, has become quite commonplace, but it has also become progressively remote from most common practice. It offers appearances that we may label "fashion" but that we really know to be media inventions created especially to stun, provoke, and dismay us. At the same time, some conventional outrageous effects have been revived in the realm of accessible fashion, which always has room for them. But ordinary outrageousness and perverse daring in dress are the signs of licensed play, not of serious action. They are licitly engaged in by basically powerless people—including clowns and children and other innocuous performers, who are allowed to make extreme emotional claims that may stir up strong personal responses but have no serious public importance. Women's fashion made use of outrage in such ways during the centuries of female powerlessness, and selective borrowing from men was one of its most effective motifs.

After the 1960s and before the present menswear mode, the masculine components in women's fashion still made girls look either excitingly shocking or touchingly pathetic. The various neat tuxedos made famous by Yves St. Laurent, for example, were intended to give a woman the look of a depraved youth, a sort of tempting Dorian Gray. "Annie Hall" clothes swamped a woman in oversized male garments, so that she looked at first like a small child being funny in adult gear, and then like a fragile girl wrapped in a strong man's coat, a combined emblem of bruised innocence and clownishness. These are both familiar "outrageous" devices culled from the theatrical past.

Long before modern fashion took it up, the conventionally outrageous theme of an attractive feminine woman in breeches was an invariably stimulating refinement in the long history of racy popular art, both for the stage and in print. The theme's most important erotic aim was not to make a woman actually seem to be a man—looking butch has never been generally attractive—but to make her assume the unsettling beauty that dwells in the sexual uncertainty of an adolescent boy. It is an obvious clever move for modern fashionable women to combine the old show business–like excitement of the suggestive trousered

female with the cultivated self-possession of early twentieth-century menswear—itself already a feminized male style. It suits, especially in the present disintegrated erotic climate, which has rendered the purer forms of outrageousness somewhat passé.

Such uses of men's clothes have nothing to do with an impulse toward androgyny but instead invoke all the old tension between the sexes; complete drag, whichever sex wears it, also insists on sexual polarity. Most drag for men veers toward the exaggerated accoutrements of the standard siren; on the current screen, *Tootsie* and *Yentl* both demonstrated how different and how divided the sexes are.

While the extreme phenomena are getting the attention, however, we are acting out quite another forbidden fantasy in our ordinary lives. The truly androgynous realm in present personal appearance is that of active sports clothing. The unprecedented appeal of running gear and gym clothes and all the other garb associated with strenuous physical effort seems to lie in its alternative mode of sexual expression: beyond the simple pleasures of physical fitness, and the right-minded satisfactions of banishing class difference that were first expressed in the blue-jeans revolution of the 1960s, this version of pastoral suggests a new erotic appeal in the perceived androgyny of childhood. The short shorts and other ingenuous bright playclothes in primary colors that now universally clothe bodies of all sizes, ages, and sexes give a startling kindergarten cast to everybody's public looks, especially in summer. So the excitement of androgynous appearance is once again revealed to be associated only with extreme youth—apparently the more extreme the better. Meanwhile, the natural androgyny of late middle age has no appeal. The tendency of male and female bodies to resemble each other in late maturity is still considered ridiculous and deplorable; sportswear on old women looks crisp and convenient, not sexually attractive. But the fresh, unfinished androgyny of the nursery is evidently a newly expanded arena for sexual fantasy.

In the increasingly common unisex look of ordinary clothing during the past decades, we see a submerged but unmistakable element of child-worship. This note has been struck a great distance away from the slick, expensive ambiguities of high fashion when it includes couture children's clothes aping the vagaries of current adult chic. Instead, it resonates in the everyday sexual ambiguity of rough duck or corduroy

pants, flannel shirts, T-shirts, zipped jackets, down jackets, colorful thick socks, shorts, sweaters, and sneakers—all the formerly traditional costume of the playground and the schoolyard, now amplified by profuse references to the gymnasium and the locker room. Any subway car or supermarket is full of people dressed this way. The guises for this fantasy have extended past playclothes to children's underwear, the little knitted shirts and briefs that everyone wears at the age of five. One ubiquitous magazine ad for such underclothes even showed a shirtee sliding up to expose an adult breast, emphasizing the sexiness of the fashion; but the breast was prudently canceled in publicly displayed versions.

Our erotic obsession with children has overt, easily deplored expressions in the media, where steamy twelve-year-old fashion models star in ads and twelve-year-old prostitutes figure in dramas and news stories. The high-fashion modes for children also have the flavor of forced eroticism. Child abuse and kiddy porn are now publicly discussed preoccupations, ventilated in the righteous spirit of reform; yet unconscious custom reflects the same concern with the sexual condition of childhood. Androgynous sportswear that was formerly the acceptable everyday dress only of children is now everyone's leisure costume: its new currency must have more than one meaning.

On the surface, of course, it invokes the straight appeal of the physical life, the rural life, perhaps even especially the taxing life of the dedicated athlete, which used to include sexual abstinence along with the chance of glory. The world may wish to look as if it were constantly in training to win or equipped to explore; but it is also less obviously longing for another condition—freedom from the strain of fully adult sexuality. These styles of clothing signal a retreat into the unfinished, undefined sexuality of childhood, which carries no difficult social or personal responsibilities.

From 1925 to 1965, four-year-old girls and boys could tumble in the sandbox in identical cotton overalls or knitted suits, innocently aping the clothes of skiers, railroadmen, or miners, while their moms wore dresses, hats, and stockings and their dads wore suits, hats, and ties—the modern dress of sexual maturity, also worn by Gable, Lombard, and all the young and glittering Hollywood company. Now the whole family wears sweat suits and overalls and goes bare-headed. Such gear is also designed to encourage the game of dressing up like all the non-amorous

and ultra-physical heroes of modern folklore—forest rangers and cow-boys, spacemen and frogmen, pilots and motorcyclists, migrant workers and terrorists—who are constantly urged on children. The great mas-querade party of the late 1960s ostensibly came to an end, but it gave ordinary grown-ups the irreversible right to wear fancy costumes for fun that was formerly a child's privilege. Traditional dress of the sepa-rate adult sexes is now reserved for public appearances, and in general it is now socially correct to express impatience with it. "Informal" is con-sidered the only proper style in middle-class social life; and for private leisure, when impulse governs choices, kids' clothes are the leading one. Apparently the erotic androgynous child is the new forbidden creature of unconscious fantasy, not only the infantile fashion model or rock star but the ordinary kid, who has exciting sexual potential hidden under its unsexed dress-up play clothes.

Fashions of the remote past dealt straightforwardly with the sexuality of children by dressing them like ordinary adults, suitably different according to sex. But in Romantic times, children were perceived to exist in a special condition much purer and closer to beneficent nature than their elders, and to require clothes that kept them visibly separate from the complex corruptions of adult society. The habit of putting children in fancy dress began then, too, especially boys. They were dressed as wee, chubby, harmless soldiers and sailors, or Turks and Romans, to emphasize their innocence by contrast. Children's clothes still differed according to sex—girls had sweet little chemises and sashes instead of fancy costumes—but their overriding flavor was one of art-lessness.

Later on, the Victorians overdid it, and overloaded their children with clothing, but it was still two-sexed and distinctively designed for them; finally, the enlightened twentieth century invented the use of mock sportswear for the wiggly little bodies of both boys and girls. Never-theless, the costumes now deemed suitable for children on display still tend toward the Victorian, with a good deal of nostalgic velvet and lace. Conversely, and in line with romantic views of women, certain femi-nine modes also used to feature infantine suggestions related to con-ventional little girl's costume: the last was the tiny baby dress worn with big shoes and big hair in the late 1960s, just before the eruption of the women's movement. Only since then has a whole generation of adults felt like dressing up in mock rough gear, like androgynous children at

play, to form a race of apparently presexual but unmistakably erotic beings.

Once again, very pointedly, the clothes are male. Our modern sense of artlessness seems to prefer the masculine brand; and when we dress our little boys and girls alike to blur their sexuality—or ourselves in imitation of them—that means we dress the girls like the boys, in the manifold costumes that celebrate nonsexual physical prowess. At leisure, both men and women prefer to suggest versions of Adam alone in Eden before he knew he had a sex, innocently wearing his primal sweat suit made only of native worth and honor.

The Romantic sense of the child as naturally privileged and instinctively good, like Adam, seems to stay with us. But we have lately added belief in a child's potential depravity, its capacity to perpetrate disgusting social and sexual evils that may go unpaid for and unpunished, given all children's categorical innocence. Perhaps our society abuses its children, and also aggressively dresses them in lipstick and sequins, for the same reason it imitates them—from a helpless envy of what they get away with. The everyday androgynous costume is the suit of diminished erotic responsibility and exemption from adult sexual risk. It clothes the child's license to make demands and receive gratification with no risk of dishonor—to be erotic, but to pose as unsexual and therefore unaccountable.

Even more forbidden and outrageous than the sexual child is its near-relation, the erotic angel. While the ordinary world is routinely dressing itself and its kids in unisex jeans, it is simultaneously conjuring up mercurial apparitions who offer an enchanting counterpoint to life's mundane transactions. In the rock-star form, they embody the thought that the other side, the opposing fantasy-face of the troublesome domestic child or adolescent, is an angelic visitor who needs to obey no earthly rules. Funny little E.T. was only one version. The type includes all those supremely compelling creatures who may glitter while they stomp and whirl and scream and hum, and never suffer the slightest humiliation.

A child, however ideologized, is always real and problematic, but an angel, however palpable, has a fine mythic remoteness. The opposing kind of androgyny invests him: he exists not before but beyond human sexual life, and he comes as a powerful messenger from spheres where there is no taking or giving in marriage, but where extreme kinds of joy are said to be infinite. Our rock-video beings cultivate the nonhuman

look of ultimate synthesis: they aim to transcend sexual conflict by becoming universally stimulating creatures fit for real existence only out of this world. Like fearsome angels, they profoundly excite, but they don't excite desire. We can't want them, even though they do make the air crackle with promise and menace. Their job is to bring the message and then leave, having somehow transformed the world. Michael Jackson reportedly leads a life both angelic and artificially childlike, and he makes his appearances in epiphanic style. David Bowie still appears to be the man who fell to earth, not someone born here; Grace Jones also seems to come from altogether elsewhere. Such idols function only in the sphere of unattainability. While they flourish they remain sojourners, leading lives of vivid otherness in what seems a sexual no-man's-land.

Angels were once imagined to be firmly male and uncompromisingly austere. The disturbing sensuality they acquired in the art of later centuries, like that of the luscious angel in Leonardo's *Virgin of the Rocks*, reads as a feminization—and one must conclude from this that adding feminine elements to male ones is what produces androgyny's most intense effects. Almost all our androgynous stars are males in feminized trim; their muscular and crop-haired female counterparts, such as Annie Lennox, are less numerous and have a more limited appeal. The meaning in all our androgyny both modish and ordinary still seems to be the same: the male is the primary sex, straightforward, simple, and active. He can be improved and embellished, however, and have and give a better time if he allows himself to be modified by the complexities of female influence.

The process does not work the other way. Elegant women in fashionable menswear expound the same thought, not its opposite: traditional jackets and trousers are austerely beautiful, but they are patently enhanced by high heels, flowing scarves, cosmetics, and earrings. Robert Mapplethorpe photographed Lisa Lyon the bodybuilder to show that her excessively developed muscles do not make her mannish but instead have been feminized to go with, not against, her flowered hats and lipstick. Ordinary women wearing men's active gear while wheeling strollers on the street or carrying bags across the parking lot are subduing and adapting harsh male dress to flexible female life and giving it some new scope.

Androgynous costume is essentially male costume that has been feminized, infantilized, or fantasticated—some kind of suit or jumpsuit, or

pants, shirt, and jacket, not some kind of dress, bodice and skirt, or gown. A hat may go with it, or perhaps a hood or bandanna, but not a coif or veil. A few real female skirts (not kilts or Greek evzone skirts) are very occasionally and sensationally tried out by highly visible men— daring designers, media performers and their imitators, fashion models and theirs—but all kinds of pants are worn by all kinds of women all the time. We can read the message: The male is the first sex, now at last prepared to consider the other one anew, with much fanfare. It is still a case of female sexuality enlightening the straight male world, still the arrival of Eve and all her subsequent business in and after the Garden being celebrated. The "androgynous" mode for both sexes suggests that the female has come on the scene to educate the male about the imaginative pleasures of sex, signified most publicly by the pleasures of adornment. About its difficulties, summed up by that glaringly absent round belly, she is naturally keeping quiet.

Meanwhile, the more glittering versions of modish androgyny continue to reflect what we adore in fantasy. It would seem that many of us feel the most erotic condition of all to be not that of any man or woman or child, or human being with two sexes, but that of a very young, effeminate male angel—a new version of art history's lascivious *putto*. Such a being may give and take a guiltless delight, wield limitless sexual power without sexual politics, feel all the pleasures of sex with none of the personal risks, never grow up, never get wise, and never be old. It is a futureless vision, undoubtedly appropriate to a nuclear age; but if any of us manage to survive, the soft round belly will surely again have its day.

In the meantime, at the end of the century and the millennium, the impulse toward a certain fusion in the habits of the sexes may have a more hopeful meaning. After a hundred years of underground struggle, trousers are no longer male dress sometimes worn by women: they have been so successfully feminized as to become authentic costume for both sexes, and have gained the authoritative bisexual status the gown once had in the early Middle Ages. This development is clearly not a quick trend but a true change, generations in the making. Male skirts have yet to prove themselves, though men have succeeded in making long-term capital out of the short-lived, now forgotten Peacock Revolution of the late 1960s. Whole new ranges of rich color, interesting pattern, texture,

and unusual cut have become generally acceptable in male dress since then, and so has a variety of jewelry. The sort of fashionable experiment once associated only with women has become a standard male option. Some new agreement between the sexes may actually be forming, signaled by these persistent visual projections; but just what that accord will turn out to be it is not safe to predict, nor whether it will continue to civilize us further or only perplex us more.

Transvestism

Early in her fat book, Marjorie Garber poses the question that clearly inspired it: "Why have cultural observers today been so preoccupied with cross-dressing? Why is it virtually impossible to pick up a news-paper or turn on the television or go to the movies without encoun-tering, in some guise, the question of sartorial gender bending?" She then offers some evidence: dozens of television programs about cross-dressing and transsexualism, movies based on the theme or referring to it in passing, a rise in transvestism and transsexuality as subjects of intense academic interest. "What are we to make," she wants to know, "of this evidence of what Freud might have called an 'overestimation' of cross-dressing, in high culture and low, as a phenomenon of our time?"

In case her theme doesn't strike everyone as quite so salient as she finds it, Garber, a professor of English at Harvard, makes it loom espe-cially large by stretching the term "the Transvestite," her main character, to mean the creature who comes into existence whenever any person of one sex is clad in any form or any part of the other sex's dress, in life or in art, for any length of time, and under any circumstance. Since something of this kind has been happening fairly often in the long his-tory of culture high and low, Garber can make much of her central character not just as a current preoccupation but as a recurrent presence. The figure can be both Cary Grant, momentarily wearing a frilly neg-

Review of *Vested Interests: Cross-Dressing and Cultural Anxiety* by Marjorie Garber (New York and London: Routledge, 1992) in *The New Republic,* August 31, 1992.

ligee in *Bringing Up Baby*, and Dr. James Barry, Inspector General of the Medical Department of the British Army, who, after serving for more than forty years as a physician and surgeon, was discovered to be a woman upon her death in 1865.

The term "cross-dressing," a recent word coined to replace "transvestism" with something more respectable-sounding and also to enlarge its scope, certainly does well for such a study as this, whose author wants to link together Boy George, Shakespeare's boy heroines, Madonna, Lawrence of Arabia, Jan Morris, Lucy Snow in Charlotte Brontë's *Villette*, Peter Pan, George Sand, and the 350 transvestite members of the Tiffany Club of Waltham, Massachusetts, "mostly male, middle class, and 90 percent married." A narrow new subject has been created out of various broad and ancient currents in civilized life, been isolated for theoretical scrutiny, sometimes despite the variegated textures from which its threads have been plucked. Since the subject involves sex at its most visible—that is, in clothes—the result is naturally sensational, and this large book, filled with startling lore and vivid anecdotes, carefully tries to make it even more so.

In behalf of her protagonist, Garber makes both a plea and a claim. The plea is that the transvestite be looked *at* directly, as a separate phenomenon, a complete figure, and not looked *through*, as a fleeting circumstance in an ordinary female or male existence. Her claim is that this distinct figure plays an important role in collective emotional life and, hence, in all cultural life—that it does creative work in direct proportion to its disturbing power. Garber finds her personage appearing in art as a signal of what she calls a "category crisis," a moment in a given "text" when established cultural boundaries of any kind, not only sexual, are crossed or put in doubt. The transvestite thus stands for, or "marks," any transgressive leap that creates culture itself, or as she puts it: "Transvestism is a space of possibility structuring and confounding culture, the disruptive element that intervenes, not just a category of male and female, but the crisis of category itself. The transvestite is the figure of and for that crisis, the uncanny supplement that marks the place of desire."

Garber reiterates to clarify her terms:

> By "category crisis" I mean a failure of definitional distinction, a borderline that becomes permeable, that permits of border crossing from one (apparently distinct) category to another:

black/white . . . noble/bourgeois . . . master/slave. The binarism male/female . . . is itself put in question or under erasure in transvestism, and a transvestite figure, or a transvestite mode, will always function as a sign of overdetermination—a mechanism of displacement from one blurred boundary to another.

She further specifies, a little more comprehensibly, the larger goal of her enterprise:

One of the most important aspects of cross-dressing is the way it offers a challenge to easy notions of binarity, putting into question the categories of "female" and "male" whether they are considered essential or constructed, biological or cultural. The current popularity of cross-dressing as a theme in art and criticism represents, I think, an undertheorized recognition of the necessary critique of binary thinking, whether particularized as male and female, black and white, yes and no, Republican and Democrat, self and other, or in any other way.

Garber clearly aims to "theorize" that "recognition" properly, although she does not explain why a "critique of binary thinking" is necessary. I wonder what she makes of night and day.

Garber sees a persistent uneasiness, the "cultural anxiety" of her subtitle, clouding our true perception of the transvestite's significance, and repeatedly causing us to explain away this powerful figure or otherwise make it disappear. Authors or screenwriters, for example, who have a character put on garments meant for the other sex will also make the effect provisional, whether it's absurdly comic or tactically necessary, and they will be sure to reverse it by the end of the story, so that the character's original sex is restored and the ephemeral "transvestite" seems never to have existed.

Garber makes this point through citing anxious responses to transvestism. This often means, however, that she must spot transvestism when it is posing as something else, or is suggested only in partial effects. Since she has isolated the figure of the transvestite on purpose to illustrate how desperate people are to preserve the boundaries that transvestism allegedly challenges, more has to be firmly called transvestism than firmly is, to support the idea of a general blindness to it and

denial of it, along with its importance. By the end of the book, she is calling the recurrence of the transvestite figure a return of the repressed.

Any time a woman in history, literature, or cinema has cut off her hair or momentarily put on pants, or a man has put on an apron, painted his face, or hidden his male identity in a kerchief and skirt, Garber sees this huge personage coming to life, pregnant with crisis, especially when a practical reason for the other-sex costume is insisted on. Her section called "The Transvestite's Progress" is laden with stories, true and fictional, of transvestites who say that they only did it to get the job, or to make an escape or a journey, or to survive in a hostile environment—to "make progress" of some kind. Garber sees all these explanations as denials, not just some of them. She also rejects the idea that a provisional transvestite condition might be a liberating, enlightening, or creative phase of a distinctly male or female life, or a comic moment with a delicate rather than a thundering resonance.

Linked to this claim for the power of the transvestite is another appeal, a brief for the right understanding of gay culture. She observes that the public has sometimes wrongly linked transvestite displays to homosexual life, and also that homosexuals have been ghettoized, marginalized, medicalized, sociologized, explained out of existence, or actively persecuted, even while that same public finds them perpetually fascinating. Her aim is also to sort out the truth of transvestism's role in gay life, restate its meaning, and reclaim its true cultural function for the whole of society.

Garber tells us a great deal about the details of life led in gay and lesbian gear of different sorts, and writes fully about the inside sentiments and politics of clothing among homosexuals, sometimes in somewhat impenetrable language. She describes the minutiae of the drag world, and she has a long section on transsexuals, the ultimate and irreversible transvestites. Homosexuality and transvestism are rightly shown to be separate though related subjects; but the two are obviously connected in the public mind, which wants to know not only how to tell male from female but how to tell straight from gay. Garber has wished to show at great length how small-minded and unworthy both those desires are, as is the desire to determine anyone's "real gender."

Belief in the illusory quality of "gender categories" is fundamental to this study. Such a belief seems natural enough in a time when the model for existence is a flickering screen, where apparently solid objects are

known to be made only of tiny soluble and quickly re-formable streaks of light, and perception follows the same pattern. The notion has easily arisen that there "is" nothing, and we "see" and "know" nothing; our vision and knowledge have been put together, just like existence itself, out of easily dispersed and reassembled bits. Maleness and femaleness are no exception. The current suspicion is that we may not only *wear* temporary masks, or even lifelong ones, but *are* masks, deceptively solid bits of concocted imagery easily reconcocted, like everything else. According to that notion, our bodies are certainly no more authentic than our clothes.

Thus for Garber, it is hopelessly wrong, or anyway lamentably insufficient, to go on stubbornly insisting that most people are either male or female, however they may dress or otherwise behave. If we look at the transvestite the way Garber wants us to, we must see something neither male nor female but the presence of a theoretical "third." Garber says: "The third is that which questions binary thinking and introduces crisis . . . a mode of articulation, a way of describing a space of possibility. Three puts in question the idea of one: of identity, self-sufficiency, self-knowledge." Later on: "The transvestite makes culture possible . . . There can be no culture without the transvestite because the transvestite marks the entrance into the Symbolic."

Although Garber goes devotedly to the movies and concentrates a great deal of her thought on aspects of the theater, she apparently looks carefully at very few pictures, and her illustrations are offered with insulting disrespect for the actual works of art. Since there is no list of them and they are unnumbered, with no numerical reference to them in the text and no reference to the text in their captions, it's very hard to make use of them. She even describes some of them inaccurately. Although her whole subject is founded on the theme of dress and its manifold power over the inner and outer eye, she seems to flout the actual character and history of dress by being careless of its visual representation, where its meaning has been so consistently expounded.

This study seems to be based on its own kind of blindness. Throughout her book Garber holds to a theoretical apparatus that sheds a rather unenlightening glare, devoid of color, texture, or any trace of warmth, despite her very jokey prose. In her formulations about transvestism, Western culture seems deprived of its richly uneven and messy continuity, and sexuality seems to have lost its connection with other variable layers of human experience, most especially with visual memory.

The most noticeable quality of this big book is that its dense web was spun by a literary scholar and theorist, by someone who reads rather than sees, sees mainly to read, and prefers decoding to either reading or seeing.

To study transvestism, I should have thought, you would need a fairly subtle understanding of the flux of fashion through time. Since the Middle Ages, Western fashion has dealt profoundly with sex, creating a fluid system of references and allusions that preserves and recycles much more than it discards or adopts. The changing look of clothes, famous for reflecting the spirit of the moment, is nevertheless built on its own history, most of it dealing with aspects of sexuality. Surely transvestism means something only against this background, which is to say, against a larger background of visual expression. Fashion does not co-opt transvestism from time to time, as Garber suggests; it has always contained it, indeed has largely invented it for the modern world.

Garber's central notion, moreover, that male and female sartorial exchange is an image of crisis, doesn't work very well for actual vestimentary expressions in history. Rather than first-order binary categories being perpetually destabilized by the "realm of the Symbolic," I think that the model of a spectrum or a palimpsest is more fitting for "cross-dressing," as I believe it also is for actual sexuality. Male and female clothing has certainly been discussed, described, prescribed, and proscribed in fairly rigid and anxious terms, in laws, rules, sermons, and memoranda, in the Old Testament and the New, in letters, satires, and various fictions, some of which Garber quotes. But in wear, it has been more complex, and has behaved much more imaginatively, than any writings reveal.

This truth shows up in pictures, where a stylistic unity, reflecting current visual tolerance, knits together the jarring elements that might appear in whatever current bargain is being struck between male and female bodies and their clothes. This unity is ignored by writers concentrating on what Garber calls "dissonance." Vested interests have been more discernible in polemical utterances about clothes than on the actual backs of men and women; but it is in such writing, of course, that evidence of "cultural anxiety" can easily be found. In dress itself, contradictory suggestions on several different levels about sexual boldness, common taste, and personal quirk can be made at one time, some stronger than others. What gets written about is the one thing that

pleases or offends, and the writing is what indicates crisis, not the clothes themselves. Everything else about clothes fails to get described or perhaps even noticed, including the harmonizing principle, the *Gestalt*. Much that Garber says about what she calls "transvestite effects" leaves that out, too.

Her examples are accompanied by a great amount of extra lore that thickens the book and captivates the reader without necessarily supporting the theory, so that the cumulative impact comes more from the anecdotes themselves than from their supportive function. Their purpose seems to be an exercise in consciousness-raising, and as such may be welcome; but meanwhile, tendentious examples slide by on rhetorical skates. One of these is the figure of Captain Hook in *Peter Pan*, the pirate villain whose seventeenth-century curls and lace collar Garber wants us to see as transvestoid gear. But Hook is, in fact, a reminder that, in clothing, references to the other sex are perpetually complicated by independent reference to other epochs. Since Garber omits this dimension of historical allusion in dress, she misses Captain Hook as a reference to King Charles II, a notorious womanizer and not a transvestish figure at all. Hook's is a case of what I would call plain Historical Drag.

Garber's book overflows with the fascinating life stories of individual transvestites from many different periods in the past, but she has omitted most of the visual context from their different historical moments. Before the late eighteenth century, for example, elegant people of both sexes wore scent, rouge, high heels, and wigs, along with lace and brocade, and artificial arrangements to enhance physical shape. Male transvestites such as the famous Chevalier d'Eon looked no more bedizened in their female clothes than respectable gentlemen did in their male ones. Transvestism did not lurk disturbingly in small surface matters, as it has come to do since, and people did not worry about the sexuality of men in lace, spangles, and embroidery. There was consequently less excitement about actual transvestism, especially for men.

Since the Middle Ages, European fashion, like clothes all over the world, has differentiated between the sexes but even more sharply among the classes. Though differing in shape, the dress of men and women was made out of the same stuff, was constructed according to the same principles and by the same craftsmen, and had the same degree of richness or plainness, which differed according to rank and region,

not sex. But beginning in the late seventeenth century and culminating in the late eighteenth, the clothing of elegant men and women increasingly came to be divided. With the ascendancy of the Romantic movement, elegant feminine dress had become fantasized and theatricalized, literary and legendary, full of historical and mythological allusion; and it was made by female dressmakers and milliners out of a wholly feminine repertoire of delicate materials and embellishments following rules of design that concentrated on variable surface effects.

Men's tailoring, still in the hands of male craftsmen, continued to evolve, as it has always done, but it began to change in the direction of simplification, concentrating less on the ornamental breaking up of surface and more on the subtle relations of basic form, using matte textures in simple planes, as if to imitate fundamental natural structure and morphology, the character of earth and rock, the way practical architecture did. Women preferred, by contrast, to fill the role of fanciful statuary and ornamental water, of leaves and clouds, of shifting visions and dreams. "Natural man" was thus fully created in clothes by the end of the eighteenth century, along with "fictional woman," or rather, Woman, as she came to be styled. These changes obviously had a great effect on general notions of theater, and of the expressive gear proper to the two sexes in modern life and art. If men became solid natural creatures with integrity, women came to represent the malleable and changeable aspects of nature.

Garber has declined to look at the dramatic continuum of fashion history and talks of fashion mainly as something recent designers think up; so she has missed the way women's clothes for the entire modern period have engaged in every sort of transvestism, not just sexual. It's true that modern women's clothes have most often imitated male elements, but that has meant male dress of all kinds, classes, occupations, and historical periods, not just current male counterparts. Female dress has also imitated all sorts of animals, machines, extraterrestrials, bric-a-brac, furniture, ships, plants, and little children—and all sorts of foreigners, performers, and historical characters of both sexes. During those same two hundred years, male fashion has made no such moves, sticking firmly to a first-order, evolutionary, "natural" development. I would emphasize that the developments in fashion I have described were not *reflections* of the intellectual, economic, and political developments in history but tended to precede them.

The large topic Garber repeatedly considers is that of the alleged "construction" of femininity through the agglomeration of artificial parts—makeup, coiffure, and dress accessories, propped by corseting, falsies, and high heels. Modern male-to-female transvestism creates its illusions by these means, forever suggesting, says Garber, that a real woman is actually made of nothing else, and prompting some feminists to say that women have been female impersonators for years. "Construction," however, has always been the whole point of fashion for both sexes. Dress works as any visual art does, drawing on unconscious fantasy to create material projections that sustain imaginative health. The very function of clothing is figurative and representational; the plain scheme of modern men's clothes is no less the invention of fantasy than the complexities of the women's version. But the opposing sexual imagery displayed by male and female dress in the last two centuries has indicated that only women should actually *seem* invented or, perhaps, conjured like so many apparitions. So we have arrived at simple bodily envelopes for men and the showy accoutrements for women that modern male transvestites so energetically seize upon.

Complete drag even further suggests—with the help of reference to the stylized Japanese theater, where all the exquisitely garnished women are really male actors—that only men can be perfect females. Dustin Hoffman in *Tootsie* continued that theme, brilliantly adumbrated by Jack Lemmon's Daphne ("Nobody's perfect!") in *Some Like It Hot*. The implication is that men are truly imaginative and universal, both natural and naturally creative, and that the scope of their creativity includes Woman, who can be perfect only if men invent her, even out of their own living selves.

Modern women seeking to escape from such conceptions of femininity have understandably sought the opposing look of first-order existence by adopting (not artfully imitating) male dress, which has seemed to stand for Not-Fashion, for Integrity, for Nature—much more for those things, indeed, than for masculine sexuality. Women have consequently failed to look very kinkily sexy in most modern men's clothes, especially not in the masculine informal wear—pants and shirts, boots and sneakers, sweaters and jackets—that now are staples of their wardrobes. Only truly fetishistic male gear (the necktie, for example) has given a spicy, forbidden look to modern woman's male borrowings. For a large portion of the modern public, transvestism seems to go only

one way. It does not mean a woman in a tuxedo: that's not transvestism, that's just fashion or show business. Transvestism means a man in elaborate drag, an imitation high-style sexy woman with a real penis under the sequins; and at this phenomenon people obviously love to look, to stare and marvel and feel the intense power of fetishism, and the force of a redoubled erotic appeal.

There is a tradition in the history of feminine fashion that does mock male gear in the same erotic spirit, but it has different effects. Formal male evening dress, the white tie and tails famously worn from time to time by notable female stage and screen women, is a costume now firmly associated with both sexual license and cultural decadence. Marlene Dietrich and Josephine Baker wore it; Julie Andrews, imitating them, wore it; Madonna, always obliged to look licentious in various ways, sometimes wears it. Now waitresses wear it, too, and a host of mediocre female performers. I propose that this outfit, a centerpiece for Garber's idea of transvestism, is actually entirely feminine. It has been seen so often as a suit suitable for sexually daring women that it doesn't suggest real transvestism at all; and the actual men now wearing it are visible mostly in symphony orchestras. Even in the tuxedo versions, it's no longer generally on view. The white-tie-and-tails version on women therefore has much the same flavor as Historical Drag, with the additional familiar one of female sexuality in its more challenging styles, which have so often been offered in bits of male gear.

Ever since Joan of Arc in the fifteenth century, women adopting masculine dress or parts of it have arranged to look extra erotic by implying that the scope of their own sexual fantasies is larger than the ideas expressed by standard feminine attire, whatever those have been. For many centuries women's clothes combined a great deal of traditional modesty in the form of long gowns and veiled hair, with a few grams of allure in the form of restrained décolletage, a mixture reflecting the view that women don't really have sexual fantasies; they cannily lend themselves to those that men have about them (we may remember that men made the clothes for both sexes until 1675).

When Joan the Maid adopted her knightly costume, masculine fashion had recently developed an extremely erotic style for men that showed the legs and modeled the figure, permitted flamboyant hats, remarkable shoes, and expressive coiffures. These vigorous reflections of

sexual fantasy were not believed to be an appropriate or naturally expressive mode for women, and certainly not for virgin Joan; but ever since then, whatever the form of general fashion, elegant women have naturally enjoyed laying claim to some or all of the male visual image, now and then letting it be known that demure allure is not the only thing on their minds. Prostitutes and fast court ladies especially went in for it. Dietrich's modern male evening dress of 1930 had the same thrilling look of libertine dandyism, something not possible in the soft, clinging feminine modes of the moment, even though they were short, free-moving, and easy-fitting; it was the look of the erotic imagination that initiates sexual experiment, which can be aggressive and even cruel, not the look of masculinity itself but of an erotically enterprising femininity.

A 1924 portrait by Romaine Brooks of the lesbian Una, Lady Trow-bridge, insufficiently described by Garber as showing her "in male attire," is another example of creative female adaptation. With her tailored jacket and striped pants (the picture cuts her off at the hips; she might well be wearing a skirt), she wears an old-fashioned stock and collar obsolete by that date, thus availing herself of Historical Drag rather than current male usage, and she has a feminine hairstyle and earrings along with her male monocle. She looks thrilling, even menacing with her two dogs as accessories, but she does not look like a man.

Garber's favorite "crossover" theme, the idea of "crisis" in any such display, seems wrong in view of the way dress really works. Despite the sumptuary laws, forbidden clothes are never completely forbidden under the unwritten laws of Western dress, which since the beginning of fashion have questioned even the very forming of boundaries. To focus on a theory of anxiety, Garber is setting up a stronger tension than is really there. All the flashing signs tend to obscure the landscape and form their own exciting pattern.

Not only has modern women's fashion since 1800 seized on the privilege of ignoring the boundaries of sex, history, species, age, class, and even material category, it has also retained the exclusive right to gaudy embellishment, a habit given up by men once they agreed to be "natural." Now most men can wear lavish trimmings and makeup only on the stage and screen, unless they are serious transvestites; and one com-

ponent in the male impulse toward transvestism can't help being the pure desire to benefit from the beauty of brilliant adornment, still comprehensively offered only by feminine dress.

I believe that some of the spectacular trappings Garber sees as transvestite effects in the clothes of male performers such as Elvis Presley, or the even more flamboyant Liberace and Michael Jackson, do not primarily work as the disturbing feminizations or gender confusions which she "reads" them as being. All these performers insist on trousers and masculine hair, too, including the uniquely male sideburns; and they borrow the details of their glorious plumage not from women but from the lost heritage of the glorious masculine past—the huge pearl-laden sleeves, the splendid embroidered coats with diamond buttons, the plumed hats, the lace frills, the sparkling or gold-braided uniforms in vivid colors, and the sweeping, fur-lined velvet capes sported by the powerful males of centuries ago. Liberace and the rock stars recall the truth that display was once a serious option for men, not a questionable feminine wile, not a crude show of wealth, but something truly magnificent, meant to show a link with divinity.

The beauty of serious finery is its capacity to render the wearer dazzling whatever sexual modulations are at work; it is a primary instrument of attraction. To focus the rays of God's sunlight on the royal person and rightly illuminate his kingship, diamonds and cloth of silver were essential. The descriptions and pictures of King Henry VIII and King Francis I, both of them unappealingly fat-faced, paunchy monarchs, show how they were made into fabulous, compelling icons by such means. Now rhinestones and sequins will do the trick under a follow-spot. But Liberace, Elvis, and Michael Jackson invented their images in a world hostile to male display, and have had to support their masculine glitter with extra erotic charge carried by the flavor of narcissism, now most keenly expressed in personal qualities that need not owe anything to ornamental dress.

In this sexually and morally nervous country, often called puritanical, ordinary men from the beginning of independent American history obviously had a hard time righteously forcing themselves to give up finery, firmly extinguishing the impulse to shine, forever telling themselves that all such effects are trivial, artificial, sinful, characteristically feminine or unspeakably foreign and somehow dishonorable, associated either

with the aristocratic tyranny of the Old World or with primitive bar-barism. Ordinary Americans still can't stomach much of it for them-selves, although times are changing, partly under the influence of rock performers, indeed of drag performers, and especially of women. Male earrings and long hair are back to stay, now often worn with business suits.

But in comic movies of the 1940s and 1950s, such as *A Connecticut Yankee in King Arthur's Court* or *Kiss Me Kate*, much joking about homo-sexuality had to accompany the temporary appearance of the actors in beautiful Renaissance doublets—heaven forbid they should simply like wearing them. And Garber shows that in anxious America, much jok-ing about homosexuality naturally had to accompany Liberace's gor-geous stage appearances. He was in fact gay, but he seems to have rightly wished to dissociate that fact from his enormous glamour. He avowedly loved wearing his magnificent garments, and he looked beautiful in them, rather like Kings Henry and Francis.

But Garber wants Liberace for her "category crisis" theory; what she sees as his transvestism marks the crossover between classical and popu-lar music. She wants Jackson and Elvis as transvestites for the same pur-pose, to mark the one between black and white music. But I think the independent power of glitter has had a lot to do with the appeal of these performers, a magic working separately from the strong erotic charge of their personalities and their music. Placido Domingo and Luciano Pavarotti, on the other hand, play the parts of actual Renaissance princes and baroque noblemen, dressed in the great sumptuous male trappings of the past that match their great living male voices, with no suggestions of transvestism whatsoever, since the original clothes had none. The old "constructed," nonnatural character of the straight male of the past is wonderfully explicit in operatic dress, as it is in much cinematic dress for serious historical epics. Errol Flynn and Charlton Heston have taken full advantage of it.

In her many discussions of theater as a transvestite arena, Garber seems to have missed a striking 1970s example of modern female sarto-rial flexibility: Joan Plowright playing Portia in Jonathan Miller's pro-duction of *The Merchant of Venice*, set in the 1880s, with the men in frock coats (including Laurence Olivier as Shylock, whom Garber does men-tion, in her section on the feminized Jew). Between her early scenes

played in corset, curls, and bustle with train, and her courtroom scene played in legal robes and wig, Plowright plays the short complicitous scene with Nerissa in perfect drag, wearing a Victorian gentleman's tweed suit with a neat cravat, homburg on clipped head, umbrella and Gladstone bag in gloved hand, the image of a young barrister coming to town from his country house. Male costume in this scene is not at all necessary to the plot; Portia is alone with her maid. But it was a stunning way to establish Portia for the audience as finally delivered from the feminine prison of her father's infernal caskets, having convinced *herself* that right now she is a creative and resourceful young man, fully able to be a Daniel come to judgment and to save her lover's life. Garber would say she was transformed into a creative *transvestite* to do the job; and that the robe and wig of her triumphant scene were still too feminized to make the point. Jonathan Miller seems to have got the point long before Garber made it.

On the modern realistic stage, however, only women still seem to be such perfectly flexible stage presences, able to shift sexes as most male actors do not. The perfect youth or boy may, indeed, be played by a woman, as in the case of Peter Pan—Garber has a long essay on why; and we are now convinced that the complete actress may certainly play Prospero or Lear as well as Ophelia or Cordelia, just as Sarah Bernhardt played Hamlet as well as Lady Macbeth. Women can be boys or sprites or heroes at will; but despite the great rage for drag performers of all sorts these days, we still do not hear of a serious production of Ibsen, Shaw, or Shakespeare with Dustin Hoffman playing Hedda Gabler, Candida, or Cleopatra.

With the modern feminization of all dress-ups, everything obviously became very complicated, especially on the stage. Garber doesn't point out, for example, that the transvestite women in traditional stage "breeches" parts are usually wearing male garb from the eighteenth century and before, most of which now registers much more strongly as fancy-historical than as masculine. In fact, on modern female performers, it seems more feminine than not, since women's clothing has been borrowing so many bits of historical male dress for so long. The Shakespearean female characters, all originally played by boys, often play boys themselves; but the women who now play them in doublet and hose look entirely female throughout. There is nothing transvestite about the effect, and nothing disturbing or threatening to boundaries. Even the

woman playing Peter Pan wears a sort of "Ye Olde" Robin Hood out-fit, not real boys' clothes.

Yet the idea that an artificial femininity is created by assuming artificial elements of dress is very current, masking the fact that all adult humanity is created that way. People submit to joining the human race by putting on awkward, ridiculous, and demanding clothes, just like Adam and Eve; and of course, our first parents' garments were exactly alike. When it comes to sexual awareness, we have really been trans-vested from the start. It's plain that male and female dress have the same function: to create a fictional body that is the right image of a state of mind and that perpetually tells its story to its owner, even when only God is present. Getting dressed is something done to satisfy an inward desire to be rightly *completed* by clothes. It is certainly pertinent to the issue of transvestism, since people are fully aware that clothes create selves, rather than sitting on top of them.

A person wearing some of the clothes of the other sex immediately suggests a person for whom sexuality is of the first importance, someone who feels complete (at least for this or that occasion) in clothes that draw attention to sex in general and all its possibilities, not just to personal attractions. This alarms many people, since sex is so alarming. Garber describes the fear, expressed by certain seventeenth-century Puritans, that allowing boys to dress up as women for the stage would arouse their sexual feelings and even perniciously turn them into girls; perhaps make them feel feminine desires of other kinds. The same kind of idea persists in ordinary modern life, although the understanding that the way we dress creates us goes well beyond sex. The whole subject is alarming to people who think it is right and good to deny, or at least to despise, the creative power of clothes.

Clothes seek their own ways to contradict what they mainly purport to mean, even while illuminating and elaborating it. The body blends with the other components, often lending its parts to a variety of con-flicting visual transformations. Clothes can suggest the felon in the churchgoer, or the other way, just as much as the female in the male, or the other way. Clothing has shown it can complete a person as a ghost inside a machine, or as an engine behind a ghost, as the soul inside a beast, or as a beast animating a sylph. All these effects are essentially erotic, since the body is their first element, even if sexuality is not their theme.

In this realm, "the place of desire" is everywhere. The figure of the tranvestite does not need to return; it never leaves. Clothes show how a sense of sexual interchangeability and fluidity is deeply ingrained in our civilization, just like the sense of other permutations. The tensions evoked in dress are serious rather than urgent, the product of long accretions rather than strategic deployments of conflicting force. In Garber's compendium of theories and stories of transvestism, I don't find the one from Ovid about Zeus dressing in the body of Diana, the better to seduce her nymph Callisto; nor any other tales from that ancient master of love and metamorphosis. And no mention of Tiresias, our old prophet of these imponderables, whose sage presence I sorely miss in these pages.

Modern Arts: Film

Chaplin

By the end of 1919, when he was thirty, Charlie Chaplin had already been internationally recognized as a unique cultural event—rather like Hitler, as Kenneth Lynn several times points out in his biography. Many other unique phenomena of the period, such as George Bernard Shaw and Nijinsky, soon hastened to welcome him into their company; and Hitler himself may well have trimmed his mustache to match Chaplin's, as Proust is also said to have done.

Chaplin rose to such high-level international fame in just five years, from appearing in vulgar comic film shorts for Mack Sennett in 1914 to making his own personal brand of tragicomic movie in his own studio as a co-founder and co-owner of United Artists. In the spring of 1915, while working for Essanay Film Manufacturing, Chaplin crystallized his film image for all time in a short called *The Tramp*, to the degree that later on, even if he played the part of a prospector, a waiter, a janitor, a pawnbroker's assistant, or a fireman, the role was plainly only a disguise for the essential tramp character he really was, the true Charlie the world delighted to honor. His film costumes might vary according to circumstance, but some version of the too-tight coat, too-loose pants, too-big shoes, bowler hat, and cane were the gear the Charlie personage always assumed when he was being himself, uncoerced by

Review of *Charlie Chaplin: His Life and Times* by Kenneth S. Lynn (New York: Simon and Schuster, 1997) in *The New Republic*, June 9, 1997.

the provisional plot. With these accoutrements went the subtle semi-clown makeup that never concealed but only emphasized the play of his face.

The image-fixing year 1915 was the first in which he was hailed as a "genius"; but by 1919, working completely on his own, he was commanding respect as an "artist." Chaplin has been called both ever since, but without ever losing the further attribute of being a sort of cultural marvel, not your usual brand of artistic genius. By 1925, he was the most famous man in the whole world, known by name and face to more people than were heads of state, notorious criminals, or other celebrated performers.

And that, of course, was because of the movies—the silent movies, which were instantly affecting and intelligible everywhere. Chaplin's rise mirrored their rise, too, the tightening of their complicated grip on public feelings at every level where visual art operates. Institutional distrust and dislike of Chaplin were also connected to a distrust of cinema itself, its possibilities for uncontrollable indecency, for unlimited propaganda, for unaccountable emotional sway over millions. The force in movies and the amount of money to be made from them were alike staggering to the American public; and at the same time the quality and variety of artistry possible to them was a growing revelation to aesthetic understanding all over the world. Chaplin seemed to embody it all at once—insouciance, vulgarity, neediness, laughter and tears, the link between heartbreak and huge revenues.

Thomas Mann and many other writers (Edmund Wilson, John Peale Bishop, Somerset Maugham, H. G. Wells), along with many great dancers and musicians and the odd scholar and scientist, were entranced by both Chaplin and his films, as they were not by most other film people and theirs. The same was true of the society ladies and gentlemen and political stars who took him up on both sides of the Atlantic. Chaplin loved all forms of high life, and felt he belonged in them, as many movie people did not. The Tramp character obviously did, too, with his tattered courtesy and refined sensibilities forever intact in a universe of squalor and violence.

Despite general adulation from creative folk, painters were noticeably not numerous among Chaplin's admirers. Picasso, for one, had no use for Chaplin's blend of sentimental pathos and crude comedy, though he is reported to have said it might appeal to Chagall. In fact, although

Chaplin was the acknowledged genius of a potent new visual art, the strictly pictorial capacities of the medium did not interest him. Chaplin is known for resisting the formal possibilities of cinema that Keaton was to explore, and he caused much pain to later associates with his obtuseness about camera technique. Chaplin wanted the camera for personal drama only, as if cinema were a pure extension of the stage and had no heritage in the history of art. Lynn himself is clearly uninterested in what might be called the illustrated history of America, the paintings, prints, and engravings that perpetually created American visual expectations and enabled the movies from the beginning.

Some of Chaplin's personal success among so many people with serious pretensions was undoubtedly due to the clever fusion of the appealing screen character with the man himself, which Chaplin seems to have encouraged by displaying his acting techniques in social situations. He offered versions of the clowning, flirting, mimicking, dancing, extemporizing, and improvising that the beloved Tramp did, to keep the company in stitches and earn their exhausted gratitude, to play the true court fool with absolute license. "Charming" was the universal society word for him; and in the years of his rise, "modest" and "unassuming" were also words the reporters who interviewed him used about him, along with "hardworking"—the whole Horatio Alger list, in keeping with his well-known Humble Origins (vaguely Dickensian) and his Successful Career, the rags-to-riches tale that needs a good boy for its hero. Later in life Chaplin could no longer be called modest, but he repeatedly proved that active narcissism is immensely appealing.

Chaplin's international social rise was made possible by another great cultural change manifest in the breakdown of the old social categories after the First World War—the same breakdown that facilitated the career of Gabrielle Chanel during the same period. In the century just past, elegant society did not dine with comedians or dressmakers or violinists, no matter how famous, or invite them to weekends at country houses. But in the first third of the twentieth century, celebrities of all kinds began to mingle on terms of unprecedented equality in a fluid mélange then called Café Society. The couturier or the film comedian, if they were sufficiently "charming," could now sit around the swimming pool or play tennis or dine in evening dress with the Duchess and the Prince, along with an assortment of financiers and artists, promising

politicians and performers, not all of them of known pedigree or exactly honest. Hollywood became a center of just such heady new mixtures, but they were found in many capital cities, and they were as exciting for the participants as movies were for the world.

The young Chaplin clearly worked hard at being constantly loved by any audience, journalists included, displaying his most acceptable self both on and off the screen, determined to seduce and to captivate everybody. Yet companions of his early years in show business before he was a star often found him somber, irritable, and inclined to solitude. Since early boyhood he had been trained to sell himself to audiences, not to be genial to comrades. Most of his unrelenting work on films went into perfecting his own irresistible screen appearances in every detail: the bodily comportment and facial gestures, the perfect imitations both delicate and exaggerated of conventional behavior, the pathos, the irreverence, the appealing discomfiture, the dance, the walk, above all the timing. Once he became a public figure, all this could serve as well in off-screen life, and many came to feel that he was never not acting. So Chaplin had formidable inward demons to contend with, like other creative souls who arrange their public behavior as a continuous performance.

Kenneth Lynn's biography concentrates on the man in his era rather than in his art, except where the art illuminates both man and epoch. He's most interested in the dark side, those very demons that gave Chaplin his well-known divided nature, his personal behavior both adorable and horrible, his movies both tacky and sublime. Apart from the objective greatness of Chaplin's films, which was largely the product of his carefully applied artistry, their most insistent power over people's feelings came from the uncontrolled operation of Chaplin's own unconscious, of which Lynn wants to discover the secrets, if only to fit him into the collective American psyche during its own Modern Times.

He gives an absorbing explanation of late-nineteenth-century America's extreme loathing for tramps, for example, and tells how that feeling about them later changed from fear and disgust to a romantic sort of envy and affection. With the help of quotations from Stallybrass and White's *The Politics and Poetics of Transgression*, Lynn reflects on how society marks out and expels certain things as Low, or Other, which nevertheless "return as the object of nostalgia and fascination." The stage, the slum, and the savage are some other examples.

Tramps had become an ugly national phenomenon during the five years of economic depression after the Panic of 1873, when thousands of homeless men wandered over the country begging, stealing, vandalizing, and worse. They came to be inveighed against as "incorrigible" and "depraved," truly base and hateful outcasts. By the 1890s, the worst depression of the nineteenth century had set in and there were many more of them, more fear, and the crystallized belief that the Tramp was a generic figure of horror. He was used as a terrifying villain by sensational playwrights and by D. W. Griffith in a 1909 film.

But a countercurrent of sympathy also served to render him comic after the turn of the century, so that tramps were also appearing as characters in printed cartoons and vaudeville skits; Jack London had added an element of romance to the tramp image with lyrical reminiscences of his own spell of vagrancy during the 1890s. By 1912, prosperity had in fact begun to alleviate the real problem. In that year, Chaplin was already on his second tour in America with a London acting troupe, absorbing the conflicting emotional flavors then prevalent about tramps. In 1914, already at work in the United States, he would have learned that a large number of tramps had apparently been radicalized by political agitators and were creating violent disturbances, among them a bombing in a church.

Chaplin's 1915 screen persona made him seem the tramps' advocate in a world openly hostile to them. Was this, asks Lynn, the beginning of his interest in championing the "wretched of the earth"? Chaplin's Tramp was eventually caught up in a general shift of feeling, and helped to tease out a secret American tenderness for the tramp's benign and superior form of lawlessness, the freedom from tight shoes and tight morals that also fitted him for generous gestures and Robin Hood–like adventures, even if they came comically or pathetically to ruin and exposed him as forever vulnerable.

Lynn is aware that there have already been hundreds of books on Chaplin, and he obviously felt there were some things he need not do. His book has neither a chronology nor a filmography, since those are to be found in David Robinson's biography of 1985. Nor has Lynn given us a separate bibliography; the sources are incorporated into the notes, so we can't check quickly on whether he's used a particular one, since they're not indexed either. These, however, are small technical irritations. The point is that Lynn is not aiming to be definitive but to fit his

own book into the mosaic of Chaplin studies as an idiosyncratic critical contribution, especially with respect to tone and emphasis.

The tone is quite censorious, no doubt to counteract others' tendency to canonize Chaplin. The primary emphasis is psychological, however, and it allows for sympathy; and the remaining emphasis is sociological and literary. Lynn steadily relies on works of literature and cultural criticism contemporary with Chaplin's early career and from the preceding generation or two, in an effort to gauge America's sense of its own soul during the time it was preparing for the Chaplin phenomenon.

One aspect of this he finds manifest in the numerous and very popular female impersonators on the vaudeville stage since the 1880s. This situation underlay Chaplin's great triumph with drag acting in his early comedies, notably *A Woman* of 1915, a film so erotically campy that it was banned in Sweden. Lynn finds background for all this—and for Chaplin's swift rise to fame insofar as it was due to his strong and ambiguous sexual appeal—in Walter Lippmann's provocatively entitled book *Drift and Mastery*. This work appeared in 1914 and deals with what the author saw as the breakdown, already occurring before 1910, of traditional relations between men and women. Lippmann is quoted as saying: "Man's sexual nature is chaotic through the immense change that has come into the relations of parent and child, husband and wife. Those changes distract him so deeply that the more 'advanced' he is, the more he flounders in the bogs of his own soul." And later, about the period after 1910, that America "was being blown hither and thither like litter before the wind." Lots of drift, not much mastery. On the subject of sexual confusion, Lynn himself notes, as others have done, the direct effect of stage female impersonators on the stage style of Mae West; her career in show business began about the same time Chaplin began in films.

Lynn is not only a student of American mores and attitudes but also a history professor. He has allowed himself to thicken the book's historical dimension with digressive accounts of the lives and personalities of many subsidiary characters on the international scene of Chaplin's career, so that all told, there's much more here than we need. Still, it is good to learn how cruel and brutal the American comic theater had been for generations, and its audience, too. The British comic stage of Chaplin's boyhood, on the other hand, had been loved and patronized by upper-class gentlemen and celebrated writers and painters as well as the working class, and its themes were often artfully comic expressions

of working-class discontent. Sennett's comic films with Chaplin simply continued with the normal American brutality and nastiness to suit a crude public, until the comic film medium, with immigrant Charlie as chief exponent, was enriched and leavened with real feeling and finesse without sacrificing its potent old grossness. And then the American writers and gentlemen paid attention.

Lynn's earlier biographical books have been about William Dean Howells, Mark Twain, and Ernest Hemingway (the last two also wearing jovial masks to hide dark souls), and he repeatedly refers to Chaplin's work as "poetry," meaning, presumably, American poetry. He seems to imply that Chaplin's *oeuvre* has a natural family relationship to the works not only of Walt Whitman and Herman Melville but also undoubtedly of Bret Harte and James Whitcomb Riley, of Edwin Markham and Ogden Nash. Lynn makes no reference to these, but he's patently entranced by Chaplin as an example of the variability and waywardness of American taste and American style, its volatile combinations of original madness and serious hilarity, extreme crudity and rare delicacy, pretentious nonsense and hardness of head. He does mention Hart Crane, whose "Chaplinesque" is quoted in its entirety.

Yet Chaplin was not an American. He wasn't born here, he didn't die here, he was never a citizen, and he lived in Switzerland for the last twenty-five years of his life, more than a third of his long career. He underwent his entire education and formation in London, and the unalterable core of his art was the tradition of English music-hall pantomime, along with the deep memories of his English music-hall mother and his own early work on the English stage. But for his "poetry," of course, this all made him more American than being a native ever could. He's an American artist the way George Balanchine is, a transplanted talent more robust and inventive here than he could ever have been back home, and much, much more successful. Chaplin's British accent had no existence, of course, in silent film. His movies made him famous as an entirely American comedian, with no perceived links to British sources.

The American professional scene on which Chaplin arrived and flourished soon included the novel requirement that movie stars be respectable. The theater had long been accepted as a raffish universe at every level, never a career for the virtuous. The demanding schedule that made normal life impossible, the backstage world and long tours

that fostered questionable intimacies, the commitment to constant falsity, the emotional strain and excess—everything about stage life traditionally led to occasions for sin, and people expected stage actors,
serious or comic, to be amoral. It was, however, very important not to
allow the huge American movie public to expect amorality from movie
actors. If the stars were known to be depraved, people might stay away
from movies, as many did from theaters. It had to be emphasized that
movies were made by the ordinary rules for work, with everyone quitting at the end of the day to go home for family dinner, and that movie
stars were naturally home-loving and God-fearing, just like everybody
else, only more so. To succeed in films, Chaplin would have to create
and maintain this fiction about himself, as all film actors did after early
scandals had caused boycotts that seriously hurt the budding business.

One of the ways Chaplin did it was to create a respectable past for
himself, with only respectable demons in it. Lynn examines Chaplin's
My Autobiography of 1964 mainly with a view to unraveling the gauze
of romance Chaplin was still drawing over early grim facts and feelings,
even at that late date. Lynn the historian, by checking on the addresses
where they lived and when, painstakingly disproves Chaplin's insistence
that he and his family lived in abject poverty, subsisting on his mother's
sewing and her two sons' jobs in the theater. He also establishes pretty
firmly that Chaplin's lovely and loving mother was, after an unsuccessful stage career, a kept woman and a part-time prostitute, and that he
himself was not the son of his alleged father. Hetty Chaplin also went
gradually insane, intermittently imposing unspeakable emotional burdens on little Charlie, and she was ultimately institutionalized when he
was about fourteen. Chaplin clearly never forgave her, nor himself for
being unable to rescue her from her life and her madness.

The thread of Lynn's story is the track of that whorish, spangled,
dancing, and unbearably abandoning mother through Chaplin's career,
on screen and off. Twice his movie star's need to look decent forced
him to marry girls he had seduced and impregnated and would have
preferred to abandon. He had a chronic, reckless hatred of contraception, wanting to be absolute master of all sexual circumstances, often
telling girls not to worry, he couldn't have children. He loved very, very
young and slightly hysterical girls, whom he would cast in show-business roles where they might wear dancer's costumes like his mother's,
and whom he could help out, master, mistreat, and then feel mistreated

by. Eventually he was a tyrannical father and the demanding, inconsiderate husband of submissive Oona O'Neill, whom Lynn sees as delivering a vengeful slap at her own disapproving and abandoning father, Eugene, by succumbing to his near-exact and notorious contemporary.

Chaplin couldn't really stay out of trouble despite his conscious efforts to charm and manipulate the world, and he seems to have been as amoral as they come. Lynn not only compares him to Hitler, of whom he really was the exact contemporary (they were born four days apart), but points to his obsession with Napoleon (Chaplin was also very short), and his abiding need to be rebellious, dominating, and right all the time. Chaplin wished to defy oppressive institutions, but mainly so as to establish himself as oppressor-in-chief. As Lynn's account proceeds, it becomes more and more heavily laden with tales of Chaplin's bad behavior, his cruelty not only to many girls and other intimates but to the workmen on his Swiss house, to secretaries, to collaborators and cameramen who tried to intervene when Chaplin's sovereign rightness was clearly wrong. His wickedness went further. After doing a scene holding a cat that unexpectedly scratched him, Chaplin didn't replace the cat; he had it killed and stuffed for the next take.

Lynn wants very much to emphasize that "moral turpitude," not Communist leanings, was the grounds on which Chaplin was finally denied re-entry into the United States in 1952, despite the widespread belief that he had been hounded out of the country for his politics. He had just been involved in a long and extremely sordid sexual scandal, which was only the most vivid of a sequence including both his divorces. Then, too, there had been a case of tax evasion. Lynn is an inexorable judge. He even follows the reach of Chaplin's badness beyond the grave, describing the wreck of Oona's widowed life as a wild-spending, boy-chasing drunk, once she lost her taxing job as Chaplin's slave.

Chaplin's famous and persistent left-wing political affiliation had differing effects according to the historical moment, and it was another thing he painted over in his autobiography. He was part of the Red Hollywood group in the 1930s but he seems to have identified very generally with workers and the dispossessed, rather than being very precisely aware of Soviet policy and activity. He praised the purges, for example, as healthy cleansing devices—another bit he deleted from his own account. It was alleged by one reviewer of the autobiography that Chaplin's pro-Soviet activism mainly showed the desire of an ill-

educated man to get accepted as an intellectual, to hobnob with Bertolt Brecht and Hanns Eissler so he wouldn't get stuck with Marion Davies.

Chaplin's public political remarks were always rather woolly, even if they were delivered at specifically Communist events; and sometimes they were near-echoes of actual Communist rhetoric at its most bland. But when quizzed about his own exact loyalties, he would always say, I am a human being, not a Communist; or I am an artist, not a Communist; or I am a peacemonger. Although it was stated in 1952 by a former Communist district organizer that in the 1930s Chaplin had been a loyal Party member-at-large, taking orders directly from the Central Committee, no sufficient evidence supported the claim. Lynn himself has latterly found no trace of Chaplin after pursuing inquiries in Moscow, and he allows us to conclude that the claims were false.

Chaplin eventually gave up discussing politics altogether, seemingly with relief, as if he had never really been seriously interested. It is true that he loved to be loved by intellectuals and to feel he was one of them; he carried Schopenhauer around with him (so did Hitler), and Spengler, too, reading bits and pieces without much system. His critics on the left said he "lacked ideological discipline," or indeed that he was the "accomplice of capitalism in decline." He certainly lived very high and spent all his spare time with millionaires, intellectual or no.

The great artistic crisis in Chaplin's career was the advent of sound dialogue, which quickly sent all moviemaking back to square one. Chaplin's cinematic sensibility, born of pantomime, was wholly bound up in the medium of powerful visual drama supported only by apt music. Dialogue might be part of the performance—people might be seen to speak—but the actual words conveyed should be minimal, easily compressed in short captions. This method works perfectly, as all true movie lovers know, and the many hundreds of movies based on it had thirty years of galloping success behind them. But the bottom line finally won out. In 1926, the last year of entirely silent film, 50 million people a week went to the movies in America. In 1930, the first year of the total dominance of sound, 90 million a week went. So that was that.

Chaplin nevertheless finished *City Lights* in 1931 using no sound dialogue at all. It was his last silent feature with the full-time Tramp, but the Worker in *Modern Times* bears a close resemblance to him—and no wonder, since that film also had no sound dialogue even in 1936, the year of *Romeo and Juliet, Mr. Deeds Goes to Town, The Petrified Forest,* and

Show Boat. Chaplin was not going to give in easily, and he made the point in *Modern Times* by singing a highly communicative song made entirely of nonsense syllables. Meanwhile, in off-screen life, Chaplin's own utterances began to veer toward the homily or the harangue, to the point where he was lecturing Ramsay MacDonald on domestic policy and Albert Einstein on economics. Unfortunately, so did his utterances when he finally spoke in his movies. Speechifying was his mode in *The Great Dictator, Monsieur Verdoux, Limelight*; his best acting was still being done with the face and body and the inspired use of whatever props came to hand.

Chaplin was certainly aware of the flaws in many of his movies, although he had to believe each was his greatest while it was being made. His true judgment is confirmed by his belief that *The Gold Rush* of 1925 was the best of them all, and the one he would like to be remembered by. It was made at the peak of his fame, and he worked hard to make it great. He shot 231,000 feet of raw footage for a finished cut that was 8,498 feet long. Following Lynn's insight about Chaplin, the story seems to be the only one to fulfill his lifelong submerged dream of saving and having his forever vanishing mother, not without great pain and risk, but with ulti-mate success, and with a fortune to ratify the emotional triumph.

The cinematography and direction, often uneven in Chaplin films, have great harmony in *The Gold Rush*. There is a finely tempered inter-play among the hot dance-hall crowds, the tiny people in the perilous snowy spaces, the outsider-looking-in moments, and the comedy-in-the-cabin routines, of which there are some in other movies but none better than in this one. None of the gags goes on too long, as they often do in earlier films such as *A Dog's Life*; none is too nasty or too grotesque.

As a showcase for the Tramp's soul, *The Gold Rush* is perfect. He can prevail in the most inimical surroundings imaginable, not the grim city or the harsh army, but the impersonal frozen waste, laced with hidden gold, that can turn anxious, lonely, greedy people into beasts charging around the cage of their isolated little mining town. The lovely dance-hall girl whom Charlie secretly adores is repeatedly offended by the cru-dity of her steady admirer, but she is ready to settle for him out of boredom, until the real love she sees in the little Tramp's heart opens her eyes to the possibility of finer things, and she rebuffs the hunk. But the Tramp has vanished to find his gold mine, and he returns only to sail home a silk-hatted if still love-hungry millionaire. The two meet again

by a fluke on the homebound steamer, and they are affianced within minutes, as if by a dispensation from Venus, with Charlie still playing the Tramp (dressed in "his mining clothes" for a publicity photo), so we know she really loves him for himself, even though she quickly learns about the millions.

The movie is peppered with famous comic scenes, of Charlie turning into a big chicken in the eyes of his famished partner, of Charlie and partner in the teetering cabin, Charlie doing the dance with the rolls, cooking and eating the shoe, waltzing attached to the dog, and finally millionaire Charlie. Here we have a glimpse of the high-life Chaplin, as he walks with suave grace in his fur-collared coat, treating servants with understated aplomb, his face handsome with muted melancholy, looking for all the world like Proust. But he still unthinkingly scratches himself and picks up cigarette butts, and he removes his smoothly cut cloth coat only to reveal another whole fur coat underneath.

At certain moments in this movie, as also in *City Lights*, we can see Chaplin apparently stop acting and just quietly feel passion or anguish, and that seems to be his secret. We are all his at those moments, drawn by the erotic pull of strong male feeling intensified by helpless infantine and feminine need, held inactive in a limbo of despair. At the immensely satisfying end of this film, Charlie's pure sexuality has conquered the girl, the gold, the adversity. The force of true love incarnated in his mobile, infinitely resourceful, and creative body has proved irresistible. And so his mother has rejected her men and her dementia and come back to him at last.

After 1952, Chaplin lived in splendor in Switzerland, playing himself as a king in exile. Lynn nevertheless finds evidence that he had long been meaning to go and live in Europe at the time he sailed over for the London premiere of *Limelight*, even if he hadn't been prevented from returning. Both the American public and the government had turned savagely against him during his long double trial resulting from Joan Barry's false paternity accusation; and he ultimately turned against them, especially as the McCarthy witch-hunting continued. A generation later, Americans had forgotten everything about him but his work, and in 1972 he was invited back to receive an Academy Award and other honors, and to accept a devoted public's irreversible love for the immortal Tramp. He was, of course, delighted to come.

Silent Movies

James Card thinks of himself as a precious vessel, and he's right, for those who prize living memory. He is a walking archive, a human repository of cinematic experience, and his book is the personal account of a passion for movies that began in 1918, when he was a child, a decade or so before sound. Card's youthful obsession was eventually channeled into fifty years of relentless collecting and perpetual championship of movies from what he calls the pre-dialogue period. It is there, during the first forty-five years of moving pictures—he dates cinema from Muybridge's zoopraxiscope of 1880—that Card finds all the cinematic artistry that would ever be necessary for the life and health of the medium during its subsequent history. He is not alone in holding this view, of course, but he can claim to be among the few with personal experience to support it. He eventually helped found the George Eastman House of Photography in Rochester, whose film archive began with his own collection of silents.

Card tells how he became an avid collector of movies when he was in high school, cleverly rigging his hand-cranked Keystone Moviegraph (bought in a Cleveland department store in 1921) to take 1,000-foot reels of 35 mm film, so he could show full-length features at home instead of the short excerpts that were quite enough fun for most people. And so he began a kid's collection, buying and swapping movies

Review of *Seductive Cinema: The Art of Silent Film*, by James Card (New York: Alfred A. Knopf, 1994) in *The New Republic*, December 12, 1994.

with fellow enthusiasts; but he never grew out of it. The advent of sound dialogue seems only to have confirmed his passion for silent film and his belief in its superiority, at the same time confirming the limits of his cinematic perspective and, consequently, of his aesthetic judgment. Card's wish to keep faith with his adolescence has resulted in a wonderful celebration of early movies and their makers and stars, marred by somewhat thick-headed objections both to later movies and to all later critical treatment of the cinematic enterprise.

Card becomes lyrical describing the opulent movie palaces of his childhood, during the brief epoch when dressed-up audiences were politely ushered to their seats, before popcorn and soda vendors desecrated the grand lobbies and noisy, untidy throngs crowded the house. Before sound, Card suggests, movies were believed to be a new art, and they were treated with a respect that the dream-factory productions of later decades rightly lost. In the big theaters, musical accompaniments were played by a full live orchestra or an organist; and it is clear, although Card does not talk about this, since his book is not a critical study, that early cinema had a certain similarity to opera as it used to be. Early movie audiences, as Card describes them, seem like those for the repertory opera companies that existed in small cities all over Europe, when opera was meant to be generally entertaining and was not yet an expensive urban luxury with weighty social pretensions. Opera, too, provided beloved and magical stars, recurrent themes of passion and deception or comedy and tragedy, and the exercise of an intense suspension of disbelief during an evening of acutely unreal reality, swept onward by overwhelming music and unintelligible dialogue. Despite the obvious differences, there are suggestive connections, including the international character of both media. Without spoken dialogue, movie titles could be translated into any language; now the opera, reclaimed for the general public, has supertitles offered in an arrangement rather similar to the one used for silent film.

Card doesn't tell us what he used for music when he first showed his own reels at home, and the specifics of background sound altogether seem not to have interested him much, then or since, although he is careful to remind us of Lillian Gish's remark that "silent films were never silent." The details of the underscoring for all those early movies need another book—there may already be more than one. Card instead concentrates on explaining the visual effects used in the branch of early cin-

ema first devoted to creative fictions, for which the invention of the close-up was the crowning achievement. This artistic breakthrough he attributes to James Williamson in 1901, ten years before Griffith claimed to invent it, and he tells us: "Thanks to the pioneering of Muybridge, Méliès, the Lumières and Williamson, the motion picture entered the twentieth century equipped with all its basic properties: editing, close-up, multiple exposures, speed alterations, sound and dialogue, moving camera, large screens, even surrounding screens. The essentials were all there. The next fifty years would be devoted only to refinements."

These refinements, Card seems to believe, were also fairly well perfected by 1930, even including color and, alas, speech. After that, American film ceased to be an art and became a business, popcorn invaded the lobby, Card lost interest, and aesthetic and social respectability deserted the movies—except perhaps in Europe, Russia, and Japan. But all the real groundwork had been done; and if movies have lately regained their status as important cultural expressions and are taken very seriously, they owe their elevated rank only to the original accomplishments of the pre-dialogue pioneers.

Modern movie lovers, including lovers of the silents and the earliest sound dramas, may well be unaware of how many films were made in those very early days, how many hundreds and hundreds of movies of different kinds and qualities existed before 1930 that are now utterly gone. Before their conservation was even considered, and methods for it discovered, movies were born and died with prodigal rapidity, with the result that we are now dependent for our entire awareness of old cinema on a pitiful remnant. Card, his head still filled with the hundred thousand movies of his youth, is indignant at the modern reverence accorded to certain celebrated antiques, the landmark favorites that he often finds wretched compared to certain others lost or more obscure—especially when they are now screened at the wrong speed from horrible prints, with inadequate music or none. He is particularly scathing about the universal worship of D. W. Griffith, whose *Intolerance* is still being called by some the greatest movie ever made. Card is at pains to describe the ways in which that film was a hopeless abortion and Griffith himself a vulgar sensibility, especially when compared to his European contemporaries.

Card is also chronically indignant at the presumption of anyone under seventy who teaches film courses dealing with the silent movies, and especially of those daring to formulate theories of film. He has no

respect whatever for opinions about the silents put forward by persons who didn't see them when they came out, with their tinted stock or hand-tinted frames, their hand-cranked variable speeds, their organ or orchestra accompaniments. He claims a fresh effectiveness for those movies that is almost impossible to reproduce now, and especially difficult to appreciate after the intervening decades of internalized response to latter-day moviemaking. In his own person, Card demonstrates the battle between opposing aesthetic camps—the engaged testimony of a contemporary eyewitness versus the detached judgment created by historical distance. How, Card might inquire, can we presume to teach courses in Michelangelo's frescoes, and to form theories about them, since we didn't see them in the sixteenth century?

But we do presume, and we should; and I believe Card really knows this about movies, too, despite his indignation. Still, his book is about love, that celebrated nexus of the ephemeral and the eternal which likes to defy augury—and theory, too. So his emphasis is always on those acute responses that have produced his own love, on the specific forms of cinematic beauty, brilliance, and pathos that called those responses up, and the persons and techniques that made them possible. He writes about actors, directors, producers, designers, and cinematographers whom he has actually known and whose work he knew from its first appearance; and he offers himself as a surviving ideal spectator, still entranced and, as his title suggests, forever seduced.

And perhaps he is, after all, in the best position to judge, since nothing—not even the putting away of childish things—has ever dissipated their pristine effect on him. Without such impact, films are nothing. They must have audiences, people caught in the dark who are thrilled and irreversibly changed, or perhaps uneasy and impatient; you have to feel the movie's force directly before you are allowed to be objectively intelligent about any of its components. One could say the same thing about Michelangelo. His frescoes were so materially changed over centuries that their optical impact itself gradually became a different thing, even apart from the issue of different eyes and shifting expectations. And we know that they could still strike home. We all bear witness to feeling the power of things we have only in ghostly versions that reach us across time's gulf. Painstaking restorations, like those in the Sistine Chapel or those lately made possible for old films by the devotion of

James Card and others, are wonderful acts of faith for which gratitude is due; but even without them, we get it. It may be tarnished, but it's a true thing.

But Card possesses something that nobody born later can ever have, and that is the experience of innovation, the revelatory newness of original screen marvels as they first appeared to eager eyes. He seems to have guarded this possession, and to have stayed away from anything produced more recently that might compromise its worth and his fidelity. Card describes some early movies that have the same power as recent ones, and which were the very first to use the effects now still doing the same work: flash-forward, for example, was used in 1914 in T. H. Ince's *The Gangsters and the Girl*, where two imagined future outcomes of a situation are filmed as if real, though neither is the one that eventually happens. He points out that this was used much later in Alf Sjöberg's *Miss Julie* of 1951; and I remember it in the form of false flashback in *Stage Fright*, also from the 1950s, where lying testimony is enacted as if real, so we think it's true until we learn better. The same 1914 Ince film first used other elements very familiar on modern screens: shoot-outs on rooftops, car chases, tension raised by clever camera angles, taut pacing achieved by masterly editing, and naturalistic, unmelodramatic acting. Obviously, any modern moviegoer would love this film; but he could never see it as new, and Card still can.

Card's book serves as a reminder that the unique art of movies has its own unique art history, with a founding set of origins that has passed through its own unique developmental stages. The great early filmmakers had neither established academies nor private ateliers in which to transmit the secrets of their work to new film artists. Everybody learned by seeing and conceiving, trying and doing, hunting support and success; nobody taught and studied. Throughout early movie history, the influence of one filmmaker on another seems to have been haphazardly and unconsciously created rather than deliberately sought and acknowledged; and this situation is something Card clearly likes. It makes his personal researches and collecting, and his later work of conservation and display, into one great creative endeavor. The early practitioners worked unselfconsciously; it is only the devoted, attentive lover of their films who can create their true history, and show and tell it to the world.

In this book, the moviemakers and the stars tell Card their stories,

display their compelling qualities and gifts; but they have no sense of continuity and history, only a sense of themselves. Card loves them all (although he has his favorites), and he expounds his own insights, not theirs, about their work and its relation to other movies. He's the one who can do it, after his faithful years of seeing and searching and comparing—the great surviving personalities are really no help, other than their continuing presence and glitter. But those things, of course, are the core of movie magic. Just as he wishes to deflate the overblown reputation of Griffith, so Card wants to record his appreciation for the spellbinding cinematic excellence of works by Cecil B. DeMille, whose name is forever being taken in vain as a synonym for nothing but ridiculous excess.

Card seems jealous about his own expertise, with respect not only to ignorant and unloving latter-day theorists but to others in his own game. He is quick to insist on how limiting the creation of a film archive can be, using the Museum of Modern Art under the snobbish leadership of Iris Barry as an example, or how generous and visionary, as in the case of Henri Langlois at the Cinémathèque Française. He claims that the whole history of movies has been (and could still be) gravely distorted by ill-founded decisions to save some films and not others. He would have it that movie art history, young as it is, has already become biased. Our understanding of past work has been rendered faulty simply by our inability to see enough of the right material, to have the right responses, make the most interesting comparisons, see the true connections. Card wants to make his own endeavor in Rochester seem like the only team to beat, and maybe it is; but he does start to seem like the Giorgio Vasari of movie history—later historians won't be able to do without him, since he's a witness, but they'll have to wade through his prejudices and wearily try to sort them out.

Card is wonderfully eloquent about *The Cabinet of Dr. Caligari*, made in 1919, of which he finally rented a print in 1933. This movie is still a touchstone, the one about which more has been written than any other. It was foremost among the first movies exhibited by the Museum of Modern Art Film Library in 1935, the first also to be collected by Langlois. Card himself only managed to buy it by going to Germany late in the 1930s, on an express pilgrimage—never mind politics, apparently—to find an original print of *Caligari*, see and buy as many movies as pos-

sible, and only operationally to be a student at the University of Heidelberg. He was there, he tells us, in August 1939, when both he and his movie collection were "collected" by the Gestapo; but he got home safely. No details.

About *Caligari*, Card says it has all sorts of flaws and shortcomings, but was the first movie to "serve dramatic notice that film was a *graphic* art rather than a theatrical form or a branch of photography." This brings up, though again Card doesn't really discuss it, the positive value of soundless dialogue in originally creating the art of film. If people actually speak, we might as well be at a play; but if they only seem to speak, we are in a sort of fluid picture gallery, dependent for everything on our eyes, especially for the subjective interpretation of faces and bodies in all their minute incalculable motion. The close-up was a necessary element specifically in film without dialogue; it gave scope to that distinctively subtle form of acting known only in the movies, or maybe in paintings like the *Mona Lisa*. The face must do the speaking, and under close scrutiny. Card praises, as everyone does, the great silent actors who first understood how to stop theatrically mugging and posturing and trust to the delicate intuitions of the moving camera—Gloria Swanson, Greta Garbo, Louise Brooks, Emil Jannings.

Brilliant color, too, would clearly have served as a distraction from the refinements of this new camera art, although Card points out that different tints of film made a great difference to the flavor of scenes, and frames were sometimes even hand-painted, one by one, like Victorian fashion plates. *Caligari*, however, in its groundbreaking graphic message, would certainly have been compromised by any chromatic interference. Color photography and cinematography altogether complicate the direct effects of camera work, since their results depend on printing processes that are themselves difficult and often questionable. "Naturalism" is made far more abstract with color film, and abstraction far more arbitrary. To establish the aesthetic credentials of the movie camera, the work of directly capturing and then printing the emotive effects of light and darkness in action had first to be controlled. Such work had to be made into supreme dramatic art by itself, before color and speech could safely be brought in. Spoken-film acting certainly could not have flowered without its roots in magnificent silent-movie achievements; color cinematography could have no force without its foundation in pure chiaroscuro.

It is only lately, however, that moviemakers have become self-conscious and started to quote the past works of their art with evident deliberation. They've sometimes even been scorned for this, as if it were not one of the great established modes in which all art is continued. To amplify Card's view that the art of movies has acquired nothing new in its later days, we would have to insist that it has acquired a sense of its own multiform past as a generative source. This means not just having past masters and past failures, but having discernible lines of tradition and filiation in all elements—cinematography, direction, acting, design, editing—which have been laid down and can be specifically followed, altered, or challenged.

Since so much junk has always been made along with good things and real masterpieces, a critical faculty has also had to develop and refine itself. Much of this has been done by the third and fourth generations of movie lovers and movie creators, who have had to make do with whatever of the past has taken possession of them—and, of course, to deal with sound and color in all their registers. Wonderful childhood memories, just like Card's, have inspired Steven Spielberg and many others, only from a later date. They're still inspiring the movie critics born since 1960, whose love can match Card's anytime, even if it's not only for the silents but also for what has never ceased to keep appearing and seducing us all ever since.

Woman's Movies

"Movies," says Jeanine Basinger early on in her huge book, "were really only about one thing: a kind of yearning. A desire to know what you didn't know, have what you didn't have, and feel what you were afraid to feel. They were a door to the Other, to the Something Else." She might well be defining all fiction, certainly much opera and theater, or poetry itself, the imaginary garden with real toads. In the movies, perfect camera reality, like the ravishing music in an opera, serves to sharpen both complete belief and complete disbelief in the conjured world of the story, to produce a simultaneous acceptance of its realities and unrealities together. Basinger applies her description to the traditional woman's film in order to demonstrate the particularly sharp ambiguity embedded in the genre. Her aim is to defend it against unimaginative film scholars who have assumed that it mainly sold women a bill of goods.

The outrageous plots created for a woman's picture such as *Shopworn* (1932), for example—in which Barbara Stanwyck "is sent to prison by her rich young lover's mother and, when she gets out and can't find a job as a waitress, has no choice but to become a famous Broadway star overnight"—have frequently been seen as plain idiocy meant to numb the female mind in an unenlightened era. Or take *Deception* (1946), wherein Bette Davis's husband turns up after being presumed dead, and

Review of *A Woman's View: How Hollywood Spoke to Women, 1930–1960* by Jeanine Basinger (New York: Alfred A. Knopf, 1993) in the *Los Angeles Times*, November 14, 1993.

Davis decides to shoot her current lover because he might spoil the husband's cello debut at Carnegie Hall. Far from seeing such plots as perniciously ridiculous, Basinger finds a liberating value in them, not only for the women of their time, but for all female Americans still caught, and often still crunched, between conflicting ideas about the course and purpose of their lives. Basinger writes:

> What's astonishing is that these plots work. They are cautionary tales of a particularly desperate stripe, but they contain real passion, real anger. The lunacy verifies them . . . Although many women's films are unquestionably demented, I salute their reckless plots, in which well-dressed stars act out the woman's form of heroism: living outside the rules of correct behavior, which in story terms is realized by living outside the rules of logical narrative construction.

First, however, she has to define the genre itself, which actually had no crystal-clear boundaries and qualities even though it is easily recognizable behind all its amazing range of flavors. In a "woman's film," a woman is the center of the universe. Everything she thinks and feels and does is of sovereign importance, and moreover, what she can do is often seen to be infinite—fly a spaceship to Jupiter, command troops, run corporations, foil enemies, do primary research, rule countries, star in cabaret, win elections, perform brain surgery, etc. Nevertheless, the movie eventually makes clear that her real job at all times is being a woman; and what she actually tries to do is always at specifically female risk. Such a film sends the message that until "being a woman" has been figured out, nothing else will work. The great rewards of effort and talent will ultimately be compromised.

In such movies, "love" is the name of the great obstacle and problem that being a woman entails, and the name of any woman's actual career, however many millions she makes or however great her contributions to science, art, and politics. "Love" takes various forms; it is not always synonymous with marriage, which often shows its own miserable aspects during the course of a woman's film, and can prevent "being a woman" (that is, "love") from properly developing. Marriage can even be dangerous to the health, as in a film like *Dragonwyck* (1946), where Gene Tierney, playing a nineteenth-century country girl who longs for something different and wonderful, marries wealthy and compelling

Vincent Price, only to find herself being slowly poisoned by the flowers he puts in her room. It shows what can happen when a romantic girl, blinded by courtliness and seductiveness, fails to perceive that they are no guarantees of "love."

"Love" was actually the female biological imperative, says Basinger, the real trap, the emotional or perhaps glandular disposition that eventually leads straight to laundry, floor scrubbing, and multiple pregnancies; but all this was only secretly and wordlessly implied in the word itself. The career of "love," moreover, clearly did not mean a life devoted to a series of passionate love affairs. It meant one man, or one child, a unique vessel for a unique personal devotion, a sort of female religion.

Before arriving at its particular final acknowledgment of this right path for all women—which often required sacrificing the operating theater, the Broadway stage, the boardroom, or the Senate, and sometimes happiness or life itself—the woman's film gave its heroine a liberating scope, a vivid milieu and set of circumstances in which to operate freely and very effectively. The story was usually built around a choice or set of choices posed only because the woman *is* a woman: "love," or the right path, would be on one side, and some form of Other would be opposed to it—family, class, work, talent, success, goodness-and-niceness, wildness-and-badness (either one)—or indeed honor, although Basinger doesn't talk about that concept by name.

"Love" must eventually be chosen even if it clearly destroys the perilous, carefully wrought structure of a whole life, and must be considered (in the movie, anyway) worth it. The heroine, for example, might make a different sort of wrong choice early in the movie: she might pick a man to love, only to have him drink, die, or desert. Then she would have to struggle adroitly, transcend the disaster, and painstakingly turn adversity into hard-won advantages that often included furs and jewels. Much later, another man would appear, the same choice would have to be made again—we knew what she would inevitably do. In the meantime, "love," although it might lurk below the surface and triumph at the very end, often stayed well out of the picture while the woman's personal success, the result of her far-seeing ambition and her intelligent competence, her glamorous talent or perhaps simply her prestigious loveless marriage, was demonstrated in wonderful cinematic clarity, with emphasis on her fine wardrobe and the rapturous devotion of several extraneous men.

Women are also shown to take on decisive power in the furthering of the story, often by lying and otherwise using deceitful methods to determine the fate of the man for his own good, or to preserve his honor at the expense of her own. She may even secretly get together with her archrival, the Other Woman, the Wife or the Mistress, the Mother or the Secretary, and go behind the man's back to make a deal with her about how things will go. This is vividly done near the end of *Wife vs. Secretary* (1936), which isn't even mentioned in the book. A wonderful scene occurs between wife Myrna Loy and secretary Jean Harlow, who is secretly in love with Loy's adored and adoring husband Clark Gable, her own very rich (and very unobservant) boss. A misunderstanding threatens to end the marriage of Gable and Loy, who has walked out; and Harlow, sacrificing a love that will succeed only if Loy leaves, persuades her to come back. Gable, naturally, never suspects a thing. In such movies, women make the real decisions, men only think they do; but very often a woman needs to lie to accomplish this. She is therefore seen by audiences to be both right, in having the right aims, and wrong for lying— although Basinger does not emphasize her compromised moral position, only her unavoidable choice as a fundamentally oppressed person.

Basinger explores the possible effect of such woman's films on actual women in the audience whose men may well have been abusive, weak, or otherwise unsatisfactory, and who may themselves have lied to keep the peace and who wished to feel justified in practicing deception. Either the supreme nobility (the "niece" is really a daughter, but he must never know) or often the high comic virtues of cinematic female deception might well reassure real women of its necessity in actual life. Marriage in woman's movies is almost always portrayed as a difficult state, but it is always portrayed as the universal female ideal anyway— if not immediately, then eventually; and women are shown to have real power in marriage only if they are prepared to be liars.

Alternatives to marital happiness and unhappiness are offered, however, in the form of "love" in other forms, often maternal. Bette Davis can't marry Paul Henreid in *Now, Voyager* (1942) because he's indissolubly married; but amazingly she insists on replacing their happy clandestine love affair with her new and noble love for his afflicted daughter, to whom she will transfer all her passion at the end of the story. The content of many woman's films shows that love for a man is quite eas-

ily superseded by love for a child, and an ideal situation is often portrayed as "love" without sex.

Sexual relations in fact bring misery. Basinger finds it a consistent subtext in these films that all men playing their sexual roles are largely useless in other ways, troublesome and untrustworthy. Movie situations where a couple marry only for convenience are often shown to be quite jolly until the sexual element enters into the plot. Tracy and Hepburn in *Without Love* (1945) undertake a perfect marriage based on mutual respect, a sense of humor, and a comic intelligence, but no sex. Once they develop a passionate relation, "they suddenly begin to behave like jealous idiots," says Basinger. "This fresh and friendly relationship between two strong individuals changes into a silly mess that demeans them both. It looks as if to become truly married, two people not only have to have sex, but also have to make each other miserable."

Meanwhile, plots with a mentor or father or doctor as the main male character offer great emotional and even material satisfactions without sex, although much eroticism may infuse such a man's relations with the heroine. This can go very far if the heroine is in fact a child. Shirley Temple in *Curly Top* (1935) sits on John Boles's lap wearing the shortest of skirts, gazes flirtatiously into his eyes, climbs into bed and bounces there with him; but then he marries her older sister at the very end, to placate the censors. Motherhood, as difficult as sexual love, may also seem to have a purely theoretical emotional power: if the unwed heroine has a baby, she may tearfully give it up for its own sake; but she will spend the rest of the movie as an untrammeled free agent, spending her money on her own clothes or her own business enterprise. If she is not punished by the plot, she will get the child back only at the end, when "love" has to win after all, having neatly skipped all the dentistry, schooling, and outgrown winter coats.

Basinger throughout emphasizes the difference between what such films *show* and what they *say*. The plot will speak of the rightful power of "love" over the fates of women, and will also speak of it as a pure and absolute good, even if all it ultimately means is sexual relations with one man, followed by children, housekeeping, and a speedy old age; but the movie will simultaneously display complete programs for living powerful and often luxurious lives as free women endowed with sexual as well as professional choices. Such lives are often shown to have twice the

scope of men's, since movie women never have to give up the traditional privileges of femininity—well-tended beauty and flattering garments, but also a gift for warmhearted sympathy and skilled social management, to say nothing of deception in a good cause—while demonstrating that they can outstrip men at most of their competitive worldly games. Thus women can be men, too, with increase of prestige; but men, of course, cannot be women without being degraded.

In a woman's film, women are thus entirely superior beings, and attention is riveted on them from beginning to end; but of course they have to give it all up, or else men won't love them. Basinger might have added that men will indeed fear and loathe them, and strive to humiliate them; and then sometimes they will love them. Women can do anything; the question always is, should they? Modern films tend to assume that they should if they wish, and the difficult matter of the cost troubles the plot in quite straightforward ways. In the old films, the overt message was that women shouldn't, but the movie showed them doing it anyway, often in a fine frenzy. And so the general message in woman's films is about having your cake and eating it, having things both ways before the movie is over. Basinger insists that women got the entire ambivalent message, and that enough in woman's movies had real relevance to real lives to qualify them as serious fictions, not pure escapist nonsense.

Basinger emphasizes the importance of fashion in woman's films, treating this as if it were a distinctive and rather hilarious failing of the genre. She seems to forget that film is both a visual art and a performing art, and that *all* clothes must matter intensely in it at every moment. Dress has defined character in drama ever since theater began, or for that matter since pictures began; costume changes have dramatically signaled character changes and mood shifts since the dawn of time. Basinger wishes to find the female hats and shoes and other garb of the movie period she deals with unusually ridiculous; but what she is really responding to, I think, is their flavor of being costumes, the obvious concoctions of a wardrobe department, never simply a woman's clothes as she might wear them. This very effect was a large part of their appeal then, and is now, if modern critics can refrain from the stock laughter regularly evoked in print by the demanding female finery of the past.

The themes explored in this book are provocative and the descriptions of films are often very funny—Basinger even tends to kid her material a bit too much, and she can verge on the flip. I would have liked more connections with other kinds of fiction—there is a great deal in woman's movies that has real links with the old literary and dramatic myths that underlie modern assumptions about men and women. Some placement of these woman's movies inside the general continuum of what has always "spoken to women," in Greek tragedies, say, or in French novels, might have been illuminating. But the main fault of the book is its excessive length, considering the simplicity of the idea it expounds.

Garbo

It is significant that Greta Garbo's appeal endures as much in her pho-
tographs as in her movies. Above everything, it was and is the Face, the
first face made for the camera, the face that wants to be alone, that barely
moves. The acting was mostly done with the eyes, into which the camera
plunged again and again; the rare smile and rarer laugh never obscured the
inward look. She had fantasized about acting when she was a little girl, and
she had appeared in plays as part of her training at drama school, but a stage
career would have been a disaster. It was the close-ups in movies and the
portrait photographs that drew forth her real gift and made her immortal.

The voice, once it was heard in *Anna Christie*, was fortunately no
hindrance. Her particular brand of foreign accent had no connotations
whatsoever in America, neither good nor bad nor comic, and her speak-
ing voice had a low timbre with a touch of hoarseness that went per-
fectly with the Face. Garbo's brand of Swedishness in general had a lot
to do with her appeal, although not much was made of this. She had
grown up in the working class of a self-contained liberal society, where
her family was poor and life harsh but not miserable, streets were safe,
pleasures were simple and available. Having been obliged to leave school
at the age of fourteen to go to work, she never entirely grew out of her
childhood attitudes and feelings. Her relatively stable background did
not require desperate, self-creative escape.

Review of *Garbo* by Barry Paris (New York: Alfred A. Knopf, 1995) in *The New Republic*, April
3, 1995.

In her later financial wrangles with her studio, it was clear that Garbo really did feel she could happily leave the whole business to go and live by herself in a cabin in the woods, and this independence gave her great power. Other stars, deeply committed to the prestige of luxury and brilliant personal display, might talk like that for effect but never mean it for a minute. What was often perceived as a pose, a strategic and deliberately provocative withdrawal on Garbo's part, was really a form of uncultivatedness, of plain simplicity—the same quality that always made her seem to be shrugging detachedly out of her luxurious costumes. She had a similarly schoolgirlish kind of self-discipline, always on time and well prepared, but quick to claim absolute freedom and privacy at the stroke of the bell.

And then there was the melancholy—more Swedishness, many thought, just look at the suicide rate—and the ambiguous eroticism that went with it, both more tellingly communicated on film than in any other form of art. The melancholy seems to have reflected a lifelong tendency toward depression that only intensified after her adored father's death, which brought about the end of her formal education. The ambiguous sexuality would have intensified with it from then on, too, as part of an ambivalent identity, a wonderfully cinegenic inner dissatisfaction. She had been an unusually tall and ungainly child. Later in her career she turned this internalized awkwardness into a form of quasi-masculine grace, a propensity to feel better in pants, which struck a thrilling modern note.

This flavor was unusual at the time and subliminally conveyed in all her very feminine roles—nothing overt and depraved, in the Dietrich style. Garbo's body thus supported the effect of the Face, with its searching and receptive air. Its very lack of smug assurance is what drew so much feeling from audiences. The one movie in which this uncertain bodily style was quite ridiculous was *Grand Hotel*, in which she made a totally unconvincing ballet dancer.

Garbo seems to have hated crowds, strangers, and observers all her life, but always to have loved both acting and being photographed. At a precocious fifteen years old, she happily posed for the millinery ads printed for the department store where she sold hats, and also appeared in two short promotional films. That was in 1920. In 1922 she quit the store to make movies, and appeared in one undistinguished comedy. Fortunately, she was taken up by Mauritz Stiller only a short time later during her subsequent drama-school period, while she was trying to

improve her chances in movies by acquiring acting technique on a scholarship to the Royal Dramatic Theater Academy. What she obviously needed was not more school but a new father, the one with a creative Patriarchal Gaze aimed at her through the lens. She put herself in Stiller's hands, but it was doubtful he ever touched her; in her case, his hands were his eyes. He took over her life, her clothes, her behavior as well as her acting. Although her famous "first" movie, *The Saga of Gösta Berling* (1924), was the only one she ever made with Stiller, she was still following his precepts about how to be a movie star many years later, long after he had left Hollywood and other directors were fostering her rare cinematic qualities.

In his scrupulous and detailed biography, Barry Paris is at pains to emphasize that at this point, right after *Gösta* and right before Hollywood, Garbo came under the influence of another great director, G. W. Pabst, with whom she made *Joyless Street* in Berlin in 1925. She and Stiller were stuck in Berlin, penniless after a film project in Turkey had fallen through. Pabst gave Garbo a job in his movie so she and Stiller could survive until they went to Hollywood, where Louis B. Mayer had already seen *Gösta Berling* and had come to Berlin to sign the two of them on before the Turkish fiasco began.

Garbo's appearance in a Pabst film was thus a piece of pure chance, but Paris finds Pabst's influence even stronger than Stiller's on Garbo's actual screen acting. His part (and just at this moment, hers) in the flowering of 1920s German cinema helped to add an intense psychological dimension to filmmaking. An emphasis on authentic inwardness characterized the New Realism movement in all German art, following the externalized violence of Expressionism, and film proved its natural exponent. Paris points out that Pabst, like Freud, was not German but Austrian, and perhaps instinctively more apt at emotional nuance than German filmmakers or even Swedish ones.

Barry Paris's last book was a biography of Louise Brooks, the striking and articulate star whom Pabst made famous in *Pandora's Box* (1928). Paris uses telling quotations from Brooks's uninhibited writings throughout this book on Garbo, but especially in his essay on Garbo and Pabst. Brooks said: "A truly great director such as G. W. Pabst holds the camera on the actors' eyes in every vital scene. He said, 'The audience must see it in the actor's eyes' . . . Pabst's genius lay in getting to

the heart of a person, banishing fear, and releasing the clean impact of personality which jolts an audience to life." Just so. Garbo responded very well to Pabst, who whispered and suggested where Stiller had commanded and bullied, and she produced the first example of the subtle "vulnerable despair" that later became her trademark. In *Gösta*, it had been her beauty alone that seemed remarkable; in *Joyless Street*, it was the impact of her personality that came through, as she played a serious girl helplessly compromised and maneuvered into prostitution by corrupt villains.

Once she settled in Hollywood, Garbo's life seemed to become mainly an ordeal, a constant effort to stay out of the game while winning it at the same time. Her spirits were further depressed by the early death of her sister and later by that of Stiller, which coincided with the breakup of her much publicized but always less than idyllic romance with John Gilbert. Garbo's personal reclusiveness was backed up by an ordinary North European reticence not much valued by the new American movie industry, which was largely created by extroverted East European Jews. But she made personal friends, among them Salka Viertel, who ran a sort of elevated European salon in the middle of crude Hollywood. And she eventually developed strong female attachments, notably with Mercedes de Acosta, the famous, rich, and aristocratic lesbian who by her own account knew everyone of importance in the first half of the twentieth century.

Paris is careful to say that the whole of Garbo's sex life is a matter of gossip, and he shares the opinion of several people that she was not much interested in sex and may have "done" nothing. She certainly acknowledged nothing, in appropriate respectable fashion. Her extraordinary appeal to the public of both sexes was quickly established, however, especially after the success of *Flesh and the Devil*, her first film with Gilbert, in which they shared the first open-mouth kisses to appear on the screen. Despite her shyness and solitary inclinations, her inspired screen acting made it possible for her to develop single-handedly a new Hollywood female character, that of the woman consumed by passion, the *grande amoureuse*.

Until Garbo, attractive women on the Hollywood screen had either been wicked vamps or sweetly chaste wives and childlike virgins, with an occasional tempted matron or madcap heiress. The woman who

risked everything for love—Anna Karenina, Christina of Sweden, Marguerite of the Camellias, and numerous others—had to wait for Garbo. Most of the time the character had to die, although sometimes she had to make wrenching sacrifices other than the supreme one; but she was always a serious, intelligent, and sympathetic character, felled only by the implacable force of her love. The vamp destroyed men, and laughed to see them grovel and suffer; Garbo's character brought about her own destruction, often wearing a faintly ironic smile.

Along with the enigmatic self-mocking face and ambiguous body, Garbo had extremely expressive hands, which she used in movies as vessels of erotic feeling, especially autoerotic. It was said by several writers quoted in Paris's book that Garbo's love scenes take no real account of the man in them, of his feelings or even his individuality. She caresses him as if stroking her own passion, dwelling only on her own mounting desire, exploring the force of her own sexual feeling—perhaps complex, powerful, and conflicted—and not of the man himself or his. She was, said one commentator, in need less of leading men than of altar boys, and her own hands ministered to her own flame. Sometimes she would even play a love scene alone, with a prop or two. It was strong stuff to watch, much more potent than the submissive fluttering and possessive clutching deployed by the vamps and virgins.

She was, and she still is, famous for her self-absorption. Garbo notoriously ignored all wars, politics, and the various wretched of the earth, right along with the irksome press and publicity people. She allegedly hated her lack of education and read widely on her own; but not newspapers, one would have to conclude. She was apparently devoid of racial or class prejudice, basically a non-snob; but the point was that all groups of people were equally uninteresting to her or, perhaps, equally threatening. Only individuals meant much, a few at a time: Stiller and Gilbert, Salka and Mercedes, Cecil Beaton, Gayelord Hauser, and Leopold Stokowski; but also her nephew and her housekeeper, and much later on, helpful and comforting friends not fond of the public eye or insistent on unacceptable degrees of intimacy.

And she did find an exclusive Hollywood circle to join. It is hard now to imagine the character of the cultivated European colony that maintained itself in Hollywood during Garbo's active career. Movies began silent, and therefore international; and a great many talented and

educated Europeans were helping to make movies in Hollywood in the 1920s and 1930s and before. Others settled there for a time, too, as friends and fellow artists—musicians such as Arnold Schoenberg and Igor Stravinsky, writers such as Christopher Isherwood and Lion Feuchtwanger. Later the tide of refugees swelled their numbers. Garbo quickly became part of what was called the "European ghetto," not always with good humor, by local American talent struggling for success and recognition in movies. Cinema was a serious artistic medium in Europe before movies became a serious entertainment industry in the United States. For two decades and more, Hollywood was struggling to match high European standards, and dealing with imported European practitioners, well before developing a distinctive product with its own unsurpassed brand of American excellence.

Garbo became our great movie star because our movies—American movies—were somehow confirmed by her way of acting in them, just at a time when they were coming of age as the great expressive medium of the century. She obviously hated Hollywood the whole time she was there, and had very little respect for her own films, preferring her work in the German version of *Anna Christie*. But Hollywood had a real need of her. It was very important that the uniquely gifted Garbo stay in Hollywood to be identified with the rising success of American movies, and not return to Europe, to an assured cinematic home in the Old World artistic mode. And so she commanded an immense salary and had her choice of working conditions, and set a new standard for every aspect of modern American stardom.

Garbo's self-absorption and isolation worked marvelously on film, along with her basic indifference to public opinion, her acknowledged but muted sensuality, her strong will and deep inner life made cinematically manifest only in the tiniest shifts of expression and gesture, and in limited utterance. The whole combination produced the magnetic effect of someone at once vulnerable and unattainable. In the 1940s and since, American movies went on to elevate and idealize these qualities in American movie performers of both sexes, in distinct contrast to the stage actor for whom constant projection is essential and utterance primary. Gary Cooper and John Wayne partook of this ideal, besides a succession of American female stars such as Lauren Bacall and Bette Davis. Garbo, however, was the first to embody it.

Paris's biography joins a host of Garbo books, several of them quite recent, but his turns out to be the only one we must have. Paris has taken full account of the other works on Garbo and registered their value as well as their differing brands of emotional bias while clearly sorting out his own feelings as he proceeds. Along the way, he soberly corrects many factual errors that mar the public sense of Garbo's life. The results make a comprehensive study, comprising careful essays on Garbo's character and personal relationships, her difficult-to-discover financial arrangements, her effect on individuals and on the public at different moments, her actual film performances, and, most valuable, the exact circumstances of her long term as a living legend. He is very good on Garbo's shortcomings and bad behavior, both sympathetic and unsentimental; he has gone into the testimony of others in admirable depth (this book is more than 650 pages long); and he has found quite a bit of new material—tapes, documents, and a bunch of striking photographs from every period of Garbo's eighty-five-year-long life, both dumb snapshots and posed masterpieces.

It is interesting to know, for example, that Garbo's retirement from the screen in 1940 was not sudden, a prima donna's colossal fit of temper after her first failure. She and her studio constantly considered new projects during the next two decades, and several interesting collaborations were conceived that eventually came to nothing, leaving only the stark fact that she made no movies after *Two-Faced Woman*, which had been a disaster. Paris examines all the later negotiations in detail and every single earlier element contributing to the failure of Garbo's last film—and indeed, if Paris's book has a fault, it is excessive thoroughness of speculation and investigation.

We should certainly welcome this biography as an exemplary work of reference. It sets all the Garbo records straight, provides a sane assessment of a collective hysterical phenomenon together with a fine historical study of Garbo's life and times, and it is annotated, indexed, and appendixed to the point of being encyclopedic. But in the end I found it psychologically indigestible, partly because the subject has obsessed the author so intensely, and for so long, that he has unconsciously rendered it burdensome even to a movie lover and a Garbo fancier. It is hard to feel the need of caring so much about every mundane detail of this woman's private existence, especially during her last thirty years,

when it became clear that she would never work again. Her career had slowly sunk under the huge weight of her negative spirit, a cumulative force of refusal that eventually discouraged hopeful planning and creative suggestion on the part of rising filmmakers who had her in mind.

For a while, Garbo's life was peripatetic in the manner of the modern idle rich, moving from islands to mountains to Paris, from villas to yachts to châteaux. At length she came to a stop on East 52nd Street and began to travel only around Manhattan, being spotted on foot in her big coat and straight gray hair. Her efforts to flee observation were as tireless as ever, while she apparently found the effort to have domestic repairs made and to get successful clothes shopping done as difficult as career decisions had ever been. Near the end, Garbo spent a good deal of time in cozy intimacy with her housekeeper, who took care of her and her endless problems as a loving sister might have done. She died on Easter Sunday, April 15, 1990.

Garbo's beauty, talent, and presence are undeniable forces in modern movie life, poetic life, visual and imaginative life. When all is said and done, however, her own life in the world was not so very interesting, neither as a historical passage nor as a personal trajectory. Her secretiveness made her life seem interesting to others, but in these pages Garbo gives the impression of boring herself: the transcripts from tapes of her phone calls during her last years are tedious, not piquant. She had magnetism, all right, and a telling way of displaying her soul and her sexuality, but not much wit or heart. Garbo herself might even agree that the important reality of her life was enacted in the pictures, moving or still, and those are perhaps all that the rest of us really need.

Elizabeth Taylor

She has lately stepped gracefully down a few notches from her pedestal and eased up on her job as an icon; but she can afford it. She has been glittering up there since childhood, and she has earned the right to a certain voluntary eclipse. Now in her later sixties, an age at which Marlene Dietrich was still appearing nightly in sequins and feathers before live audiences in Las Vegas, Elizabeth Taylor is a select apparition, visible only here and there. But that's because her image is in fact indelible, and her iconhood can get on very well by itself.

As a child star whose chief charm was striking beauty, not cuteness or wistfulness, not rebelliousness or comic talent, Taylor was trained early to glow for the camera, to sustain herself as a perfect image rather than as a particular character. Acting a part, reading lines with conviction, transforming herself into a certain personality were always subsidiary to being perfectly beautiful. That had its own character, potent and supreme. If you catch Taylor's performance as Helen Burns, the heroine's saintly little schoolfellow in the black-and-white *Jane Eyre* (1944), which she made when she was twelve along with *National Velvet*, you can see how her beauty does all the work: it produces the sweetness and saintliness and the pathos of her death. The performance needs no other flavor, and it creates a perfect foil for the responsive acting and plain face of Peggy Ann Garner as Jane. All by itself, Taylor's unquali-

The New York Times Magazine, November 24, 1996.

fied natural beauty stands for hope, virtue, and spiritual consolation in that ugly school.

Elizabeth Taylor learned early how to play the role of beautiful woman without effort or self-consciousness, to enact the part in life as she did in movies, and it made her immensely compelling. Her luscious womanly ripeness, complete before she was seventeen years old, was added to the incandescent look she had at twelve, and they gave her an extremely traditional sort of dark feminine beauty, classic and unguarded, pure and strong, devoid of caprice or guile.

Taylor could be besotted Cleopatra or devoted Rebecca in *Ivanhoe* or a doomed Southern belle in *Raintree County*, because she herself seemed to be one of those mythical dark ladies who are all the same Dark Lady, ever since the Bible and ancient Greece. She could not only play but appear to be the glowing Brunette, who stands for imprudently excessive passion or devotion or fury, and who eventually loses out, the one who may well die or go mad or be otherwise sacrificed—for a man's duty or ambition and for the reticent Blonde who will be his ultimate prize. Taylor could have played Dido, left behind to kill herself in Carthage, so that Aeneas can found Rome and marry the Blonde; or Medea, banished from Corinth with her two children, whom she is driven to kill because Jason wants to marry the Blonde. In *The Sandpiper* she played the Bohemian Artist version of the Dark Lady, finally abandoned by the sinful clergyman lover who was already married to the Blonde.

Artlessness was a good part of the mixture. Taylor herself gave off this flavor during her sequence of public romantic attachments, most of them marriages undertaken in that spirit of optimism that made her so American as well as so universal a feminine type. She never played a feline, devious, and manipulative schemer, in life or on film. Trouble sought her, she never perversely invited it or deliberately stirred it up. The classic Dark Lady may often go all out for vengeance, like Medea; but she is never an enterprising and accomplished villain, like fatal faithless Carmen in her many avatars. Carmen would be no part for Elizabeth Taylor—too much active sinew, raunchiness, and stratagem, not enough breathtaking physical perfection and helpless rushes of feeling. The true Fatal Woman may even be nonbeautiful, and certainly nondark; her power lies elsewhere.

When Taylor played Katharina in Zeffirelli's 1967 film version of *The Taming of the Shrew*, she once again showed off her beauty's aptitude for

period costume, so familiar in many other movies. Her figure is universal, too, fully fleshed and apparently boneless in the classical manner, and her short stature, straight spine, and full bosom have always been well set off by the long skirts of olden days. Her rounded chin and oval face have always gone well with period headgear, however ridiculous or lofty: she looked fine in a Nefertiti hat as Cleopatra, and in a towering white wig as the sweetheart of Beau Brummell. But in *Shrew* she combined period beauty not only with ferocious rage, which she had done so well in *Who's Afraid of Virginia Woolf* the year before, but with high comedy, also a new twist; and with some real pathos. We began to see the New Dark Lady she was becoming.

As the 1960s and her thirties were ending, she began to play the part of Fading Beauty, on film and in life; and she became much more interesting to her public. More hysteria and bitterness, more anxiety and desperation came to flavor the perfect face and body; and she began to gain weight. Her personal life became more baroque, along with her figure and her roles; she lost the weight and gained it back; she had well-publicized medical crises; she began to seem truly human, more like the fleshy brunettes of real life.

This gave her iconhood more dimension than ever. A tinge of the victim, never absent from her Dark Lady role and image, was subtly increased and gave zest to public perception of her now-threatened perfect beauty. Leveled at her chin and waistline, her fans' gaze sharpened as they held their breath. An obscure satisfaction could be felt at the precariousness of her perfection, at the incipient overripeness in the line and texture of the classic dark goddess who had reached her physical peak at seventeen.

She is indeed of a type that easily thickens and coarsens, the sort whom poets once urged to gather rosebuds while they might. Taylor kept on gathering, and to go with maturity she married a silver-haired senator. He harmonized nicely with the becoming public clothes that suited her new and riper age, shape, and station; and the role, too, suited her well for a time. It kept her from even slightly resembling an overblown and superannuated diva, when it was certainly much too soon for that. She kept her beauty. It underwent more changes and continued at full strength.

The artlessness remained, with no increase of somber wisdom or

harsh cynicism, and with it her undeniable intelligence; and both of these have kept her continuously appealing. Her intelligence had already come through strongly in *Shrew* and even more in *Virginia Woolf*, where she had deliberately canceled the beauty and won an Oscar, and it has been consistently borne out in her personal interviews on television. I heard one anecdote about her, too: a writer I knew happened to be at her house in the late 1950s and spoke about a strange portrait of her over the mantel. "Do you think it looks like me?" Taylor asked. "That doesn't even look like a human being!" exclaimed my friend, and Taylor flatly replied, "I am not a human being." At that date such a thing wasn't usually said aloud by famous movie stars intently fostering the image of an outsize humanity. Taylor clearly knew the score and did not kid herself.

Taylor's partial eclipse has come from the fact that her roles in life and art, so closely linked, have not been the most important recent ones for women. The Dark Lady is not a loser in today's world, though she may be again in future ones. Instead, the eternal Fatal Woman has come to the fore in many fictions, especially the ruthless and lethal villain played by Sharon Stone or Kathleen Turner or Glenn Close in the blond version, or by Demi Moore, Linda Fiorentino, and other sulfurous new brunettes, all of them purposeful, wised-up, and heartless in very un-Taylor-like ways.

The *grande amoureuse* is out of style, the woman who risks all for love, like Cleopatra, or who is swept into earth-shaking adultery by the will of the gods, like Helen of Troy. So is the straightforward adventuress or professional beauty, in the manner of Gloria in *Butterfield 8*. Present-day adventuresses have separate ambitions and don't make careers entirely out of liaisons or marriages. Apart from the painter in *Sandpiper*, Taylor has rarely played somebody with professional work to do. She's been Wife, Daughter, Queen, Siren, Sister, Mistress, Mother—and she's done no housework, either. Just like Mae West, Elizabeth Taylor has never worn poor women's clothes on the screen, the tacky uniforms or faded housedresses that Claudette Colbert or Sophia Loren might wear. In modern or period modes, in life or on screen, vivid and carefully designed clothing has always rightly complemented the classic style of Taylor's dark looks, along with no jewelry or very serious Jewels, when circumstances warranted.

And the darkness is an absolute. The one time she was seriously miscast as a beauty was as golden-haired little Amy in the 1949 version of *Little Women*. The curled blond wig on top of her precociously mature body gave her pretty-little-sister role a dreadful whorish look; and in fact, Elizabeth Taylor should never have been in that movie, in the same family with June Allyson, Margaret O'Brien, and Janet Leigh. Modest, old-fashioned domestic fun was not a note she could convincingly strike.

Since Taylor's beauty has always been the central expressive agent of her talent, it sometimes got in the way of her characterization—as Maggie in *Cat on a Hot Tin Roof*, for example, where she was much too spectacular for the part, though she played it very well. If Taylor ever publicly permits her beauty to desert her, although I doubt she will, she might come back in *Virginia Woolf*-style character parts. She might even decide to take up the role of Serious Actress, one she has never played in films, nor much in life. That role does sit a bit uneasily with the Taylor icon, based as it is on immediate feeling and lack of cynical calculation: a serious actress is basically a faker. Taylor hasn't played an opera singer, a ballet dancer, or a music-hall song-and-dance artist, either. To satisfy the public eye, Taylor's concentrated physical quality could not seem at home with the vigorous bodily distortions required by active work in show biz. Her own role as Dark Lady following her feelings and having her difficulties has been echoed in her films, so that people could easily forget that she has been a professional performer all her life.

Taylor has appeared on the actual stage, perhaps to confirm her existence as an actual actress; but the roles I know about were not ideal for her gifts. Worldly Amanda in *Private Lives* has no room for Taylor's essential innocence, and Regina in the *The Little Foxes* has too much wily malice for her impulsive optimism. Besides, although both parts go perfectly well with Taylor's brains, neither can use her lush body to advantage. In fact, the mundane stage, where illusion is paramount, is no place for this mythic creature, who has always played herself in the purest cinematic tradition.

Little Women *in the Movies*

The successful recent version of *Little Women* (1994) puts a movie fan in mind of earlier attempts to render Louisa May Alcott's book on film, and to compare the qualities that mark each as belonging to its moment. Each *Little Women* film, moreover, still demands from an Alcott fan a stern comparison with the book, which is rich enough in psychological and material detail to read like a screenplay, at least sometimes. Alcott's novel, although based on her own family history, is nevertheless a careful work of art, an honest effort to turn the fruits of personal experience into fiction, not autobiography. But her story is full of unconscious fantasy, to which her later interpretive screenwriters are often more faithful than they are to her conscious and conscientious artistry.

All three versions within living memory—1933, 1949, and now 1994—have omitted, for example, most of the religion that permeates the novel, personified by the wise, unworldly father of the family, to whom all final moral and spiritual authority is given, and whose august male presence is perpetually felt, whether he is present or not. This absent but potent domestic deity is given short shrift by the moviemakers, so that his late bewhiskered arrival and presence on the scene lacks the dramatic emotional importance Alcott gave it and makes him into a mere prop. The male characters have a similarly thin quality in all three movies, although Alcott worked hard to give them distinct psychological dimension and personal flavor. She made Laurie incredibly hand-

some, sexually attractive, and sexually enterprising, a musician and vigorous lover of beauty—altogether too much for unsensual, clumsy Jo.

The latest film version preserves the custom of short-changing the males, especially the father. It's part of an effort to keep the girls' struggles moral and practical, not spiritual or sexual, to evade the essential patriarchal core of the story to which Alcott paid such careful attention. Gillian Armstrong, the director of this new version, even insists that the consciousness of Jo March be wholly identified with Alcott's own and be at the core of the film. Jo's existence as a writer is the whole point, the emotional and sexual center; it allows the film's own existence. Armstrong makes Meg prissy, although Alcott makes her ideally womanly, and her lover, Brooke, is buttoned up and fussy, although Alcott makes him dark, sweet, and serious. Modern-style moral authority is given to Susan Sarandon as Marmee, whose fitness for it is displayed by her objection to child labor, slavery, and corsets, but who has no visible religion. She is shown to have advanced views, lots of spunk, and to be outspoken, so we can see where Jo got it; and the film makes those qualities into the paramount female virtues, sexually attractive into the bargain. Literary judgment, the other authority which Jo needs and which her mother lacks, is here also made erotic by Gabriel Byrne, fresh from playing Byron, now giving us Professor Bhaer as a held-over Romantic with dark hair, intense gaze, and no glasses.

Alcott herself tried to be even-handed in her sympathetic treatment of the four sisters, especially in the second half of the book, when everybody is grown up. There we get what all three movies lack— the personally hard-won transformation of Amy from a selfish brat to a woman both truly virtuous and sexually attractive—the object, clearly, of Alcott's own envy. The filmmakers, especially Armstrong, who are intent on Jo's awareness as Alcott's stand-in, don't mind skipping this crucial change, so the romance between Amy and Laurie, lengthily worked up by Alcott, is given short shrift in all three films. In the book it has the flavor of inevitability: the two acutely erotic creatures properly get each other, and Jo gets the ultimate God-the-Father figure, the benevolent "Jovian" professor. From his brow, Jo as Athena may forever leap fully formed and fully dressed, with no involvement of Eros.

For viewers of George Cukor's 1933 *Little Women*, the look back at family love and home-made pleasures, enjoyed in long skirts and horse-

drawn vehicles, contrasted favorably with harsh modern horrors, to say
nothing of harsh modern pleasures. Poverty, all too grim in breadlines
and Hoovervilles, in the filmed March home had the comfortable glow
lent by historical distance, which also gave conviction to expressions of
courage in the face of want. At the time, such expressions might even
truly hearten those for whom the safe nineteenth century seemed only
a few years back, and modernity a real shock. Some of them, perplexed
by the idea that fast cars and fast music are ultimate delights, doubtless
agreed with Thornton Delehanty, who wrote in the *New York Post* at the
time that the film was "a reminder that emotions and vitality and truth
can be evoked from lavender and lace as well as from machine guns and
precision dancing."

The screenplay, by Sarah Y. Mason and Victor Heerman, frequently
borrowed word for word from the book; and in fact the nineteenth-
century tone could still be unselfconsciously assumed by screen actors
in 1933, many of whom, like Katharine Hepburn, were accustomed to
stage rhetoric and at home with theatricalized expression. The addi-
tional material fitted in well with the Alcott transcriptions; and the gen-
eral atmosphere of effortless decorum in the film threw Hepburn's
farouche quality into fine relief. She flung herself about with just enough
abandon to look right as gawky Jo, without being gawky at all, only
modern and ready to move away from Victoriana. Hepburn looked just
as great in the March family theatricals wearing boots and doublet as she
had on the stage playing Rosalind. In either case, audiences knew she
was still a proper feminine heroine quite prepared to wear skirts and fall
in love, even though the original Alcott story makes her truly ungainly
and prickly, quite unfit for nice dresses and coquetry.

The 1949 screenplay was virtually the same as the earlier one, with
additional material by Andrew Solt, and it is a self-conscious fifties
update directed by Mervyn LeRoy. The same dialogue carries less con-
viction but is given more emphasis, and the additional material and
direction simply underline and make unrealistically obvious what was
rendered with sublime ease in the first. The 1949 Technicolor helps and
hinders in its usual way—it's more fun but less real—and enables the sis-
ters at least to have hair of the right color. Disbelief is far more painfully
suspended at the sight of gorgeous, strapping seventeen-year-old Eliza-
beth Taylor as Amy, playing the younger sister of tiny and waiflike

twelve-year-old Margaret O'Brien, than it was at the sight of slightly pregnant Joan Bennett playing Amy in 1933. As usual in 1949, every head is rigidly coiffed, the girls' faces are always thoroughly made up, and everybody's clothes look straight from an expensive department store. So does everything in the house, despite the loud talk of family privation.

While once more telling the story of the impoverished Marches, this film actually celebrates the fresh postwar pleasure in acquiring sleek new possessions. The 1949 March girls don't just dream of what they'd like to buy with their Christmas money, before really spending it on presents for their mother; they actually make a gala expedition to the general store and purchase wonderful things for themselves with great fanfare. Then they change their minds, take everything back to the store, and buy brand-new useful gifts for Marmee—no homemade presents from these dedicated young consumers. Two elaborate shopping trips in rapid succession are required. The national female pastime for the next decade is thus clearly marked out, in the context of virtuous domesticity and family love. Girls henceforth must stay home and prepare to have large families, which they must lovingly supply and resupply with new purchases in all categories. The Alcott March family's makeshift, homemade amusements and threadbare arrangements are visually played down in this *Little Women*—postwar Americans could not find such signs of poverty entertaining. What was clearly very pleasing, however, was the sight of many girls in full skirts, with aprons firmly tied over them.

June Allyson's Jo flings herself around far too much, so that her skirts often go straight up and allow many total views of white pantalettes—an effect no doubt considered comic in 1949 but truly out of bounds in the 1860s, tomboy or not, and in the 1930s, too. The parents, however, are in fact well played by none other than Mary Astor and Leon Ames (Father actually has more than one scene), who had some fine practice together in the immortal *Meet Me in St. Louis* a few years earlier, even then being the parents of Margaret O'Brien in a different family of nineteenth-century girls. The memory of that film, rather than of Alcott's story, sustains these good performances—O'Brien's, too—in an otherwise arch, rather hysterical movie, and accounts for its musical-comedy take on the nineteenth century. Astor is a truly beautiful woman; her serene maternity is a joy to behold, in St. Louis or in Concord.

Gillian Armstrong's new film was written by Robin Swicord, and

Alcott's own fictional dialogue has largely gone by the board. Instead, we get what sound like some entries from her journal, read in voice-over by Winona Ryder's Jo. We also get a great deal of entirely modern dialogue apparently designed to create a believable reality for these creatures from an American world almost a century and a half gone. But it is possible to recognize a few holdovers from the two earlier screenplays, included as if in deference to cinematic tradition. Jo's New York night at the opera with Mr. Bhaer, for example, does not occur in the book, and it is here given an impossibly out-of-period amorous cast. It was, in fact, a wholly out-of-period social impossibility for the earlier film-Jo and film-Bhaer. Alcott's Jo did not go out alone at night with strange gentlemen; her evening excursions in New York are made under the wing of Miss Norton, a mature and cultivated spinster in the boardinghouse.

Whereas the period detail, especially the period shabbiness contrasted with the period luxury, is admirably rendered in Armstrong's film along with wonderfully evocative color and lighting, the modern language is largely out of keeping—certainly the diction, as well as many of the lines. The present-day habit of speaking in pinched, squeaky tones and slurred syllables was not tolerated in the 1860s in the March class of society. Educated speech was of utmost importance in maintaining self-respect, especially among people who had lost the solid income that used to sustain their honor in the public eye. The public ear, including that at home, could not be deceived. These gentlewomen, though distressed, would have been instantly known as such to others and to themselves, in large measure by their clear articulation and modulated tones.

Winona Ryder as Jo talks with the same crude, chirpy squawk she used in *The Age of Innocence*. In that movie, simply because of her speech, Ryder was not believable as an upper-class girl in Edith Wharton's Old New York; but this new film role seems intended to resonate with her performance in the earlier one. It's clear that strength of will, not a credible speaking voice, is the desired quality for Ryder as a woman of the nineteenth century, but her acutely modern utterance keeps both performances linked to her modern movie persona. In like manner, Susan Sarandon's Marmee has been invented to rhyme with Sarandon's several attractive-feisty-woman-and-heroic-mom parts

rather than with the gentle Alcott character. She also says "different than," in present-day incorrect fashion.

The film is nevertheless an emotional success, by virtue of its excellent condensation of much more of Alcott's dramatic sit-com material than the others used, and some really good acting, especially by Claire Danes and Kirsten Dunst as ailing Beth and little Amy. In this version we get the vengeful burning of Jo's manuscript, the ice-skating disaster, and the Pickwick Club and Post-Office as well as the theatricals. We even get a few (invented and modernized) scenes in Europe between adult Amy and Laurie; but we don't get grown Amy attracting serious respect and admiration for behaving nobly at the charity fair, or Meg having serious problems as a new wife and mother. Alcott's own ambivalence toward her sisters and sense of her own superior importance apparently still allows cinematic emphasis to fall only on Jo's struggles for the moral and aesthetic high ground. I believe Alcott the earnest writer would be sad to know how many of her well-rounded situations and characters have been slighted on film, in favor of the things about herself she was aiming to transcend in her fiction.

Remarkable in the present version is Jo's utter lack of the lanky physical awkwardness Alcott made into such an important social failing. Fictional Jo's bodily rebellion against polite feminine society has to be omitted, since polite feminine society itself can no longer be credibly represented, and Ryder's neat, tiny prettiness has to convey eager Jo quite differently. Instead of Jo seeming modern against an old-fashioned background, the whole of Concord is as modern as she is, especially Marmee, with only Meg and Brooke made unusually prudish and reactionary, and the formerly thunderous and terrifying Aunt March quite subdued.

Although this Jo can still believably say she longs to be a man, she can't believably say she'll never marry, as the book's Jo could. That's because her blunt boyishness and sympathy with boys are missing; even the scheme to found a boys' school is here transferred to Marmee's invented restless imagination, and Ryder's Jo is left simply with the longing to write professionally. There should be no problem with this, either, since she's already embarked on *Little Women* during the course of the film, and she must be aware that serious female authors abound in the canon. But this Jo also seems a singularly uneducated girl. Despite

her eagerness to quote Walt Whitman, she permits herself to call Dickens's novel *Dombey and Sons*; and no editor has corrected her. Not even her learned professor.

The contemporary feeling expressed in these three movies from different epochs is essentially a taste in cinematic women. Through the medium of a beloved girl's story, each displays the current fashion in what girls in movies should be like. And that means specific girls, the most popular stars of the moment who have done their thing in other movies—or on television, as in the modern case of Claire Danes, from the *My So-Called Life* series. The mirror of modern life is not at issue; it's the film performances that must measure up to the good movie life in each decade and offer the desired range of known female flavors. Hepburn with her refined recklessness backed up by ripely sullen Joan Bennett, Allyson with her girl-next-door bounce backed up by sexy Taylor and sweet Janet Leigh, Ryder with her smile and chirp backed up by fiendish little Dunst, artless and inward Danes, and wild Sarandon—these are bouquets of the most-wanted movie girls from the 1930s, the 1950s, and the 1990s. All are doing their special turns, each capturing the several momentary notions of Little Womanhood for their time—screen little womanhood, that is. We can only wait eagerly for what the next group will be like, after the millennium; but we could probably reconstruct the silent *Little Women*, made in 1918, from what we know of the movie girls of that date. Had Alcott been able to make movies instead of novels, her contemporaries might have seen Meg the Sweetheart, Jo the Rebel, Beth the Sufferer, and Amy the Princess in their own favorite living versions. But Alcott as film director would undoubtedly have favored Jo, too.

Other Arts, Other Legends

Little Women: *The Book*

Little Women has been a justly famous children's classic for a century, even though none of the characters is really a child when the story begins. Amy, the youngest, is already twelve, well beyond the age at which girls first read the book. In consequence, this novel, like many great childhood books, must serve as a pattern and a model, a mold for goals and aspirations rather than an accurate mirror of known experience. The little girls who read *Little Women* can learn what it might be like to be older; but most important, they can see with reassurance in Alcott's pages how the feelings familiar in childhood are preserved in later days, and how individual character abides through life.

A satisfying continuity informs all the lives in *Little Women*. Alcott creates a world where a deep natural piety indeed effortlessly binds the child to the woman she becomes. The novel shows that as a young girl grows up, she may rely with comfort on being the same person, whatever mysterious and difficult changes must be undergone in order to become an older and wiser one. Readers can turn again and again to Alcott's book solely for a gratifying taste of her simple, stable vision of feminine completeness.

First published as "Reflections on *Little Women*," *Children's Literature* 9 (1981), pp. 28–39. References to *Little Women* in the text follow the reprinted "Centennial" edition published by Little, Brown in 1976.

• • •

Unscholarly but devoted readers of *Little Women* have often insisted that the book is good only because of the character of Jo. Most modern response to the novel consists of irritation at the death of Beth and annoyance at Amy's final marital success, accompanied by universal sympathy for Jo's impatience with ladylike decorum and her ambitions for a career. In current perception these last two of Jo's qualities have appeared to overshadow all the struggles undergone by the other sisters, in a narrative to which Alcott herself tried to give an even-handed symmetry.

The character of Jo is the one identified with Alcott, not only on the biographical evidence but through the more obvious interest the author takes and the keener liking she feels for this particular one of her four heroines. For many readers the memory of Jo's struggles remains the strongest later on. This enduring impression, along with dislike of Amy and impatience with bashful, dying Beth, may reflect the force of the author's own intractable preferences, not quite thoroughly transmuted into art.

But art there certainly is; and among those readers not themselves so averse to ladyhood as Jo or Alcott herself, or so literary in their own personal ambitions, there are other problems and conflicts in *Little Women* that vibrate in the memory. Alcott's acuteness and considerable talent were variously deployed among her heroines; and by using a whole family of sisters for her subject, she succeeded better than many authors have since in rendering some of the complex truth about American female consciousness.

It remains true that among the sisters Beth receives somewhat summary treatment and the least emotional attention. She is there to be hallowed by the others, and for that she is in fact better dead, since her actual personal experiences are not very interesting even to her creator. Her goodness serves as a foil to the moral problems of the others; we really cannot care what her life is like for her. None of us, like none of them, is quite good enough. Beth's mortal illness, moreover, is accepted with no advice from medical science. She seems to die a moral death, to retire voluntarily from life's scene so that the stage will be more spacious for the other actors.

The badness of the three other sisters, however, like their virtues, is

more interestingly distributed than is usually remembered. If one can set aside the pervasive memory of impulsive tomboy Jo, whose only fault now seems to have been being ahead of her time, we can see Alcott's moral scheme more clearly. The novel is not just Jo's story; it is the tale of four Pilgrim's Progresses—admittedly with Beth fairly early out of the race, having won in advance. The three others all have thoroughly realistic "bosom enemies," personal failings that each must try to conquer before their author can let them have their rewards. It is clear enough that certain of these failings privately seemed worse to Alcott than others, but she gives them all a serious look, keen enough to carry across generations into modern awareness.

As the book transparently shows, Alcott cared a great deal about troublesome anger and rebelliousness and nothing whatever about shyness; but she does give a lot of thought to vanity, envy, selfishness, and pride. She likes literature and music much better than painting and sculpture; but she has a strong understanding of frustrated artistic ambition and the pain of not being very good at what you love best to do. Meg, for example, is the only sister with no talent, except a fleeting one for acting in childhood dramatics. Her chief struggle is with envy, and it is manifestly a harder one for a girl with no intrinsically satisfying and valuable gifts. She has only personal beauty, in a period of American cultural history when fine clothes really mattered.

In the second half of the nineteenth century feminine dress made strong visual demands, and the elements of conspicuous consumption had a vigorously gaudy flavor and an imposing social importance. Modest simplicity in dress and furnishing was unfashionable and socially degrading; and Meg is keenly aware that her own good looks would have more absolute current worth if they might always be framed and set off by the elaborate and costly appurtenances of contemporary taste. Fortunately, she is not only beautiful but also basically good, and so able to respond spontaneously to true love in simple garb without any mercenary qualms when the moment arrives. Later, however, as a matron of slender means, she has some very instructive struggles with her unconquered demons. Alcott is careful to demonstrate that such inward problems are not solved by love, however true it may be.

Meg, in any case, has no trouble being "womanly"; her rebellion is entirely against not having the riches that she rightly believes would show her purely passive, feminine qualities to better advantage. Moth-

erhood, wifehood, and daughterhood are her aptitudes, and she has to learn to accept the virtuous practice of them without the scope and visibility that money would make possible.

Jo is famous for hating feminine trappings and for wanting to get rich by her own efforts, and thus apparently has no real faults by modern standards. "Womanliness" is not for her, because she is afraid it will require idiotic small talk and tight gloves. The roughness of manner for which Jo suffered was called "unladylike" at the time, and thus the character earns a deal of sympathy in the present, when "lady" is a derogatory word, and most nineteenth-century views of middle-class female behavior are under general condemnation. In fact, despite the red-flag term, Jo is never condemned by her family, or by her author, except for what we still believe is bad in either sex: quickness of temper and impatience, lack of consideration and rage. Otherwise, her physical gracelessness is lamented but not chastised, and the only prohibition that seems really strange is against her *running*. This requires explanation.

The nineteenth-century stricture against running for ladies seems to have been an aspect of sexual modesty, not simply a matter of general decorum. In an age before brassieres, when corseting constricted only the thorax below the breasts, a well-behaved lady might not indulge in "any form of motion more rapid than walking," for fear of betraying somewhere below her neck the "portion of the general system which gives to woman her peculiar prerogative as well as her distinctive character."★ Bouncing breasts were apparently unacceptable to the respectable eye, and at the time only the restriction of bodily movement could ensure their stability.

Freedom-loving Jo is not loath to accept male instruction and domination; she is delighted to submit to her father, just as the others are. She is afraid only of sex, as she demonstrates whenever Laurie tries to approach her at all amorously. Jo's fear of sex, like her impatience, is one of the forms her immaturity takes, well past the age when an interest in sex might seem natural. Her fear erupts most noticeably during the period when Meg, who is only a year older, is tremulously succumbing

★Attributed to William A. Alcott, an influential educator and writer on educational subjects in the mid-nineteenth century. The phrase is quoted in Robert Palfrey Utter and Gwendolyn Bridges Needham, *Pamela's Daughters* (New York: Russell and Russell, 1936), p. 384, an extremely interesting survey of changing tastes in literary heroines.

to John Brooke's attractions. Jo, far from feeling any sympathetic excitement about this, or any envy of the delights of love, is filled with a fury and a misery born of terror. She is not just afraid of losing Meg; she fears Meg's emergent sexual being and, more deeply, her own. Later, she is shown as preferring literary romantic heroes to live ones, who might try to arouse her own responses. Very possibly many young girls who read about this particular aspect of Jo's late adolescence may find that this, too, is a sympathetic trait, along with Jo's hatred of the restrictive feminine "sphere."

The three older "little women" have faults of a fairly minor character—feminine vanity, impulsiveness, shyness—which are often objectively endearing and are also apparently so to the author herself. These weaknesses are shown to be incidental to truly generous natures: Meg, Jo, and Beth are unquestionably loving and good-hearted girls. Amy, the youngest, is basically different and (to this reader at least) much more interesting.

Amy is undoubtedly the Bad Sister throughout the early parts of the book. Alcott seems to have very little sympathy for her shortcomings, which are painted as both more irritating and more serious than those of the other girls. She is the one who is actually bad, whereas the others are only flawed, thus:

Meg—pleasure-loving and vain
Jo—quick-tempered and tomboyish ⎫ *generous*
Beth—shy and timid ⎭

Amy—conceited, affected, and *selfish*

One is tempted to believe that Alcott detests Amy for those same traits that George Eliot seems to hate in certain of her own characters: blond hair, blue eyes, physical grace, and personal charm. And Amy's faults are not endearing. This sister, judging from her behavior in the beginning at least, is really both nasty and pretentious—a true brat; and not only that, she is the only one seriously committed to high standards of visual appearance, that well-known moral pitfall.

I have heard Amy described as "insipid," as if literary blondness must always guarantee a corresponding pallidness of character; but in fact her inward conflicts are harder than those of her sisters, since she has much

graver faults to overcome. And she is successful, not only in conquering her selfishness, but in turning her love of beauty to good spiritual account. It is not for nothing that Alcott has given her a "determined chin," wide mouth, and "keen blue eyes," along with the charm and blond curls that seem to blind all eyes to her real strength and to inhibit the interests of most readers. Amy has a hard time being good—all the harder because she has an easy time being pleasing—and gets hated for it into the bargain, even by her author. But Alcott is nothing if not fair, and she is scrupulous in her portrayal of Amy's trials, especially her efforts to be a serious artist, even though she writes of "artistic attempts" with considerable condescension. Alcott seems to find visual art somewhat ridiculous, whereas literature is *de facto* serious.

Unlike Jo, Amy aims for the highest with a pure ambition. Jo simply wants to be successful and to make money, but Amy says: "I want to be great or nothing." She refuses to be "a commonplace dauber." Her desire to be great is only finally and correctly deterred by the sight of true greatness during her visit to Rome; and so she gives up trying. This particular renunciation can also clearly be seen as part of Amy's refinement of character, a praiseworthy if symbolic subjugation of her overt sexuality. It may be pointed out, incidentally, that we hear nothing of any humility on the part of Jo in the face of great writing, since success, not creative excellence, is her standard.

On the face of it, Amy is a frivolous, failed artist, while Jo is a serious, successful one. But in fact, Amy's creative talent can be seen as more authentic than Jo's, because Amy does recognize and accept and even enjoy her own sexuality, which is the core of the creative self. Alcott demonstrates this through the mature Amy's straightforward, uncoy ease in attracting men and her effortless skill at self-presentation, which are emblems of her commitment to the combined truths of sex and art. Her childhood selfishness and affectation are conquered quite early; she fights hard to grow up, so that her love of beauty, her personal allure, and her artistic talent may all be purely expressed, undistorted by vanity or hope of gain. Nevertheless, the too-explicit erotic drive in Amy must be suppressed, and this can be symbolically accomplished by the transmutation of her serious artistic aims into the endowments of a lady.

Jo's literary talent, on the other hand, is qualified in the earlier part of the book, even as her sexuality remains willfully neutralized. Her writing is not yet an authentic channel for the basic erotic force behind all

art, as Amy's talent clearly is. Jo's writing, rather, is the agent of her retreat from sex—she uses it to make herself more like a man. Alcott expresses the slightly compromised quality of Jo's literary ambition (and of her sexuality) by having her primarily desire fame and financial gain, along publicly accepted lines of masculine accomplishment. She writes for newspapers in order to get paid, for instance, instead of struggling to write great poems, which might never sell. Jo can write as a true artist only later, when she finally comes to terms with her own sexual self and thus rather belatedly grows up in her own turn.

In the end, after Amy gives up art, Alcott permits her to use her taste and her aesthetic skill for the embellishment of life with no loss of integrity or diminution in her strength of character. It is Amy, the lover of material beauty, not Jo, the lover of freedom, who gets to escape and go traveling in Europe, but only after she has earned the regard of all concerned for her successful conquering of self. Jo finally says, after Amy does the right thing in a compromising social situation: "You've a deal more principle and generosity and nobleness of character than I ever gave you credit for, Amy. You've behaved sweetly and I respect you with all my heart." And Amy repeats what she has already said a bit earlier in a different way: "You laugh at me when I say I want to be a lady, but I mean a true gentlewoman in mind and manners . . . I want to be above the little meannesses and follies and faults that spoil so many women." Amy actively and painfully resists being spoiled, and so she wins—at first the trip to Europe and at last the one rich and handsome husband on the scene, not because of her blond beauty but rather in spite of it. She proves a true March daughter (and she, at least, is certainly not afraid of sex), and thus Laurie may love her at last.

Laurie, the neighboring, rich young man, finds his most important function in the novel not as a possible husband for any sister but as a student of the March Way of Life. Born to riches and idleness and personally neglected as a child, this youth is clearly destined for depravity, especially since he is half-Italian, and we must know what that means. Alcott lets this fact, plus a talent for music, stand (as she lets Amy's talent for art stand) for sexuality itself, the whole erotic and artistically creative dimension in life. Laurie, like Amy, seems always to be an

acknowledged sexual being. Alcott shows this quality in him, as she shows it in Amy, by making him a lover of beauty who reveals his commitment to it through a natural, unsought creative talent—in his case, inherited directly from his Italian musical mother—and not in detached or cultivated appreciation. In both characters, their own physical beauty represents the fusion of art and sex.

This youthful and passionate male neighbor, an obvious candidate for the dissolute life, comes under the variously superior moral influences of all the females next door—Amy at this point, however, being still a nasty child of little account. We are given a good, old-fashioned demonstration of the redeeming power of love in the persons of virtuous women. But it is, of course, love minus sex, an American Protestant love without unhealthy and uncomfortable Italian overtones, love which uses music to calm the fevered spirit of Saul and uplift the soul in German fashion, rather than to stir the senses or the passions in Italian operatic style. An energetic American lack of cynical European prurience, which Henry James often so tellingly describes, is emphasized by Alcott in her account of Laurie's relations with the Marches. Fellowship, insisted on by Jo, appears here as an American ideal for governing the conduct between the sexes. Passion had better be quiet, and perhaps it will be if no one insists on it too much in advance. Later on, Laurie tears up the opera he had tried to write about Jo. In doing this, he seems to accept the incompatibility of sex and art with love and virtue; and, like Amy in Rome, he renounces the former and thus proves worthy to regain them—suitably transformed, of course, by the latter.

The passionate, creative element—frightening, powerful, and laden with danger—is set forth disapprovingly in both Amy and Laurie as an aspect of selfishness, laziness, and generally reprehensible narcissism entirely lacking in the book's "good" characters, however imperfect they otherwise are. The action of the book in part consists in the taming of this dangerous force in both Amy and Laurie, a process which nevertheless then permits them to have one another and so cancel the threat they might otherwise represent to the rest of virtuous humanity. Amy, in an unusually explicit scene near the end of the book, after she is safely married to him, is shown stroking Laurie's nose and admiring his beauty, whereas Jo, during her long sway over him in the main part of the novel, had done nothing but tease and berate him and deflate his possible vanity and sensual temper. It is only after such harsh training for both these selfish and talented young beauties that they

may marry; and it is also obvious that indeed they must. Laurie cannot marry Jo because he is immutably erotic, and she refuses to learn that lesson. Amy is saved from the "prostitution" of a wealthy, loveless marriage, Laurie is saved from "going to the devil," because the March morals have prevailed over them both, and they agree in unison to that domination.

But it is also very clear that they have been permitted to have no reciprocal influence, to teach nothing in return. In the course of *Little Women*, the creative strength and possible virtues of art and eroticism are gradually discredited, subdued, and neutralized. Amy must give up art, Laurie must give up composing, and even Jo must abandon the sensational creations of her fantasy life— her one such outlet—so that the negative and unworldly virtues may triumph: denial of the self; patience in suffering and, more important, in boredom; the willing abjuration of worldly pleasures. The two who have understood and acknowledged the creative, positive power of pleasure in physical beauty have got each other, and the rest can get on more comfortably without it and without wanting it.

At the core of all the interesting moral distributions in *Little Women* is not sex, however, but money. The riches of patience and self-denial are especially necessary to the self-respect of the women in this particular family because it has lost its material fortune, but not because it has always been poor. It is significant that the modest Marches are not "congenitally" poor at all, and they have very little understanding of the spiritual drain of that condition. Being really poor is very different from having lately become relatively poor, in an increasingly affluent society like that of later-nineteenth-century America. American wealth in Alcott's time was in the process of reaching the outrageous stage that was later to require antitrust legislation, income tax, and other basic socioeconomic adjustments suitable to a democratic nation. The unworldly girls in *Little Women* must hold fast to what they hope are immutable values and to the capacity for inner steadfastness in a shifting and increasingly materialistic society. They are people with Old Money now vanished—a situation that could bring with it those advantages that leisure offers, such as education, reflection, the luxury of moral scruples, and the cultivation of the feelings. Indeed, these are the Marches' only legacy, and they must use and enjoy and hope to rely on

them, always asserting their superiority over material riches newly, mindlessly, and soullessly acquired.

All this provides a foundation for an enduring American moral tale, one which continues to register as authentic even in a world changed out of all recognition. A notable absence in modern life of irksome rules for female decorum still cannot cancel the validity of the view that money may come and likewise go; that the status it quickly confers may be as quickly removed; and that some other sources of satisfaction and self-esteem had better be found.

When the March girls are first introduced, the two oldest are already following the first steps to modern American female success by earning money. But they are not pursuing careers, they are simply augmenting the family income; and a particular message comes through very clearly in every page of *Little Women*. Whereas impoverished American men may make use of drive, intellect, ambition, personal force, and the resources of public endeavor in order to gain the basic honor due to self-respecting males, poor women have only the resources of tradition-ally private female power and passive virtue. And these, as suggested in the case of Meg's enviousness, are best cultivated in circumstances of material ease. Poor, middle-class women may not simply cut loose and try to make their way by their wits and strength of mind, as poor men may do, to preserve their self-esteem in degraded circumstances. Impoverished women have to bear not only poverty but the shame of poverty, because they may not wipe it out through positive action. As Amy admonishes Jo, poor women cannot even wield their moral power so successfully as rich women can, smiling and frowning according to their approval and disapproval, affecting the behavior and presumably elevating the souls of their male friends. As Amy explains it, poor and thus insignificant women who express moral scruples and judgments may risk being thought of as prudes and cranks, while rich women can perhaps do some good. Excellent goals for impoverished women seem to be to observe life closely but to keep their own counsel, to refine their own private judgments, and to develop an independence of mind that requires no reassuring responses. The female self may thus develop in its own esteem without requiring either male or material support.

Wealth—inherited, married, or earned—can thus be incidental to female personal satisfaction and sense of worth, and so can marriage. No

attitude about money must be taken that might cloud the judgment; and so the judgment must be continually strengthened, even while prudence may govern the scope of speech and action. Money may be thought of as an obviously desirable thing but clearly detachable from virtue, including one's own. One may marry a wealthy man or may inherit a fortune, or one may never do either; but one keeps one's personal integrity and freedom in all cases. Again, Alcott does not attempt to instruct the really poor, only the potentially impoverished. Being "a true gentlewoman" in this transcendent version of the American way is seen in part to consist of being supported only from within. Money and marriage are uncertain, especially for women: character lasts for life.

Alcott further demonstrates that to achieve a good character the practice of patience, kindness, discretion, and forbearance among one's fellows must totally absorb one's creative zeal. Such zeal may not be expended on the committed practice of any art, or any intellectual pursuit which might make the kind of demand that would promote the unseemly selfishness of the creative life. Alcott's little sermons against the seductions of serious art and abstract thought, at least for women, are peppered throughout *Little Women,* but she is most explicit in Chapter 34. Jo has been present at a serious philosophical discussion in the city; she feels fascinated and "pleasurably excited" until Professor Bhaer defends Truth, God, Religion, and all the Old Values. Then she is corrected: "She began to see that character is a better possession than money, rank, intellect, or beauty," or indeed, *talent*, one might believe Alcott privately added, in case it, too, should fail the severer tests of life.

Thus does Alcott excuse herself for not being a genius and justify the minority of her own gifts. The linked faculties of erotic, artistic, and intellectual scope—again, especially for women—are sweepingly dismissed in favor of the cardinal virtues. These, she shows us, not only bring their own rewards but deserve and sweeten all other kinds of success. She is careful to offer her pilgrims no serious and interesting external temptations—no quick artistic triumphs, no plausible and exciting seducers, no possibilities of easy luxury, no compelling pressure of any kind toward the compromise of honor. Therefore we get no vivid image of the bitter costs virtue may exact, the very real losses entailed by those lasting gains she so eloquently describes and advocates. She may perhaps have felt them too keenly for words.

Mary Magdalen

Mary Magdalen can't help being a suggestive character; she's always the Other Woman in Jesus' life. The Virgin Mother's essence is eternally fixed, but the nature of Mary Magdalen's otherness has been forever open to question. Christianity's long-term and variable construction of Mary Magdalen's character, history, and meaning and its diverse effects on religious and worldly life, on art and popular culture all over Christendom make a complicated tale, which has now been prodigiously expounded by Susan Haskins in one trim, powerful book. The work's power comes partly from the author's great sympathy with the immense religious, imaginative, and scholarly labor behind the many texts she has consulted. This is not a sensational essay that pretends to break free from the ancient body of other people's effort on which it really depends; Haskins is eager to share in the devotion of her sources, to join their scrupulous and patient number in explaining her own idea. Her book is a fine event, a work of impassioned scholarship.

Like many people, Haskins first met Mary Magdalen in a work of art. As a child, when she saw the print of a trecento Crucifixion, she was captivated by the golden-haired woman in red who wept at the foot of the cross; but that was at a convent school, where the Magdalen's role was always glossed over in favor of the Virgin Mary's superior glory.

Review of *Mary Magdalen: Myth and Metaphor* by Susan Haskins (New York: Harcourt Brace & Company, 1993) in *The New Yorker*, October 3, 1994.

Haskins seems to have become a champion of Mary Magdalen from that moment, inspired to plumb the depths of her legend and take up her cause; and she has at length done her full justice in what now appears as a companion and an alternative to Marina Warner's important 1976 book on the Virgin Mary, *Alone of All Her Sex*.

In any collection of Old Masters the Virgin is everywhere. Her head is veiled and her face is calm, her hands are crossed or praying when not busy with her baby. Her arms are always covered, and her legs and feet are unfailingly discreet. Whether she appears as a village maiden or the crowned Queen of Heaven, there is no mistaking the gentle Mother of God, the submissive Handmaid of the Lord. Nearly as ubiquitous is Mary Magdalen, foremost among female saints as the intimate of Christ, equal in importance to all the original disciples. But it doesn't take long to notice that the Magdalen's image has its own visual language, different not only from that of the Virgin but from that of any other saint of either sex.

Steady exposure to the saints in art yields a pretty firm sense of the fixed garb and attributes of each, the motifs that have defined them through time. Sebastian is naked and stuck full of arrows, always beardless and beautiful; John the Baptist is gaunt and unkempt, carries a cruciform staff, and wears a camel skin; John the Evangelist is also beardless and beautiful, but he's muffled in robes from neck to instep, while the equally b-and-b George and Michael always wear armor, and Michael has wings. Most of the virgin martyrs have loose hair and carry the instruments of their martyrdom so we can tell them apart; and among the vast troupe of robed and bearded Apostles, martyrs, and Church Fathers, each displays a special characteristic or two—Peter has a white beard and keys, Paul has a dark beard and sword, Jerome has a cardinal's hat. We soon realize that we wouldn't recognize Sebastian with his clothes on, the Baptist without his fur piece, George in robes, or John the Divine in the nude. But whatever separate trappings they bear, most saints in art also display a uniform solemnity of expression, a holy seriousness that sometimes veers toward exaltation during tortures or visions, or toward a certain somber pain in the face of earth's iniquities,

but that always resolves into saintly composure. Their bodily comportment is equally measured and transcendentally decorous, just like the Virgin's.

None of this applies to the image of Mary Magdalen. Her figure has a unique instability, her face a multiform emotional cast, her gestures an unpredictable range, and her hair, costumes, circumstances, and attributes keep changing. They also seem to conflict. Only a little art-historical study can lead to the conclusion that she's really the best saint, the one with the broadest saintly experience, the strongest and most contradictory human feelings, the most interesting life, and the most varied wardrobe. She acts, reflects, and feels; and she behaves with great freedom in all situations, never placing a distancing serenity between herself and what's happening, or between herself and us.

The Magdalen's life in art is one of extremes. In a Duccio painting we see her wrapped in clinging red from head to foot, coming with others toward the angel at the tomb, mournfully dipping her head as she tells him whom she seeks; in Titian's famous portrait she gazes up in ecstasy, clutching a mass of golden hair around her naked breasts and shoulders. In Rogier van der Weyden's fragment, she sits on the floor in a green wool dress and white wimple, quietly reading a book; in Botticelli's *Deposition* she frowns, kneeling with closed eyes and pushing her wet face against Christ's dead cheek, embracing his head with her veil as if to bind it to her own.

In William Etty's portrait from the 1840s, she sits stark naked except for earrings, thrusting up her plummy nipples and showing off her furry crotch as she lets her hands hang down and glares fiercely at a nearby crucifix. For Hugo van der Goes she is robed in stately brocade, her red hair bound up in delicate braids, one slim hand balancing an ointment jar; in Correggio's painting she flops to the ground on her stomach like a teenager, pushing up her rippling yellow hair as she props up her head to read, sticking her bare feet out below the thick drape around her middle. Masaccio's *Crucifixion* shows her from the back, sinking down under a heavy red cape at the foot of the cross, while both arms rise up stiff with grief.

In some paintings Mary Magdalen is borne up to heaven by angels, covered only in what looks like her own thick pelt. In some portraits she scourges herself and weeps naked in a cave, accompanied by a skull.

In still others she sits at a jewel-strewn dressing table, wearing lush décolleté satin and a worried face; elsewhere she wears the smug features of a royal mistress above milky nudities veiled in curls. And in one twelfth-century psalter she appears in a figured cloak, sandals, and a neatly pleated wimple, eyes wide with vision and one eloquent finger raised, announcing Christ's Resurrection to eleven stunned disciples.

The sculptors gave her limbs and clothes a vivid turn: Bernini drapes her in twisting fabric, her nude body so twisted with sorrow that her knees give way and she falls against the side of her niche. Her twisting hands are clasped to her tearful cheek, her jar sits under one unsteady foot. An earlier sculptor turns her into a maenad, arms flung out, veil flying wide, face a mask of rage. Donatello alone among Renaissance sculptors shows her old, her face hollow with long suffering, her dress an animal skin. We are poignantly reminded that this saint had no early martyr's death.

In almost all her images Mary Magdalen is young, beautiful, and full of sentient vitality, whether she's wretched and naked or soberly draped, nervous in silk, swooning in hair, or cheerfully arrayed to tell the good news. Her most usual attribute is her covered jar of ointment, which she brings along to works of art when she needs to be picked out immediately. Her other signal attribute is her emphatic hair, often uncovered among veiled heads, often abundant and undisciplined; but we have seen that her hair may be hidden and her jar absent. Bitter tears, too, she often sheds; but she evidently knows love and fury, spiritual transport, thoughtful concentration, great dignity, and deep anxiety. In fact, the conflicting data, the suggestive drama, and often the sheer beauty of the Magdalen's apparitions in art may well send the viewer straight back to the Bible for the real story. What is behind all this?

The story is amazingly sparse. Spread out among the four Gospels are references to a Mary Magdalen whom Jesus cured of seven devils, who followed him as a disciple, and witnessed his Crucifixion. She also observed where Jesus' body was stowed, but when she and other women went back to prepare it for proper burial, they found the tomb empty and an angel waiting. When the angel told them Jesus was risen, Mary and the others told the disciples, who didn't believe them and came to look for themselves. In the Gospel of John, however, Mary Magdalen goes by herself with the funerary unguents, weeps alone at the empty

tomb, and then alone meets the risen Christ in the garden. They speak, and he tells her to tell the disciples of his Resurrection; she does, and in this version they believe her.

That is the sum of the Mary Magdalen story. But, of course, there is the other Mary who lived in Bethany, the sister of Martha and Lazarus, who sat at Jesus' feet and let her sister do the housework, and whom Jesus approved for this. Near the time of his betrayal, when Jesus was again in Bethany having supper at Simon the Leper's house, a woman opened a jar of expensive ointment and emptied it over Jesus' head, causing the shocked disciples to object. Jesus told them to let her be, she was doing it for his burial and would be remembered for it. But this woman with the jar has no name, except (again) in the Gospel of John, where it is firmly stated that she was Mary, the sister of Martha and Lazarus. John, moreover, plainly says that she poured the ointment on Jesus' *feet*, not his head, and wiped them with her hair. So we have one Mary anointing Jesus in life and a different Mary attempting to do so after his death, each of them his close friend.

And then there is the dramatic story, told only in the earlier Gospel of Luke, of how Jesus scandalized his friends by agreeing to dine in the house of Simon the Pharisee. At this urban dinner party, an unannounced woman arrived whom the others immediately recognized as "a sinner." She stood weeping behind Jesus, washing his naked feet with her tears (the dinner guests would have been reclining) and drying them with her hair, after which she kissed them repeatedly and rubbed them with ointment from an alabaster box. Looking on in disgust, Simon the Pharisee decided Jesus couldn't possibly be a true prophet or he would have known she was bad and rejected her attentions. But Jesus instead told a story about forgiveness, and went on to forgive the woman her sins because of the love she had just shown him—pointing out that Simon, the proud host, had offered him no marks of respect whatsoever. Then Jesus told the woman that her faith had saved her and bade her go in peace, and that's the last we hear of her. For all the Gospel says, her name could have been Rachel or Deborah, and her sins those of cruelty and bearing false witness.

But Haskins describes how the Fathers of the Church, in developing and codifying the elements of Christian faith, could not resist the temptation to blend this woman with the two Marys, and to make them all

into one person. The first two could share tears, hair, ointment, and devotion between them, along with those obscure devils, and easily become one. But then, if you cleverly added the wicked woman in Luke's Gospel to her character, you could lay on her shoulders the role of Sinner and the burden of Repentance, theretofore missing from any Mary, but increasingly necessary to Catholic belief and practice.

Thus Mary of Bethany, the eager listener who understood Jesus' destiny before anyone else, and Mary of Magdala, the loving mourner who first saw the risen Christ and told all the others, eventually became merged and identified with a third woman, now adroitly christened Mary Magdalen, who became the figure of the penitent sinner saved by faith. The unhappy woman at the foot of the cross could then not merely mourn her dead leader but weep for the world's sins that had brought the Son of God to this pass.

But there was more. As a woman, Mary Magdalen could weep not just for all human sins but for the permanent stain of mankind, the inherent sinfulness of the body. She is, of course, a very physical saint. Her own body—through her eyes and hands, her tears, hair, and gestures—is the vessel of her devotion; and her tactile spiritual offerings are delivered without any question of sin. But if she's to represent Sin itself, she must correspond to frail Eve, who touched the apple and thereafter introduced both sin and sex to the entire human race. And so Mary Magdalen, with her active hands, eager kisses, and fluent hair, can easily come to stand for sex and sin together. She became the saint who represents the whole fleshly process whereby Eve's presumption and disobedience were passed on to later generations through her body, which forever tainted the original sin with carnality. Only a Virgin Mother could produce the redemptive Christ; every other human female was the image of Eve, the mother of sin and death.

To counter the sinless virginal maternity of the Virgin Mary, Magdalen's own personal sins had to be entirely sexual. Her cast-out devils had to be the demons of lewdness, and the faults known to the Pharisee's guests had to be lechery and fornication. The Church gave her the task of fomenting constant war between the flesh (always female and tempting) and the spirit (always male and pure). It was steady work for quite a while.

The occupation of the Magdalen's later life came to be figured as the

endless self-abasement of an endlessly seductive but endlessly repentant prostitute. This moral condition would naturally include a steady hatred for the vain trappings of the profession—all those repulsive silk dresses, loathsome jeweled bracelets, and sickening gauzy chemises with their nauseating lace. Only total nakedness could rightly become her, the dress of innocence (including Eve's artless and endless hair) recovered through penitence, as she kept out of men's sight in a cave and brooded on salvation. Of course, an artist might find her there and glimpse a pearly flank. Deep in prayer, she wouldn't notice him sketching.

Thus the nameless sinner in the Gospel of Luke eclipsed the two staunch Marys, troubled the waters of Christian theology, and immensely enriched the Magdalen's artistic and legendary history. Her allure simultaneously produced centuries of great strain in the Church's policy about women's role in religion and great stress in women's actual lives throughout Christian society. Her appeal remains potent right now, and Susan Haskins tackles it head on. Her book glows with a personal zeal that irradiates its careful scholarship; she has mobilized her large project by taking a definite stand on her subject. With all her fairminded, good-humored, and thorough inquiry into every view and facet of the Magdalen's long story, she is herself a partisan.

She wants to reclaim and celebrate the original Gospel character named Mary Magdalen, to detach her from the devout girl in Bethany and certainly from the weeping sinner at the Pharisee's house. That, she tells us, is indeed what the Eastern Church has always done. And when we do it, and we get away from sin, repentance, loose hair, and expensive oil, we see a very different and very specific saint. She becomes the Apostle to the Apostles, the one who first witnessed and then announced Christ's triumph over death, which was the Church's founding moment. This makes Mary Magdalen the first prophet of the new religion, the very first of Christ's disciples to see and hear, to believe and speak—the first Christian. Haskins is careful to point out that Mary Magdalen and the other women who traveled with Jesus were not different from his male disciples, that men and women had equal functions in the spreading of his gospel. Later translators, however, rendered the same Greek word as "followers" for women and "disciples" for men, as if to suggest that the women had tagged along to make the coffee.

Haskins also reminds us that Jesus himself treated women as equals

and paid no attention to their famous uncleanness or conventional infe-
riority. During his ministry, he made no distinction of value between
male and female works, words, or faith. As a result of this, the Early
Church in its first few generations had both male and female teachers
and leaders, including priests, deacons, and bishops. Such practices, so
foreign to both Jews and Greeks, often brought the early Christians into
disrepute. It was only later, during the establishment of the One
Catholic and Apostolic Church, that women were definitively banished
from service at the altar and began to acquire their dependent posture
in Christianity, along with the crippling blame for all human sexuality
and moral weakness. The Gospel's Mary Magdalen was notably inde-
pendent, a woman defined only by her village and not by any man, nor
by any occupation. Her life was clearly her own, and she made the risky
choice to be the disciple of Jesus.

The nature of Mary Magdalen's connection with Jesus inspired the
invention of many stories, legends, and theological explanations. In
Gnostic writings she was identified as the earthly vessel of the heavenly
wisdom, the closest of Christ's companions and therefore first among
his disciples, not just among the women. She was seen as his complete
spiritual mate, and as his necessary mediator, the one who understood
and interpreted him to the others; she was the Seeker of the Beloved in
the Song of Songs, with the sexual metaphor in full operation. But the
Gnostic aim was finally to merge sexual difference, to undo the fatal
division between Adam and Eve, so that human beings could be all
asexual spirit and death could be undone.

Such versions of Christian thought had become heretical by the
fourth century. Both Christ's female companion and his mother were
taken over by views of religious truth that abolished all feminine ele-
ments from the core of divine power, and gave all female roles only a
derivative force. Christ may crown his mother in heaven, but she
doesn't share the throne with Him, the Father, and the Holy Ghost.
Goddesses, even the faintest trace of them, had long since been
expunged from Judaism, and Christianity eventually followed suit.

Since her Gospel story is so sketchy and she's not mentioned in the
Acts and Epistles, stories arose about the Magdalen's later career. While
Susan Haskins was doing research in Europe, she was struck by the
strong presence of Mary Magdalen in France, where every other

church, town, and even field seems to bear her name. Haskins soon discovered the legend of the Magdalen's own apostolic arrival in France at the port of Marseille, where she sailed with her brother Lazarus to spread the gospel in Gaul. When her missionary work in the region was accomplished, the legend has it, Mary Magdalen withdrew to a local grotto to spend the remaining thirty years of her life as an anchoress, in total contemplative seclusion. It was said that the hermit Magdalen ate no food but lived on the Eucharist, for which she was lifted bodily up by angels so she could receive it directly from heaven at the canonical hours. She wore no clothing, either, but her hair grew extra thick to cover her up in the chilly cavern. Eventually she received extreme unction from the local bishop and died, leaving her remains to be fought over by later generations of relic-mongering princes of both church and state. Over time, bits of her bones and hair were distributed among many sites; but a reliquary believed to contain the Magdalen's head is still carried in procession on her feast day in the Provençal town of St. Maximin, near the site of the cave where she lived for so many years. Haskins includes a recent photograph of this ritual.

Mary Magdalen became, in Haskins's words, "the star of the Middle Ages," as the abbey churches of France struggled for possession of her relics and control of her miracles, each hoping to swell its own treasury and increase its influence as a favored international site of pilgrimage. Royal, aristocratic, and papal recognition was constantly at stake as well, and Saint Mary Magdalen took on her own considerable value, which was no longer dependent on her role at the Crucifixion or her closeness to Jesus. She became a potent holy personage in her own right, with many miracles to her credit and a reputation as an effective intercessor. From the eleventh century, her name was being given to baby girls. The Dominican order took over the Magdalen's grotto, built an important monastery there, and eventually spread her cult all over Europe. The attractiveness of her legend was meanwhile increased by the kinds of material created for morality plays and Easter dramas: Mary Magdalen might figure, for example, as John the Evangelist's rich and beautiful bride, whom he jilted at the altar in order to follow Jesus, so that she vengefully plunged into a life of luxurious debauchery until she saw the light and followed him, too. Other thrilling episodes involved dramatic roles for brother Lazarus as a soldier and sister Mary of Bethany as mistress of the family estates.

The stronger the medieval cult of the Virgin Mary, and the more the monastic tradition elevated virginity and degraded all sexual life, the stronger also grew the palpable sexuality of the Magdalen's image and its insistence on her bodily qualities—her personal attractions and material possessions, her licentious past and the very physical mode of her repentance. Her great apostolic role was all but forgotten. When Titian later came to paint the Magdalen as a radiant, golden-haired courtesan in sixteenth-century Venice, Christian Humanism had all but transformed her into Venus. By then, her fleshly beauty could seem the rightful mirror of God's love and the sum of all His earthly gifts, a benign virtue and nothing to be ashamed of.

It was during the Counter-Reformation that Mary Magdalen was put to hard labor as a full-time penitent, since her whore's repentance could now stand for the depraved Church's quest for forgiveness after its return to God. It was in this period that she so often froze with horror in the act of considering her finery, and sat uncomfortably for so many naked portraits with the skull and the scourge or the crucifix and the book, while her expressive hair kept failing to hide the best part of her quivering flesh. She was also made to participate artistically in the rampant female mysticism of the seventeenth century, to undergo seizures of quasi-sexual rapture in the style of St. Teresa and many others who reported like experiences.

The Magdalen's repentant posture only intensified during the Victorian era, when she lent her name to its famous star, the Fallen Woman. This frightening personage was forever swelling the tide of prostitution that was thought to be contaminating the world's moral health. Reclaiming her soul was virtuous, even heroic, and of course eminently Christian work, often undertaken by women. Hospitals and convents for the rehabilitation of prostitutes had been established centuries earlier in various countries, usually in the Magdalen's name and without much fuss; but in nineteenth-century England the enterprise heated up, and much was made of the grim economic conditions that forced young girls into a hideous life of shame.

The shame-free sexual behavior of Mary Magdalen the disciple of Jesus, on the other hand, has received much imaginative attention in the modern world. The ebb of faith and rise of scientific inquiry have led not only to the quest for the historical Jesus but to the simultaneous quest for the human unconscious, and there was a corresponding liber-

ation of themes and styles in art. Fantasies about the erotic couplings of the woman Mary of Magdala and the man Jesus of Nazareth began to take many forms, some of them pictorial and poetic, others cinematic, theatrical, and novelistic, and indeed pornographic. Haskins gives an array of examples, but she finds most of them less than satisfactory, especially recent fictions insisting on a vigorous sexual appetite as the Magdalen's chief quality, along with blasphemous and mystical leanings. She finds everyone still blindly entranced by the sinner in Luke's Gospel, still ignoring the witness at the empty tomb and the strength of her vision and mission, still forgetting the remarkable spiritual journey she undertook, apart from whatever sexual life she might have led.

Haskins is truly impatient with the colorful mythical Magdalen and would like to get rid of her. The myth has certainly been responsible for exacerbating an ancient fear, hatred, and self-hatred of women that still plagues the world, and Haskins is resentful of the way Mary Magdalen was used for centuries as "an instrument of propaganda against her own sex." It's true that the Magdalen's part in the history of moral life has largely consisted of reinforcing the dreadful invention of Woman, the genus with only two species, Good and Bad, of which all examples are either frivolous, sexy, and probably dishonest, or serious, modest, and undoubtedly loyal. True perception of female life has been seriously compromised again and again by versions of the compelling dichotomy between the impossibly virginal Virgin Mother and the sinfully sexual Magdalen, whose tempting female body is alone responsible for all human lust. It's under the influence of the mythical Magdalen that prostitutes are punished and their clients are not, and that mothers with lovers can be deprived of their children.

But the sinful Magdalen has also been responsible for obscuring Mary the active disciple, witness, and apostle, and this is Haskins's real objection to her. In 1969, the Catholic Church removed both the Penitent Sinner and Mary of Bethany from the character of Mary Magdalen, and reinstated the faithful follower and witness—but not the minister and apostle. The cumulative result of the myth, together with that of the Virgin, still permits the Church to oppose the ordination of women, even though the Early Church rejoiced to have them as successors to the ministering and apostolic Magdalen. Now that the Church of Eng-

land has begun to ordain women, as the American Anglicans had already done, Haskins, like so many others, thinks the Catholic Church should do the same, and let women follow the Magdalen's original example of active female service at its heart. If the Church were to cease forcing the passive and submissive Virgin Mother to be the pattern for every woman's life, she says, the gifted and enterprising Mary Magdalen might at length exert her proper sway in the modern Christian world.

I believe, however, that the sinful, colorful, mythical Mary still has good work to do. The image of female sainthood that she represents in art offers a powerful combination to modern viewers and gives a larger sense of her exemplary importance than Haskins allows. I wouldn't want to do without the modern ambivalences she represents, the loud tears and silent gravity, the rich dresses and plain drapery, the dignity and the hysteria, the intelligence and the self-abandon, the bare body and the cloak of hair. Although the legendary Mary Magdalen begins her life in riches and lechery, leaves them behind for devotion and grief, and comes to nakedness and contemplation at the end, her image in art mixes these things up, heedless of sequence and narrative sense. Haskins's book describes how the varying imagery created for the Magdalen over time reflected the perspective of each age; but in the modern age we have them all at once, all bearing her name together. And we get from her composite image a more realistic picture of human female experience than was ever intended.

The Magdalen in art allows us to see that a deeply religious and virtuous woman may love sex and fine clothes, and that a simply dressed woman may be profoundly vain. She suggests that calm and dignified women have violent feelings, and that a fainthearted woman may be a courageous genius. She shows that a woman's erotic expressiveness and unworldly inwardness do not rule each other out, any more than her love of jewelry and love of humanity do—that, in fact, opposing qualities may be unevenly distributed throughout the same woman and present her with a certain challenge.

The Mary Magdalen we inherit is reassuringly complex, struggling to keep her balance in a very demanding world, to reckon with her soul and keep her moral credit as intact as her costume and complexion. I am reminded of the account of Gabrielle Chanel's funeral, which took place in the center of Paris at l'Eglise de la Madeleine. The congrega-

tion gathered before the coffin, right below the statue of Mary Mag-
dalen ascending into heaven, and waited for the chief mourners to
arrive; whereupon the complete parade of Chanel's mannequins entered
the church in single file, exquisitely dressed in her latest collection.
They paced slowly down the aisle and into the first row, ready to do
solemn honor to the dead and her talented, mercurial saint. It was not
for nothing that the Magdalen had come to France.

The Power of Images

The theme announced in the title of David Freedberg's book is illustrated on the dust jacket by a glowing reproduction of Poussin's *Dance Around the Golden Calf.* Inside, the disturbing frontispiece shows the same painting after it was attacked with a knife in 1978, its surface crossed by long slashes that focus on the calf itself. Freedberg wants to dwell on strong effects—the force inside the idol whipping the people into a dance, and the force inside the picture striking the eye so hard that an armed hand rose up to strike back. When he begins by saying his book is not about the history of art but about "the relations between images and people in history," we already know he means passionate relations.

Freedberg, however, is an art historian. His dense and challenging book is rooted in a dissatisfaction with the way his fellow art historians and art critics have consistently written about images so as to deny the importance or even the existence of such responses as Poussin's picture records or its unnamed assailant acted out. Far from considering such behavior relevant to the study of art, they have consigned it to the domain of the "primitive" and the "magical," or to the realm of the sensational and the psychopathic.

Open acknowledgment of the physical effect of images is thus made out to be either a matter strictly for psychiatrists and anthropologists

Review of *The Power of Images: Studies in the History and Theory of Response* by David Freedberg (Chicago: University of Chicago Press, 1989) in *The New Republic,* January 22, 1990.

or else vulgar, and only a matter of crude reaction to vulgar kinds of art, some of which may even be called non-art—pornography, cult images, waxworks, and the like. If raw power is ever allowed as the property of High Art, it is supposed to work only on unsophisticated children, uneducated people, or madmen like the Poussin slasher. According to Freedberg, the very ranking of images into categories of serious and vulgar or high and low is a way of creating an artificial barrier, one that limits the whole domain of emotional response to the kinds of images that are not taken seriously and sanitizes the effects of great works.

Even the deep respect of critics for the vivid objects in ethnographic collections, formerly called Primitive Art, emphasizes a gap between the reactions they may originally have evoked and detached Western appreciation of them—or even Western emotional reaction, which is scrupulously assumed to be quite different from what was intended. We are also prone to call the style of figuration in such works "symbolic," Freedberg thinks, partly to retreat from the idea that the figures are meant, like so many Western figures, to be or resemble real beings both living and divine, not to stand for them—to contain divinity and life, not refer to them.

Freedberg would say that critics and scholars do the same thing with Western paintings and statues, denying the life in the image in favor of more tractable qualities that can be caught in a net of expertise and described from a position of detached superiority. He cites the main flavors in which art-historical talk comes. First, there is the High Formalist Method, whereby works of art are discussed as if they were exercises in formal strategy based on earlier achievements using similar strategies, so that the whole aim of art may appear to be reference to itself. And second, there is the more recent Original Context Recovery Plan, according to which works of art are perceived to be chained like slaves to their own time and place, so that nothing true can be seen in them and nothing truthful said about them except in the light of other days, which is all that scholars of art should ever try to see by. Both these ways of dealing with art render it harmless in itself, and they guarantee a refined immunity to its troubling power in the here and now. There is some idea behind them that art, especially great art, says Freedberg, cannot be truly redemptive—that it does not directly change or save the fallen world.

Freedberg wants the critical study of art to confront exactly what is troubling or exciting in it. The barrier between the legitimately affecting arts (or non-arts) and the contents of galleries and museums must be collapsed, he says, and all images must be considered together, as he considers them in this volume, claiming that art can learn a lesson from non-art in the study of response. He advocates the right application of Nelson Goodman's theory that, as he quotes him: "In esthetic experience the emotions function cognitively. The work of art is apprehended through the feelings as well as through the senses."

This is plainly true. Museumgoers do seek to receive art directly with open hearts and tingling nerves, just as they do movies and television (perhaps all the more now because of movies and television), although they usually don't faint, scream, embrace the statues, or kneel, and most don't slash, even if they feel like doing these things. In Freedberg's view, such direct responses universally precede quick, covering moves people make toward aesthetic detachment, distancing mechanisms that he claims denature what he calls "the hard, brute sweet reality of the image." Immediate reactions are obviously not the same for everyone, he will allow; but in his view they are always there, and have consistently been denied in modern writing and teaching about art. He wants the study of art to contain the study of cognition—to treat art not as a variable and interesting mediator between actualities and the beholder but as one of the actualities that is directly grasped, just like the sun and the moon and other people. Studying art must include the study of how we know it, which begins with how we feel it.

The problem with Freedberg's view is that in the apprehension of art, instant cognition is larger than feeling, even if dependent on it. The inherent power in a work of art is not all of a kind, although this may be so in a work of non-art. Freedberg would say that we fear the power in the things we call art, that we have in fact called them "art" so as to be safe from them—but we don't fear it in all the other kinds of image to which we assign lower status; and that our fear gives rise to repression, the radical defensive measures that inhibit full understanding. We relish the fantasy that the department-store dummy might come to life, but fear the same potential in a Rubens nude—and so we keep the Rubens in a museum and decline to feel, and therefore to discuss, its department-store features.

But the immediate responses to a Rubens nude include other forms

of cognition—the instant knowledge that it *is* a Rubens, for example, and therefore gets responses engineered by Rubens himself, who knew perfectly well that they depend on your sense that the woman lives and breathes, but who never left it at that. Surely aesthetic appreciation of the picture is not really a defensive move toward detachment, since it yields a stronger engagement with more and not less of the power in the image, and allows you even more excitement than the plain naked lady can give you.

The main body of Freedberg's book deals with the overwhelming evidence of what images have done in history to make people feel and know them, and also with what has given them their active power—the power to heal and to slay, to appease lust as well as arouse it, to chastise, to console, to receive legal punishment, to save from harm, to speak and move, to give milk, to bleed, to weep, to fly. Such evidence is largely ignored by art historians, or simply disbelieved. And yet the amount and persistence of such lore have a telling weight, a force that still promotes pilgrimage journeys all over the world. Freedberg is concerned to describe the exact form that such evidence has taken, to anatomize and specify the kinds of close relations that people have formed with images and the kinds of reports they have left, including not only chronicles but tales and legends, even literary tropes and figures of speech ("The eyes follow you around the room!"); and then to account for the power itself, the apparent capacity of many images not just to reflect life but to live and act.

Images are, of course, dead. Their life, therefore, has been a matter of investiture, of evocation, of attribution and projection, of consecration, of creating or recognizing a vitality in them that can be activated in certain ways. If not actually brought to life, they are nevertheless made to *work,* to live somewhat the way machines are often perceived to live, through mental processes that depend on the general perception of how anything works. An important element in this perception is the sense of a thing being properly made, whether by man or God, with all the right basic components and the essential finishing touches that then set it going. The story of such processes has nothing to do with crude superstition and primitive understanding, but involves a variety of subtle psy-

chological agreements, apparent in all civilizations, about the dynamic relation between inert matter and active spirit, and between man the creator and God the Creator.

At what point, and by what means, does a collection of marks or a piece of shaped clay acquire its undeniable life? When and why does the crude matter wrought upon by the artist separate from him and take on a potent independent existence? The agreements about this have differed according to time and place and purpose. Freedberg describes many of them and the practices founded on them. These include the naming, embellishing, and enshrining—the "finishing"—of unformed stones fallen from the sky and worshipped by ancient Greeks and the "eye-ceremony" of the Theravada Buddhists of Ceylon, in which the statue of the Buddha gets its potency and becomes a god only when the artist finally paints in the eyes during a dangerous and exacting ritual. After this ceremony, the artist's own gaze is thought to have a destructive power, and so he is blindfolded until he can look at something he can shatter with a sword. Freedberg doesn't follow up the meaning of the artist's dreadful burden in this story; and in general he only occasionally touches on the artist's role in the drama of image and response. But he does recount the impassioned artist's prayer to Venus in the moving fable of Pygmalion, whose superb masterpiece was forced by the goddess to give up its immortality and become a living girl, fit only to love and die like the others. And it is the very fear of this, Freedberg would say, that keeps scholars of art from dealing in such matters—the common fear that an image really might come to life and wield its power among the living instead of staying safely lifeless in a controllable world of painted canvas or carved marble. With that goes another deep fear, of the body and its unaccountable forces, which can enslave the life of reason and the practice of art, and impede the path to salvation. Denial of the vital power of images is bound up with a need to deny the power of material objects, of which the human body is by far the most troublesome: objects forming images of it thus only compound the trouble. A further common fear is that of perfect likeness, the sense that a completed portrait draws into itself the soul of the original. This fear is not confined to unlettered barbarians; it appears everywhere, sometimes disguised as a pleasure, as in the case of memorial portraits that can preserve the living presence of the dead or photographs of loved ones far away.

Even the artistic impulse away from figuration can be seen, thinks Freedberg, as another example of such a fear. Perhaps the non-figurative artist flees nature so that he needn't dread returning Pygmalion-like to the studio, to find his work offering an unholy invitation or making a fearful claim. But this idea fails to account for Abstract Expressionism, for example; and in fact, there is no lack of life in unfigured objects, as Freedberg elsewhere notes. Even about the maker of lifelike images, there are other myths that he leaves out—what about doomed Narcissus and all makers of self-portraits? What about our intense response to the living artist who breathes so palpably in any image he makes, right along with the subject?

Indeed, in the apprehension of abstract art, the artist's own beating pulse is the living power that we usually feel first. Surely a non-figurative painting can be a deeper mirror than any other, a gathering place of private forces unscreened by the veil of surface likeness. Retreat from life was obviously never the point about the movement toward abstraction anyway, since it began with a closer exploration of landscape and still life, which were observed to contain even more fundamental living forms than the ones in mere human situations. In the pictures, the visible pressure to go still further into first-order creation without prototypes feels to a viewer like a search for the secrets of life, not a retreat from them, something like the search for the energy in the atom.

Response to abstract art is often to that very urgency. It can be called aesthetic, but it is certainly not detached, since it is based on the same empathy with which we follow, holding our breath, the antique sculptor's quest for the perfect image of perfect bodily beauty—the creation of something close to divine that we have not yet seen, something always yet to come. Apprehension of the effort and the result are fused in the beholder's response; the object can't be disconnected from its maker. Freedberg seems to want to wrench them apart in his program for the study of response, to insist wrongly that our first perceptions of art exclude our sense of the artist's own desire and ally themselves only with the feelings we have when we are stunned by the photo in a full-page ad or feel our flesh creep in the waxwork museum. It is as if he thought poor Galatea came to life to call attention to herself at last, so people would really look at her and stop endlessly praising Pygmalion's genius.

• • •

To discuss the large issues at the root of his subject, Freedberg naturally must penetrate the linked realms of sex and religion, where art has led most of its life. Consequently, apart from the history of art itself, his book is built on scholarship in anthropology and theology, in patristic writings and Church history, in the cultural history of both East and West, in ancient history, and in several branches of psychology and philosophy. It is hard for his own clear thought to shine through the thick hedge of learning that surrounds it, bristling with quotes and references and tags in several ancient languages, and blossoming with small phrases and asides in many modern ones. Nor is it easy to persuade us while his esoteric vocabulary in English hampers the march of exposition like a cumbersome suit of armor. The book is so jammed with words like "telestic," "catachrestic," "apophantic," "syndetic," "eristics," and "iconodule," along with recent critical terms like "ekphrastic" and "hermeneutic" and philosophical terms like "ontology" and "hypostasis," that it is too bad of him to insist on "temerarious," "patriarchality," and "soteriological" (I like "salvific," though).

Freedberg is inventing a new subject, one that clearly needs heavy support from many other subjects and also some powerful defenses, just like a new republic. A nervous donnishness, or donnish nervousness, informs these pages; but it can't snuff the flame of original thought and rebellious feeling in them. He rightly wants to expound his daring subject from a firm position high inside the academic citadel, but since his scholarly caution is at war with his private zeal, the result gives the impression of being written through clenched teeth. Religion and sex are volatile topics in any milieu, and positively explosive in connection with art, vision, and feeling, and so this weighty book has a slightly bomb-like aura.

The lifelike image has been a figure in erotic mythology all over the world, not just in Ovid. Everybody knows how eagerly love comes in at the eye, and that looking at a lifeless image can arouse desire even more promptly than the sight of a live body, and even without hope of seeing one. It follows that love in its devotional form may also be aroused that way, since the lust of the eye has such a force of its own. Religious devotion may receive its greatest stimulus from a compelling visual rendering, especially if the deity is supposed to have its true being only in the spiritual universe beyond the grasp of the senses. You may be able to believe without the help of images; but love for unseen things is much harder to achieve than faith in them or fear of them.

There is a long history of the ways sexual desire works in relation to modeled and pictured figures. Some past examples given here are suggestive: it was once thought that a wife's lust, kindled by an arousing picture hung in just the right place in the marital bedroom, might benignly affect the character of the child she conceives by her living (but perhaps less arousing?) husband. How nice to find an old story saying that pure female lust, born of a picture and not a partner, is creative and auspicious. And then there are the many tales of men bewitched by amorous statues whom they are forced to espouse in place of the beloved, or of men compromised by clever simulacra of themselves into entanglements with lustful sorceresses, who have made and manipulated the figures to entrap them.

Stories of male desire and its blind readiness to interact with images far outnumber those about women. Freedberg gives some space to discussing the idea that the lustful gaze of the art lover has always been essentially male, an engendering agent that rapes the object and quickens life in it with the insistent thrust of the desire to know, and so possess. Fortunately, he doesn't sound convinced. The intense fetishizing gaze that art lovers turn on images is not necessarily male, but its action does feel as delicious and dangerous as sex, and as much in need of controlling sanctions, both internal and institutional, especially in the sphere of religious art.

Sexual and sacred energy have combined in the image of the Virgin, whose bodily beauty expresses her virginal and maternal character. Her power is bound up with her female physical being, and making images of her has never seemed to need an excuse. Making them beautiful, and therefore even desirable, was both a duty and a risk. She had to have a perfect beauty free of sin, but the image maker was not accountable for the responses of the sinful viewer, who had the responsibility of sorting out and dealing with the kinds of love he felt. Making the image "true to life," however, was essential. St. Luke was believed to have painted a portrait of the Virgin from life—with her own gracious permission, of course—of which the many copies and copies of copies formed a foundation for the general spread of her image, together with the belief that each is authentic. To modern eyes the realism of many such Virgins seems swallowed up in what looks like a stylized, somewhat hieratic formula, often stiff and harsh; but they were seen as tender and truthful when they were made, real and not symbolic, receptive to real love.

Many are still seen that way, right along with the vividly natural Madonnas sanctified by the history of art. The Virgin's image has been fragmented into hundreds of working versions, each distinct, each with its history of special deeds and effects, each giving the Virgin's blessings and benefits in unique ways and receiving the love and thanks of her local devotees, often in the form of *ex votos* that are pictures of the event. In such votive scenes of miraculous help, the Virgin herself appears precisely rendered as her picture or statue, as if to show how her power really works. She is not shown as a spirit intervening directly from heaven but as a specific image living in the neighborhood, with the exact characteristics of the local Our Lady. Freedberg emphasizes that all such images somehow are the Virgin. They don't stand for her but embody her completely as she does her holy work in each of their shapes. The true Virgin is perceived to inhere in her authentic image just as the soul of an individual is perceived to be "captured" in a perfect likeness, and to have a real life there. Similarly, when the Roman emperor's image was carried about to remote parts of the empire, the event counted as a visit from the emperor himself; homage rendered to the image was considered to be received directly by him.

While Renaissance artists were perfecting the human face and figure in paint and stone, absolutely lifelike effigies were also being made in wax, with real hair, real clothes, and glass eyes, to be treasured as memorials of the virtuous dead. On certain occasions, however, such effigies were also made expressly to be tried and condemned in court and then publicly beheaded, or eviscerated (animal guts being previously inserted), or otherwise tormented and executed in place of an absent malefactor whom they had been made to resemble. The man himself might be long gone or already dead, but public feeling and justice were apparently both satisfied by such proceedings. The realism of the figure was a necessary feature. It was not a crude stuffed effigy with a cartoon head but a perfect reproduction of the man himself, made (and perceived) to house his actual spirit. As in the case of the revered funeral effigies, the making was often overseen by well-known artists. Modeled wax was used for its lifelike qualities; and the general respect for living resem

blance in all human images meant that this medium, along with the taxidermatic effects of applied hair and eyes, had an aesthetic status on a par with carved wood or stone. Work in those noble materials consequently had to aspire to the lifelikeness of wax.

Holy figures for narrative scenes were sometimes made life-size in wax, or in painted wood with real hair and glass eyes, and arranged in realistic settings the better to impress the faithful with the immediacy of sacred events—but again Freedberg points out that such startling groups are fastidiously ignored by modern historians of art, unless a famous artist's name is associated with them. Gradually, during the seventeenth and eighteenth centuries, wax images lost caste altogether and slowly became marvels entirely of the entertainment business, made to arouse cheap thrills rather than authentic family piety, spiritual enlightenment, or any serious artistic consideration.

Baroque art had abandoned an ideal of death-mask realism in favor of dramatic stylizations that irreversibly stretched the perceived capacities of stone, paint, and wood; and so using glass eyes and actual cloth came to seem naïve, and eventually tawdry and vulgar. The aim of exactly reproducing the look of human life had reached a certain peak, and with it the artist's fame for achieving that effect above all others. In the apprehension of art, a division became conventional between the direct perception of reality and the perception of a realistic image, which was acknowledged to be obeying laws of representation, not of life. And it follows that the sense of what the artist was doing in making the image, rather than what the image itself might do, gradually became primary.

But well before then, lifelikeness in religious art went to considerable extremes. There are sixteenth-century crucified Christs in painted wood with movable arms and heads, which now look like the evidence of base deception practiced on gullible worshippers. They were in fact used in religious dramas, during which a live actor would play Christ as a living man and the wooden figure would portray him as crucified, taken down, lamented over, and buried. The rest of the year, the crucified body would stay on its cross in the church, and the boundary between wooden image and living reality would stay dynamically ambiguous. Consciousness of a further boundary between art, meaning what artists personally work to create, essentially for themselves, and non-art, meaning something without any filial ties binding it forever to

its maker, had not yet arisen to fragment the perceptions in the way Freedberg describes.

Legends of miracles continued to pile up, including those of saints whom the painted Jesus leaned down to embrace from his painted cross, or to whose mouth the carved Virgin would direct a stream of real milk from her carved breast. In such cases, as in most cases, the image was understood to remain an image: its living powers came from just that fact, that it had been made so vitally and truthfully, and consecrated so correctly, that divinity was pleased to course through it when a miracle was needed, like electricity through a well-made appliance. Artists themselves might receive divine help from their own works—an especially realistic Virgin might reach down to save her sculptor from falling off his ladder, as if his superior gifts made him deserve saving, just as Pygmalion's gave him the right to wed his own creation. These stories do suggest that it is precisely the best art, not the tackiest, that permits the most intense connection with humans. Great artists themselves have always enjoyed such intimacy by right; and others who give themselves the chance can share in it.

But stories of the artist saved or loved by his work come from the old tradition of perfect lifelikeness as the artist's best achievement. And that tradition allows the artist to step back from the autonomous life of the finished work, like God from Adam, leaving it wholly free to choose whether to make an advance toward him or toward others. In fact, we can easily imagine a fickle, perfidious, vengeful, or self-interested Galatea (as Shaw did), just as we have always known about the disobedient Adam—but the ideas for images like that in the modern imagination are about fantasy robots in the sacrilegious Golem tradition, not works of art. The images that once leaned out of their frames or gestured from their pedestals were free of their makers and ready for intimate engagement with any human being, but the images we now know as art can't do that any longer. Our awareness of them contains a sense of their bondage to their parent. We know they cannot call their souls their own and that they can't allow themselves to form those ties of which Freedberg has found so many in the eventful lives of images from the past. Modern intimate relations with works of art can't, and shouldn't, have the unencumbered and unenlightened quality that Freedberg would like to believe in and preserve; but they have something else instead.

Freedberg's rhetoric suggests that we have willingly relinquished something of great value in favor of dilute or ersatz connections with art. But we have not reduced or vitiated our perceptions of the Virgins of Piero della Francesca, for example, or even of the Mantegna Freedberg mentions. We have intensified them, ever since we learned to take more into account than Mantegna's ability to make the Virgin seem real. The impact of a Piero Virgin now contains more than the force of her perpetual beauty and holiness, because it contains the palpable drive of the artist to make a perfect vision, to create that heaven on earth that can be so moving even in non-figured paintings, so that the beauty of the Virgin and the beauty of the picture both strike at once. The tears of awe must now be a response not just to her but to what Piero has done to make a world for her to move in. The image comes to more than life.

Of all the acts people engage in with art, the most intense is destruction. Nothing demonstrates belief in the power of images more keenly than the need to get rid of them. Freedberg thinks that the wish to keep some of them at an elevated distance in museums is a version of the same need, a similar index of their dread force in emotional life. He has elsewhere written extensively on inconoclasm, however, and here he discusses the various moments in the history of religious images when they have been in real physical jeopardy, and often systematically wiped out, along with much secular art. In the early centuries of Christianity, images were associated with paganism, and the use of them for the new faith had to be strongly defended. Idolatry, meaning chiefly the worship of the many old gods, was a present danger. But the need for holy images remained, and stories arose of them aiding in conversions by surpassing the powers, or even toppling the figures, of Venus and the other pagan deities.

Conflict between those who advocated Christian images and those who would forbid or destroy them arose again during the Byzantine Iconoclastic Controversy in the seventh and eighth centuries, and yet again after the Reformation. In antiquity, many had believed for centuries in the moral danger of devotion to beautiful objects. It was

thought by both Greeks and Romans to have a softening effect, rendering one too much like the Persians or other Asiatics—i.e., like the enemy, with his disgusting habits and vile beliefs. Such ancient associations could only reinforce the fear that the use of beautiful images might weaken the Christian soul and turn it from the true God. Many believed that God alone might create, and feared not only the inherent sacrilege in making images of natural things but the worse one of presuming that they might have their own power. Many also believed that God alone had the right to create Beauty, and that any of man's works made to please the eye were bound to displease Him, even if put to sacred use. Belief in the unworthiness of beautiful religious artifacts is still reflected in modern views that money given to the church should not be used to preserve the fine mosaics but to help the poor, or even that the whole building should be sold for their benefit. Freedberg points out that the poor usually don't agree.

But far beyond a mere love of beautiful things, the wish to contain and circumscribe the all-encompassing and endless God in finite man-made figures was deeply repugnant to many. The famous stricture in the Old Testament against graven images, which Freedberg tendentiously claims was in large part metaphorical and simply cautionary against false gods, was adduced again and again by the fervent enemies of religious art. Yet people continued to need and love images, which had their staunch defenders. Among these was Gregory the Great, who is responsible for the famous idea that holy pictures are the books of the illiterate and therefore good for supporting their simple faith. He is thus also responsible for the disgraceful but enduring notion that the direct power of images works only on the lower classes (women, children, and madmen being naturally among those), and that strong, rational, superior persons are naturally immune to it.

The thought that God might be properly accessible to everyone only if contained in some comprehensible vessel, just as an idea is formed by language, and that the container of holiness might rightly fuse with holiness itself and be the just recipient of worship, was frightening. The lame notion that images only stand for what they represent, and so may be harmlessly admired while the prototype receives the true worship, is also obviously false to the way images actually are perceived and truly operate; and that is frightening, too. But clever Byzantine apologists for

images pointed out that Christ is himself the physical image of God, the living proof that the unknowable deity did make himself known to us as a finite and mortal man, manifestly for our salvation; and so the Incarnation justifies not just the making but the worship of holy images, being the first instance of one made for the purpose. The idea nevertheless sustains the view that the Old Testament God of Abraham, Isaac, and Jacob should still not be offered in an image for worship, as Christ may; but that God the Father may appear as part of the Trinity, and as part of the drama of Christ's life and lineage.

Freedberg claims that those most drawn to images are the ones who often feel compelled to destroy them. Those who feel the power of art, "who cherish it and are afraid," are the very ones who wish to attack it, reform it, censor it, or sweep it away. That clearly includes the ones who live close to it, study it, and so must try to keep its power within bounds. As a nation, we are certainly conforming to his view in our treatment of works by Richard Serra and Robert Mapplethorpe, and in the rising antipornography movement. A recurrent iconoclasm accompanies our obvious reverence for the priesthood of artists and the sacred mysteries of art, along with our consuming passion for visible and tangible objects, often called materialism. Our fear of images now extends to the artist, so that we remove Serra's work as if we were afraid of him, not his sculpture. He reinforces this by insisting that his work has no message whatever—we must conclude that he's the one carrying the threat.

Just because of the deep emotional importance of images in modern life, individual cases of iconoclasm are even more sensational than the institutional kind. Freedberg's book contains pictures not only of Poussin's wounded *Calf* but of Michelangelo's exquisite Virgin of the *Pietà*, with her face smashed; Rubens's fleshy *Fall of the Damned*, scarred by a big splatter of acid; Rembrandt's *Night Watch*, bearing an array of vertical knife slits; and—most dreadful of all—Velázquez's delicate "Rokeby Venus" stabbed again and again in her naked back as she quietly lies down to study her mirror.

Among all the legends surrounding works of art in history, Freedberg cites not one about an image that healed itself. However charged they are with power, the inert stuff of which they are perilously made

has none of living matter's rich defenses. The iconoclast knows his target offers no resistance; his act is total injury. Mighty efforts are made to mend the thing so that the damage is hardly noticeable; but it can never be quite the same again. And yet for all that, short of absolute destruction, its life (by contrast with its vulnerable body) is often quite untouched. Once the wounds are repaired, Venus' pliant spine, luminous buttocks, and brooding gaze remain serenely unaffected by what she has been through. Her real wholeness has defied being hacked apart.

The attack was made on her in 1914 by a suffragist named Mary Richardson protesting the imprisonment of Mrs. Pankhurst. For Richardson, the constant homage paid to beautiful Venus, luxuriating in her public boudoir and in her privilege as a national treasure, and especially to a Venus made of dead paint and canvas, was in too sharp a contrast to the heartless neglect of the living, breathing Mrs. Pankhurst, confined out of sight and forced to sacrifice her comfort and precious liberty to the cause of legitimate rights for real women. But what could be done for Mrs. Pankhurst by stabbing the poor picture?

Decades later, Richardson confessed she couldn't stand the way men looked at it all day. And there lies another general motive for iconoclasm—jealousy. Images have enough power to steal the rights of others, to be preferred in place of those who know they have a better claim, to supplant the rightful prophet in the spreading of the true word, to seize and attach the gaze that should be free to fall elsewhere. And so images are at risk from disappointed lovers of persons and causes, from too-clear-sighted visionaries, from unrecognized knowers of better truths, and naturally from unsuccessful artists—sometimes, though Freedberg doesn't talk about this, from the very artist who made the work.

Although the newspapers have made much of attempted image murder, those who run galleries and museums tend to keep the matter quiet—"so as not," one of them has said, "to put ideas in people's heads." The slashing lunatic is always carefully categorized as quite separate from the sane public. Freedberg believes, however, that close behind every art lover's eyes, the idea is already there. The arrogant fragility of art, with its motionless components so minutely arranged, with its false life so undeniably able to compel true love—to say nothing of respect and awe—is an offense to the forever intractable, absurd, horrific, and chaotic state of

real human life, and a goad to the latent righteous anger against it in all of us. Images obviously take their chances when they go into the anxious world and try to live there without getting involved.

Titian's *Venus of Urbino* is another famous nude with a long emotional history, although Freedberg has no stories of physical attacks on her. For him, she illustrates the way images are considered harmless once they have been categorized as Great Art, even though they obviously keep their power and simply operate without a license. Unlike Velázquez's introspective Venus, Titian's is an explicitly inflammatory erotic picture—the naked woman lolls on her back with one hand in her crotch and her nipples erect, gazing moistly right at you. And yet Mark Twain was outraged to realize that while she might freely stretch out and fondle herself before the very eyes of inquisitive little girls, old maids, and impressionable boys, to say nothing of lascivious *bon-viveurs*, he would not be able to publish an accurate description of the picture without being severely censored. Twain smelt hypocrisy; Freedberg calls it repression. In modern art-historical writing, he scathingly notes, pages are written on the deeper meanings of this Venus in its Neoplatonist context, or with respect to other social and intellectual forces at work in Titian's time, without ever mentioning her direct message.

She certainly has one. In the Uffizi the lascivious gentlemen still gaze from under half-closed lids and the agitated children are still nudging each other and whispering; and everybody else still stops to look and swallow hard. Elsewhere in Florence, giggling throngs of young girls also cluster around the pedestal of Michelangelo's *David*, milling about under the electrifying impact of his gigantic young bare body. Others who don't giggle nevertheless stare and feel the force in those huge genitals, those great veined hands, that bony chest and tense neck. Not much dispassionate critical discussion can be heard in either of these tourist shrines, nor in all the other internationally known museums; the public seems not at all at the mercy of linguistic distancing mechanisms.

Nevertheless, Freedberg is unfair to sneer at scholarly efforts to explain the Venus, or elsewhere to ridicule Janet Cox-Rearick's calm and learned study of a St. Sebastian by Fra Bartolommeo, which in its day was so lusciously disconcerting to the female worshippers in the church where it hung that it had to be moved to the sacristy. I think it might be presumed that the erotic impact of David, Venus, and St.

Sebastian goes without saying; and that what must be said is that in each case there's more to it than raw sex. Even realistically sexy nudes don't all come across in the same way. The power of Titian's Venus comes from Titian's ability to fuse the complex surface with the simple subject, so that the smooth naked woman with the knowing gaze and gesture is simultaneously a vision of cosmic repose that living prostitutes do not usually suggest. The picture contains something that immediately feels more potent and more interesting than the straight invitation it portrays. The dog, leaves, drapes, and maids have been made circumstantial but also poetically necessary to an image of abiding sexual ease possible only to this goddess under the hand of this artist. Titian has seen to it that we can't simply get hot for the woman without simultaneously getting hot for the painting. The repression, if any, has been foreseen and organized by Titian himself, so that sex and aesthetics together give you the charge; and that's what all the people feel who stare at Venus. Michelangelo and Fra Bartolommeo managed the same amazing thing. And figuring out how they did it seems honorable work.

Freedberg is keenly interested in the discrepancy between what official texts say about images and what people actually do about them. There have been many times in history when images were forbidden in religious practice by decree, or when rituals were described as lacking them, and yet the material evidence shows that they were indeed made and used in abundance. The ancient association between high spiritual longing and the rejection of images, the old connection between true holiness and the invisible, has persisted and given rise to what Freedberg calls the "Myth of Aniconism"—the idea that certain cultures, such as the Jews and others who invented monotheistic religions, were so spiritually advanced that they transcended the need for images and did not make them.

Freedberg states that there is absolutely no physical evidence for such a notion: all cultures, Jews included, have needed and made images, whatever the texts say, and there is no evidence that spiritual purity requires the lack of them. As he points out, Buddhism is full of them. Jewish fear of idolatry comes down to the fear of that same "fetishing

gaze" that feels just like lust in action, a fear that therefore must ideally seek to wipe the whole potential array of images off the retina like a feast of forbidden sexual delights—but failing that, at least to sweep them off the altar. Since visual lust is just like sexual lust, it has the same volatile and wayward susceptibility. If the one true God is to be the one true fate of the Jews, they must keep their deepest passion strong and free from the casual entrapment of the eager eye by art, and keep faithful intercourse with the deity unsoiled by wanton visual living.

To say that Jews have loved, made, and feared images in their time is to say that they are human; but Freedberg the art lover seems also to suggest that the fear forbidding the image of God can have long-term pernicious side effects. It can try to prevent the benign power of visual art from holding its proper sway over the visible world, over the satisfying apprehension of natural appearances, and over all the imaginative seeing that permits the truest relish of God's handiwork and man's. It can distrust the delicious machinery whereby staring makes the fields look like Constables, the city like a film set, and Swann's coachman like a Bellini doge—or indeed a Rubens like a fruit salad. This inward process can be thwarted, along with the active impulse to seize on scruffy hills or nondescript faces and turn them into living images of consummate mastery. The lust of the Jewish eye, thinks Freedberg, can be permanently inhibited, both for the life of art and the life of criticism. "We see, we gaze, we create false idols that we must destroy," says Freedberg, as if loving to look at things were indeed a painful moral burden full of desperate conflict. He even has a wry note on himself toward the end of his many scholarly references about the fell heritage of a Jewish art historian with additional Calvinist elements in his upbringing. He plainly feels the weight of all those centuries of fear pulling heavily against the demands of his own eyes and heart. His move to slash the art historians may represent a struggle for some relief.

Freedberg thinks that pure aesthetic appreciation ought not to exist, and that its high status has been a false goal cravenly set up to aid the repressed efforts of art critics, and to make other people feel small if they can't manage it. Purely abstract decoration, on the other hand, is some-

thing he believes does not exist at all, although he thinks others believe it does. Again it seems to be the "purity" of the aesthetic response that is at issue, his strange idea that critics find it their high task to keep the appreciation of unfigured lines, forms, colors, and textures—or even of those things in a carved or painted nude—free of immediate emotional and sensual response.

But I don't think that people, even art historians, believe in this any more, nor in the "purity" of abstract decorative form. We are aware that the impulse to make figures informs all decorative effort, and know that waves and snakes and leaves and beasts lurk in all ornament along with bodies and parts of bodies. The experience of apprehending art is well understood to be aesthetic and emotional together. I don't believe that critics really repress feeling because it might cloud the purity of aesthesis, even when they write only about the latter and keep silent about the former.

I suspect that many of the art historians Freedberg chastises actually went into the field out of an obsessive desire to be forever looking at works of art, on purpose to feel and even to wallow in the sense of their power. But no doubt such seekers found it necessary to control their lust, simply in order to move forward, to get somewhere beyond staring transfixed, to try penetrating the mystery of the object by any means, so as not to feel so helpless in its spell. And that attempt might well mean giving up strong personal response as a subject, since one can so easily talk only about oneself instead of trying to find out how the image got that way. It is true that not many people have written about the two halves of the subject together, except of course the psychologists and philosophers quoted in this volume, along with the theologians of the iconoclastic periods. Leo Steinberg is one of the exceptions.

To get on further with trying to understand the force of art, and how it actually works while people are looking at it, Freedberg is undoubtedly right: we need to invite our modern souls and consult them once more. His powerful, demanding, turgid book, however, only projects the need by describing some of the failures that have caused our lack of understanding, and showing in broad, rich detail just what we have been missing. At the end, the power of images remains almost the same mystery as before.

Trying to discover the sources of art's mystery ought not to preclude

continuing to feel it, or helping to preserve the feeling in others. The dissection of art, just like slashing, cannot truly murder. Much appreciation of art used to consist of nothing but subjective responses, after all, unhelped by the consideration of social and historical influence or any understanding of artistic convention whatsoever. The invention of ways to get a grip on art by conceiving of it as part of history was a boon to people struggling to understand, feeling so much moved and yet so ignorant in the presence of the life that burns in painted eyes and vibrates along granite limbs, and even now continues to explode in unfigured structures of twisted iron and poured acrylic wash.

The Culture of Flowers

It is easy to put flowers into the same group with water and sun and the other things that all humans have to reckon with. We are given to thinking of a flower as one of the universally respected earthly phenomena, the beautiful sign of nature's essential goodness, or perhaps of its artistic superiority. Flowers are thought to have graced the Garden of Eden, where God first put his wonderful works at Man's disposal; and we can well imagine that all human culture has ever since taken account of their beauty and made something of it, and of them.

But in fact there were no flowers in the Garden of Eden, or in the sum of God's earthly creation as recounted in Genesis. Fruit, trees, and herbs are mentioned, but flowers not at all; and the God of Genesis produced a race of people for whom flowers were not primary, naturally or culturally, or of any importance in their all-important relations with Him. Flowers, it turns out, are not universally interesting, attractive, or even noticeable. Sometimes they are irrelevant, and often they are offensive and wicked.

Whenever flowers have taken on serious importance in human life, however, they have been swiftly rescued from brute nature and attentively shaped into complex cultural phenomena. This happens first by sophisticated horticultural intervention, then by commercialization

Review of *The Culture of Flowers* by Jack Goody (Cambridge and New York: Cambridge University Press, 1993) in *The New Republic*, November 8, 1993.

(often on a large scale), by representation in a host of styles and media, and by symbolization in liturgy and literature. Flowers have been trained to mark crucial links between the living and the dead, between the mortal and the divine, the man and the woman, the virgin and the married. Meanwhile, the ordinary wildflower left behind in the tall grass has consistently benefited from retrospective tenderness. In fact, flowers are not flowers, forever pure explosions of natural perfection; and if we think they are, we simply reflect an advanced floral consciousness that has been developing through five millennia of European and Asiatic horticultural history, fostered by art, trade, religion, and science. These are what have gone to make both the rose window and the roadside poppy so breathtaking.

In western and southern Africa, by stark contrast, there has been no culture of flowers and not many actual ones. In those regions, only people and beasts have had symbolic power and natural beauty. Plants are valued for their bark, their roots, their leaves, or their seeds, and all that these may bring or do, or be made to mean or to create, mostly in a dry or otherwise processed state. The flower is acknowledged only as the fleeting sign of coming crops, a thing without visual or other value for itself alone. African art has ignored flowers to dwell on human and animal forms in multiple shapes; and ritual offerings to god or friend have involved cooked food, not raw vegetation.

Such differences and their meaning and history are explored at length in Jack Goody's dense anthropological inquiry into the "culture of flowers." His scope is global, and the material is immense; and one cause of his exhaustiveness is the perpetual need to temper and qualify all such sweeping descriptions as those that appear above. Studying the use and meaning of flowers across world history, including the present, Goody nowhere finds any custom or assumption perfectly stable and absolute. The book serves, rather, as a study in cultural ambivalence and a sermon about the right way to view the effects of cultural change and exchange upon firm belief and established practice—or indeed, of the latter on the former. Just by following flower culture, Goody can expound the fragile nature of what has been taken for granted by one society about others, or about its own past, about nature, divinity, and ceremony. He is adept at describing simultaneous contrary cultural trends in one place and period—the iconic and aniconic, for example—and at maintaining our awareness of the uncertain boundary

between sacred and secular usage, or of the gap between accepted practice and real popular behavior.

This refreshingly wide anthropological gaze, without special political, artistic, or economic emphasis and with no greater interest in either the present or the past, permits an aloof view of convenient oppositions such as East and West, Christian and Muslim, Ancient and Modern. Flowers have known no such boundaries, traveling from one end of the earth to the other, from one religion to another, and from one millennium to the next, changing reputations from sacred to profane and back again within the same society, finding conflicting functions without ever losing their looks or fragrance. We can see how English allows the "flower" or "flowering" of anything to mean its essence or perfection; but we also use "florid" and "flowery" as derogatory terms about English itself.

Flowers have been cultivated for display in noble gardens and in urban pots and tubs, but display is only a small part of the culture of flowers—some gardens, like Eden, don't have them at all. In both ancient and modern worlds, flowers have more commonly been raised like crops to be harvested and sold, for use in local worship and festivity and for export. Thousands were grown and culled to feed the ancient Roman profession of garland making, and thousands are now beheaded to feed its modern Indian and Balinese counterparts. Meanwhile, other flowers have been collected, dissected, and classified; crushed, cooked, and distilled; extolled, venerated, and apostrophized. The same ones have been made to symbolize the carnal and the spiritual, the emotional and political, the exotic and the intimate.

Similarly, but not always at exactly the same time, representations of flowers have moved throughout the world and through time, changing significance with equal freedom, often bringing ornamental blooms where no real examples are, creating visual floral custom where no practical one exists. The sacred lotus, for example, originally a native of China in one form and of Egypt in another, became everywhere familiar on architectural borders, and on vessels and fabrics used by generations of people who might not even recognize a live lotus, let alone think of offering it to a god. Modern women wearing lavishly rose-printed dresses to restaurants do not go there with big garlands of fresh ones on their heads.

Flowers in art have been perfect replicas or schematic diagrams, tremulous with fresh beauty or rigid with hieratic significance; or they have been drained of meaning, lost in the great Eurasian sea of vegeta-

tive pattern. But flowers have also been the subject of exquisitely precise botanical illustrations, accompanied by descriptive and often poetic written material; and Goody emphasizes the fact that flower culture has always been closely connected with the graphic impulse. The early development of writing had links with the early development of small-scale flat ornamentation, as well as with the desire to make written classifications of knowledge and then increase their scope. Floral shapes lent themselves to the decorative graphic art carried out on portable surfaces; but flowers also offered themselves as an expansible field of information and understanding that could be promoted in writing, drawing, and diagramming.

Before flower culture could spread, it had to begin. Speaking very broadly, Goody shows how floriculture was the offshoot of the advanced agriculture that began in Mesopotamia after 3000 B.C., which produced the possibility of stratified societies and cultures of luxury. All European and Asian cultures were thereafter developed to permit the deliberate growing of plants for other than immediately practical uses— for pleasure, worship, or science. In dry, non-floral Africa, however, crops were grown by hoe culture, society was not stratified, and writing was not used. Cultural transmission was oral and visual expression was three-dimensional, so that instead of graphic ornament done with brush or pen, elaborate sculptural and other plastic systems of art and decoration were adopted. Color, so thoroughly explored in the art produced by flower cultures, was carefully limited in African art to a small range of infinitely variable shades of brown, black, and white, with some red. These were human, animal, and earth colors, naturally more serious than anything offered by flowers, which in any case were not naturally abundant. Famine was a more frequent occurrence than any natural floral excess; and Goody sees the absence of floriculture as possibly born of aesthetic discretion as much as of necessity.

China, counting the dry north and the wet south, has always had more native varieties of plant than any country, and without question the most remarkable flower culture. This was not one thing for nobles, painters, scholars, and scientists and another for ordinary citizens, but a rich continuum linking high and low culture for three thousand years,

fed by interchange with Greece and Rome and the Near East, and eventually by Europe. The art of flower painting was closely linked to calligraphy, and the two were combined in the same compositions; a refined training in both at once was developed for centuries. Poetry, painting, and ordinary communicative writing were thus connected and contained in a net of floral assumptions.

Natural scenery and flowers are the most common subjects in Chinese works of art, but many of them represent artificially created gardens, artificially bred plants, and artistically created floral arrangements. Thus the continuum between art and nature was also completed, and each was refined to imitate the other. It was in ancient China that heating techniques were first used to force flowers to bloom out of season, and fruit trees were first cultivated to blossom excessively without bearing any fruit. As always, female beauty and all sexuality and pleasure, if not fruitfulness, were bound up in floral reference. Ordinary women, ordinary prostitutes, elegant courtesans, and court-ladies would all be thought to resemble flowers themselves and would wear them; but some would also be expert at growing them and skilled artists at painting them. Flower painting was a lucrative profession for both sexes, and motifs, styles, and technical standards were uniformly refined, whether in the austere art of the educated literati or among artisans serving a popular market.

Once a culture of flowers existed, floral relations between the Near and Far East, between Asia and Europe and North Africa were opened and maintained, largely following the Silk Road. From Persia, roses and jasmine went east to China and west to Greece and Rome, and then to Egypt from Greece; and the lotus went the other way. Flowers painted on paper and glazed pottery, flowers embroidered on textiles or woven into rugs, flowers poetically and clinically described, flowers transmuted into perfumes, unguents, and honey journeyed around the Mediterranean and across Asia, along with seeds, cuttings, bulbs, and blossoms.

When flowers began to be cultivated in lands quite distant from their origin, their form and color were often modified and their meaning changed, so that new floral generations became natives of the new country, with new memories. Thus chrysanthemums, autumnal flowers

signifying fertility and longevity in their native China, came to Europe and were used as gifts for the dead on All Souls' Day, with the result that they became associated only with death. They became unsuitable as gifts of esteem or love. Even today French florists often label them "marguerites" so they will sell.

The famous Hanging Gardens of Babylon, cleverly engineered to overlook the roofs of the palace and city, had fulfilled the wish of the queen, a Persian princess homesick for the paradise gardens of her own lush country. There, a "paradise" had originally been an enclosed space where various plants, some of them flowers, were grown to be offered to the gods. Such a garden eventually became a retreat for the delight of its owners, a little world of shade and water, color and fragrance, a concentration of earthly pleasure that could even include animals and fish for royal sport. Aristocratic Persian gardens set the standard for the ancient world. The idea was copied in Egypt and China as well as in Babylon and its neighbors, and broadened to include public gardens for the delight of whole cities. Goody demonstrates how closely flower culture has been related to urban culture, where wildness of every kind is processed and transformed, and thereafter more admired in its natural state. He observes, as others have done, that the love of nature is an urban phenomenon, mightily sustained by literary tradition.

Most cultivated flowers have been raised, however, expressly to be sacrificed, not enjoyed while they lived. Having begun as sacred offerings, sometimes replacing blood sacrifice and sometimes accompanying it, they also came to be abundantly grown and reaped for secular pleasure, for social rituals of all kinds, for adornment and for perfume. Following Persia, Assyria, and Babylonia, ancient Egypt, China, India, Greece, and Rome all developed the use of fresh floral ornament for every purpose. In Rome, no respectable dinner party omitted professionally woven garlands for the heads of guests, for the room, and for the vessels on the table. The expense could be heavy and careful planning was necessary; and so a vast flower industry existed to serve such needs, along with the similar ones of civic and religious institutions, to say nothing of imperial ones. The depraved teenaged Emperor Elagabalus (A.D. 204–222) is reported to have once fatally smothered all his dinner guests in a ton of roses, which had been cunningly arranged to drop down on them from a false ceiling.

And here is where ambivalence comes in. The appurtenances of ele-

gant dinner parties, floral and otherwise, are upper-class luxuries that can be grossly abused; and besides that, the abundant use of flowers in ordinary worship imparts a highly material, sensual, and of course wasteful dimension to religious observance. Such facts were periodically remarked upon by thinkers and reformers, often with telling effect, within the ancient societies that had raised flower culture to such a high level. Cutting off the flower robs the plant of its fruit. Growing thousands of flowers to be cruelly wasted robs the land of crops that might feed the hungry. In the wake of excesses that incurred not only censure but ridicule, waves of restraint in the use of flowers, along with other fashions for austerity and understatement, became current from time to time in Greece and Rome and ancient China in a way quite familiar to the modern world.

Critical observation about religious use was more profound and long-lasting in its effects. Offering flowers or their perfume to a deity, chiefly by adorning its image with them, can suggest that the god expects a rather primitive level of devotion, and invites no active spiritual effort. Contemplation and reflection of a high order must be carried on, therefore, at a distance from religious practice, and the satisfactions of religion must remain quasi-physical. They may reach trance or frenzy, but the human soul can find in them no link to divinity unmediated by sensual devices.

These devices included the images themselves, of course, along with the perfume and the flowers. In the monotheistic religions that arose after flower culture was established, in Judaism, Christianity, and Islam, images were either omitted in observance or perpetually questioned; and at the same time, floral garlands were banished from the altars and the heads of the faithful. It was crucial to all these faiths that their adherents distinguish their own practice from that of other religions—those that made no proper distinction between the one Creator and his multiform creatures. Flowers were integral to the rites of the old gods, carefully prepared as sacred trappings for worshippers, sacrificial beasts, and idols alike. The custom expressed the ancient idea that gods, beasts, and humans, along with divine and human creations such as flowers and images, are joined together inside a vital universe that urges their steady interaction, demanding a perpetual re-creation, through art and ritual, of divine and earthly life, death and rebirth.

Monotheists sought beyond all material cycles for the single, immaterial, ineffable Source. The intense physicality of flowers, the fragrance and visual beauty that promote their reproductive function in nature, makes them obviously dangerous enemies of the Unseen. Flowers, after all, are noticeable reminders of the way physical attraction works in reproduction, and they have always been associated with the beauty of women, another great enemy of the Unseen. In the orthodoxy of all these religions, women have been required to cover up their beauty, and flowers have had a compromised position, mainly because of their old associations with the loathsome behavior of pagans, gentiles, and infidels.

Things were different in Buddhist, Jain, and Hindu cultures, where floral custom was never associated with the threat of alien sacrilege and the web of divine and earthly relations continued to be elaborately woven through floral imagery and usage. There, too, excess has brought on self-censure and an austere reaction; but the abiding reliance on a spiritual dimension in physical life has kept flowers immensely important in the religions of China and Japan, India, Pakistan, and Indonesia, from ancient to modern times without interruption. These civilizations also developed poetic and linguistic modes of flower culture to match their sophisticated horticulture and their complex faiths, so that floral metaphors and references proliferated at many levels of thought. The number of actual varieties was broadened as well by constant experiment in breeding and cultivation.

By the time Christianity was officially established, flowers were deliberately absent from its rituals, along with the representations of divinity long since forbidden by Judaism. Images of flowers vanished, too, and in the first ten centuries of Christian Europe, the flourishing culture of flowers withered entirely. Advanced horticultural knowledge was lost, along with the techniques for garland making and crown weaving that generations had practiced in the ancient world. Flower crowns in particular were viewed as blasphemous and unacceptable for humble followers of the thorn-crowned Christ.

It is indeed curious how persistently absent a crown of fresh flowers has been in the later history of Western personal adornment, especially for men. Crowns of fresh leaves, though more traditionally permissible, have always been strictly ceremonial and temporary. Vegetative crowns were always all right for allegorical or theatrical figures but became unbearably ridiculous for ordinary citizens. Western men invented curi-

ous hats and amazing wigs instead, and saved the wreaths for monuments. In Greece and Rome, the making and selling of garlands and flower crowns had been a female occupation, and some flower-women were prostitutes, though most were not. Still, the connection was always easy to make, and Goody points out the link, still strong in modern times (especially in the nineteenth century), between the selling of flowers and the selling of sex. Flower-crowned Flora, the Roman goddess of fertility, was identified in the Italian Renaissance with a famous courtesan of that name, and fanciful paintings of that goddess were often portraits of real whores. The revival of antiquity in Italy had brought real flower crowns temporarily into vogue, along with artificial versions, but only briefly; respectable Western women have since tended to wear floral crowns only if the emphasis is firmly bridal or otherwise virginal, and men have stuck to hats.

Flowers themselves were brought back into official Christian favor in the same way the images were restored, with many heavy references to the need for instructing the illiterate faithful. It was a long, slow process, since recurrent iconoclasm and ecclesiastical reform had a devastating effect on both image and flower. Protestants banished them both from the churches, just as Early Christians had done; Jews and Muslims never had either in the sanctuary. Orthodox Christianity, however, managed to get flowers back into the center of religious thought. An important symbolism was eventually created for certain privileged ones, especially roses and lilies, in connection with the purity of the Virgin, the martyrdom of Christ, and the mystery of the Incarnation. By retroactive sanctification, all living flowers could then be seen as God's precious gifts with holy lessons to teach. But perhaps only from a safe distance: during the early Middle Ages, floriculture was practiced in monastery gardens, mainly for medicinal use and botanical research. Deliberately decorative, fresh-cut flowers kept their questionable associations—luxury, sacrilege, eroticism—and secular flower culture remained primitive.

Some change in emphasis was clearly needed, as Western culture speeded up in the eleventh and twelfth centuries when both antique and Eastern civilizations began to exert an influence on Europe. Flowers were appearing everywhere on the exquisite textiles and objects designed in the East. Islam, while eschewing flowers in religious practice, nevertheless had a rich secular heritage of their representation in literature and art, along with a great garden tradition learned from the

Persians. Flowers had, moreover, figured in the poetry and science of a recently rediscovered Antiquity—never mind unholy practices. A permanent if ambiguous place for flowers was slowly being prepared in Western cultural life.

Ancient rural customs had continued, such as gathering wild blossoming branches in the forest every spring or creating maypoles with wildflowers. And so for urban pleasure, now that hand-wrought garlands were totally discredited, fresh flowers might be tied together in bouquets, as if artlessly plucked from country hedges. Eventually churches, houses, and women might wear cut flowers in bunches; the theme of their natural innocence was built into their spontaneous-looking arrangement. Western poetry and other writings made use of bouquet metaphors, the "posy," the "anthology," and the "florilegium"; manuscript illuminations of sacred subjects replaced schematic floral borders with perfect renderings of fresh blooms that looked as if they had just been picked and strewn around the edges of the page.

The impulse reached a climax in the fabulous bouquets depicted by the artists of seventeenth-century Holland, where floriculture had finally once again become a huge business and speculative enterprise, as it still is. The Dutch flower pictures of the seventeenth century were nevertheless vessels of lingering ambivalence. While the paintings celebrated the breathtaking results of a serious floriculture and the riches of its entrepreneurs, they also illustrated the vanity and the brevity of life, emphasizing the cut flower's all-too-transient freshness, the "flesh is grass" idea; and they often included a few vivid flies and worms as emblems and reminders of human mortality, When a flower painter apparently recorded with reverent fidelity the fleeting beauty of God's gifts, moreover, he was often flaunting his own capacity to immortalize their image, showing a mixed bouquet of flowers that actually never bloomed at the same time and could never pose together in real life. Artifice again proved indispensable for the truest rendering of nature.

Bouquets of flowers are nicely detachable ornaments. They may freshen the atmosphere of a sumptuous interior, but they may also stand up in brilliant opposition to an otherwise stark room. Bouquets are portable, and everyone looks wonderful carrying one, not just brides. That's because a bouquet looks provisionally festive—a gift just received

or soon to be made, never a vain personal adornment, always becoming and never shameful. The bouquet has seemed like the proper dress of Western flowers for a thousand years; it fulfills most emotional requirements in our modern world of dialectic and stress.

In the center of *The Culture of Flowers* is an interesting essay on the famous "Language of Flowers," which turns out to have been the invention of a French nineteenth-century lady, one Mme de la Tour. Her book was received with great seriousness in 1819 and quickly imitated, transmitted to England and America, and further imitated—its history illustrates the way haphazard lore can accumulate, solidify, and gain authority. The Romantic idea was born, which has had great influence ever since, that flowers have universal meanings known everywhere in the past and perhaps only partially retrievable in the present. Mme de la Tour's "language" and those of her imitators and followers were compiled from different questionable sources, old and new and by no means all in agreement with one another, and new arbitrary meanings were made up where no earlier ones could be found. These were incorporated into flower-books along with other historical and botanical information about individual flowers, so the whole enterprise took on the air of solid knowledge. Part of the story had the touch of Orientalism: Europeans liked to think that subtle Turks and Arabs had a complete floral language in which they communicated without words, so that tongue-tied sweethearts could freely express their tenderness, enemies could obscurely insult one another, and harem ladies could receive secret floral messages from clandestine lovers.

Goody points out the curious paradox in this idea—the floral language was supposed to have been both secret and universally understood. The modern people Goody interviewed all said that yes, there certainly was a universal language of flowers, and they thought their grandmothers had known it; or maybe it had been lost in the Old Country—it was clearly felt to be something of a present secret, but definitely a past science. This vague modern sense of loss about the true meaning of each flower does suggest the lingering effects of those centuries of floral suppression during the early Middle Ages. They seem to

have generated an obscure latter-day belief that modern Western knowledge about flowers must be a pale ghost of the true understanding that once enriched the world. The same flavor surrounds the modern occult uses of flower symbolism, the Secret of the Ancients idea.

On page 284 of Goody's heavy book, there is a footnote: "On the advice of the publisher I have excluded not only sections on rituals of love, but also a chapter entitled 'The shapes of flowers' dealing with the different forms in which they are used, a chapter on Japan, a general theoretical chapter and short appendices on 'The classification of flowers,' 'Heraldic flowers,' 'Artificial flowers,' 'Flowers in New Guinea,' and 'Flowers in Polynesia.' I mention this only to draw attention to the fact that these topics were not neglected and I may publish on them elsewhere." Tired readers may feel relieved to find this information. But the vastness of the subject that so weights the present volume has also somewhat misshapen it, and there are things on the list of omissions that might well have displaced some of what's here. Since Goody is largely taking up the role of anthropological historian, he has been careful to demonstrate the difficulty of knowing what people really did in the past: how chronicles can diverge from facts, how strict rules are often broken, how the staunch practices of the main group are greatly modified by some members of it, how people say one thing and do another—so that the texture of the historical sections is thickened by many back-looping amplifications and digressions. As a straight anthropologist, Goody has also wished to include his own direct observations about present floral custom, and we are therefore given long detailed sections on the current state of flowers in Bali, China, and India, and a lot about France and America. All of it is fascinating, and I wouldn't want to be without it; but it's hard to absorb in the same book that contains elaborate discussions of early Christian writings, early Chinese art, and Renaissance iconoclasm.

I would rather have had Love, Shapes, Heraldry, and Artificial Flowers, and Old Japan to go with Old China, instead of quite so much detail about the present south Chinese New Year; and perhaps less on the Church Fathers and fewer repetitious discussions of the questionable

role of images and icons in religious observance, or reiterations of the same insights about ambivalence. If I am to have modern China, then I really miss New Guinea and Polynesia, and I want more on Central America, ancient and modern. There is strikingly little floral reference culled from modern European, English, and American literature, or painting other than the Dutch, although there is some. I waited in vain for Zola's *Le Ventre de Paris*, and *Le Lys rouge* of Anatole France; I did find Balzac's *Le Lys dans la vallée*, but no "Rappaccini's Daughter"; Goody is after all not claiming to be a literary critic or a historian of art.

Still, his book contains enough diverse material, offered with a singularly comprehensive and energetic intelligence, to brighten and perfume any other realm of cultural study. It has large consciousness-raising power. Once you have read it you cannot fail to note the real or figured flowers that spring up at every turn of modern life and in every corner of the past. It offers the chance to acknowledge and perhaps understand how wrong flowers can seem as well as how welcome, to notice exactly when they signal the banal or serve the devil or figure the sublime, to observe with a wider-open eye both the daisy printed on the paper napkin and the painted lily in the angel's hand.

Caspar David Friedrich

Only nine oil paintings and eleven works on paper made up the Metropolitan Museum's 1991 exhibition of Caspar David Friedrich's works from Russia; and they were only minimally augmented by a few engravings, owned by the museum, which were made by the artist's brother from some of Friedrich's 1803 drawings. Housed far to the rear of the main floor in a small section of the Lehman wing, this show had to be sought out, but it was important despite its small size and ascetic flavor. Caspar David Friedrich (1774–1840) is now generally acknowledged as a great Romantic painter, and space has been made for him next to Turner, Gericault, Blake, and Goya on the roster of Early-Nineteenth-Century Originals. Reproduced Friedrichs now appear on book jackets, record albums, and in other public places, and pictorially conscious people have added *The Cross in the Mountains, The Monk on the Seashore,* and *The Arctic Shipwreck* to their mental furniture along with *The Raft of the Medusa* and *The Third of May*.

And yet virtually all of Friedrich's important works are in Germany, with some in Austria and Russia, whereas England, France, and the United States boast just one painting each, and no major ones. This

Review of "The Romantic Vision of Caspar David Friedrich: Paintings and Drawings from the U.S.S.R." (exhibition); accompanying catalogue, Metropolitan Museum of Art, Art Institute of Chicago, and Harry M. Abrams, ed. Sabine Rewald; essays by Robert Rosenblum and Boris L. Asvarishch; and *Caspar David Friedrich and the Subject of Landscape* by Joseph Leo Koerner (New Haven: Yale University Press, 1990) in *The New Republic,* April 1, 1991.

show offered an unparalleled view of the works now held at the Hermitage and the Pushkin Museum, none of which had ever been to America before, and many of which are not even commonly reproduced. It is even possible that many more Friedrichs still lurk in the Soviet Union, unknown in the West, even in reproduction.

The paintings in this exhibit are mostly very small, although two of them, measuring about 53 by 67 inches, are the largest he ever did. None of his most celebrated and popular works are among them, but they span Friedrich's whole career and give ample evidence of his unique quality at every stage of his life and in the different media he used. The first noticeable thing about them is the consistency—Friedrich had perfected his method by 1808 and never changed it until his death in 1840, even during the period after his stroke in 1835, when he worked very little.

Friedrich did not date his paintings, and he showed none of that obsession with development so common to artists of his period and to others ever since. Apparently he had no need to enact a visible fight for artistic territory, to be seen to be struggling steadily along inside the medium itself, to give perpetual evidence of his personal battle with the intractable eye, the pesky materials, the superior predecessors, the present rivals; with abiding artistic problems and new self-imposed technical tasks, with dominant opinion, with the laziness that gives in to facility, and with the stupor that blocks definitive vision and action. Unlike everybody's other favorite Romantics, Friedrich refused to demonstrate the new drama of the painter's work, the phrasing of a personal career in paint.

There are, instead, certain tightly controlled shifts in a prevailing idea that itself is not about painting, although it has to do with art. Friedrich gives the strong impression of being glad to be alone with his preoccupations, eager to satisfy only his inward eye. He is quite free of the artistic self-importance that places itself inside a current idea of the state of painting. Instead, he seems bursting with a particular spiritual consciousness that requires illustration, and that's what gives such peculiar intensity to his works. Packed into these soberly wrought views of various sober subjects is a single concentration, a uniform focus that has the same register whether the artist is dealing with Gothic ruins in the moonlight or with a local fence or window in the morning.

It is the very difference among these subjects that makes Friedrich's single-mindedness so uncanny. He was devoted to his native North German landscape around the Baltic port of Greifswald, and to the nearby places where he did his only traveling, and he celebrated them again and again with his usual concentrated reticence. But he was also wonderfully unafraid of owls and moons, sunbeams and crosses, swans and ships, anchors and towers, the whole warehouse of old spiritual emblems. He found they would do very well, just as they always had. He wasn't afraid of absolute symmetry, either, which also did splendidly, just as in the Middle Ages, to impose its ancient authority on a seeker's needy eye. In Friedrich's works, a taut new atmosphere is held in place by very old devices.

For Friedrich, the new meaning then being discovered in land and light and water, the things Turner was working with so explosively, had to be fused and integrated with potent old emblematic machinery, and so did the casual beauty of homely details. Friedrich did not try to look revolutionary by scrapping those old vocabularies, but he quite clearly did not rely on them either. He made plenty of pictures without any crosses, coffins, or ruins, indeed often with nothing but trees, images that are nevertheless tense with the same fateful longing that informs the moonlit graveyards.

With his unprecedented advances in the spiritual use of pure landscape, Friedrich discarded nothing he had inherited from the austere Northern tradition that began in the fifteenth century. This meant he could help himself to landscape motifs used by Northern Renaissance masters like Altdorfer and Seghers, artists who had already understood the appeal of larch trees seen against the sky, without even having to consider intervening classic models such as Claude. He internalized the Northern pictorial heritage, not needing deliberately to repudiate but only to transform. When he presents a funeral among Gothic arches and dead trees in murky lighting, everything is offered with the circumspect clarity of Van Eyck, Bosch, and Vermeer. Later in the nineteenth century, other German Romantic painters did insist on overdoing it, as eighteenth-century painters of varying nationalities had already overdone it, exaggerating plain ancient methods for rendering nature with the tendentious theatrics suggested by baroque horror merchants such as Salvator Rosa. Friedrich stayed with the old Nordic school that renders fearful material with limpid modesty.

He was dubbed great in the United States and acquired popularity here, as in France and England, only during the last twenty-five years, and in Germany only in this century. Having been successful at the beginning of his career, he had already fallen into disfavor by the second half of it, even at home, and was forgotten at the time of his death. He was revived in Germany in the early 1900s and became celebrated, but only there. Some art historians and art lovers outside Germany encountered his works on their travels or in books and fell in love with him; but theirs was a subterranean passion at odds with a hundred years of prevailing taste.

Reasons have been adduced for Friedrich's lack of modern fame outside Germany, beginning with the proposition that the Nazis took him up and so no one else could. But I don't believe that. It might have been true of Böcklin, for example, except that people hated Böcklin not just because Göring liked him but because most of Böcklin is truly dreadful. Friedrich had other qualities that rendered him unacceptable in an aesthetic climate dominated by French ideals of perpetual artistic revolution, of the abiding value of an avant-garde.

Friedrich's program could not meet the modernist requirements that were being applied retroactively to the whole history of art. The fealty of great artists was now seen to be pledged not to academic tradition or to the truth of nature, and certainly not to external political or religious mandates, but only to the inner dynamics of painting itself. These alone were seen to generate the true spiritual core of great art on any subject, religious or not. Thus the Virgins of Bellini, the mythologies of Poussin, and the rocky hills of Cézanne could all appear to have a single spiritual source. Spiritual expression required some personal transmutation through paint itself, not just by means of the old lexicon of religious terms. Artists of the past with a claim to greatness, whatever their announced themes and known patrons, must appear to have fundamentally detached their artistic selves from the requirements of the Church, the duke, or the academy, from everything but their personal responses to the demands of painting when they actually took up the brush. One sign of this was that they would appear especially detached from too careful (usually called slavish) imitations of realistic appearance that might seem intended to make base appeals to sentiment or idiot stupefaction.

•　　•　　•

Until the 1960s, Friedrich's fate as an obscure cult figure was sealed by his utter unwillingness to expound any painterly turbulence or spontaneity in a set of energetic new graphic terms (the quality that made Delacroix and Turner so appealing to the modern world); by his obvious comfort with the rigors of his technical training, and his belief in sober speech devoid of elliptical or fragmented rhetoric; and especially by his unreconstructed expression of a religious desire, unmediated by new literary mythologies in the style of Blake, or by political passion and social satire in the mode of Goya, and unashamedly rendered in the tight simplicities of an outmoded painterly system.

In 1975, in *Modern Painting and the Northern Romantic Tradition* his book about the kind of modern painting that expresses spiritual longing, Robert Rosenblum offered Friedrich as a source for painters such as Gottlieb and Rothko, whose versions of intense nothingness he demonstrated to be similar illustrations of "the search for the sacred in the secular modern world." But it is important to remember that Friedrich's own search insisted precisely on that verity that had been abandoned by modern seekers, that delicate respect for each twig that continued to be essential to his quest, as it was not to Turner's at the time, nor certainly later to Rothko's. Friedrich's paintings with nothingness as their subject always insist on the absolute presence of something, often in detail. Adherents of modernism could comprehend spiritual longing, but not if a cross was still part of the composition or a person pointedly staring into the distance.

In an essay for the catalogue of the Metropolitan's show, Rosenblum points out that Friedrich used the same themes as the Dutch painters of the seventeenth century. Here are the marine scenes, the woman at her window, the neighboring terrain, the views of churches, all closely observed and set forth in a unifying luminous atmosphere. But again a difference should be noted. Modernist demands were quite satisfied by seventeenth-century Dutch artists, who had, despite their careful realism, a firm grip on the right sort of painterly detachment. They preserved the correct look of wishing chiefly to address artistic problems, to force art to work for them alone, never mind the patron and the subject. Hals with his wizard strokes and twenty shades of black, Vermeer with his points of light and amazing perspective dispositions had clearly submitted themselves to stiff painterly tests and had visibly triumphed.

Let the philistines admire the faces and fabrics; serious painters and modern critics understood the real point, the artist's real work, which united him to all other artists, past and present. Tears of awe were appropriate, but only for viewers appreciating the feat of genius, the act of art, not the beauty of the room or the view.

Many of the neutral themes and the lucid technique are unchanged in Friedrich's art, but it is clear that his works aimed at the soul without recourse to uniquely painterly methods for doing so. He repeatedly signaled his spiritual intention in an archaic way, organizing the picture around a central axis, which can always force the most primitive psychic attention on even the most banal phenomena. Friedrich would even place figures along the same axis and make them stare with the same attention at the same sight, blocking and emotionally filtering the view; and so in his landscapes he denies any unselfconscious detachment even to his incidental figures and wrenches still more empathy from the hapless spectator. When it isn't a person, it may be a stunted tree or a pregnant shrub, a crude hut brooding under its cap of snow or a small gate sagging in a sunlit wall that fills the picture's center with fateful importance. It may be a coffin or a cross; or it may be nothing but water or sand, seen against a luminous emptiness.

It was Friedrich who single-handedly made it natural to summon religious feeling when looking at the calm sea and the local evening sky, or while watching boats slide quietly into the mist. It was he who managed the transfiguration of the unremarkable nearby hills or the uninteresting grove of firs behind the house, insisting on a sharp spiritual need quite different from the divine awe aroused by big sublime vistas. There were contemporary British watercolorists also exploring local subjects in a restrained transparent mode, but their interest, just as with the old Dutch masters, was vehemently secular. Their works always look briskly committed to the extreme possibilities of paint, not piety.

Friedrich's great contribution was swallowed up in the increasing tide of modern scorn for the popular arts that fostered cheap versions of religious impulses and that were thus at odds with modern views of seriousness. But at the same time, the pictorial strategies Friedrich invented were being steadily redeemed and perfected by photographers and cinematographers. It has been they, not modern painters, who have shown how an artist, by bringing the viewer's gaze to bear with a certain med-

itative intensity and a certain use of light on undistinguished bits of the
natural world, can convey the pain of transience and the naked force of
spiritual longing in just the way Friedrich had first done it. All during
the later period of his eclipse many moviegoers have felt the power of
Friedrich's originality without knowing its source; they have learned
from the camera to see God in plain landscape without ever having seen
a Friedrich. Now, after the steady rise during the last thirty years of
all camera art on the aesthetic scale, along with the recent irreversible
disintegration of the solid modernism that used to govern so much
response to art, Friedrich's time has come again.

The works in the exhibition in New York were organized by
medium, so that an assortment of small sepias and watercolors occupied
one small room and the array of nine oils was disposed around the
adjoining quasi-hemicycle at the back of the Lehman wing. The sepias
included several studies of owls, coffins, and moonlight where the pale
and delicate texture is in eerie contrast to the somber theme; a water-
color of the Gothic ruins at Eldena, often used by Friedrich in urgently
grim compositions, is here seen with urgent tenderness.

The big wall of oil paintings included Friedrich's vision of the mari-
tal journey entitled *On the Sailboat*, where a man and a woman sit in
the bow of a small ship, outward bound. The relative scale is striking;
Friedrich's original sketch shows a very small vessel, but he here en-
larged it to rise protectively around the small pair silhouetted against the
sky, who hold hands on the gunwale and stare ahead. The big boat has
no visible crew or cargo, only the two passengers perched far forward,
the better to see what's coming, both of them oblivious to the appar-
ently supernatural handling of their craft. What's left behind is also
behind us; our view is from amidships—but the boat may well have no
stern, the journey no beginning. He wears a hat, but there is no port-
manteau, no shawl, no basket, no umbrella, no rug, and no hat for her.

These absences are noticeable because of the sense of present life the
plain technique permits us to feel, the artist's refusal to adopt a fairy-story
style. The lady's coiffure and the shape of her clothed body are acutely
contemporary, and so is the boat. But wait. Other strange things are only
slowly apparent. The shore for which they are making bears a row of
towered structures, which have been identified as coming from three dif-
ferent towns; but more than that, it bears a certain resemblance to Dürer's
incandescent 1495 watercolor of Innsbruck, viewed from the north over

water. And what about the man's hat and those long curls? Dürer again, by golly, and the amorphous garments he wears below the neck only confirm this idea, since they are otherwise seamless and pleatless and buttonless in any modern scheme. And what is that spiky collar she has on? It is not, although it might seem so, a fashionable detail. It is in fact a standard picturesque reference to the olden days, meaning anything even vaguely from the Middle Ages, and a common international device for illustration and stage costume between the 1770s and the 1820s. So maybe we are in the past, but clearly right here at the same time, and circling over the ocean to the future, where the past still remains.

The clothes in Friedrich's pictures need further discussion, mainly because his ability to convey the subjective mode so well owes a great deal to his excellent sense of current fashion, a gift he shares with Goya. Both artists turn pointedly contemporary dress into a visual sign of corporeal subjectivity; they use it to illustrate the currency and presentness of the self in its body, and to engage our sense of our own physical selves. *Sisters on the Harbor-View Terrace* is a nocturnal view of two women standing with their backs to us, looking over a parapet at a forest of masts, spires, and one monumental cross, which are illuminated only by milky moonlight and a few high stars. This pair—a version of his wife, Caroline, and her sister-in-law—wear long dark gowns with trains and high collars, and the catalogue says that these are Old German medieval gowns. But I believe that's wrong. The ladies are wearing the new *douillette*, much in vogue between 1820 and 1822, a warmly lined and long-sleeved evening dress invented for the extra cold winters of those two or three seasons.

Friedrich's sketch for this painting shows modern seaming and gathering for the dresses and the modish braids, ribbons, and combs he liked to use for women's hair. Here the women's fashionable evening wear only enhances their rapt concentration on the dim crowd of old towers and dark ships. Their visible adherence to modernity, their link to the constant present is all the more sympathetic in a setting that evokes a sense of melancholy and even of doom. Indeed, Friedrich's most compelling view of Caroline is *Woman in the Evening Sun*, where she has put on another cozy *douillette* and a lovely pair of coral earrings in order to walk out and stand alone, arms outspread, before all the sacred mysteries of nature.

But writers about Friedrich want mainly to talk about something called *altdeutscher Tracht*, translated as "Old German costume," that many

of his figures are in fact wearing. Except for Joseph Leo Koerner, in the book under discussion here, critics haven't said what that actually was, and nobody writes about the range of ordinary clothing that adds such poignance to Friedrich's works, or about any other interesting departures from it. Koerner has finally explained that the *altdeutscher Tracht* was not medieval clothing at all but a bit of politicized counterculture wear devised and adopted by students and artists and ex-freedomfighters around 1815, who had struggled against the imperial might of Napoleon and were afterward trying to foster a nascent opposing sense of German nationalism. The clothes were supposed to suggest the sixteenth century and the great days of German cultural ascendance— Dürer, Holbein, Martin Luther. The style naturally became an issue only when it was banned in 1819, along with other forms of nationalist expression. But Friedrich thereafter continued to put it in his pictures, in a spirit of solidarity that also inspired his views of the tombs of ancient German heroes and other treasured monuments. The costume itself made no pretense of copying real historical style, being intended mainly to look very different from anything modern and French. Its chief effect, defying the chic cropped hair, smooth chins, and high hats of the day, was the wearing of long hair, beards, and the big floppy berets that are still associated with the Middle Ages.

Ever since Rembrandt, artists often affected such hats to suggest Raphael, not Dürer, and to claim an apolitical solidarity with painters of all epochs, not with current national issues. They were certainly worn by many German Romantic painters for just those unworldly reasons; you can see them in many portraits, and I believe you can see them in Friedrich. At the same time, there were many sorts of soft student cap in use, worn with ordinary tailored coats, and these are also shown by Friedrich, notably on the younger man in *Two Men Contemplating the Moon*. The older, meant to be Friedrich himself, does indeed wear the "Old German" version; but there is clearly a point to the different clothes these two have on.

The man on the sailboat, however, is wearing something truly peculiar, even with the strangely familiar hat and hair, a sort of indefinable timeless jumpsuit. In this picture, Friedrich really did take up his Romantic license to use imaginary garb, clearly part neither of current fashion nor of current politics. The woman's pointed collar and the man's blurry suit and antique hat instead indicate a standard attempt

at universality through antiquity, whereby an artist invents bits of legendary-looking raiment that evade specific practice, old or new, to make clear that we are in no time but in a mythic past that may encompass a mythic present. Friedrich once did the same thing with vaguely classical drapes, in an earlier painting of lovers called *Summer.*

Yet this hat, too, this monumental mushroom cap, bears uncanny traces not only of Dürer and Rembrandt but of the historical hat Vermeer wears when he paints himself into his allegory of painting, where the muse is the model holding fame's trumpet and his hand holds the brush. Is this a vision of Friedrich the Painter, newly married at forty-four, finally sailing forth hand in hand with his radiant new muse to join the company of great Northern artists, skimming over the water toward his own eternal Greifswald, Dresden, Stralsund, his own tropes of the immortal Innsbruck, the everlasting Delft, and all the holy cities of the Northern landscape painter? Maybe; but probably not, since he probably did not know the Vermeer.

Anyway, such speculations connect Friedrich with past history, whereas the exhibition was devoted to Friedrich the Romantic, to whatever attached him so vitally to his own moment and now makes him so necessary a figure for our understanding of Romanticism. Joseph Leo Koerner's book on Friedrich provides a most valuable background to this display. His many ravishing reproductions of Friedrich's other works show how smoothly the exhibited examples interleave with even more vivid ones, and his discussion of the artist is riveting and instructive.

Koerner wants to describe how Friedrich transformed landscape painting into as definitive an exponent of Romantic thought as landscape poetry became with Wordsworth. In so doing, he can link Friedrich to modern aesthetic principle, just as Romantic poetry has been shown to be linked to it during the last few decades of literary criticism. Friedrich helped produce a new art criticism, as Wordsworth a new literary history, by forging a new relation between nature, the artist, and the viewer, one that would serve a new art of experience instead of the old quest for ideal perfection.

Thus began the modern aesthetic idea, according to which the point of natural landscape lies in how it is personally seen and subjectively felt.

Such seeing and feeling may best be demonstrated by an artist (poet or painter) whose individual genius perceives, transmutes, and presents the world so as to make the subjectivity become ours. It is only through the contemplation of nature, moreover, that such individual subjective exercise authentically occurs; and so landscape will have to become the modern subject for art, because its own true subject is subjectivity itself. Thereafter art could replace religion, supplementing outworn creeds by rightly showing us what to make of nature in the modern world.

It is true that the importance of Romanticism to modern thought was explained first by literary critics, while Romantic painters were mainly valued by art critics for their expressions of painterly freedom, usually seen to pave the way for more serious exponents of personal vision in later decades. They were not seen as modern themselves. Koerner convincingly offers Friedrich as the Wordsworth of painting as no other artist was, neither fellow Briton nor French analogue, another founder of emotion recollected in tranquillity—and not just recollected but re-created as a form of deep contemplation, out of the deliberate exercise of the artist's contemplative talent.

Friedrich thus becomes the first pictorial poet of loss, the one who wishes to show the natural world as an image of something that feels as if we once possessed it but that really was not ours, something that is always still desired and still unattained. He is the painter who can give the sense of all experience as weighted with unretrievable memory—with the loss of the visionary gleam, the fleeing of that music. Such a dip into the unconscious is an early move toward modernity quite familiar to students of Romantic poetry, but less so to those accustomed to the idea of Romantic painting as primarily spontaneous.

Koerner's book opens with one of Friedrich's haunting clumps of centrally organized shrubbery that seem to fill the universe, here a thicket you can't see past. His text begins: "You are placed before a thicket in winter." Indeed you are; and Koerner goes on to show in detail how this thicket is meant for you, to display your feelings to you, to illustrate the psychic barriers you recognize between yourself and your desire. Then he goes on to show a symmetrical group of fir trees in the snow, and begins again: "You are placed . . . " And now he shows how this group forms not just a wall but an embracing chapel, not just a barrier but an invitation and a discovery; and how both pictures seem to suggest that you are the first person ever to stop just here and to look at

these particular shrubs in just this way. But since they also bear the careful look of having been previously seen, the look of memory, they can never quite be yours. "You stand before the pictures," he says, "as before answers for which the questions have been lost"; and that seems right. Thus he begins his discussion of *"Erlebniskunst,"* the Art of Experience, which is most thoroughly expounded in a later chapter entitled "The Halted Traveller," where he includes a discussion of the *Rucken-figur,* the figure seen from the back who is so insistent a presence in Friedrich's art. He connects this personage also with his or her replacement by the viewer in such works as the thicket picture, again showing how Wordsworth manages the same thing with a smooth change of tenses and persons in his poetry. The participation of the viewer is invited as essential to the completion of the picture; which is no completion, but only a continuation, a constant sharing in the sense of God's inexplicable promise.

Between these two discussions comes Koerner's study of Friedrich as a specifically German Romantic, whom Schlegel, Novalis, and other unpictorial German Romantics felt to be their exponent without having very articulate ways to say why. It was, thinks Koerner, his old-fashioned critical enemies who understood Friedrich's innovations and explained them best, notably the Freiherr von Ramdohr, who wrote a sustained attack on *The Cross in the Mountains* when it was first exhibited in 1808. His stout defense of the classic principles of landscape art and his outrage at what Friedrich made of them give a good view of the artist as a crucial figure for his date, someone after whom nothing would ever be the same. The subjective, emotional claims offered in Friedrich's painting were directly opposed to Enlightenment views of art's normative function to create, refine, and maintain timeless aesthetic ideals, and thus even to impose a detached morality on taste and judgment.

Koerner further describes how Friedrich's clear adherence to the old religious and emotional qualities in Northern Renaissance painting showed him to be suspiciously prone to the new habit of reviving Old German glories. The unenlightened medieval artistic style was seen by neoclassic critics to have been rightly swept away forever by the sane principles articulated in the classical seventeenth century. By reverting to the old ways in the current climate of emergent nationalism, Friedrich could seem not just naïve or incompetent but even a bit artistically compromised by his political views.

In his various attacks on *The Cross in the Mountains*, Ramdohr makes us see how purely subversive Friedrich's painting then appeared. Instead of offering a subtle progression back through the overlapping planes of the scene, alternating degrees of light and spatial gradation to draw the eye gracefully into the distance, he brutally thrusts a mountain up in front of the sun. He thus plunges the entire front half of the view into shadow and prevents us from rightly seeing any of its recessions in the remaining available light; and then he sinks even the immediate foreground into deeper shadow, digging a pit just where we need firm ground on which to move into the picture. And just where are we standing? We seem to be floating; and there's that huge obtrusive crucifix, no quaint wayside fixture but a looming presence with which a too-symmetrical array of overinsistent pines is contending for God's distant light and our instant response. Friedrich has notably failed to integrate the rough elements of a given prospect into a harmonious interwoven whole, to create a visual symphony out of uneven natural appearances, and so on. More obviously, he has failed even to try.

This picture instead expresses the thought, unwelcome to the Enlightened academic critic, that nature is the one true cathedral of personal worship, and that art's real task is to show how this is so, even to make it so. To accomplish this, art must abandon its old desire to make landscapes lie back among their adornments and gradually unveil themselves in a solemn dance for Beauty's sake. Obstructions must be suggested, contrasts must be emphasized, to invoke the true character of our unappeased lust; art must convey not beauty but the way nature makes us long for what we will never attain, the heaven that lay about us in our infancy.

In most of Friedrich's work it lies beyond death, which exerts its powerful pull in any setting he describes. Death waits not just in the graveyard but past the thicket, past the boat half gone in fog, waits beyond the entrance to the wood. Heaven, moreover, requires no obvious cross to guide our expectations, and death no coffin. The pull is simply there, and it's always out of reach just beyond this parapet, out there on the sea, across that chasm, beyond those rolling slopes. In all Friedrich's scenes we may observe the obstacle he never omits. Even if it's only the shore or the wall, or only a dim foreground against a light sky, there is always an impediment that separates foreground from dis-

tance, near space from far, and us from the incalculable future that seems to lie in our psychic past.

The painter made thousands of minute sketches of particular trees and the precise profiles of rock, summoning and mustering the elements of paintings he would distill later in the studio, sometimes twenty years later, with all the particularities intact. Koerner shows how the details of the foreground in *The Cross in the Mountains* are perfectly clear despite their shaded tonality and the commanding drama behind them. Nothing specific has been sacrificed to that epiphany; and Friedrich is shown as the poet of *Eigentumlichkeit*, the uniqueness, the singularity, even in an extreme sense the strangeness, of anything and anyone, the particularity of each self and each of its experiences. This subjectivist position was important to many German Romantic thinkers; and it was the way Friedrich managed to convey the same idea with his close personal visions of rather barren scenery that made them believe he was their true exponent, even without trying to be so. In his art, religious longing may be precipitated by the look only of an actual tree, never by an idealized tree, a visionary tree, an idea of trees. And the experience of observing the unique tree is also unique, a moment like no other.

At the same time, Friedrich is the poet of retrieval. He collects many unique fragments, and then he builds them into paintings that are like attempts to collect a meaning in them, not to assert what it is. And so they echo what Schlegel and Novalis believed was their project, that of "romanticizing the world." Always vaguely explained, this seems to have meant trying to rediscover its meaning according to a new sense that any such meaning is itself in a state of unfinished process, a state of becoming. Consequently only the sort of quest that moves both onward and backward together may hope to yield some awareness of what God intends; and that awareness, needless to say, will also be forever incomplete. Divine significance may or may not dwell in the thicket. The painting only shows the search for it.

Koerner's book is densely packed with thought and no less packed with an emotional drive similar to Friedrich's own, a refusal of detachment that feels quite appropriate for the elucidation of these charged works.

His prose however suffers from this obsessive tendency, so we get "recuperate" fifteen times when "recover" would certainly be good now and then, and similar repetitions that become irritating. Intensive study in German has also affected Koerner's English, so that he invents words like "enframe" to mean "frame," and uses them much too often. But forceful arguments and vivid explications, both historical and theoretical, make this essay a most welcome antidote to Helmut Börsch-Supan's ponderous tome (*Caspar David Friedrich*, tr. Sarah Twohig, Braziller 1974), until now the only book on him in English, where dreary lists of symbols keep hampering the discussion of the works.

In his careful analysis, by contrast, Koerner proves that Friedrich's Romanticism was fundamentally modern. If a painterly modernity is the point, however, the paintings alone don't make that case. The meditative precision of these owls and hills and hats and trees keeps them attached to their time, effectively preventing them from sharing in the "modernity" of a Romantic painter like Turner, whose use of primal blur detached him from his century. But on some lovers of art the effect of Friedrich's works is quite direct; and such impact suggests that he certainly had the conceptions of a modern artist, if not those of a modern painter. He was a maker of visions that can arouse deep responses in modern viewers, and especially in those trained to seek and find the sublime in films. It is in the mobile poetry of cinema that Friedrich's ideas seem to have been confirmed, in situations where the camera may sit for many seconds on the same empty patch of ocean, insisting on a meaning it can only adumbrate, capturing the viewer's unconscious without warning, setting memory in motion. At the exhibition, looking at a flock of birds skimming past some fishermen's nets drying on an empty moonlit beach, we can believe that in his own day Friedrich's modernity went beyond paint. Maybe it will go still further among the uncharted media of the future.

Schapiro on Impressionism

This fifth volume of Meyer Schapiro's Selected Papers is the second book to be published since his death at ninety-one in the early spring of 1996. Schapiro had begun preparing a book of his writings on Impressionism during the last two years of his life, while he was still working on the galleys of his *Theory and Philosophy of Art: Style, Artist and Society*, which appeared shortly before he died. By then he had already chosen the illustrations for this volume, and he had incorporated most of his pertinent later observations into his original six Pattin Lectures on Impressionism, delivered at Indiana University in 1961. Many earlier thoughts found their place in this last book, too, since Schapiro had been writing and lecturing about Impressionism since 1928. All along he kept every note and alternative text and added to them, and everything was steadily reorganized again and again by Dr. Lillian Milgram, his wife and Lady of Perpetual Help, who also presided over the final production of this posthumous volume. The Pattin Lectures, perhaps a summation when they were given, only provided a new starting point for the ceaseless forward and backward scan of Schapiro's view of the Impressionist enterprise.

The result offers essays of unparallelled freshness and mobility, rich, warm, and light as fine cashmere, all the more pleasurable since the sub-

Review of *Impressionism: Reflections and Perceptions* by Meyer Schapiro (New York: George Braziller, 1997) in *The New Republic*, March 9, 1998.

ject has been so heavily conned in the harsh light of present-day inter-
ests. As a speaker, one of Schapiro's secrets was to make you feel smarter
and wiser than you were, by sharing his thoughts in a manner so sim-
ple and fluid that you felt you were thinking them, shifting from cen-
tral to peripheral points and back, considering the idea from all angles
almost simultaneously, encompassing and possessing the subject by
means of a sort of delicious and effortless dance. Impressionism seems
to make the perfect quarry for this benign kind of chase, this gradual
gathering of the topic into a shimmering net of modern reference, his-
torical learning, insight, sympathy, and the play of a wide, glad eye.

Impressionism is itself elusive and shifty. Even the list of its practi-
tioners, its temporal scope, the meaning of the term are all indefinite,
like the boundaries of form in the actual works; and the aim of this hunt
is not to seize and fix but to pose questions, seek light, and open up
connecting paths. The theme of freedom is central in Schapiro's study
of this group of painters. He invokes it constantly, with respect to their
subjects and their objectives, their physical relation to the paint and the
surface. He finds a further exhilarating liberty in the huge reverbera-
tions of their work, seeing the whole wide-ranging future of modern
art unleashed by those first six or eight emancipators.

Schapiro is careful to state repeatedly that he does not mean libera-
tion from the importance of subject matter to painting, which many
have attributed to them. Instead, he sees freedom in the connection
between the Impressionists' new use of color and stroke and the new
life of Paris and its environs that they elucidated. The Impressionists'
subjects, far from being arbitrary phenomena serving as pretexts for
painterly exercise, were what Schapiro calls "favored texts of percep-
tion," to which they returned again and again. Themes were consistent,
always illustrating a new escape from old constraints of vision, belief,
and behavior—old constraints on artistic conception and practice, and
on everyday urban or suburban custom at the same time. These painters
offered not just people in the park, but a new way of painting people in
the park that suggested a new way the public and the painters might be
feeling, a change in what art and life were now like. Society was more
liberal, people were having more kinds of encounter with one another,
Paris and the suburbs were more connected, nature and culture were less
and less perceived to be absolutely opposed. The city seemed more ami-
able, the country more accessible. Sunday was no longer a day of ritual

gloom but of spontaneous renewal, which need not mean escape from town but maybe local pleasure at a café or a show. Accordingly, certain French painters were breaking away from careful classical forms and self-conscious traditional themes, offering instead the reflection of a new perceived value in direct experience.

Schapiro points out that all this had to be a Parisian phenomenon. Since 1789, the population of Paris had repeatedly confirmed the sense of itself as a unit with a collective consciousness. Only the self-aware Parisian crowd (unlike that in Rome, London, or New York) collectively felt itself free, no longer subject to state or church, and "jealous for its liberties," says Schapiro. By the 1870s these liberties had come to include the modern freedom to indulge in steady random flow and informal mingling without an urgent goal. Schapiro contrasts Daumier's single-minded crowds all rushing one way with Impressionist waves of multidirectional throng on the quais and boulevards. Parisians were now favoring casual outdoor clustering, says Schapiro. Picnics were à la mode, and the chic new "gracelessness" of manners they called for—munching in shirtsleeves on hand-held drumsticks, maybe even disrobing—was duly rendered by Monet and others (never Degas) in paintings where, he says, "the paint provided the elegance." Schapiro further perceives such celebrations of freedom in paint and behavior as looking forward to Gauguin's Tahitians and Matisse's dancers.

The Impressionists' new take on the link between art and life basically elevated a new freedom of vision, a freshly inebriating sense of sight as the mark of modernity. These painters now celebrated the untamable look of things, which never stays still, is free to all, and can offer everybody the sense of a universal vitality in any phenomenon. They gave to situations in the street or square, or to out-of-town trees, boats, and water, a new mobile universe to inhabit—a glittering, unified world of infinite possibility directly realized in a piercing visual joy. Thus a small church, set on a rise with nearby trees and receding hills, could be caught in a fluid net of brushstrokes that shaped them only with contrasting touches of vibrant color, applied according to the fluctuating intensity of an eager visual lust—forget piety, community, sublimity. This optical eagerness might also assimilate a rural scene to an urban one, or vice versa—the same convergent paths and intermittent structures, man-made or not, would share in the same fierce visibility. The variably colored surface would be like the air, pulsating with shifts

of both light and emotional tone. The optical sensation and the emotional flavor of the "impression" would be painted as if to imitate their vibrant fleeting state, with its built-in shifts of attention.

Schapiro finds a background for this new sense of pure nourishment through the eye in the literature of the epoch and earlier, in the imaginative writings of Gautier, Maupassant, and Fromentin. These and other writers often registered the potent visual impact of scenes and surroundings as it fed the soul directly, not as it evoked associative memory and fantasy, piety and historical awareness. Romantic and academic artists had been painting nature as if the sight of it were meant only for such evocations and the artist's whole task were to temper the raw look of the world with painterly harmony, applying ideal beauty or divinity, morality or anecdote as appropriate.

So had most painters for thousands of years. It was writers, says Schapiro—offering striking examples from antiquity and the Middle Ages, as well as the nineteenth century—who always knew how to record with startling brilliance the tonic effect of acute optical experience, which is the whole world's natural birthright. Opposing the pious idea that artists teach people how to see, Schapiro finds people naturally very good at it, and painters in fact rather slow in catching up with writers' truthfulness in dealing with the delights of eyesight.

But Schapiro's study of Impressionism dwells less on the disjunction of this school of painting from earlier ones than on its connection to them. As if he were one of them, he shows how Impressionist painters took strength from studying the work of the past, a strength that guaranteed the value of the originality they bequeathed to future painters. Schapiro shows how Renoir's *Moulin de la Galette* and *Luncheon of the Boating Party*, for example, were each constructed like a Rubens or a Veronese, and then loosened up to allow the molecular surface of Impressionist paint to create the quality of spontaneous visual impact and random interior movement. The result gives a richer satisfaction for its unnoticeable debt to past compositional strategies. He remarks on the filiation linking Corot—the classically trained, romantic-minded teacher of Boudin, the painter of beaches and big skies—and Monet, Boudin's pupil, to whom he introduced plein-air painting. Then he compares Corot and Monet works, showing both the similarities and the differences. He proves that the development of Impressionist prin-

ciples, just like those of modern poetry, depended on a most attentive and effectively larcenous rejection of earlier ones.

The universal community of artists is a natural theme for Schapiro because he was a member of it. He drew and painted all his life, ever since he had been the one child in the evening art class given at the Hebrew Settlement House in Brownsville, where his family had settled after immigrating from Lithuania in 1907. Schapiro's wide-ranging study of art history was made essentially from the artist's point of view, his study of individual works undertaken as if from inside an artist's skin. Understanding of the kinship among artists allowed Schapiro to discuss the individual differences of any two historically divided painters' works in the minutest terms—the application of individual brushstrokes, the subtlety of tiny compositional choices that affect surface flavor, the exact means by which the effect of distance or closeness is obtained, the technical moves that remain forever independent of anything else. Schapiro was single-handedly responsible for the recent study of art history that takes society as art's prime mover, since he searched for significant elements in the social ambience of artistic careers and saw influences affecting the artist's hand and mind of which the artist might have been unaware; but his purest gift and greatest virtue was his artist's heart and eye.

Most painters do in fact stare with fierce competitive attention at how Velázquez did it, never mind what the king and court had to do with it. It would seem that artists have always stared the same way, whenever works from other places and times have been available to them. We find Gentile Bellini, for example, possessively copying a Persian miniature, Rembrandt copying another Persian miniature, Rubens copying Titian, Degas copying David, all getting in tune with old secrets and solutions and feeling out a way to use them. Schapiro assumed the existence of this primal solidarity and reciprocity among artists, the view that all artists have always known they were contenders in the same game and members of the same club, despite alien politics, unfamiliar religions, or widely differing conditions of cultural servitude. He could thus permit the modernity of the antique to appear and make the crumbling Romanesque sculptures come to instant life.

It is not surprising that Schapiro's New School lectures in New York (1936–52) were attended by many more painters and writers than art historians. Schapiro was almost alone in being able to appreciate and interpret the work of artists of that period, both Europeans and those of the emergent New York School, and in being able to integrate them into the history of modern Western art—that unbroken history he specialized in describing, the one with its feet in the Middle Ages. The notes for these essays on Impressionism contain no evidence that Schapiro studied the work of his contemporary professional art historians with the idea of entering into any dialogue with them. His sources are the critics contemporary with Impressionism, along with the writers and thinkers of every kind who flourished at the period, or led up to it, or came in its wake, or foreshadowed it in antiquity.

Exceptionally learned, gifted, and imaginative in many areas since early youth, Schapiro made his own estimate of how the work of scientists, architects, and politicians, not to speak of poets, novelists, and composers, interacted with works of painting or sculpture. He sought and found his own set of connections between the role of the world in art and the unaccountable power of art in the world. While considering the genesis of any painting as if he were the painter, he never failed to take on the whole texture of living, the political climate, currents in the common will, the aesthetic flavors of the time.

Having taught himself German (via Yiddish) and having absorbed the great works of Alois Riegl and Wilhelm Vöge and Emile Mâle as a student at Columbia, and having written a brilliant dissertation on the twelfth-century Romanesque abbey of Moissac after five years of research on site, Schapiro became a lecturer at Columbia, then assistant, associate, and full professor, then University Professor, and eventually Emeritus Professor in 1973, having relentlessly gone his own way in the same place starting in 1928. He allied himself with no fixed theory of art or scheme of thought, offering his own perceptions, discoveries, and convictions, speaking extempore out of his crowded head. He probably didn't read the art historians who flourished during the middle of his career, and they couldn't read him, since he did not publish books and his essays often appeared in recondite and out-of-the-way places. Once his collected essays were successively published after 1977, recent scholars patently came under his influence; but he probably never read their

works either. He was always a solitary prophet, a distinct shape against the New York skyline.

These essays on Impressionism are probably the first to deal with the way photography and railways, for only two examples, informed and envigorated the consciousness of these late-nineteenth-century painters, along with current theories of color and light, of social improvement and political freedom, of psychology and human behavior, to say nothing of fresh departures in poetry and music, fiction and theater. Schapiro was the first to find all vital contemporary matters woven somewhere into the Impressionist net of colored strokes, even while knowing that any given picture is true only to its immediate "impression"—visual, certainly, but also psychological, personal, and unique.

The picture is always about the moment, charged as that is with overlapping inner feelings, surrounding cultural forces, and the look of the light on the snow. But for the first time, the picture is now manifestly a field of paint, laden with differing thickness of pigment, differing density and direction of stroke, differing color and intensities of color. The strokes represent the complexity of the "impression," and harmonize to convey its totality; but they simultaneously convey their own harmony, just as did the rhythmic, sinuously composed lines of the sculptured Romanesque epiphanies. In the old miraculous scene or the new suburban site, painted strokes and carved lines lead their abstract life, offering their own integrated satisfactions to the thirsty eye.

What was most new in the Impressionists' version was the freedom of individual expressiveness their works deliberately embodied. No two painters were alike; their application of the paint was like their handwriting (and here Schapiro characteristically inserts the fact that handwriting analysis was invented just at the Impressionist moment, by J.-H. Michon in 1872). No two paintings were alike, either, varying in the exact fleeting moment of action they registered and in the nature of the painterly mosaic it was registered in; and no two areas of one painting were alike, since the character of the surface would change according to the painter's shifting responses.

Schapiro extends the varieties of Impressionist individuality to include

Cézanne, Manet, and Degas, whose spirit, strokes, and subjects came to differ so much from those of Monet, Sisley, or Pissarro. He points out that horse racing and ballet had aristocratic associations suitable to Degas's upper-class status and mentality, but that Degas's view of any dancer or jockey was the same as his view of any laundress or orchestra member. Schapiro finds Degas identifying with all of them as fellow artists, workers whose precarious job, like the Impressionist painter's, is to carry off a successful performance. Whether Degas shows them relaxing or preparing, as he does bathing prostitutes (more performers), or paints a laundress making collars crisp, a cellist drawing his bow, or a modiste making a hat ribbon sit well, he sees each playing the role of minister to the general elegance, each supporting, just like himself, the high aesthetic standard of Parisian life. Schapiro says Degas never saw them as Daumier did, examples of oppressed humanity slaving for the ease of others. Manet painted the ragpickers and Caillebotte the floor scrapers and Pissarro the housepainter, says Schapiro, in the same spirit of fellowship with the work of the hands, which is the real effort painters make.

No more than the coal heaver should the painter be thought a visionary. In reality, his hands are solving hard problems in a difficult material, struggling just like the milliner's to get the right effect. Schapiro talks about Monet's ecstatic images of trains entering and leaving railway stations: "They show the most passionate, impulsive streaking, scribbling, cross-hatching and hatching of strokes that in concert evoke the original exciting phenomenon. That fury of the brush was a personal reflex . . . The abrupt rhythms and the vehemence of the brush expressed a vital personal reaction, besides imaging keenly observed features of the site." He also watches Monet seeing the railroad as a human environment continuous with nature, something wonderful added to street life and country life, part of the lyrical celebration of visible modernity. Then Schapiro links these paintings to the literary moment: "Every touch possessed an uncanny rightness and power of suggestion, as in the best French writing of the time, in which the evocative word or phrase or the rhythm of a verse or sentence was so often a discovery, an outcome of the will to realize in language the qualities of unique, unnameable sensation." Thus Impressionist painters, like the contemporary writer reinventing the language, sought to make the paint realize their personal responses with all their nuances, to suggest that painterly discovery was simultaneous with visual discovery and to make the

process as vividly apparent as the chosen scene. There were no precedents for doing this; that was the idea. There could be no formula; freedom from formula had been declared.

Always at the painter's elbow, Schapiro reminds us that arriving at this direct spontaneous effect meant slow methodical work, most of it trial and error. Impressionists made countless new versions of the whole and the part, constant experiments in color combination, contrast, and juxtaposition, in size of stroke and choice of hue to create all relations between dimness and luminosity, repose and motion, opacity and transparency, and, of course, all effect of "fury of the brush." A clear blue might convincingly appear to shade one side of a white sleeve in large strokes, but only if they were unevenly interspersed with smaller strokes of green and tiny flecks of red and yellow, to catch reflected light from the white, itself sun-struck by short strokes of paler yellow rendered still more dazzling with purple speckles; all to tell the eye that there is no light and shade, only changes of color. Nor are sea and sky separate elements; they are both woven out of variably dim gray streaks, with rose and mauve flecks of different sizes making a cool glow appear to hover over a cooler sheen.

The flickering surface became a complete material composition on its own, confected with the same slow care once put into a tapestry by many patient hands, but now meant to suggest one painter's volatile soul, clear eye, and pliant wrist joined in quick activity on the actual site. This effect would further convey that the painter was pointing nothing out for the viewer's good; he was sharing the bright moment with a fellow spectator on whom he placed no burdens at all. Ostensive delineation and modeling of form were abandoned on purpose to realize this idea, so that only the dense or sparse flecks of color, made of unbelievably life-inducing paint, had the authority to conjure the image. And that wasn't all. Whether for smooth living faces or rough open country, for dirty walls or fine clothes, fast trains or dead trees, old fences or young dancers, shrubbery or rubbish, all flecks had equal status. The mutable texture of paint on canvas became the only matter there was.

And from this, Schapiro points out, came the later authority of paint alone to create images in this century. Such total authority was lacking in pictures by Turner and many others who had wrought in sketchy strokes before. In the chapter called "Impressionism in History," Schapiro shows how El Greco (he doesn't mention Grünewald) or

Turner, Constable or Delacroix, or even Corot the forerunner, created magnificent atmospheric effects with a quivering screen of painted touches, even to the point of generating proto-mini-Impressionist works in parts of their pictures. Yet they could never wholly abandon shadow and outline, the comely arrangement of objects, the application of episode, allusion, association, and all the rest, or think of yielding the entire surface to a web of strokes with a sovereign, organic life.

Which painters were true Impressionists? Monet is the arch-example, the real thing, never wavering from the original conception throughout his long career, continually proving its further freedoms and limitless range as it filled the changing needs of his art. He is the only one to whom Schapiro devotes a whole chapter. Cézanne, Manet, and Degas are there to show the extreme scope and flexibility of the new mode of painting and the vast differences among its practitioners; Renoir is another standard example, but always less impassioned and imaginative than Monet. Sisley and Pissarro limited themselves to landscape and showed smaller development; Van Gogh, Toulouse-Lautrec and Gauguin, Seurat and Signac are part of a later stage, what Schapiro calls the reaction, during which, in the case of Seurat, the initial free play of the principle was harnessed in a formula at last. Delineation, shading, story returned; but they would never be the same again.

Schapiro compares Monet not only to his predecessor Corot but to Cézanne his contemporary, and early Monet to late Monet, using the same scene painted first in 1871 and then in 1904. He shows Monet more and more seeking "fusion," a gracious increase of harmony among all parts of the canvas, while Cézanne always urges "drama," a harsh opposition among contending forces inside the picture; he finds Corot forever distancing the viewer while Monet includes or engulfs him. Such comparisons are always accomplished through detailed attention to individual works, that passionate attention Schapiro never failed to pay to the delicate, vital, dynamic particulars of the object itself. He doubtless never stopped feeling that individual human freedom truly lives there, deep inside works of art, however mortal it becomes among human institutions.

Titian and Women

When I was an overweight and anxious college freshman, I kept a small reproduction of Titian's *Venus of Urbino* over my desk. While struggling with the desperate unwieldiness of life, I found the picture an inspiration, a solace, a hope, a constant joy. First of all, it was the apotheosis of a plump girl, intensely erotic and supremely beautiful; and then it was a glorious triumph of painting. Titian's technical mastery, conceptual genius, and deep sexual understanding had created both a sublime subject and a sublime object. It hung above my books and papers representing the perfect synthesis of sex and love, art and thought, facts and magic, desire and science. I wanted to be both Venus and her creator.

Venus' young face is sweetly intelligent as she lies naked in her bracelet and earrings. She buries the fingers of one hand in her shadowy pubic fleece and those of the other in a small bunch of roses; she turns her head gently against the pillow and looks sidelong into the viewer's eyes. Her hair is both tidy and careless, both dark and fair, her body expresses both vital sensuality and casual ease, her warm gaze is both electric and untroubled. Her form is harmonious, unmarred by

Review of *Titian's Women* by Rona Goffen (New Haven: Yale University Press, 1997) in *The New Republic*, October 5, 1998.

special erotic emphasis other than her own hand's calm pose. She breathes no whiff of depravity or abandon, of death and corruption under the velvet skin, but she is completely real. Her empty dress is slung over a maid's shoulder, her silky puppy is asleep on the bed, her room is in a sumptuous house. Her surroundings say she is rich; her peaceable curves, in tune with the universe, say she has found the love of her life. Her hand tells us she is thinking of him, her face tells us she is looking at him. The picture says that mighty Aphrodite, who rules the world, is yours alone.

Titian was able to achieve this kind of balance again and again. Hardly any other painter managed to make the pagan deities seem so palpably at home in the modern world—or the Christian saints, the Virgin and her son. Titian had his own personal way of rendering sacredness, Christian or pagan. He managed what seems a naturally random unity, the effect of life itself having brought about, for the sake of this unique revelation, the muted fusion and concord among the pictured elements. Much of this was due to his genius for delicately asymmetrical composition and for subtle facial and bodily expression, with which he could create a blend of the current and the transcendent that seemed to bathe visibly modern persons in the living air of a lost and holy time. For Christian imagery, Titian's master Bellini had already begun creating some of this effect; but Titian in particular could do it with the sensuous universe of the ancient gods.

How could he achieve it? First by being Venetian and inheriting the distinctive Venetian tradition of painting. From Bellini and even more from his colleague Giorgione, Titian learned the secrets of the atmospheric method, the famous *colorito* that the painters of Venice opposed to the Florentine insistence on *disegno*. *Disegno* meant the controlled proportions, clear drawing, and contained modeling on which a central Italian image depended for its authority, of which linear perspective was also a binding element. In the Florentine scheme for painting, where sculpture always seemed the superior model, color was the handmaid of form, casting her warming tints over its cool structures. Venetian painters made color the master, a mode of formal composition in itself. Its subtly layered arrangements—the *colorito*—alone created the proportions, the shapes and the spaces, the mobile light and shade, the drama and the details. Shifts of tone and tint gave Venetian pictures a breathing, immediate air; Florentine pictures aimed at a lucid beauty made of order and stability.

Classical themes went very well in the Florentine scheme, and

learned patrons expected mythological paintings to display the self-conscious clarity, solidity, and linearity that they found in the sculptured remains of Classical art. Patrons in sixteenth-century Venice and neighboring principalities, where actual remnants were rarer, were no less glad to commission visions of Classical antiquity, in the new Humanist spirit. But for their taste, new images reflecting the ancient world would have to seem unselfconscious, naturally sensual and atmospheric—that is, modern Venetian—without being stripped of their antique identity.

For mythological scenes, which he called his "poesie," Titian surpassed the otherworldly Bellini and Giorgone, using the modern Venetian mode as if he were employing the fresh, instinctive methods of an antique painter rendering the nymphs from life. He would not convey an ancient theme simply by quoting in paint from surviving antiquities, most of them sculpture; all Titian's classical references were very carefully modified, as were his many references to the works of his contemporaries and predecessors. He also avoided too-glaringly-modern usages, whenever he suggested the artifacts and costumes of his own time as elements in antique scenes. By this means, he could bring the sacred Venus into a modern bedroom like an impossible dream, her divinity tempered by normal circumstance, the room's actualities suddenly harmonized by her presence.

Rona Goffen's study deals only with Titian's secular and mythological women, stretching that a bit to include the conventionally errant and repentant St. Mary Magdalen, as a companion for Lucretia, the raped and suicidal Roman wife. Titian's other female Christian saints and his various remarkable Virgins are not part of this book, although I wonder why Goffen did not include the vivid *Woman Taken in Adultery* from Titian's Giorgionesque period. Goffen has written two other books and many scholarly articles on Venetian painting and on individual works by Titian and Bellini. *Titian's Women* brings some of the views she has expounded elsewhere to bear on an overarching thesis about Titian's use of women as subjects for painting.

Goffen proposes Titian as a painterly champion of women, a Renaissance feminist expressing his partisanship through his art, the unique exception to a prevailing misogyny expressed through the art of others, as well as in a variety of writings, customs, laws, and everyday assumptions, many of which still prevail. She further proposes that Titian's strong empathy with women, stemming from a deep sense of identification with

them, caused him always to render their sexuality as individual, subjective, and powerful, primary and independent—Venus-like, you might say. Goffen omits Titian's holy women because she presumes there were constraints on his rendering of them; and she may think Titian's sympathy with female sexuality does not appear in his pictures of saints or the Virgin, despite his singularly creative treatment of them. She is more interested in those quasi-allegorical compositions in which Titian exercised complete imaginative freedom, such as the *Woman with a Mirror* or the *Three Ages of Man*, where a shadowy and somewhat inert male is often seen in a close amorous relation with a brilliantly rendered female, whom Goffen sees commanding the scene and dictating the erotic terms.

One of Goffen's apparent reasons for writing this book was to express her impatience with a long tradition of writings, continued by some recent art historians, which insist that Titian's Venuses, together with his anonymous beauties such as *Flora, La Bella, Vanity*, and *Woman in a Fur Coat*, were intended as softcore pornographic images, with the straightforward single aim of sexual arousal. Such an idea seems to have arisen years ago out of Titian's known friendship with the satirist Pietro Aretino, who wrote a lot of very explicit pornography along with much other coarse and scurrilous material he was paid to produce.

Goffen is somewhat overheated in her defense of Titian against this charge, preaching largely to the converted or even beating a dead horse. The tempered beauty of the eroticism in Titian's anonymous women seems obviously at odds with the intentional distortion that is the core of pornographic representation. Plenty of the hard stuff remains from the sixteenth century, to show the required effect at the time; and the soft version—exemplified by the luscious, nipple-exposing, black-eyed dames often rendered by Palma Vecchio, who are excessively blond-haired and half-clad in excessively full and emphatically unfastened chemises—is also unmistakable. These girls are not beautiful, nor are the paintings; but they are both slick and sexy. Instead of instantly pleasing, such paintings and their subjects are instantly troubling, like any pornography, in part because they deliberately seek to avoid either serious pictorial harmony or a serious stake in natural reality. Through Palma's insistence on certain parts and not their sum, many of his pictures show themselves to be forthright sexual fantasies inciting to lust, not dreams of a consuming erotic love, the kind that moves the earth and perhaps the sun and other stars.

Goffen may believe, although she expresses this somewhat obliquely, that Titian's own imagination about sex was the kind often thought of as female; that he understood the sort of sexual desire that may possibly be linked to the capacity for overall corporeal arousal and the possibility of multiple orgasm, but which in any case is a physical desire that is always on tap, so to speak, and thus continually ready to blend with other experiences including complex emotions, thoughts, and ideas. It can be contrasted to that sexual desire which is local and immediate, involving single-minded pursuit, concentrated action, hugely satisfactory release and collapse, followed by total absence of lust and the need to rebuild from the beginning, perhaps with some crude pictorial help.

Titian's *Flora*, who bears the name of an ancient Roman courtesan as well as that of a minor Roman goddess, also wears a fully gathered, sliding-off chemise and a head of artificially blond hair, and you can find one of her nipples if you look for it. But in her portrait Titian is clearly engaging with the larger erotic imagination that is sustained, increased, and deepened by gratification, not one that is quickly fulfilled and exhausted. This painting, unlike so many Palma versions, has been carefully developed and modulated and brought to fruition as an example of perfect artistic and erotic equilibrium, a beautifully composed painting of a beautiful real woman. It bears gazing at for a long time and repeatedly, to permit its slow power and breathing presence to work on the feelings. We are not being shown a female image meant for instantaneous effect. Flora, moreover, is not Venus, who has everything and does everything in every way. This might, as Goffen points out, even be intended as an ideal Lady, here rendered as both an antique courtesan and an ever-fresh flower goddess. There is subtle action in this picture that is missing from Palma's cruder renderings. With her body still facing us, Flora looks downward out of the frame as she begins to turn in the same direction; but she seems to hesitate just an instant before holding out her bouquet to the invisible lover who is not one of us watchers.

Venetian law at the time was severe about excess in clothing, with particular restrictions on the kinds and especially the amounts of fabric used. Stiff fines were imposed on tailors as well as their customers. An extra pinch of daring in Palma's sexy images must have come from the clearly illegal yardage that went into those fluffy undone chemises—

nothing like the restrained slide of Flora's drape. Certainly great Venetian ladies wore elaborate and becoming clothes as necessary complements to their rank and beauty, and powerful families could perhaps discreetly flout the law. Paintings also show that rich ceremonial robes were publicly worn by men in Venetian government and other institutions; but to wear ostentatious clothing as a clear sign of private wealth was not done. Venetian custom, Goffen points out, also imposed a purdahlike behavior on the ladies of its first families, even though they were often the repositories of great fortunes and great names. Ladies rarely went out in the street, they watched public festivals from the window or the balcony, and they certainly did not have their portraits painted. Many Venetian gentlemen did, but their wives were not portrayed to match, as they often were in the other Italian cities.

Meanwhile, Venice was famous for its many highly visible courtesans, some wealthy, literate, and witty as well as beautiful, beautifully dressed, and beautifully housed. Booklets with engravings and descriptions of them were printed for the benefit of foreign visitors. To the dismay of many, their tastefully sumptuous clothes and refined behavior made them indistinguishable from real ladies; and well-connected courtesans also got away with a certain number of illegal excesses of dress without paying the fines. Did they have their portraits painted? They seem to have imitated ladies in this respect, too, at least in not letting their names be attached to any. Titian and Palma were only two of the many Venetian artists who painted nameless beauties wearing elaborate dresses, partial undress, and classical nudity; but Goffen hastens to tell us that there exists no documented and named portrait of any sixteenth-century Venetian courtesan—except one by Tintoretto, now lost, of the celebrated Veronica Franco. Of Titian's named female portrait subjects, all except the two of his own daughter were non-Venetian ladies.

Goffen is so anxious to keep Titian at a distance from dirty-mindedness that she plays down the likelihood that Flora and the Venus of Urbino and all his other Venuses and anonymous dressed-up beauties are portraits of specific courtesans or prostitutes, even though nobody knows which ones; because if you define courtesan as harlot, then "pornography," or picturing whores, would be Titian's crime. And for Goffen, all pornography is nothing but an intolerable assault upon women, a form of rape. Since her main theme about Titian is his deep respect for women's sexuality, she can never read him as veering over

even for a minute into any sixteenth-century sexual attitude she now anathematizes in the twentieth.

She emphasizes instead Titian's preoccupation, and that of other Italian Renaissance painters, with the *paragone*. This meant an aesthetic competition or rivalry, borrowed from antiquity, testing which of the arts best represented Reality or, if you preferred, which best represented Beauty—two aspects, one could say, of Truth. The *paragone* was a malleable idea, variously conceived as existing between Painting and Sculpture, between the Visual Arts and Literature, but also between Sight and Touch or Sight and Hearing, and between the Ancients and the Moderns; and further, by extension, between *disegno* and *colorito*, between rational, sculptural, masculine Florence and sensual, painterly, feminine Venice. It could even precipitate out as a rivalry between Titian and Michelangelo, the two longest-lived titans of High Renaissance Italy. These two—apart from daring to render heaven and Olympus as if they were right here, to bring immortal creatures to life and immortalize the living so you could not tell the difference—were both internationally famous, both the close friends of nobles, kings, and popes; both competing, in fact, for the same clientele. Leonardo da Vinci and Raphael, earlier contenders, were dead and out of the running by 1520, when the later two were just getting fully under way.

But every Italian Renaissance painter's constant rival was Apelles, the famous artist of Greek antiquity, who was the court painter and friend of Alexander the Great. And here is where Goffen's account of Titian's beauties comes in. No work by Apelles survives, only descriptions and anecdotes. The descriptions all include lifelikeness, the painted grapes the birds peck at, the painted person that almost speaks—these indicated to later ages how high the stakes were. The pertinent anecdote was about Apelles' portrait, commissioned by his master, of Alexander's dazzling mistress Campaspe, with whom the king was besotted. Apelles outdid himself in painting her likeness, and Alexander, perceiving from the picture that the painter appreciated her more than he did, rewarded the artist by handing Campaspe over to him. This was considered an equitable exchange: Alexander seems to have found that he liked her better in the picture—a lesson for the ages, indeed. Campaspe's own emotions and behavior had no role in the story, because her character and feelings came to life only in the portrait. Apelles thus deserved to have her, because he knew how to see her, and her true calling was posing for him.

In this suggestive tale Goffen locates the equivalence of a beautiful painting and a beautiful woman, as she interprets its later understanding among Renaissance painters and patrons. A beautiful Titian painting of a beautiful woman would show first of all how well the great modern Venetian outdid his ancient Greek rival; but it would further exemplify the creative beauty of art as an equivalent of the transforming power of love, both simultaneously dwelling in the beautifully pictured beauty of a woman. Patrons would seek to own the beautiful image of a nameless beauty as the quintessential example of Titian's creative genius. Although the model's beauty would be specific and individual—a speaking likeness, alive and erotic—its perfect fusion with the beauty of Titian's picture was what mattered to the patron, not her identity, and presumably what mattered to Titian. Nudity and pointed references to antique goddesses were fine but unnecessary. A beautiful modern dress was appropriate as a setting for a perfect woman in a perfect painting, to exemplify the potent sway of beauty as generated by art. Goffen neglects to say that strong feelings of lust were also appropriate to any viewer of such a work, to its depicted subject, and to its maker—in no way ruled out, and perhaps even intensified, by the larger forces invested in it.

Goffen is amazingly defensive about the idea that loose morals, suggested by their gentle air of erotic readiness, might be attributed to the women who posed for these masterpieces—meaning, why does an anonymous Venetian beauty always have to be a courtesan? One might ask, why not?— especially if respectable ladies never posed in Venice. Does she mean they might really be foreign ladies who would have posed as beauties? Does it matter? Did it then? She points to the portrait of the young, blond, and picture-perfect noblewoman, Joanna of Aragon, painted in a low-necked red dress by Raphael and his pupil Giulio Romano, which might well have been taken for the picture of a courtesan, she says, if subject and artists were not thoroughly documented. She suggests the same of Titian's highly idealized portrait of Isabella d'Este in open-collared rich garb. She also resentfully points to Titian's many portraits of delicious but nameless young men with melting gazes, which are not automatically assumed to represent men who sold their sexual favors.

Goffen appears to be forever fighting her art-historical enemies,

whom she finds assuming that Titian's beauties were all courtesans and the pictures all the equivalent of Palma's most lurid effort, and that courtesans are de facto considered degraded and immoral. She knows that Titian's patrons must have assumed his unnamed Venetian models were whores of some sort, since professional models did not exist, and that such gentlemen were not disposed to despise the beautiful subjects of pictures because of this; a susceptible look was considered a normal female trait and no disgrace. There is even a letter of Titian's saying he preferred his local *puttane* for his "poesie" to the models he might find in Ferrara. Nobody seemed to worry that the Virgins were probably also posed for by whores, with their susceptibility suitably muted. But she seems to fear we have all bought the enemy line, and that we automatically despise anyone dubbed a courtesan. She forgets that some might think worse of those dubbed ladies. Maybe the models were all exceptionally pretty housemaids?

Goffen points out that the woman who posed for *Flora* also posed for both figures in the magnificent and mysterious *Sacred and Profane Love*, now known to have been commissioned as a marriage painting. There she is neither a courtesan nor a goddess, she is a bride. She is not the lady herself, who would not be portrayed in person, but the perfect beauty who stands for two aspects of the bride's being. One wears the wedding dress and myrtle crown with sensual relish, holds the nuptial gift, and gazes alluringly at the bridegroom/viewer; the other one, a draped nude holding a lifted lamp, gazes at her counterpart while lighting love's eternal fire. Together they expound the value, only lately prized in Venice, says Goffen, of the bride's fresh and steady conjugal lust. This had become a primary marital virtue in women, we are told, ever since contemporary medical science had deemed female orgasm necessary for conception and thus for the dutiful perpetuation of dynasties.

The same value and virtue, Goffen explains, is being extolled in the peerless *Venus of Urbino*, plainly by the subject's own gesture. This vision is in fact another marriage picture, but this bride's role is being played by Venus herself, shown as if on her wedding night as she welcomes her approaching bridegroom. Meanwhile, her maids stow her finery in one of her requisite twin marriage chests, both prominent at the back of the room, and the dog in the foreground plays his part as the emblem of

fidelity. We know she really is Venus, too, because her pose imitates Giorgione's celebrated *Sleeping Venus* from a quarter of a century before, whose nearby Cupid (now effaced) identified her then.

The model for this Venus is the same woman who appears as Titian's *La Bella*, still gazing at us with her soft, intelligent eyes, and now wearing a precious dress of gold-embroidered blue to play the Ideal Beauty with all her finery on. The line traced by the two-inch edge of chemise showing above the neckline of this dress is a triumph of nuance, offering perhaps the greatest décolletage in all painting, further set off by a plunging gold chain and the modish thin scarf with which Venetian women would soften the stiff and wide opening of a heavy dress.

Courtesans or fishwives, Flora/Bride and Venus/Bella show that their true calling was posing for Titian, in whatever contexts Titian wished to render them, some of which might well have been sacred. Goffen of course doesn't compare these two with Titian's saints and Virgins from the same decades in his career; but if we are permitted to consider these crossover possibilities for a moment, it looks as if the model for Titian's nude and pensive *Venus Anadyomene* of about 1525 might well have posed for his noble *Pesaro Madonna* in the same year, and certainly received the same sympathetic treatment from the painter in each case. Beauty is its own excuse for being.

Some years after the bridal one, Titian began painting a string of supine Venuses along with versions of a seated Venus looking in a mirror. In all of these, says Goffen, he was engaging with the *paragone* of the senses, demonstrating the supremacy of Sight over Touch and Hearing. He shows Venus redoubling her power by meeting her own gaze in the glass, while one Cupid holds up the mirror and another confirms it by gazing at her. The fur stroking Venus' skin, the caress she gives herself, and the Cupid's touch on her arm are all submitted to the mirror's generative glance, as if to show that the eye creates all sensory joy.

Each of five lush recumbent Venuses lies nude on her couch with a well-dressed musician at her feet, who twists away from his instrument to stare intently at her crotch, or at her breasts as Cupid caresses them. The music continues; but she turns away her head to nuzzle Cupid or receive a garland from his hand, to look at her dog or gaze into space, indifferent to the avid stare that sets the musician's hands in motion, even unwilling to play the flute she sometimes holds. Music cannot

move her; but the sight of her strongly moves the music maker. Titian made the first three of these paintings in the late 1540s and early 1550s, the last two in the late 1560s; and in them all, Venus wears earrings and twin bracelets, a pearl or gold necklace, and well-dressed blond hair; her bed is draped in white linen and heavy silk and shaded by a swagged silk curtain.

A short while later, Titian painted his first *Rape of Lucretia*. In the sixth century before Christ, this virtuous and beautiful Roman wife's legendary rape by the Etruscan prince Sextus Tarquinius, together with her consequent public suicide against the protests of her husband, provoked an avenging Roman revolt against the Tarquins that ultimately established Rome's independence from Etruscan rule. Lucretia is thus the founding heroine of Roman power, not just a symbol of outraged conjugal faith. She is a constant subject in Renaissance art, sometimes nude, sometimes richly dressed, half-dressed, or classically draped, always turning a knife against herself. In the story, she publicly expresses her deep shame after the rape, and her need to kill herself right away lest she prove to be pregnant, or get used to the shame and stop feeling it, lest people begin saying she had enjoyed the deed. Only her instant death will show Tarquin's crime as murderous, forcing instant harsh reprisals. She must give her dishonored life for the cause.

But Goffen has put Lucretia in the same chapter with the Magdalen, the one entitled "Presumed Guilty," because there were indeed doubts of the beauteous Lucretia's absolute chastity and the usual suspicions of her share in the lust of her ravisher. Tarquin raped her by forcing a deal on her: either she submitted and nobody would ever know, or else he would kill her along with a stablehand and put their bodies in bed together. He would then show her husband how his famously chaste wife had grossly dishonored him, while righteously boasting of discovering and killing the guilty couple. Lucretia submitted, but to pressure, not main force. Did her later shame include the memory of guilty pleasure?

Goffen is so outraged by this rape, and by such suggestions, and so convinced of Titian's outrage, that she cannot quite bring herself to observe that he, like many other painters, has built the doubts about Lucretia into his rendering of her. Goffen repeatedly reminds us of the sixteenth-century belief that women's sexual pleasure was much stron-

ger than men's, but she cannot allow her feminist Titian to apply this notion, as so many did and still do, to the grim circumstances of real rape. Goffen is right that Titian paints Lucretia's expression as pure terror, but she will not admit that he has carefully decked her as another lush nude Venus, complete with twin jeweled bracelets, earrings, pearl necklace, elegantly dressed golden hair, richly draped and curtained bed. There are no suggestions of the "torn-away garments" that Goffen would like us to believe in—the gauzy scarf at her crotch is another of Venus' seductive appurtenances. It is Prince Tarquin's rich clothing that is disheveled, his sleeves shoved up, his stocking sliding down, his collar undone. As he lunges up the bed to thrust his knee between her thighs, he looks like her entranced musician at last driven mad by lust, abandoning his lute to draw his knife and force the enticing goddess to look at him for once.

Goffen's eye is deceiving her in one or two other places, notably in her first illustration of Titian's instinct for the female viewpoint, by contrast to his contemporaries. Goffen is impressed by the way Titian, in his early Paduan fresco of a modern-dress *Miracle of the Jealous Husband*, fills the panel with the extreme violence of an unjustly jealous husband's attack on his innocent wife. He holds her by the hair and stabs her repeatedly in the breast as she lies twisted at his feet with her skirt rucked up, in a landscape far from any witnesses. Already this is an outraged Titian, thinks Goffen, feeling the woman's abject terror for her life and physical pain more vividly than any other aspect of this tale, which recounts the several episodes in one of St. Anthony's miracles.

Goffen wishes to contrast this panel with a relief sculpture of the same subject, made a few years later by Dentone and Cosini. This carving shows several anxious figures gathering around in classical costume, as the wife falls over, her head drops, and her husband's fierce hand yanks her upward by the neck of her garment—but Goffen claims the sculptors have "omitted the deadly knife," suggesting that this husband offers milder violence, this wife is less threatened, and even saying this is not a "bloody drama" like the fresco. But it is. This woman's breast, too, is already stabbed, her blood already flows, and the deadly knife is right there, center stage, raised to strike again much as in Titian's version—even though the husband's arm and body are being pulled at by

men who try to stop him and two other people are there to break the lady's fall. Granted this one is more theatrical and Titian's more cinematic, these scenes are equally violent and attentive to the half-killed woman, although her draperies stay decorous in the stone version and there are other people about. Goffen, however, has refused to see the knife and the carved wound with its drops of marble blood, so that her fresco hero can get all the more credit.

Goffen candidly admits that there is very little evidence about Titian's own intimate relations with individual women. What remains is irreproachable, a fact which makes quite easy a positive interpretation of all his painted ones. He lived with one woman named Cornelia, who had their first son in 1524 and became his wife after their second son's birth in 1525. She seems to have died unexpectedly, to Titian's known great sorrow, after the birth in about 1530 of their daughter Lavinia, whom Titian was also known to love very much. Who was Cornelia? Did she ever pose for him as Venus or Virgin? Nothing more is on record about her. Titian never married again, and he had no recorded amorous liaisons with anybody else of either sex, although fictional beloveds were invented for him by later generations. His friend Aretino says that Titian loved flirting with women, kissing and fondling them, or admiring and entertaining them, but that he was no steady frequenter of brothels like Aretino himself—one must assume that he was really too busy.

Index